A Dream in Red
FERRARI
BY MAGGI & MAGGI

Published in 2023 by Welbeck

An imprint of Welbeck Non-Fiction Limited, part of Welbeck Publishing Group.

Offices in: London - 20 Mortimer Street, London W1T 3JW & Sydney - Level 17, 207 Kent St, Sydney NSW 2000 Australia

www.welbeckpublishing.com

A CIP catalogue record for this book is available from the British Library

ISBN: 978-1-80279-483-0

Editor: Conor Kilgallon
Design: Russell Knowles
Picture research: Paul Langan
Production: Rachel Burgess

Printed in China

10 9 8 7 6 5 4 3 2

A Dream in Red
FERRARI
BY MAGGI & MAGGI

A photographic journey through
the finest cars ever made

STUART CODLING

WELBECK

The power of Ferrari is pure seduction. Marque founder Enzo Ferrari well understood the irresistible allure of myth and enveloped himself within it. Even his precise date of birth in 1898 remains a matter of conjecture. Having grown up during the rapid but chaotic industrialization of northern Italy post-unification, Enzo learned the skills of making connections and charming others to do his bidding. Later in life this would serve him well as he retreated to his inner sanctum, relishing his role as a string-puller from the Maranello throne room: success on track, pretty, charismatic, and desirable road cars and the perception of exoticism and unattainability combined to woo eager customers to his door.

The Emilia-Romagna region of Italy is steeped in creativity, craftsmanship and passion for *il dolce vita*. Veterans of the Roman legions were granted parcels of land here upon retirement and took up crafts or worked the soil; in time the area became rightly famed for the richness of its produce and the quality of its artisan metalwork. Come the 20th century, small coachbuilding workshops around the region were pivoting profitably towards the construction of custom bodies for the burgeoning automobile industry.

Enzo's family home was above his father's Modenese workshop and, though he never fulfilled his father's wish of becoming an engineer, the young Enzo observed and absorbed the lessons of the family's passage into the middle class: Alfredo Ferrari acted as designer, craftsman, and salesman, and presided as fastidiously over his paperwork as he did over the products of his trade. The realities of war shattered Enzo's ambitions to become a journalist, singer, or racing driver; he lost his father to pneumonia, his brother to an unrecorded illness, and eventually returned to Modena substantially weakened by the Spanish Flu. There he realized, as he later put it in his autobiography, that he had no family support network, no money and very little education – "All I had was a passion to get somewhere."

First he talked his way into a job as a test and delivery driver with CMN, one of many small car manufacturers spun off from the war industry. There he began to make the connections which facilitated him with opportunities to race and to move on to bigger employers, soon establishing an Alfa Romeo dealership in Modena. The flow of wealthy customers, many with racing ambitions, led him to create his own racing company in 1927 when Alfa temporarily withdrew from grand prix racing. With support from Alfa and Pirelli and the financial backing of moneyed enthusiasts, Scuderia Ferrari acted as a turn-key

racing operation: they stored and prepared the cars, and all the well-heeled customers had to do was arrive at the appointed hour and jump in.

Ferrari's team was ultimately acquired by Alfa Romeo, but Enzo found himself stifled by the removal of his autonomy. This self-confessed "agitator of men", who thrived on promoting creative tension among his underlings, was now an employee himself. The arrangement didn't last, the tipping point coming when Alfa brought in a new design department headed by an outsider, the Spanish engineer Wifredo Ricart.

Ferrari spent World War II making machine tools and aircraft components, relocating his workshop from Modena to Maranello in 1943. Profitable though this was, Ferrari hankered to build racing cars again and these plans were already in train when, in December 1946, his former colleague Luigi Chinetti arrived at the workshop to propose a deal. Chinetti, a successful racing driver, was one of many Italians who had quit Europe for America before the war. He had already established a profitable business selling cars in a country relatively untouched by the hostilities – and he could sell the cars Ferrari was planning to build.

It may be hard to countenance now, but Enzo came only grudgingly to acceptance of the need to build road cars as well as pure-bred racers. What began as a side-project to subsidize Ferrari's racing efforts went on to create some of the most desirable sports cars in automotive history.

In 1984, as the company's 40th anniversary beckoned, Italian photographer Silvano Maggi embarked on a project to catalogue Ferrari's cars for an automotive journal which published images of a production Ferrari and a racing Ferrari every week. During the 1990s Silvano's son Paolo began the similarly daunting task of cataloguing the images, which by then ran to the region of 100,000, including nearly 200 distinct models. While not an exhaustive representation of Ferrari history – a handful of early examples had been destroyed before Maggi's project began or were unavailable at the time – the collection does include some remarkable historic curios, racing esoterica, and one-offs as well as the most significant and evocative Ferrari cars of the company's first 60 years. The Maggi & Maggi archive is believed to be one of the world's most comprehensive collections of Ferrari production-model imagery.

Like Enzo Ferrari's own journey, it began with a dream and was fuelled by passion.

- AUTO AVIO 815
- 125 S
- 166 SC
- 166 MM TOURING BARCHETTA
- 166 INTER COUPÉ
- 166 MM VIGNALE COUPÉ
- 166 INTER STABILIMENTI FARINA

1940s

Auto Avio 815
1940·

ENGINE // 1496CC, INLINE-8

POWER // 54KW (72BHP) AT 5500RPM

CHASSIS // STEEL LADDER

GEARBOX // FOUR-SPEED

TOP SPEED // 164KM/H (102MPH)

WEIGHT // 625KG (1378LB)

One of Enzo Ferrari's first acts after leaving Alfa Romeo in 1939 was to invest his severance pay in setting up a new company, Auto Avio Costruzione (AAC). He had signed a four-year non-competition clause with his former employer and, ostensibly, the new organization was a design office and contract machine shop – but, as Brock Yates put it in his biography of Enzo, "Even as the acrid smell of cordite drifted slowly south over the Alpine peaks, Enzo Ferrari had one final gesture of defiance in mind before Italy plunged into the fighting."

The phoney war was already underway when, in December 1939, Ferrari and fellow Alfa refugee Alberto Massimino drew up plans to build a car which could contest the forthcoming Brescia Grand Prix – essentially a revival of the banned Mille Miglia race. The Marquis of Modena, Lotario Rangoni Machiavelli, underwrote the project and in four months AAC produced two rolling chassis based on components scavenged from Fiat's 508 C Balilla 1100 model, a clever choice since the standard model's handling enjoyed a good reputation and Fiat were offering cash bonuses to class winners using their components. Since the four-cylinder engine was too small, Massimino had a bespoke 1.5-litre straight-eight block cast and adapted two of the Fiat cylinder heads to fit it. Carrozzeria Touring of Milan clothed the chassis in smoothly flowing alloy bodywork which bore a close resemblance to Alfa Romeo's 6C 2500 SS model.

Rangoni and Alberto Ascari dominated the 1.5-litre class in the Brescia event but both cars succumbed to mechanical failure.

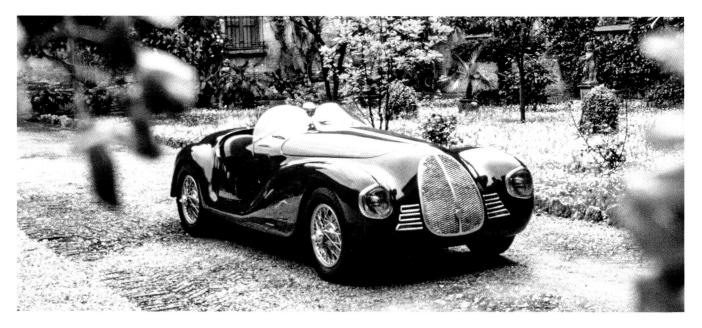

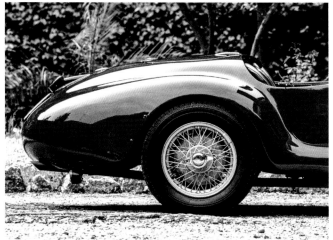

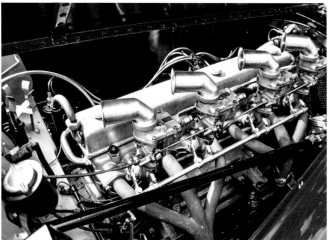

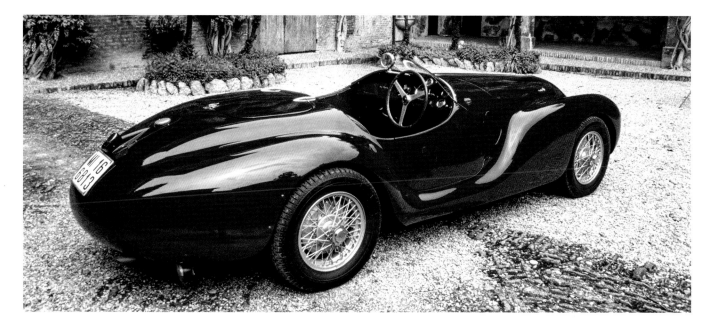

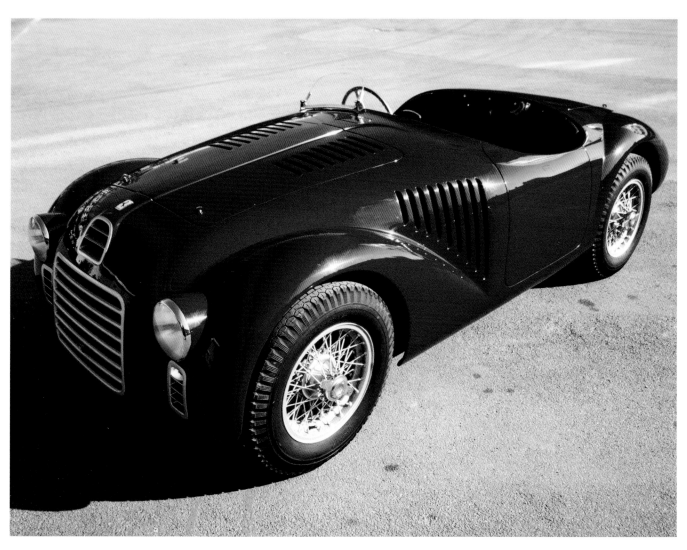

125 S
1947

ENGINE // 1497CC, V12

POWER // 88KW (118BHP) AT 6800RPM

CHASSIS // STEEL LADDER

GEARBOX // FIVE-SPEED

TOP SPEED // 169KM/H (105MPH)

WEIGHT // 650KG (1433LB)

One of Ferrari's origin myths has it that the inspiration to build a V12 engine sprang from Enzo's captivation with a 4.9-litre Packard 299 owned and raced by the Baroness Maria Antonietta Avanzo. Whether this is true or not, Enzo needed someone to design it: this was former colleague Gioacchino Colombo, conveniently unoccupied in mid-1945 when his wartime membership of the fascist party led to him being suspended from Alfa Romeo. Ferrari summoned Colombo from Milan with a simple proposition: "I've had enough of machine tools; I want to go back to making racing cars."

At Ferrari's Modena workshop they agreed on the details of a 1.5-litre V12 and on Colombo's fee, then enjoyed a convivial lunch in a nearby trattoria. Between August and November, when Alfa Romeo decided he was clear to continue in their employ, Colombo sketched out both the new engine and what would become Ferrari's first car, the 125 S sports-racer.

Ex-Alfa engineer Giuseppe Busso and aircraft engine designer Aurelio Lampredi translated Colombo's drawings into a working prototype but several elements were problematic. The short stroke and oversquare piston dimensions theoretically enabled a higher rev ceiling, but made the engine more difficult and costly to manufacture. Further development on the cylinder heads and bearings was required to achieve the performance targets.

Franco Cortese – one of Ferrari's machine tools salesmen – gave the 125 S its competitive debut at the Circuito de Piacenza in May 1947, leading until three laps from the end, when the fuel pump broke. Two weeks later Cortese achieved Ferrari's first victory, in a race around Rome's historic Terme di Caracalla.

166 SC
1948

ENGINE // 1995CC, V12
POWER // 97KW (130BHP) AT 6500RPM
CHASSIS // STEEL LADDER
GEARBOX // FIVE-SPEED
TOP SPEED // 169KM/H (105MPH)
WEIGHT // 630KG (1389LB)

Although it had been challenging to develop the Colombo V12 engine, the fundamental architecture was expandable owing to its 90mm (3.5in) cylinder-centre spacing. Giuseppe Busso had already begun work on a 2-litre version of the V12 as well as adding a supercharger to the 1.5-litre V12 with a view to competing in what would later be called Formula 1. The first iteration of the 2-litre engine, used in the interim 159 S sports-racer and actually closer to 1.9 litres in displacement, was trounced by rival Maserati machinery in competition. When Gioacchino Colombo returned from Alfa Romeo in September 1947, supposedly on a part-time consultancy basis, his hands-on approach alienated Busso to the extent that the younger man left – to join Alfa Romeo.

Colombo redrew the internal dimensions of the engine to a bore-stroke of 60x58.8mm, giving a 1995cc capacity in which each cylinder's swept volume was a fraction over 166cc, from which the cars to be powered by this engine took their names. In this format the V12 would claim its first significant scalps in competition and drive the sales Ferrari desperately required.

1948 would be Ferrari's first year of concerted action on multiple fronts with sports-racing cars and single-seaters. Allemano provided both barchetta and coupé bodies for the first 166 S models and these were soon joined by the SC, a formula-style car but with two seats and cycle wings. It was an ungainly conveyance but one which played a significant role in re-establishing Ferrari's pre-eminence on the racing scene. At the Mille Miglia that May, Ferrari had five cars in play and managed to convince the legendary pre-war ace Tazio Nuvolari to join his driver roster. Nuvolari was supposedly far past his peak, and had wintered at a convent near Lake Garda to mitigate the effects of the lung condition which would claim his life five years later.

Driving a 166 SC as if this were the last race of his life, Nuvolari roared into the lead at a pace which was only slightly impeded when a wing fell off, followed by the car's bonnet. Ignoring the blood he was coughing up, and the protestations of his riding mechanic, Nuvolari pressed on. A broken spring eventually forced him to stop, ceding victory to a 166 S coupé driven by Clemente Biondetti – who, at the prizegiving, publicly apologized to the disappointed Italian public for winning.

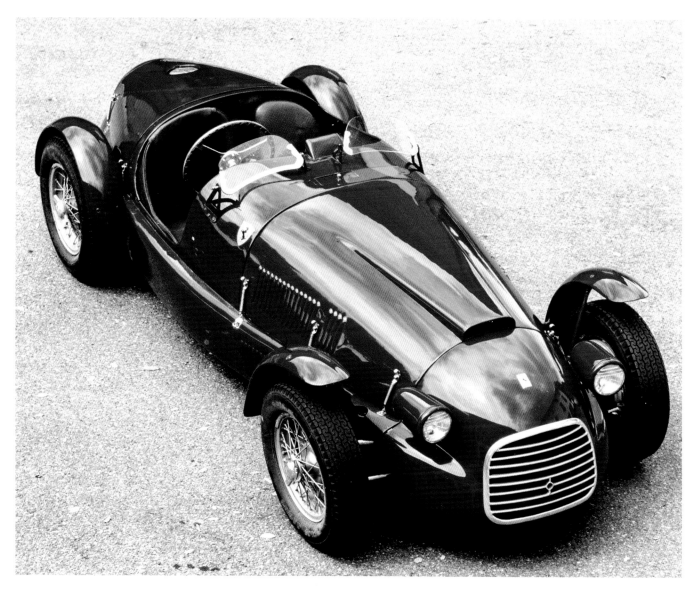

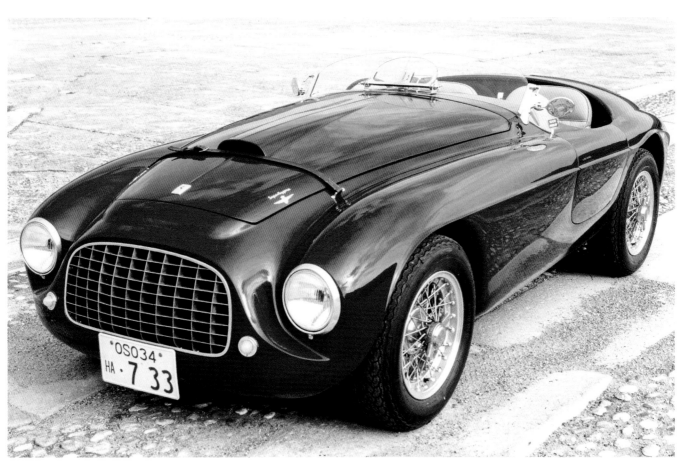

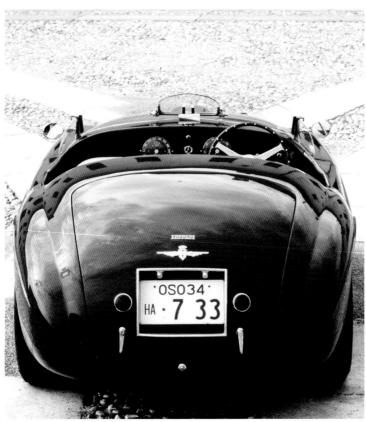

166 MM
Touring Barchetta
1948

ENGINE // 1995CC, V12

POWER // 104KW (140BHP) AT 6600RPM

CHASSIS // STEEL LADDER

GEARBOX // FIVE-SPEED

TOP SPEED // 220KM/H (137MPH)

WEIGHT // 650KG (1433LB)

In September 1948 Ferrari unveiled a car at a motor show for the first time, in Turin. It was a mark of the company's growing repute, as well as healthier finances: it's said that when Enzo Ferrari and Luigi Chinetti held their famous meeting in December 1946, Enzo's office was lit by just one low-wattage bulb and both men's breath misted in the cold air. Now Enzo was about to take the covers off a new purpose-built sports-racing car named after the famous race Clemente Biondetti had won at the wheel of a Ferrari in May: the 166 Mille Miglia, or MM.

Powered by the now-established 2-litre form of the Colombo V12 engine, the first 166 MMs carried elegant and trend-setting bodywork by Carrozzeria Touring. The long bonnet and truncated tail were connected by sweeping lines, with a pronounced rib just below the shoulder line of each flank, leading this version to be christened *barchetta*, meaning "little boat". The distinctive look would influence the design language of future sports cars both in Europe and the USA.

In May 1949 166 MMs finished one-two in, appropriately enough, the Mille Miglia, as Biondetti led Felice Bonetto home by eight minutes over the 1000-mile (1600km) course. But arguably the greatest was yet to come.

Among the many sales brokered by Chinetti was that of a 166 MM to Peter Mitchell-Thompson, the 2nd Lord Selsdon. In the 1939 Le Mans 24 Hours, Selsdon and Lord William Waleran had finished fourth in a V12 Lagonda. For the next running of the event, the first post-war Le Mans, he acquired a 166 MM with Chinetti rostered as co-driver.

Chinetti, then nearing his 48th birthday, was the veteran of seven previous editions of the 24 Hours including two victories. He knew how to win and prepared accordingly. The longevity of the new V12 and its gearbox was the greatest uncertainty ahead of the event, so Chinetti had a reserve oil tank installed in the cockpit where it could easily be refilled. He also drove the majority of the race solo – accounts vary as to how he engineered this – leaving Selsdon to take the wheel for just over an hour shortly before 4.30am on the Sunday, once Chinetti had established a three-lap lead.

In the final hours the clutch began to slip but Chinetti nursed the 166 home a lap ahead of the second-placed Delage, recording Ferrari's most significant victory yet.

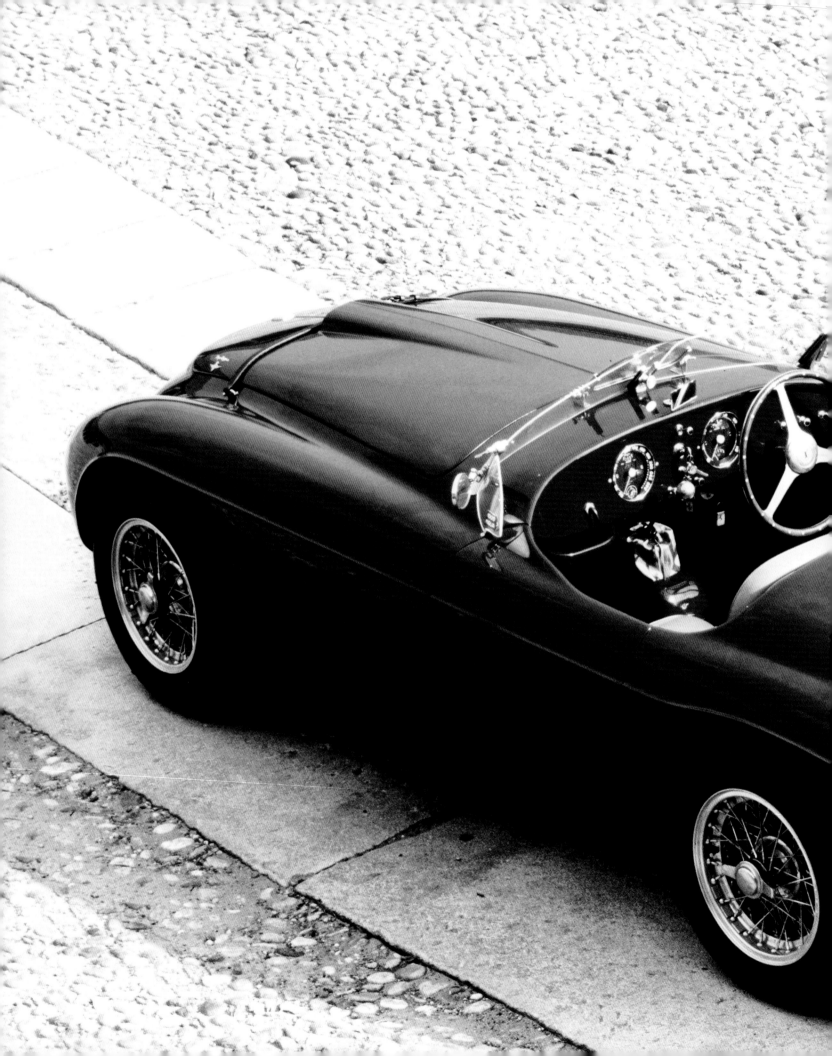

166
Inter Coupé
1949

ENGINE // 1995CC, V12

POWER // 67KW (90BHP) AT 6000RPM

CHASSIS // STEEL LADDER

GEARBOX // FIVE-SPEED

TOP SPEED // 169KM/H (105MPH)

WEIGHT // 800KG (1764LB)

Though Enzo's focus remained on racing, the proliferation of specialist coachbuilders made it relatively simple for Ferrari to offer road-going cars based on racing architecture: the rolling chassis could be shipped off for a customer-spec body and interior to be added by the outside contractor. Thus Ferrari's first road-going GT was born – and the 166 Inter, first shown at the Paris Motor Show in October 1949, was very much a race car for the road.

A wheelbase 220mm (8.7in) longer than the 166 MM enabled the two-seater's cockpit to be more generously proportioned than its racing cousin, and the engine was detuned slightly to make it feel more tractable for everyday use. Later models received an 80mm (3.1in) longer wheelbase and a 11kw (15bhp) bump in power.

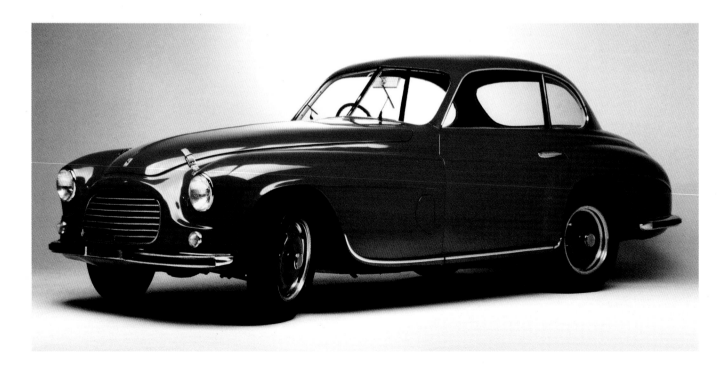

166 MM
Vignale Coupé
1949

ENGINE // 1995CC, V12

POWER // 97KW (130BHP) AT 6000RPM

CHASSIS // STEEL LADDER

GEARBOX // FIVE-SPEED

TOP SPEED // 169KM/H (105MPH)

WEIGHT // 800KG (1764LB)

While the majority of 166 MM chassis were clothed in open-top barchetta bodywork by Carrozzeria Touring of Milan, a handful were produced in enveloping coupé or berlinetta bodywork. Vignale produced the coachwork for two of the series-one 166 MM chassis: one in a barchetta style characterized by a more rounded nose and wings than the Touring 166 MMs; the other as a two-seat coupé with a steeply sloping roofline. Even more unusually, this car was right-hand drive. Contemporary photographs show it with front and rear chrome bumpers for road use, as well as with the bumpers removed for racing.

Vignale also rebodied at least one 166 MM Touring barchetta as a coupé, for José Froilán González – winner of Ferrari's first world championship grand prix.

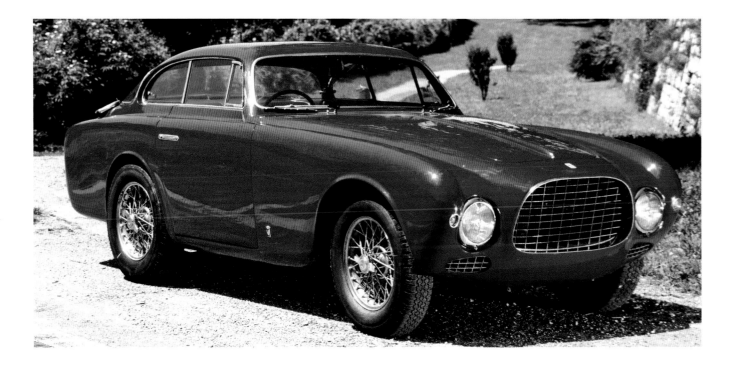

166 Inter Stabilimenti Farina
1949

ENGINE // 1995CC, V12

POWER // 67KW (90BHP) AT 6000RPM

CHASSIS // STEEL LADDER

GEARBOX // FIVE-SPEED

TOP SPEED // 169KM/H (105MPH)

WEIGHT // 800KG (1764LB)

Stabilimenti Farina had been founded by Battista "Pinin" Farina's elder brother Giovanni in 1919, but its work would later be outshone by those who had learned their trade within this Milanese coachbuilder's walls: Alfredo Vignale, Giovanni Michelotti, Pietro Frua, Mario Boano and Battista himself worked there in their formative years. By 1949 day-to-day management had passed to Giovanni Farina's son Attilia (the older son, Giuseppe, was a successful racing driver and about to become the inaugural Formula 1 drivers' champion).

The company is believed to have provided the coachwork for nine Ferrari road cars, all 166 Inters – including the first convertible Ferrari, unveiled at the 1949 Geneva Motor Show. In common with Stabilimenti Farina's other output at the time, mostly based on Fiat 1100s, the styling was rather conservative, although each varied in detail according to customer preference. Just three convertibles were built.

Though Luigi Chinetti quickly began to realize his ambition of making sales in the US market, early owner experiences highlighted the risks involved in buying such exotica built far from home. One such, the Bowman's Dairy heir and well-known automobile collector D. Cameron Peck, sent the family chauffeur by train from Chicago to New York to collect his Farina-bodied Inter Coupé from the docks and drive it home; the V12's timing chain worked loose outside Pittsburgh, marooning the hapless driver and requiring Peck to dispatch another car with a trailer. The engine needed a rebuild which had to be performed at Maranello, owing to the lack of Ferrari spares in the US at the time.

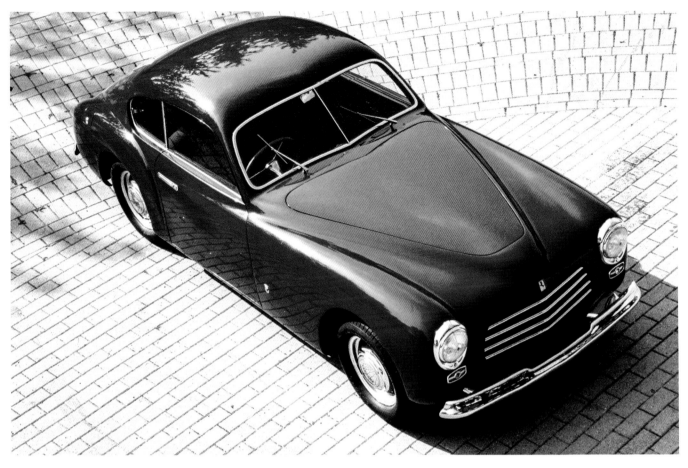

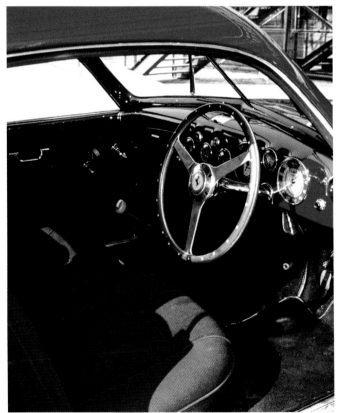

- 195 S
- 195 INTER COUPÉ VIGNALE
- 195 INTER COUPÉ GHIA
- 166 INTER AERLUX
- 166 MM BERLINETTA LE MANS
- 340 AMERICA COUPÉ
- 340 AMERICA BARCHETTA
- 212 EXPORT COUPÉ
- 212 EXPORT MOTTO SPYDER
- 212 TUBOSCOCCA
- 212 EXPORT BERLINETTA GHIA-AIGLE
- 212 EXPORT UOVO
- 212 INTER COUPÉ
- 340 AMERICA GHIA
- 342 AMERICA CABRIOLET
- 225 S BARCHETTA
- 225 S COUPÉ
- 225 S SCUDERIA GUASTALLA
- 340 MILLE MIGLIA
- 375 MILLE MIGLIA SPYDER
- 375 MILLE MIGLIA COUPÉ
- 212 EXPORT
- 250 MILLE MIGLIA SPYDER
- 250 MILLE MIGLIA BERLINETTA
- 250 EUROPA

- 500 MONDIAL BARCHETTA
- 500 MONDIAL COUPÉ
- 250 MONZA
- 375 PLUS
- 750 MONZA
- 250 EUROPA GT
- 500 MONDIAL SERIES II
- 121 LM
- 250 GT
- 860 MONZA
- 250 GT BERLINETTA COMPETIZIONE
- 290 MILLE MIGLIA
- 500 TR
- 500 TR/625 LM
- 250 GT TOUR DE FRANCE
- 250 GT SPECIALE
- 335 S
- 4.9 SUPERFAST
- 250 GT CALIFORNIA SPYDER
- 250 TESTA ROSSA
- 250 GT CABRIOLET
- 500 TESTA ROSSA COMPETIZIONE
- 250 GT CABRIOLET SERIES II
- 250 GT SWB

1950s

195 S
1950

ENGINE // 2341CC, V12

POWER // 127KW (170BHP) AT 7000RPM

CHASSIS // STEEL LADDER

GEARBOX // FIVE-SPEED

TOP SPEED // 200KM/H (124MPH)

WEIGHT // 720KG (1587LB)

The Colombo V12's next expansion would be a modest increase to 2.3 litres, by widening the bores rather than lengthening the stroke – a relatively easy adjustment to make given the spacing of the bores in the original design. This gave a displacement of 195cc per cylinder and four 166 MM chassis were converted to accommodate the new engines and redesignated 195S.

The cars' first appearance was almost by stealth, given the nature of the conversion. Ferrari entered two 195 Ss, a barchetta-bodied one for Alberto Ascari and a coupé for Giannino Marzotto, in the 1950 Targa Florio. Neither car made the finish: Ascari was laid low by an oil leak while Marzotto stopped to help a fellow competitor.

This didn't dissuade Ferrari from supplying three 195 Ss for that year's Mille Miglia, barchettas for Dorino Serafini and Vittorio Marzotto and a coupé for Giannino. The Marzotto brothers, scions of a wealthy textile dynasty, had founded their own team in the late 1940s and Giannino would emerge as one of the pre-eminent gentleman drivers of the 1950s – Enzo Ferrari likened his approach to that of pre-war ace Achille Varzi.

The 22-year-old Giannino also grabbed attention with the colour of his race car – a light blue rather than the usual Italian racing red – and his garb, a double-breasted suit which he would later claim he had worn throughout the event. After over 13 and a half hours of racing through some of the least clement weather endured by Mille Miglia entrants in years, Marzotto emerged victorious – his suit only lightly dampened by water ingress in the cockpit.

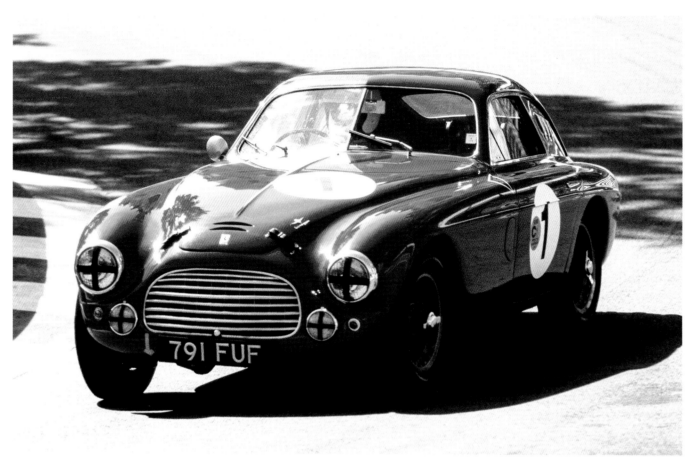

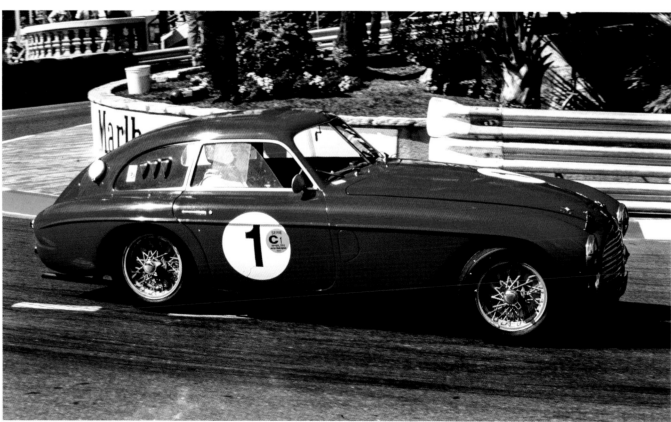

195 Inter Coupé Vignale
1950

ENGINE // 2341CC, V12

POWER // 97KW (130BHP) AT 6000RPM

CHASSIS // STEEL LADDER

GEARBOX // FIVE-SPEED

TOP SPEED // 200KM/H (124MPH)

WEIGHT // 950KG (2094LB)

The relatively new Carrozzeria Vignale had delivered a handful of impressive bodies for Ferrari cars and the company was the first to be tasked with clothing the "street" 195 chassis, with a larger wheelbase (2500mm/98in), as per late-model 166 MMs) and running a single-carb version of the enlarged V12. Alfredo Vignale had apprenticed for both Farina brothers and made kitchen implements in his basement to put together the funds to establish his own company.

Vignale regularly collaborated with Giovanni Michelotti and it is claimed by some that Michelotti drew his 195 design at 1:1 scale and Vignale, lacking certain tools of the trade, beat out the aluminium body panels using a tree stump. Certainly the 12 195 Inter coupés and sole berlinetta built by Vignale are relatively restrained in comparison with some of the carrozzeria's more ostentatious later works.

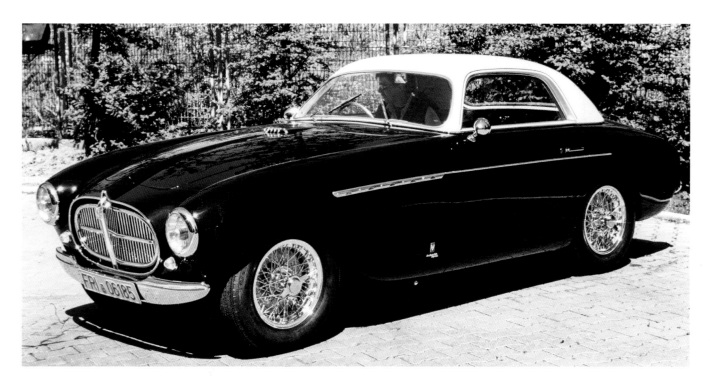

195 Inter Coupé Ghia
1950

ENGINE // 2341CC, V12

POWER // 97KW (130BHP) AT 6000RPM

CHASSIS // STEEL LADDER

GEARBOX // FIVE-SPEED

TOP SPEED // 200KM/H (124MPH)

WEIGHT // 950KG (2094LB)

Co-founded by Giacinto Ghia, in 1916, the Turin-based Carrozzeria Ghia attained prominence building bodies for sporting models by Fiat, Lancia, and Alfa Romeo between the wars. Following Giacinto's death from a heart attack in 1944, his friends Mario Boano and Giorgio Alberti acquired the company and completed the rebuilding of its bombed-out factory.

Ghia built a number of early Ferraris until the mid-1950s, including 11 coupé bodyshells based on the 195 chassis – three of which featured a so-called "2+2" cabin with minimal accommodation for two rear passengers. Besides differences in shape and proportion around the hips and tail, the Ghia 195s were distinguished by much larger radiator grilles and broad chrome bumpers; some were offered with split bumpers and slightly recessed headlights according to customer preference.

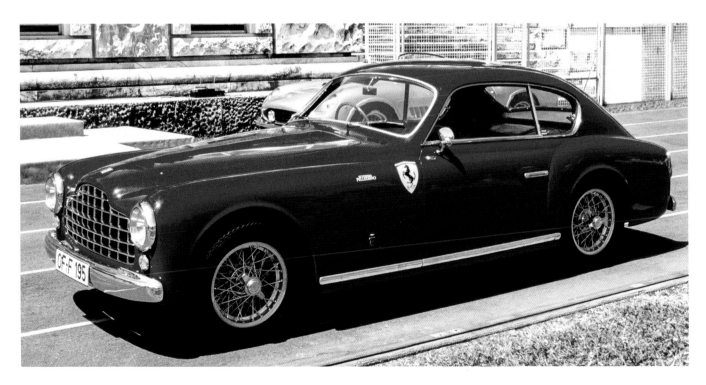

166
Inter Aerlux
1950

ENGINE // 1995CC, V12

POWER // 75KW (100BHP) AT 6000RPM

CHASSIS // STEEL LADDER

GEARBOX // FIVE-SPEED

TOP SPEED // 185KM/H (115MPH)

WEIGHT // 800KG (1765LB)

Ferrari commissions for Carrozzeria Touring began to decline in the 1950s as the company's designs drifted into conservativism, though Federico Formenti – who styled the seminal 166 MM barchetta at Touring – went on to create the classic Aston Martin DB4 shape, among others. Among the personalization options Touring offered to customers was their "Aerlux" plexiglass sunroof, a feature generally limited to the luxury car market.

Touring built a single 166 Inter berlinetta model with an Aerlux sunroof, chassis 047S, finished in bright red for a customer in Varese, Italy, who later had the engine upgraded to three-carburettor specification. Present owner Peter Carlino, CEO of the Pennsylania-based Carlino Financial Corporation, undertook a full restoration in the early 2000s during which he had the car repainted dark blue.

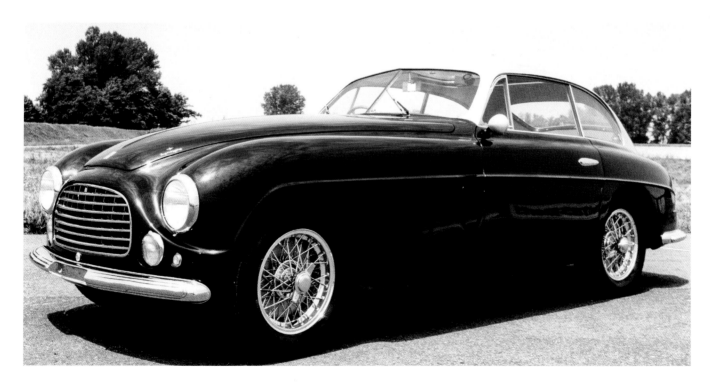

166 MM
Berlinetta Le Mans
1950

ENGINE // 1995CC, V12

POWER // 104KW (140BHP) AT 6600RPM

CHASSIS // STEEL LADDER

GEARBOX // FIVE-SPEED

TOP SPEED // 188KM/H (117MPH)

WEIGHT // 650KG (1433LB)

Carrozzeria Touring built six berlinetta-bodied 166s using their patented "superleggera" technique, in which the bodywork structure was a framework of intricately welded narrow-gauge tubes to which ultra-thin aluminium panels were fitted. The technology was influenced by World War I aeroplanes, which had used fabric stretched over a wooden frame.

Launched at the 1950 Geneva Motor Show, the Berlinetta Le Mans was clearly built for racing, as evinced by its plexiglass windows and minimalist interior trim. But despite Chinetti's win at Le Mans the previous year, putative owners were sceptical of its potential. At least one of the factory cars was fitted with the 195 engine before being fielded in competition and a number of customers also requested the larger V12, including US racer and collector Briggs Cunningham.

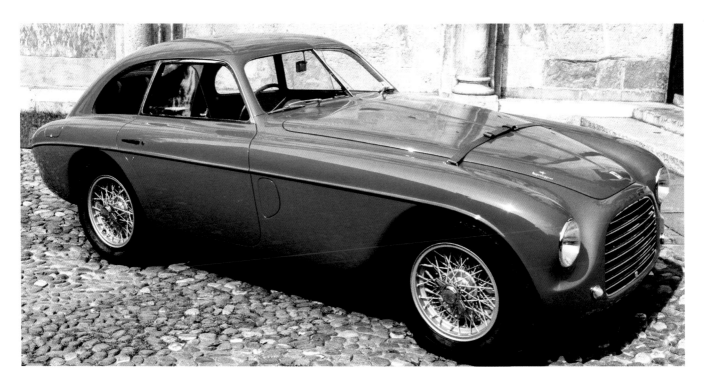

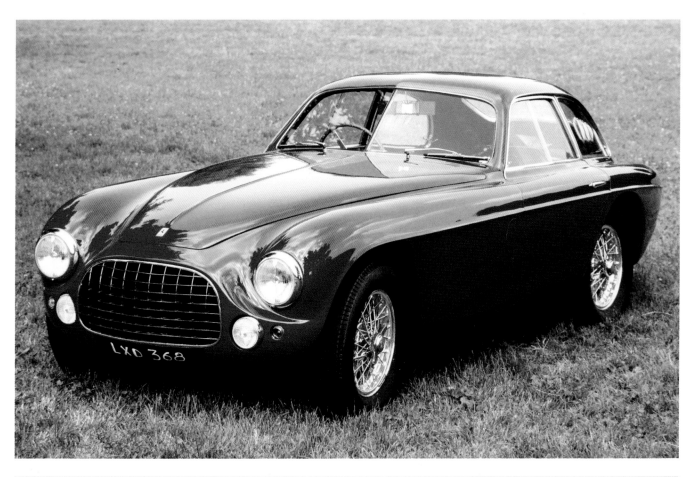
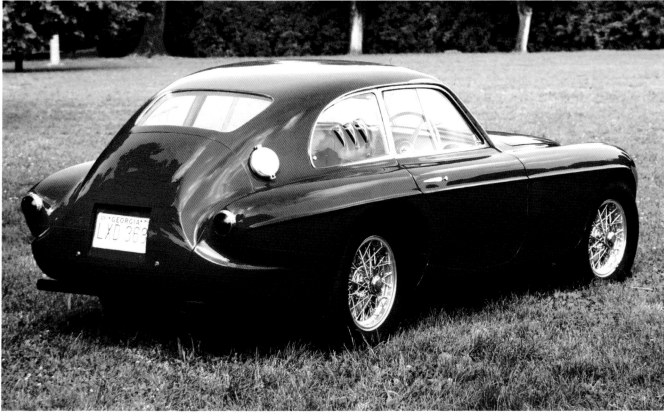

340
America Coupé
1951

ENGINE // 4101CC, V12

POWER // 164KW (220BHP) AT 6000RPM

CHASSIS // STEEL LADDER

GEARBOX // FIVE-SPEED

TOP SPEED // 188KM/H (117MPH)

WEIGHT // 900KG (1984LB)

Ground-breaking as the Colombo V12 was, it had proved troublesome in the early stages and tensions had developed within Ferrari's engineering department as they laboured to make it work in top-level racing. Fitted with twin-cam cylinder heads and a supercharger for Formula A/1, the 1.5-litre unit was prone to overheating and its power delivery was like a light switch. Giuseppe Busso's departure, following disagreements with Gioacchino Colombo, opened the way for the talented young engineer Aurelio Lampredi to return to the company, having initially quit after a few months because of frictions with Busso.

Relations with Colombo were not always cordial but Lampredi was able to advance his own idea of a new V12. This shared some philosophies with Colombo's but would be larger, more rugged and produce more torque, ultimately capable of racing in grands prix in 4.5-litre naturally aspirated form, where its driveability and relative frugality would compensate for any power deficit to the Alfa Romeos that were dominant at the time.

Work began in the summer of 1949 and, by mid-1950, the new V12 was ready for evaluation in the grand prix cars. Once proven in competition, it made its way into other Ferrari road and race cars. The 340 America – named after its target market – was powered by the interim 4.1-litre version of the Lampredi V12, which displaced 340cc per cylinder. Touring and Vignale provided the majority of the bodyshells, in open-top and closed-cockpit styles on slightly lengthened chassis. The Touring-bodied berlinetta featured here is one of only two such cars built, both using the Carrozzeria's patented "Superleggera" construction technique.

340
America Barchetta
1951

ENGINE // 4101CC, V12

POWER // 164KW (220BHP) AT 6000RPM

CHASSIS // STEEL LADDER

GEARBOX // FIVE-SPEED

TOP SPEED // 188KM/H (117MPH)

WEIGHT // 900KG (1984LB)

Carrozzeria Touring provided the shells for eight 340 Americas, two berlinettas and six barchettas, and the styling of both were evocative of the successful 166 MM. Ferrari's improving form in grand prix racing after adopting the Lampredi long-block V12 design proved highly enticing to amateur racers who wanted to follow the example of Luigi Chinetti.

 While some 340 Americas were customer-specified to be finished and trimmed for road use, the majority were destined for competition. Four of the nine Ferraris entered for the 1951 Le Mans 24 Hours were 340 Americas, including one acquired by World War II bomber pilot, amateur racer and heir to the Louis-Dreyfus agricultural business, Pierre Louis-Dreyfus – who engaged pre-war ace Louis Chiron as his co-driver and employed Chinetti's organization to run the car. They were disqualified but Chinetti and Jean Lucas finished eighth in a barchetta-bodied 340.

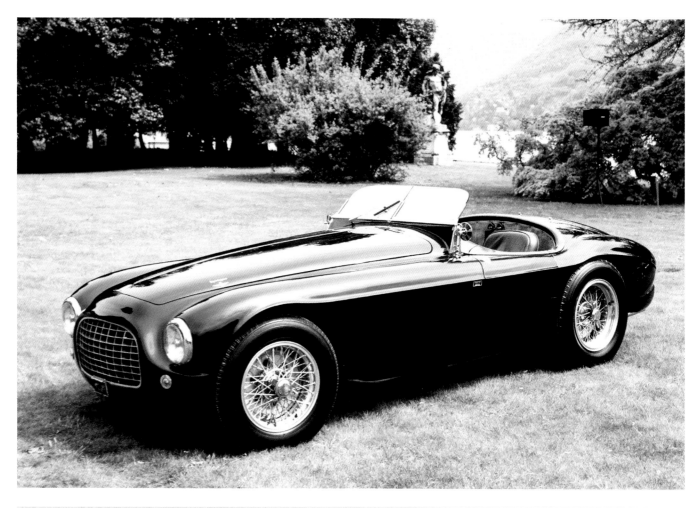

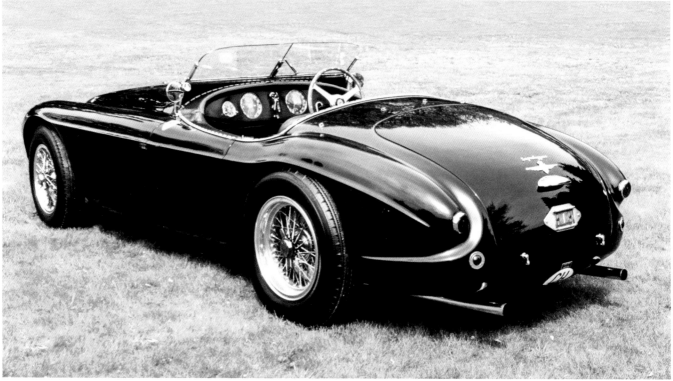

212
Export Coupé
1951

ENGINE // 2562CC, V12

POWER // 127KW (170BHP) AT 6500RPM

CHASSIS // STEEL LADDER

GEARBOX // FIVE-SPEED

TOP SPEED // 219KM/H (136MPH)

WEIGHT // 800KG (1764LB)

Ferrari's expansion into overseas markets called for more tractable engines – American buyers in particular found the peaky characteristics of the Gioacchino Colombo V12 not to their taste. Before departing for Alfa Romeo in January 1951, Colombo oversaw another expansion of his engine, widening the bores to take it to just over 2.5 litres.

Models carrying this engine would carry the 212 designation based on the swept capacity of each cylinder, though it is understood that the first model carrying the 212 Export name, a Vignale-bodied cabriolet displayed at the Turin show in April 1951, was based on the chassis of the 166 SC raced by Tazio Nuvolari in the 1948 Mille Miglia. Production models used a new chassis of similar design but with stronger members and more bracing to handle the extra power.

While the 212 Export was conceived as a racing model, customer preferences dictated the finishing and, as such, each of the 27 cars built differed – some substantially. A handful never saw action on track.

The 212 Exports built by Carrozzeria Touring – eight barchettas, four berlinettas – all broadly followed the same exterior styling template as that coachbuilder's genre-defining 166 MM. Examples finished by Carrozzeria Vignale to Giovanni Michelotti designs – three spyders, seven berlinettas – are generally considered more distinctive and appealing. The closed-roofed Vignale 212 Export pictured here was arguably the most successful in competition, entered by Scuderia Guastalla and driven to victory in the 1951 Rallye du Maroc by Jacques Peron, who was second overall in the Tour de France that year, and ninth at the Le Mans 24 Hours in the same car.

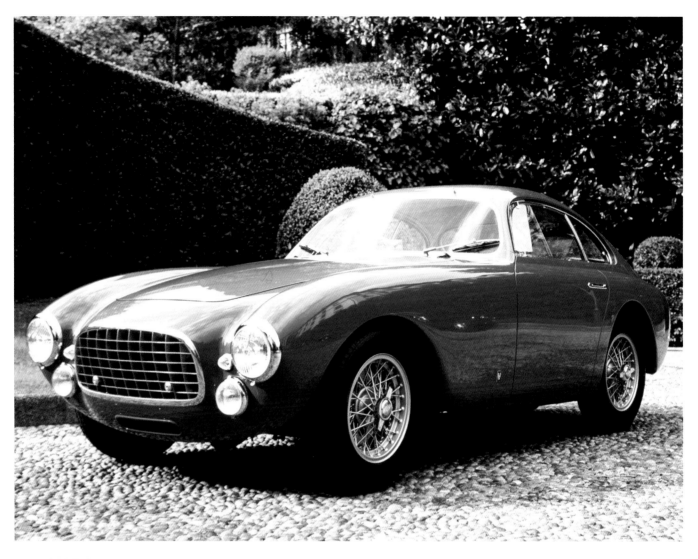

212 Export Motto Spyder
1951

ENGINE // 2562CC, V12

POWER // 127KW (170BHP) AT 6500RPM

CHASSIS // STEEL LADDER

GEARBOX // FIVE-SPEED

TOP SPEED // 219KM/H (136MPH)

WEIGHT // 800KG (1764LB)

Of the circa 27 212 Export cars sold, it is believed just two were bodied by the Torinese coachbuilder Carrozeria Motto, better known for building sportscars based on Fiat 1100S underpinnings. Company founder Rocco Motto had been orphaned in World War I and learned the metalworking trade as a teenage apprentice.

The prolific but low-profile Motto usually badged his cars with a "Ca-Mo" emblem – his company's telex address. Among the customers who found their way to his workshop was Sicilian mineral water bottler and amateur racer Piero Scotti, for whom Motto crafted a distinctive aluminium "Spyder" bodyshell with a third headlight placed below the radiator grille. Scotti placed third overall in the 1951 Mille Miglia and campaigned the car throughout the year, winning several hillclimb events before selling it on and buying a 340 America.

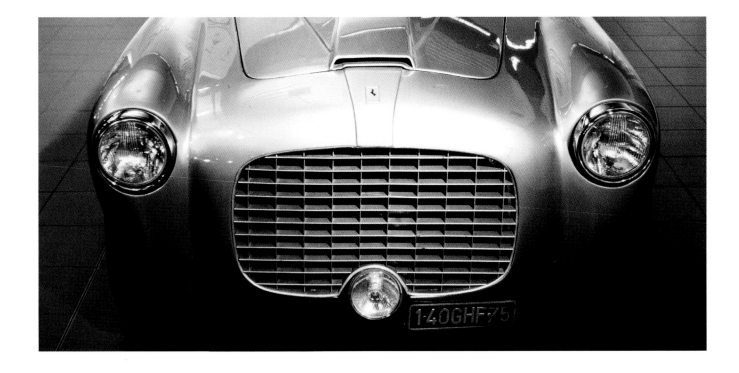

212
Tuboscocca
1951

ENGINE // 2562CC, V12

POWER // 127KW (170BHP) AT 6500RPM

CHASSIS // STEEL LADDER

GEARBOX // FIVE-SPEED

TOP SPEED // 219KM/H (136MPH)

WEIGHT // 800KG (1764LB)

While it was convenient to base cars on a conventional ladder-frame chassis, this philosophy had limited torsional rigidity and became less fashionable when alternatives proved to be better. Chassis flex was a known issue with Ferrari's grand prix cars, contributing to unpredictable handling characteristics, and the company's road cars had already reached a point where power was exceeding the capabilities of the underpinnings.

Gilberto Colombo's Gilco company is claimed to have built all Ferrari's chassis until 1958. In the late 1940s it designed an alternative in the form of the "Tuboscocca", essentially a cage formed by straight and bent tubes. A handful of Ferrari models were built around this structure in the early 1950s, though they were indistinguishable from ladder-chassis equivalents from the outside.

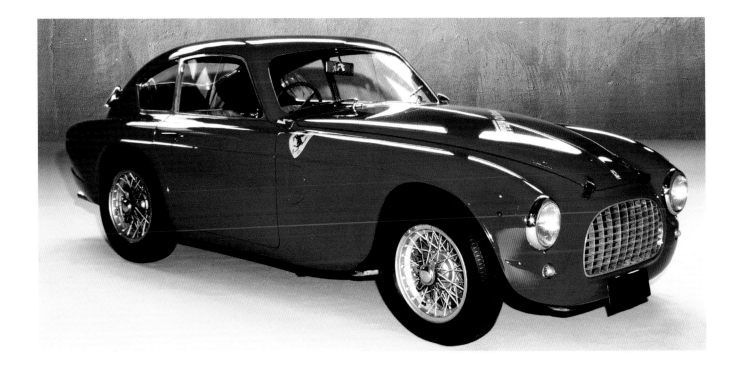

212 Export Berlinetta Ghia-Aigle
1951

ENGINE // 2562CC, V12

POWER // 127KW (170BHP) AT 6500RPM

CHASSIS // STEEL LADDER

GEARBOX // FIVE-SPEED

TOP SPEED // 219KM/H (136MPH)

WEIGHT // 800KG (1764LB)

Founded by Torinese physician and garage owner Dr Pierre-Paul Filippi, and named after his Swiss city of residence, Carrosserie Aigle's principal business was building caravan bodies. However, it also coachbuilt cars and had negotiated a licence to use the Ghia name and designs. Ghia-Aigle built two coupés on 212 chassis, commonly believed to be the long-wheelbase Inter model, although one of them is identified as an Export on its chassis plate – a cause of some controversy in historic car circles.

 If the styling seems familiar, this is because the design was executed by Giovanni Michelotti, then working with both Ghia and Vignale. The much-debated chassis 0137 E, pictured here, is now owned by Japanese musician and TV personality Masashi Tashiro, while the second is believed to be in the hands of an Australian collector.

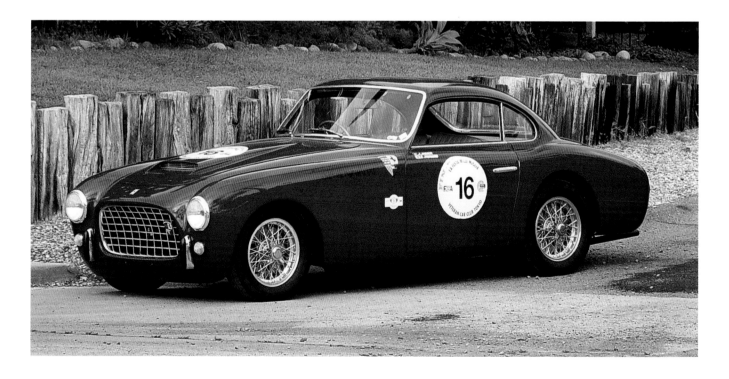

212 Export Uovo
1951

ENGINE // 2562CC, V12

POWER // 127KW (170BHP) AT 6500RPM

CHASSIS // STEEL LADDER

GEARBOX // FIVE-SPEED

TOP SPEED // 225KM/H (140MPH)

WEIGHT // 650KG (1433LB)

Another contributor to the inexact number of 212s produced is the curious one-off known as "Marzotto's Egg", a car reputed to have rendered Enzo Ferrari speechless with horror when he first laid eyes upon it. As Giannino Marzotto raced to victory dressed in a double-breasted suit at the wheel of a 195 S in the 1950 Mille Miglia, brother Umberto crashed out in his 166 MM. Giannino sent the repaired car to Carrozzeria Fontana of Padua for a money-no-object refit which included a 212 engine and a peculiar bodyshell designed by Franco Reggiani, soon to become a famous sculptor.

The shell bore similarities to Touring's superleggera bodies, in which a delicate tube frame supported thin alloy plates, saving significant weight. Unfortunately the unavailability of a Formula 1-spec radiator dictated a higher nose and body height than originally envisaged.

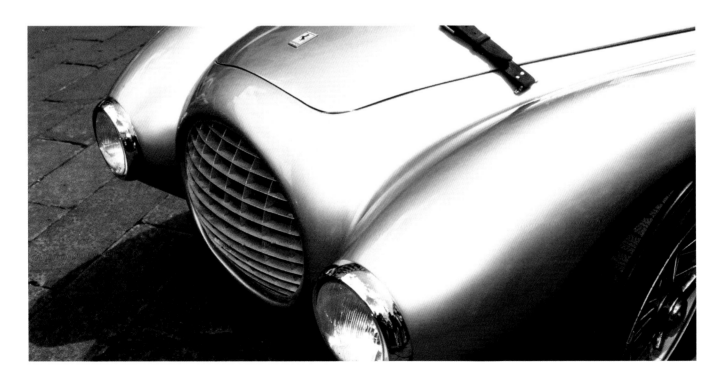

212
Inter Coupé
1951

ENGINE // 2562CC, V12

POWER // 127KW (170BHP) AT 6000RPM

CHASSIS // STEEL LADDER

GEARBOX // FIVE-SPEED

TOP SPEED // 201KM/H (125MPH)

WEIGHT // 800KG (1764LB)

Based on a longer (2600mm/102in rather than 2250mm/89in) wheelbase than the sport-focused 212 Export, the 212 Inter offered a softer-edged experience and most models built were outfitted as luxurious grand tourers. Like the 195 Inter it succeeded, the car was initially fitted with just one Weber 36DCF carburettor, though later models were equipped with three 32DCFs. Just over 80 are believed to have been built – as with many early Ferraris, inexactitude in paperwork and the tendency of chassis plates to migrate between cars has led to shifting identities.

Vignale were responsible for around 25 212 Inter Coupés in a variety of styles. The first cars cleaved to the template of Michelotto's earliest designs for Vignale Ferraris; later cars were far more flamboyant, with bulbous front wings, tail fins and lashings of chrome trim.

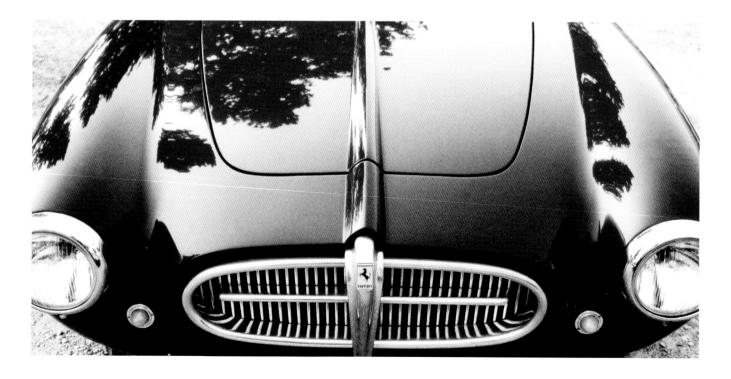

340
America Ghia
1951

ENGINE // 4101CC, V12

POWER // 164KW (220BHP) AT 6000RPM

CHASSIS // STEEL LADDER

GEARBOX // FIVE-SPEED

TOP SPEED // 240KM/H (149MPH)

WEIGHT // 900KG (1984LB)

Over the course of 1951 and 1952 Carrozzeria Ghia completed four 340 America models, all in a coupé body style. Unusually for this car, which was conceived with competition in mind, none of these examples were raced and two of them went straight to customers based in the US. This may have informed the more sober styling treatment, with a more pronounced chrome radiator grille, and a more rounded cabin featuring a greater expanse of glass and room for two small passengers behind the front seats.

While Ghia's interpretation may not have elicited much enthusiasm from Ferrari (the modern corporate history describes the Ghia 340 America as "quite staid"), it has the distinction of being the first Ferrari road car sold in the UK. Aston Martin owner David Brown bought the example first displayed at the 1951 Paris Motor Show.

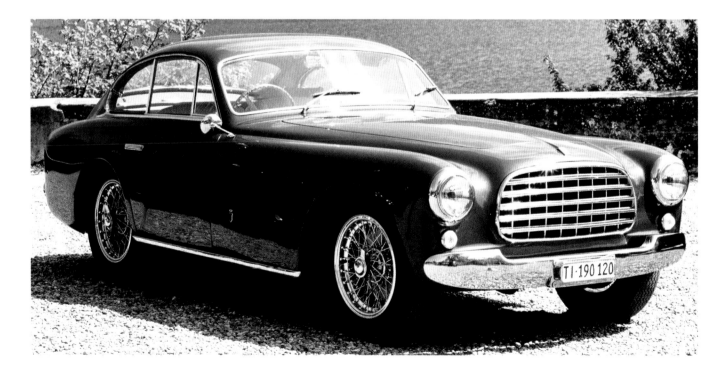

342
America Cabriolet
1952

ENGINE // 4101CC, V12

POWER // 149KW (200BHP) AT 5000RPM

CHASSIS // STEEL LADDER

GEARBOX // FOUR-SPEED

TOP SPEED // 185KM/H (115MPH)

WEIGHT // 1200KG (2646LB)

Whereas the 340 America was designed with competition in mind, and to prove the new Aurelio Lampredi-designed long-block V12 concept, the 342 America represented Ferrari's first concerted effort to build a road car that was slightly more than just a detuned racer with a luxurious interior. Despite the change in nomenclature, the engine retained the same 4.1-litre displacement. It was tuned to deliver its power at lower revs and with a broader torque curve, enabling a less racy four-speed synchromesh gearbox to be fitted. Detail changes such as swapping from dry-sump to wet-sump lubrication were all aimed at making the car more suited to life on the road, where it would be serviced less often.

Accommodation – or lack thereof – had also been an issue with the 340 America. To that end, its successor was based on an extended chassis with a longer (2650mm (104in)) wheelbase, enabling the engine to be mounted further forwards and freeing up room for a more spacious cabin.

The 342 America also advanced Ferrari's transition towards working solely with Pinin Farina. The Torinese coachbuilder provided the bodyshells and finishing for all three of the 342 America coupés, and two of the three cabriolets. Belying the "America" tag, the Farina-built example pictured here was commissioned by King Leopold III of Belgium, although it now resides in the USA.

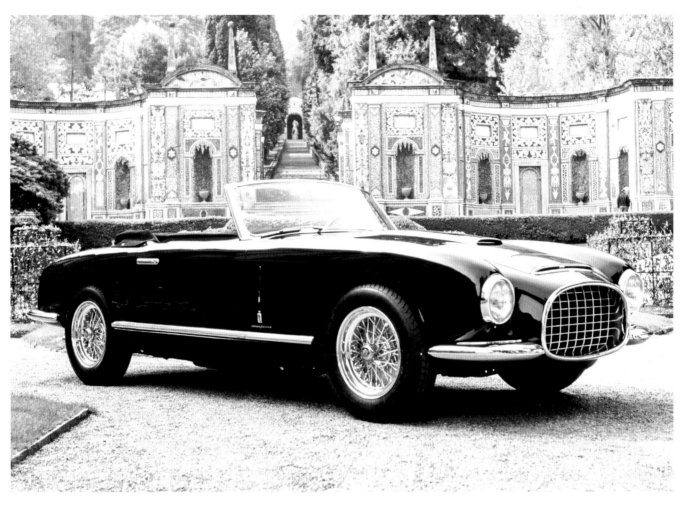

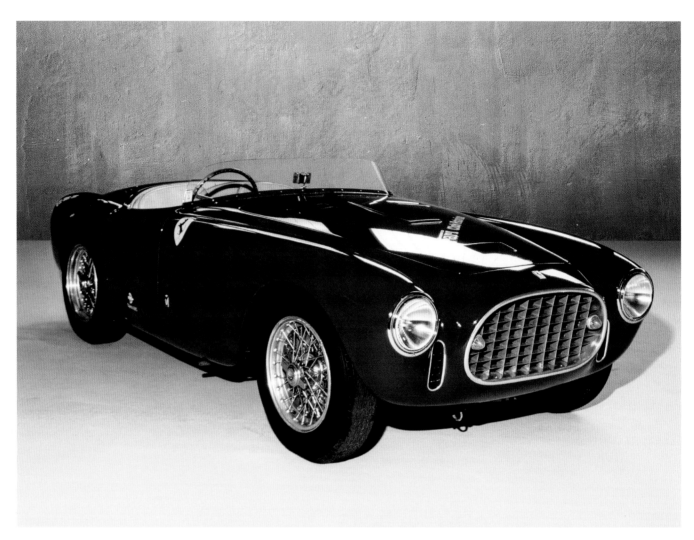

225 S
Barchetta
1952

ENGINE // 2715CC, V12

POWER // 157KW (210BHP) AT 7200RPM

CHASSIS // STEEL LADDER

GEARBOX // FIVE-SPEED

TOP SPEED // 230KM/H (143MPH)

WEIGHT // 850KG (1874LB)

Despite the departure of Gioacchino Colombo from Ferrari, and the decision to abandon development of his V12 in the supercharged version of its 1.5-litre form, work continued on the engine under Aurelio Lampredi to improve its power and resilience in sportscar racing. Increasing the bore from 68mm (2.67in) to 70mm (2.75in) raised the swept capacity of each cylinder to 226cc, from which the next models to be based on this engine took their name, and Lampredi took the opportunity to redesign the inlet manifold and adopt a new type of bearing for the cam followers in the cylinder head, following the precedent set by his own long block V12.

All but one of the cars to carry the 225 S name were bodied by Vignale in either closed-roof or open-top style; a sole example, barchetta-bodied by Touring, joined the works cars and several private entries in the car's competitive debut in the 1952 Giro di Sicilia. Despite a skilled driver line-up – including Luigi Villoresi, Piero Taruffi, Giovanni Bracco and Vittorio Marzotto – none of the works cars finished the tough 1080km (67-mile) route. Eugenio Castellotti drove the Touring-bodied 225 S to fifth place and first in class.

The Vignale cars varied in details, as was usual at the time, but several of the 225 S cars bore a new styling tic: a trio of chromed ports in each wing, believed to have been added to improve ventilation after the Giro di Sicilia retirements. While the 1952 Mille Miglia also proved frustrating for Ferrari, redemption came at the Monaco Grand Prix – held for sports cars rather than single-seaters that year – when Marzotto topped an all-225 S podium.

225 S
Coupé
1952

ENGINE // 2715CC, V12

POWER // 157KW (210BHP) AT 7200RPM

CHASSIS // STEEL LADDER

GEARBOX // FIVE-SPEED

TOP SPEED // 230KM/H (143MPH)

WEIGHT // 850KG (1874LB)

The 225 S had a relatively short life owing to the rapid development of the engine to a larger displacement. Just six of the 15 cars built were delivered in coupé form, all finished by Vignale and all destined for competition. Two are understood to have used the Gilco Tuboscocca chassis design.

 The French driver Pierre Boncompagni who, like many wealthy amateurs of the time, raced under a pseudonym to avoid alerting their families to their activities, raced a 225 S coupé to fifth in the 1952 Monaco Grand Prix, enough to warrant the offer of a works drive in the 1952 Le Mans 24 Hours. Sadly "Pagnibon" failed to finish. One of the Tuboscocca cars made its way to America where the new owners, Peter and Robert Yung, finished eighth in the 1953 Sebring 12 Hours.

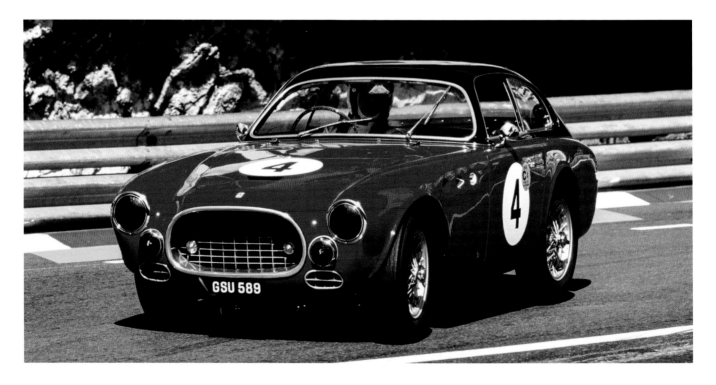

225 S
Scuderia Guastalla
1952

ENGINE // 2715CC, V12

POWER // 157KW (210BHP) AT 7200RPM

CHASSIS // STEEL LADDER

GEARBOX // FIVE-SPEED

TOP SPEED // 230KM/H (143MPH)

WEIGHT // 850KG (1874LB)

Milanese businessman Franco Cornacchia was among the first car dealers to open relations with Ferrari and was a keen amateur racer, though his enthusiasm exceeded his ability. Cornacchia enjoyed close relations with the Ferrari factory and was a prolific entrant via his Scuderia Guastalla team. Among the cars ordered through Cornacchia in 1952 was a 225 S finished to a highly unusual design by Vignale, featuring swooping, curved wings.

The buyer – Antonio Stagnoli, a Piaggio scooter dealer from Brescia – had been responsible for Zagato's first Ferrari commission in 1949. He campaigned his new 225 S energetically via Scuderia Guastalla throughout 1952, finishing third in the Monaco Grand Prix, where Cornacchia arranged for the more experienced Clemente Biondetti to co-drive. A later owner had the car rebodied in a 166 MM Touring lookalike shell, but it has subsequently been restored.

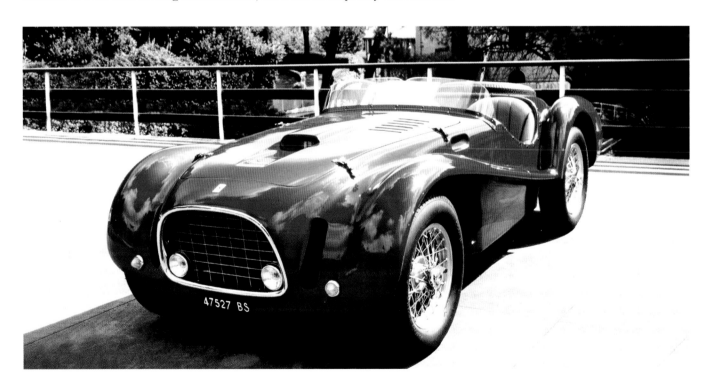

340
Mille Miglia
1953

ENGINE // 4101CC, V12
POWER // 209KW (280BHP) AT 6500RPM
CHASSIS // STEEL LADDER
GEARBOX // FIVE-SPEED
TOP SPEED // 269KM/H (167MPH)
WEIGHT // 850KG (1874LB)

In 1953 the FIA launched a world championship for sportscars and Ferrari committed wholeheartedly, fielding new cars based on the 340 America chassis and engine concept, powered by the 4.1-litre three-carburettor version of the Lampredi V12. Four so-called 340 Mexicos were built on the 2600mm (102in) chassis with a view to competing in the Carrera Panamericana, though the Vignale-bodied cars were not as successful as hoped. But the 340 MMs, built on the shorter 2500mm (98in) chassis and named to evoke Ferrari's successes on the Mille Miglia, proved more reliable and competitive.

Like the Formula 1 world championship of the time, the seven-round sportscar equivalent included a date in the US which was logistically difficult to enter (though at least bound by the same technical rules, whereas F1 cars could not compete in the Indy 500). A total of 10 340 MMs were built, four by Pinin Farina in coupé bodyshells – believed to be more optimal for the long straights of the Circuit de la Sarthe, venue of the Le Mans 24 Hours – two as spyders by Touring, and four more as spyders by Vignale.

In April 1953 the first Vignale-bodied 340 MM won on its competitive debut in the non-championship Giro di Sicilia in the hands of Luigi Villoresi. Two weeks later Giannino Marzotto romped to victory and set a new speed record in the Mille Miglia, the second round of the championship, beating the great Juan Manuel Fangio in an Alfa Romeo by nearly 12 minutes. Two other Vignale 340 MMs differing slightly in detail were acquired by prominent American amateurs Bill Spear and Sterling Edwards.

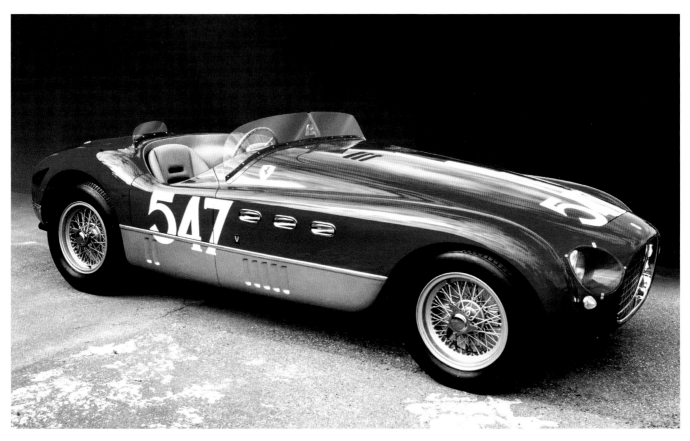

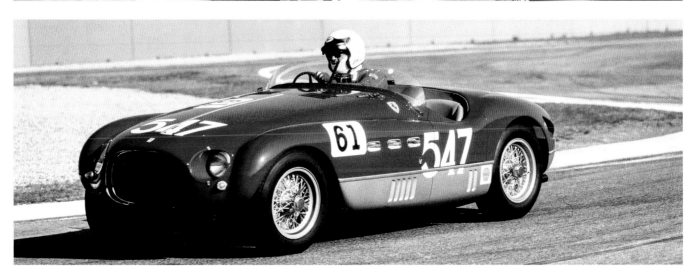

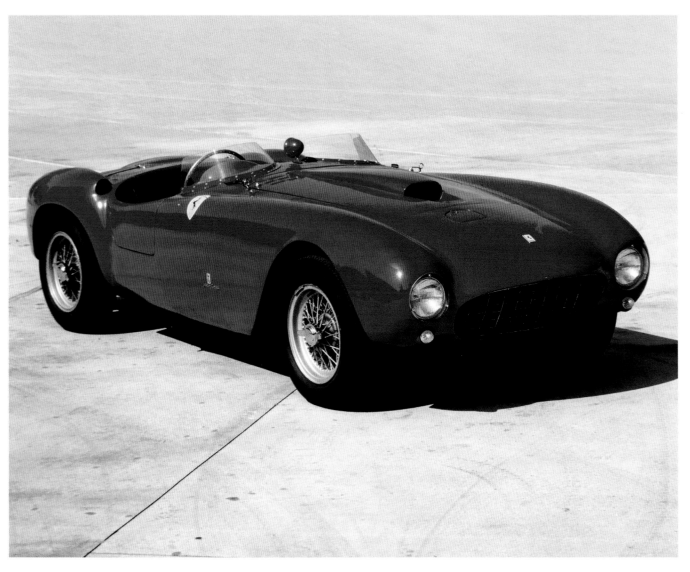

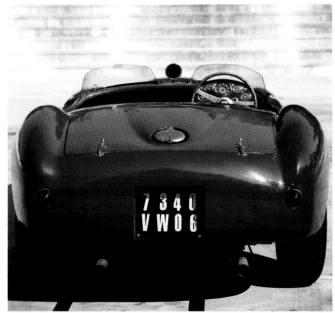

375
Mille Miglia Spyder
1953

ENGINE // 4522/4493CC, V12

POWER // 254—268KW (340—360BHP) AT 7000RPM

CHASSIS // STEEL LADDER

GEARBOX // FIVE-SPEED

TOP SPEED // 240—274KM/H (149—170MPH)

WEIGHT // 900KG (1984LB)

Although the 340 MM's first outings resulted in wins, Ferrari entertained enough doubts about the car's potential to develop a larger-engined model based on the 4.5-litre version of the Lampredi V12 Ferrari had raced to winning effect in Formula 1. Since the swept volume of each cylinder was 376cc, the new car would share the grand prix car's 375 designation – but only the works cars would receive this engine. Customers would be supplied with V12s of similar overall displacement (4522cc rather than 4493cc) but with a wider bore and a shorter stroke. This, it was hoped, would produce broader torque at lower revs for better driveability.

The first four cars were repurposed 340 MMs, one a Vignale spyder, three coupés bodied by Pinin Farina. Such was Ferrari's faith that more power would yield better results, the conversions proceeded even after the first 375 MM retired from the Le Mans 24 Hours with clutch problems.

Ultimately it's believed 26 375 MMs were built, the majority of them coachbuilt by Pinin Farina, 12 of which were in open-top spyder configuration. While the bodies varied according to customer specification, the majority of them featured slightly recessed headlights, an undershot radiator aperture which was smaller and more ovoid than Vignale's equivalents, and a large air scoop atop the bonnet.

Farina also produced a notable one-off design for US racer and collector James Kimberly, grandson of one of the co-founders of the Kimberly-Clark paper mill and hygiene-ware empire. Bedevilled by brake fade while racing his 340 America, Kimberly requested better cooling and the resultant bodyshell bore distinctive cut-outs between the wings and body front and rear.

375
Mille Miglia Coupé
1953

ENGINE // 4522/4493CC, V12

POWER // 254—268KW (340—360BHP) AT 7000RPM

CHASSIS // STEEL LADDER

GEARBOX // FIVE-SPEED

TOP SPEED // 240—274KM/H (149—170MPH)

WEIGHT // 950KG (2094LB)

Pinin Farina berlinetta-bodied 375 MMs formed the backbone of Ferrari's challenge for the inaugural sportscar world championship in 1953. But the competition was tough; despite a strong driver line-up at Le Mans, the red cars had been beaten on speed and reliability by the British Jaguar marque. Upon their return to Italy the factory coupés – two 340 MMs and a 375 MM – were treated to revised bodywork including a slimmer front end and a reprofiled roof. The smaller-engined cars were upgraded to 375 spec.

For the Spa 24 Hours Ferrari again partnered Mike Hawthorn, a young Briton viewed as a promising talent after some impressive grand prix performances in a Cooper, with 1950 F1 drivers' champion Giuseppe Farina. At Le Mans they had fallen foul of an abstruse rule forbidding car fluids to be topped up within the first 28 laps, and been disqualified. On the daunting 14km (8.7-mile) Spa-Francorchamps circuit, Hawthorn put the 375 MM on pole position and won by an 18-lap margin from an Ecurie Ecosse-entered Jaguar C-Type. Even the onset of rain late on couldn't interrupt the winning partnership's rhythm; the only disappointment was the early elimination (with a broken valve) of the 375 MM shared by Umberto Maglioli and Piero Carini, followed by clutch problems for Luigi Villoresi and Alberto Ascari in the other sister car.

Victory for Farina and Ascari in the Nürburgring 1000km, followed by fourth for a Scuderia Guastalla-run 375 MM in the Carrera Panamericana (where Jaguar failed to score), proved decisive in bringing the world championship trophy to Maranello.

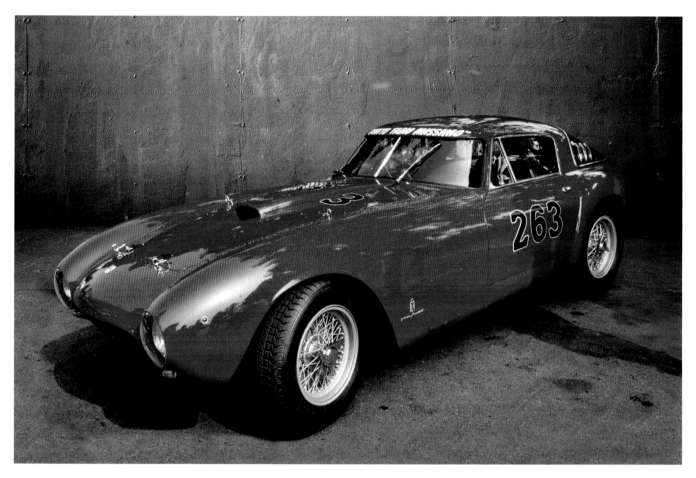

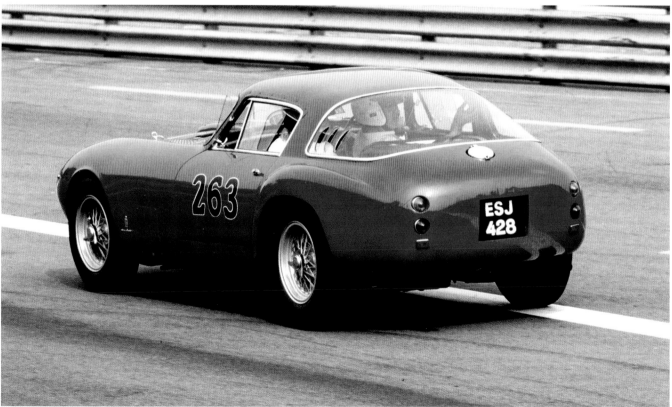

212
Export
1953

ENGINE // 2562CC, V12
POWER // 127KW (170BHP) AT 6500RPM
CHASSIS // STEEL LADDER
GEARBOX // FIVE-SPEED
TOP SPEED // 219KM/H (136MPH)
WEIGHT // 800KG (1764LB)

During 1953, 20th Century Fox acquired one of the 212 Exports previously campaigned by the Marzotto brothers and commissioned Carrozzeria Autodromo of Modena to modify the bodywork. The Hollywood studio had greenlit a screen adaptation of Hans Reusch's novel *The Racer*, loosely based on the life of pre-war driver Rudolf Caracciola – here to be played by Kirk Douglas. Dressed in its new clothes, the Ferrari would co-star in the movie – retitled *The Racers* – and was filmed in action (driven by John Fitch rather than Douglas) during the 1954 Mille Miglia before being shipped to Los Angeles for the remainder of the shoot. The crew also visited various other racing events across Europe to capture action footage.

The car was identified as a "Burano" rather than a Ferrari in the finished film.

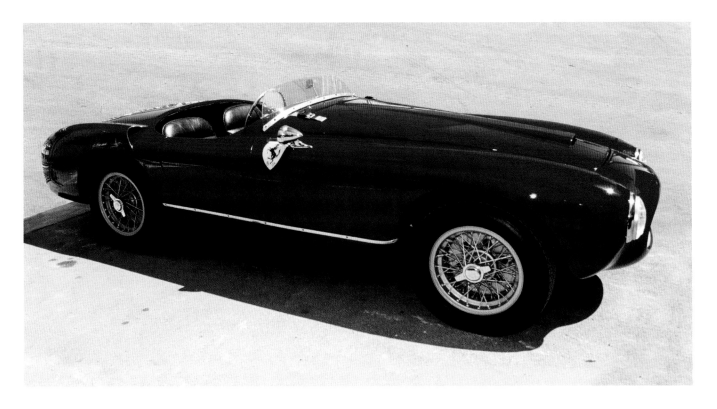

250
Mille Miglia Spyder
1953

ENGINE // 2953CC, V12

POWER // 179KW (240BHP) AT 7200RPM

CHASSIS // STEEL LADDER

GEARBOX // FIVE-SPEED

TOP SPEED // 249KM/H (155MPH)

WEIGHT // 850KG (1874LB)

Vignale built 12 spyder-style 250 MMs including the first to be seen, at the Paris show in October 1952. This was the car film director Roberto Rossellini acquired and raced in the 1953 Mille Miglia before his wife, Ingrid Bergman, prevailed upon him to quit competitive driving.

Another Vignale-bodied spyder delivered the 250 MM's first race victories in the hands of rising US sportscar star Phil Hill. Having talked his way into motor racing, offering his services as a mechanic in exchange for drives, Hill had recently finished sixth in his first international motor race, the Carrera Panamericana. In April 1953 Hill won the Del Monte Trophy in Pebble Beach, a Sports Car Club of America race, and claimed another overall victory plus a class win in later rounds in Santa Barbara and Reno.

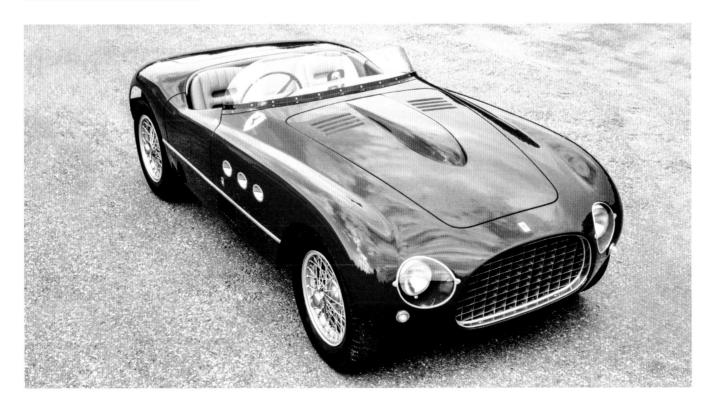

250
Mille Miglia Berlinetta
1953

ENGINE // 2953CC, V12

POWER // 179KW (240BHP) AT 7200RPM

CHASSIS // STEEL LADDER

GEARBOX // FIVE-SPEED

TOP SPEED // 249KM/H (155MPH)

WEIGHT // 850KG (1874LB)

Increasing the capacity of the Colombo V12 to 2953cc, by widening the bores to 73mm (2.87in) from 70mm (2.76in), gave a swept capacity for a single cylinder of 246cc – and opened the door to what would become a legendary and extraordinarily collectible series of cars bearing the 250 designation. The name first appeared on the entry list of the 1952 Mille Miglia, attached to a 225 S-style experimental car driven by Giovanni Bracco.

Here the legend was born. Ferrari's hopes against a threateningly strong Mercedes entry were pinned on the new and barely tested 340 America, to be driven by Piero Taruffi. It is said that Bracco, a wealthy amateur with a successful track record in hill-climbing, hired his car after Alberto Ascari was forced to drop out through injury, and that he only received works support – including tyres – after the factory-entered cars (including Taruffi's) were eliminated. Legend also has it that Bracco fortified his nerves by chain-smoking and working his way through a flask of cognac as the weather turned foul on the final leg. Regardless of anecdote, the stopwatch relates an inescapable truth: Bracco took nine minutes out of Karl Kling's leading Mercedes to win the race.

The following year the 250 MM entered production, named in honour of Ferrari's prestigious victory against the might of Mercedes. Of the 31 examples built, the majority were finished by Pinin Farina in closed-top berlinetta bodywork, which would come to define Ferrari style in the coming years. The first was displayed at the Geneva show in March 1953 before being raced by Franco Rol in the Giro di Sicilia. Two other examples were entered and one, driven by Paulo Marzotto, led before retiring.

Eight 250 MMs were entered in the Mille Miglia, including one for Bracco, but he was unable to repeat his heroics from the previous year as his car succumbed to transmission failure. Only one of the 250 MMs finished, though Ferrari honour was upheld by Giannino Marzotto's victory in a 340 MM.

While the Mille Miglia had become the domain of larger and more powerful cars built with a view to competing in the new world championship for sportscar manufacturers, the 250 MM continued to acquit itself well in rallies, circuit races and hill-climbs. Luigi Villoresi claimed one of the berlinetta variant's first wins in the non-championship Monza Grand Prix, prevailing against a field which included 14 other Ferraris and drivers with Formula 1 pedigree.

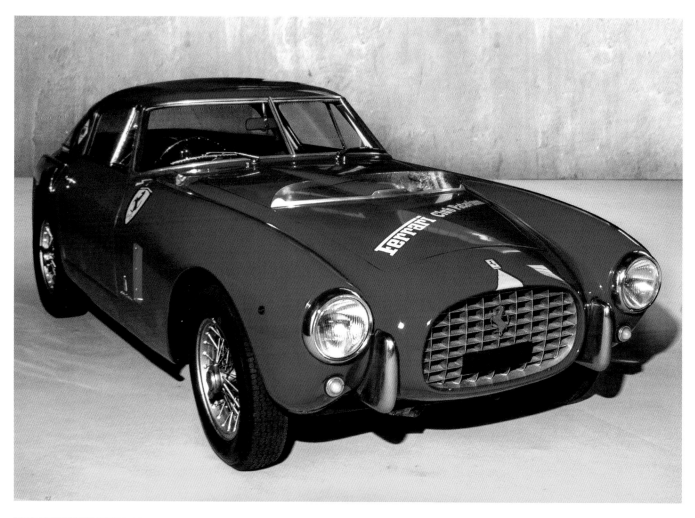

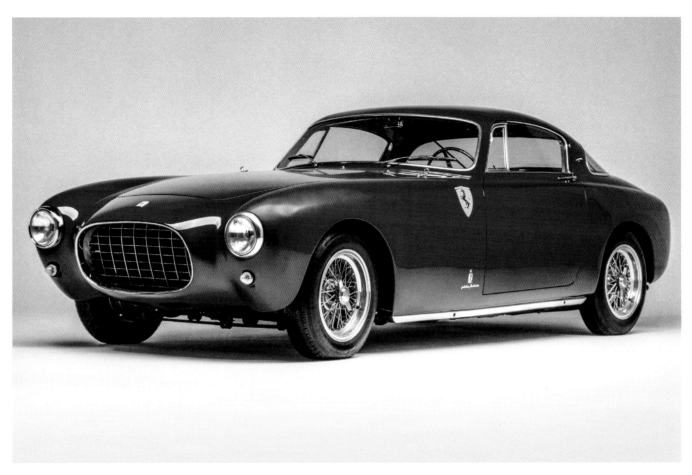

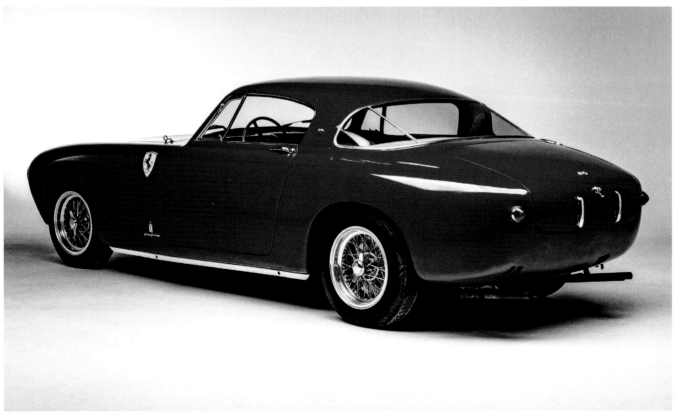

250 Europa
1953

ENGINE // 2963CC, V12

POWER // 149KW (200BHP) AT 6300RPM

CHASSIS // STEEL LADDER

GEARBOX // FIVE-SPEED

TOP SPEED // 217KM/H (135MPH)

WEIGHT // 1200KG (2645LB)

At the 1953 Paris Motor Show Ferrari displayed a new grand tourer for the European market, the replacement for the 212 Inter, alongside the US-oriented 375 America. Both sat on similar chassis with a 2800mm (110in) wheelbase. Powered by the 3-litre version of the Lampredi V12, the first 250 Europa was entrusted to Vignale. It featured many of what were fast becoming Vignale styling tics: a large ovoid "egg-crate" chrome grille integrated with split bumpers; headlights mounted slightly inboard and well below the car's shoulder line, creating a prominent ridged "brow" around the wings; slightly squared off rear wheel arches; and a large wraparound rear screen integrating into a tail bustle with ridged rear wings. Next to Pinin Farina's stately 375 America, it looked rather fussy.

Accordingly the majority of 250 Europas sold were finished by Pinin Farina, who offered a more restrained take on the fastback style: one flowing line from headlamp to tail lamp, one-piece bumpers, a less bulbous roofline and a less flamboyant meeting of the wraparound rear screen with the boot lid. Farina also built one as a cabriolet. Vignale finished four coupés and a cabriolet.

Though built as a GT rather than a race car, the 250 Europa offered remarkable performance for its time. Los Angeles lawyer and famous Ferrari collector Edwin Niles described his test drive with Rome dealer Inico Bernabei thus: "Bernabei took me on a screaming ride through the narrow streets of Rome, passing applauding pedestrians wherever we turned. I heard shouts of 'Ferrari!' and 'Forza!' I didn't even negotiate the price."

In August 2022 the last 250 Europa built changed hands for $2.1 million at auction in Monterey.

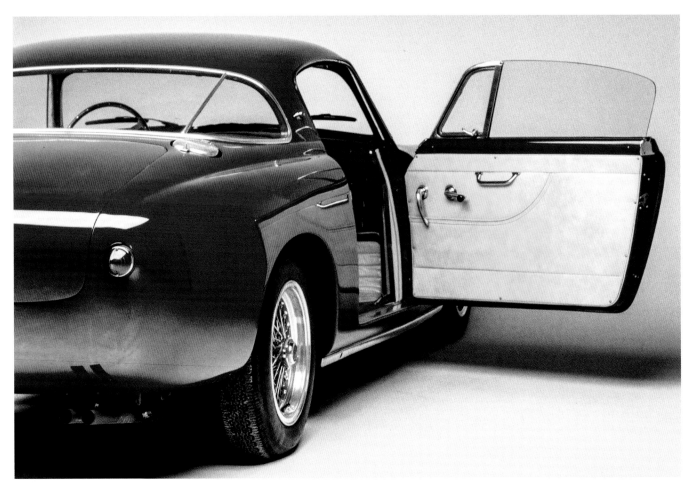

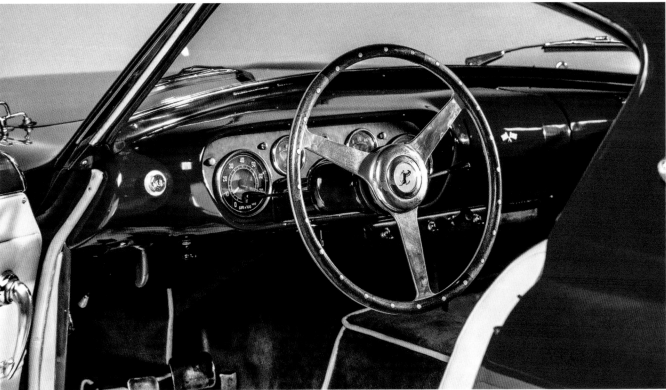

500
Mondial Barchetta
1953

ENGINE // 1984CC, INLINE-FOUR

POWER // 119KW (160BHP) AT 7000RPM

CHASSIS // STEEL LADDER

GEARBOX // FOUR-SPEED

TOP SPEED // 235KM/H (146MPH)

WEIGHT // 720KG (1587LB)

The world championship for drivers was plunged into crisis early in 1952, as Alfa Romeo's withdrawal and BRM's failure to arrive at key events moved the promoters of championship races to welcome Formula 2 cars only in 1952 and 1953, pending the start of a new F1 technical formula in 1954. If these promoters thought they had headed off the possibility of hosting dead-rubber races dominated by Ferrari F1 cars, they were to be disappointed: Ferrari already had a competitive four-cylinder, 2-litre engine designed by Aurelio Lampredi suitable for F2. Alberto Ascari duly won the world championship two years in a row, bolstering Ferrari's ever-growing reputation.

Naturally Ferrari also deployed the inline-four in their sports-racers, experimenting with enlarged versions in the short-lived 625 TF and 735 S models. These achieved mixed results, acting as a prologue for the disappointing 625 F1 car of 1954, but Ferrari's sportscar using the inline-four in its original 2-litre form proved surprisingly competitive.

Between 30 and 34 500 Mondials were built on short-wheelbase (2250mm/88.5in) chassis by Pinin Farina (pictured) and Scaglietti, with minimalist lightweight bodywork to enable nimble handling and not overburden the engine. Lampredi's inline-four was dry-sumped and featured twin overhead camshafts, a dual magneto setup and roller cam followers, but was presented in a relatively mild state of tune to enable it to compete in endurance events.

The first 500 Mondial appeared in the 12 Hours of Casablanca on 20 December 1953, co-driven to second overall (behind a 375 MM) and first in class by Ascari and Luigi Villoresi. Later Mike Hawthorn and Umberto Magioli scored a remarkable overall victory in the Supercortemaggiore Grand Prix at Monza.

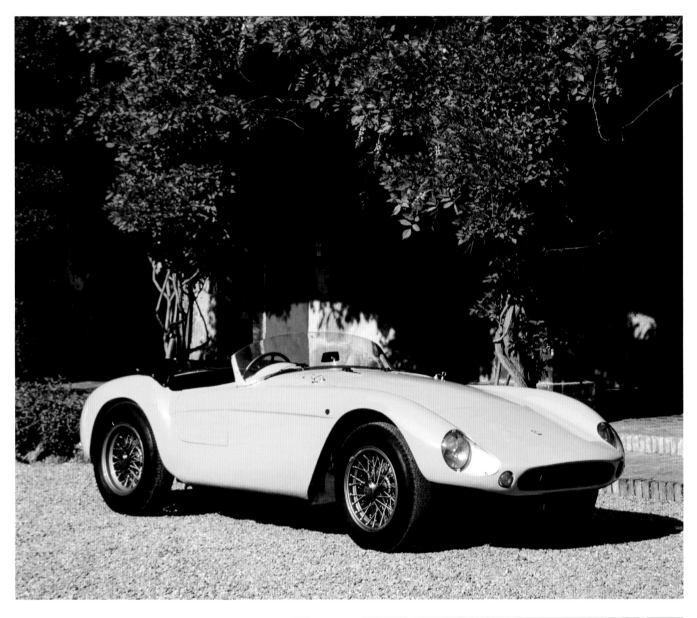

500
Mondial Coupé
1954

ENGINE // 1984CC, INLINE-FOUR

POWER // 119KW (160BHP) AT 7000RPM

CHASSIS // STEEL LADDER

GEARBOX // FOUR-SPEED

TOP SPEED // 235KM/H (146MPH)

WEIGHT // 720KG (1587LB)

Just two berlinetta-bodied 500 Mondials were built, both by Pinin Farina on the same ladder-frame chassis type, with independent front suspension via unequal-length wishbones, and a De Dion axle and transverse leaf spring at the rear. The first example has the better-documented competition history, first appearing in the Tour de France in September 1954; second owner Roberto Montali contested the Mille Miglia in it twice with a best result of 59th overall and ninth in class. It later passed around collectors in the US and Europe, last seen changing hands for $1.6 million in Monterey in 2010.

The second car also contested the 1954 Tour de France in the hands of Mario Dustaritz and Lino Fayen. Briefly repossessed when Dustaritz defaulted on lease payments, it vanished into private collections for decades until the present owners acquired it in the early 2000s and began showing it at concours events.

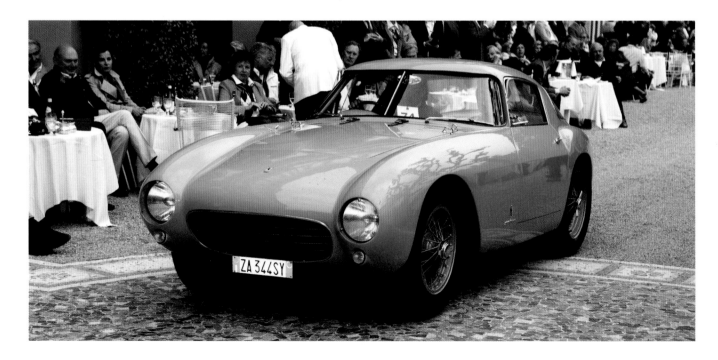

250
Monza
1954

ENGINE // 2953CC, V12

POWER // 179KW (240BHP) AT 7200RPM

CHASSIS // STEEL LADDER

GEARBOX // FOUR-SPEED

TOP SPEED // 249KM/H (155MPH)

WEIGHT // 850KG (1874LB)

Building a sportscar – the 500 Mondial – using an adapted version of Ferrari's Formula 2 chassis was deemed successful enough for the company to evaluate larger engines in it. By slightly lengthening the wheelbase, from 2250mm (88.5in) to 2400mm (94.5in), Ferrari was able to accommodate the 3-litre version of the Colombo V12 (as used in the 250 MM) driving through a four-speed gearbox.

 Just four 250 Monzas were built, three finished by Pinin Farina and one by Scaglietti, and only one of the cars was campaigned by Scuderia Ferrari (resulting in a win for Maurice Trintignant and Luigi Piotti in the non-championship 12 Hours of Hyères). The other three went to Scuderia Guastalla; one was later acquired by Luigi Chinetti and rebodied by Scaglietti with pontoon-style front wings before being offered for sale in the US.

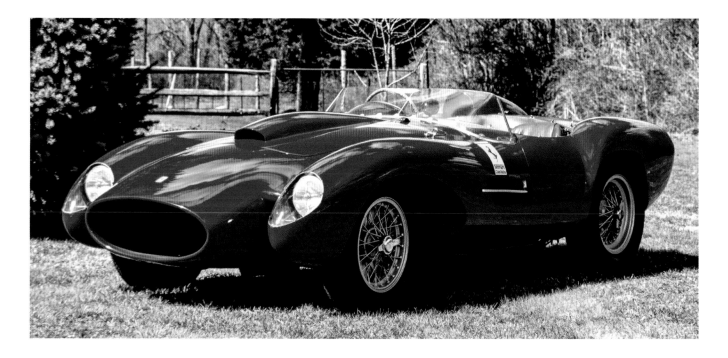

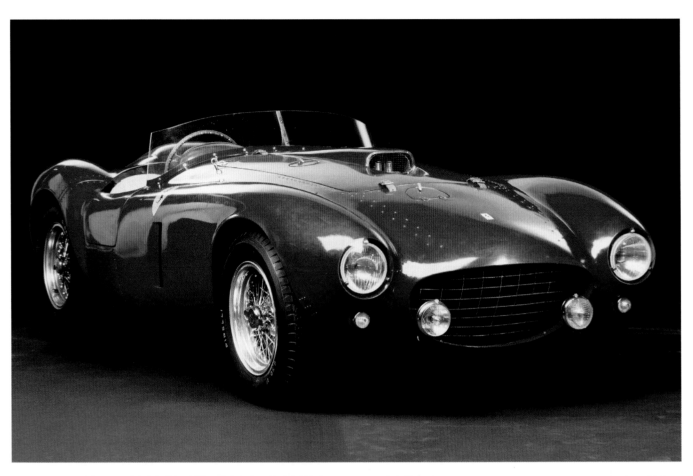

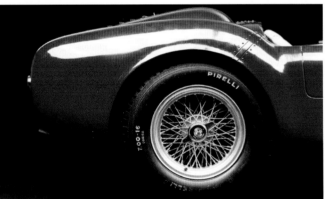

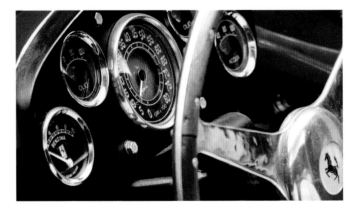

375
Plus
1954

ENGINE // 4954CC, V12

POWER // 246KW (330BHP) AT 6000RPM

CHASSIS // STEEL LADDER

GEARBOX // FIVE-SPEED

TOP SPEED // 280KM/H (174MPH)

WEIGHT // 1030KG (2271LB)

Although the 375 MM got Ferrari over the line in terms of winning the new world championship for sportscar manufacturers in 1953, against competition from the likes of Mercedes, Maserati, and Jaguar it clearly required more firepower. Aurelio Lampredi provided the answer, expanding his V12 engine yet again by combining two of its different configurations: retaining the 84mm (3.3in) bore size used in the 375 MM while lengthening the stroke from 68mm (2.67in) to 74.5mm (2.93in), as per the race-winning 375 Formula 1 car.

In a bid to manage the additional power, Ferrari fitted extra bracing to the chassis frames, and changed the rear suspension from a live axle setup with longitudinal semi-elliptic springs to a De Dion axle with a transverse semi-elliptic spring. But this would still prove to be a tricky car to tame, at its best on open tracks rather than twisting courses based on minor public roads.

Some extant 375 MMs were converted into 375 Pluses while others were built on new chassis. Pinin Farina modified the bodywork with a more pronounced "hump" in the tail, providing space to carry a spare wheel and accommodate a fuel tank expanded by 10 litres.

Giuseppe Farina furnished a winning debut for the 375 Plus in the non-championship Grand Prix d'Agadir in Morocco in February 1954, albeit against a thin field of equivalent machinery. After disappointments in the Giro di Sicilia and Mille Miglia, the car scored a memorable victory in the Le Mans 24 Hours as Maurice Trintignant and José Froilán González headed the Jaguar driven by Duncan Hamilton and Tony Rolt by less than 5km (3 miles).

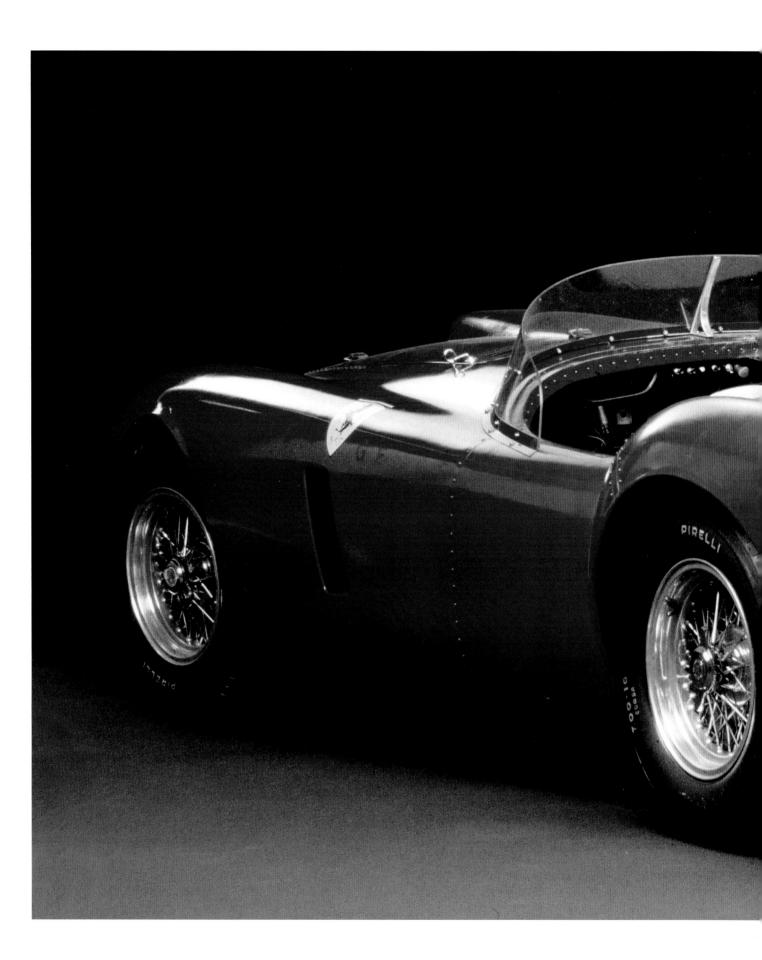

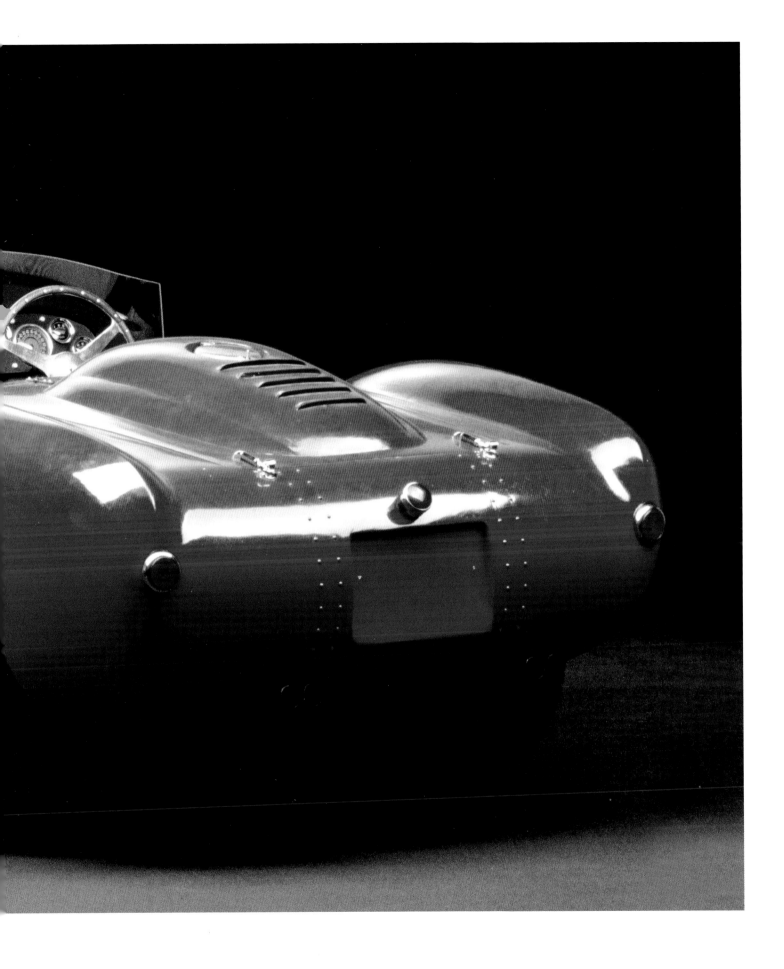

750 Monza
1954

ENGINE // 2999CC, INLINE-FOUR

POWER // 194KW (260BHP) AT 6000RPM

CHASSIS // STEEL LADDER

GEARBOX // FIVE-SPEED

TOP SPEED // 266KM/H (165MPH)

WEIGHT // 760KG (1675LB)

Racing in a class above the 500 Mondial, the 750 Monzas bore similar body shapes (by Pinin Farina and Scaglietti) and an identical wheelbase, but were powered by a 3-litre version of the Lampredi inline-four engine. Scuderia Ferrari demonstrated the interchangeability when, after Giuseppe Farina crashed his 750 Monza in practice for the 1954 Grand Prix Supercortemaggiore at Monza, its engine was swapped into a 500 Mondial chassis "borrowed" from a customer. Mike Hawthorn and Umberto Maglioli won the race while Farina spent the next three weeks in hospital.

While the 750 Monza contributed to Ferrari winning a second world sportscar championship title in 1954, by the following year it was outgunned by rivals from Mercedes and Jaguar. While testing one at Monza in May 1955, Alberto Ascari crashed – with fatal consequences – at the corner that now bears his name.

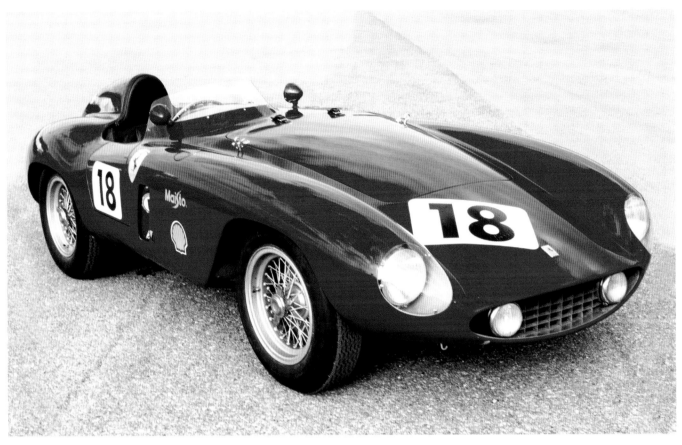

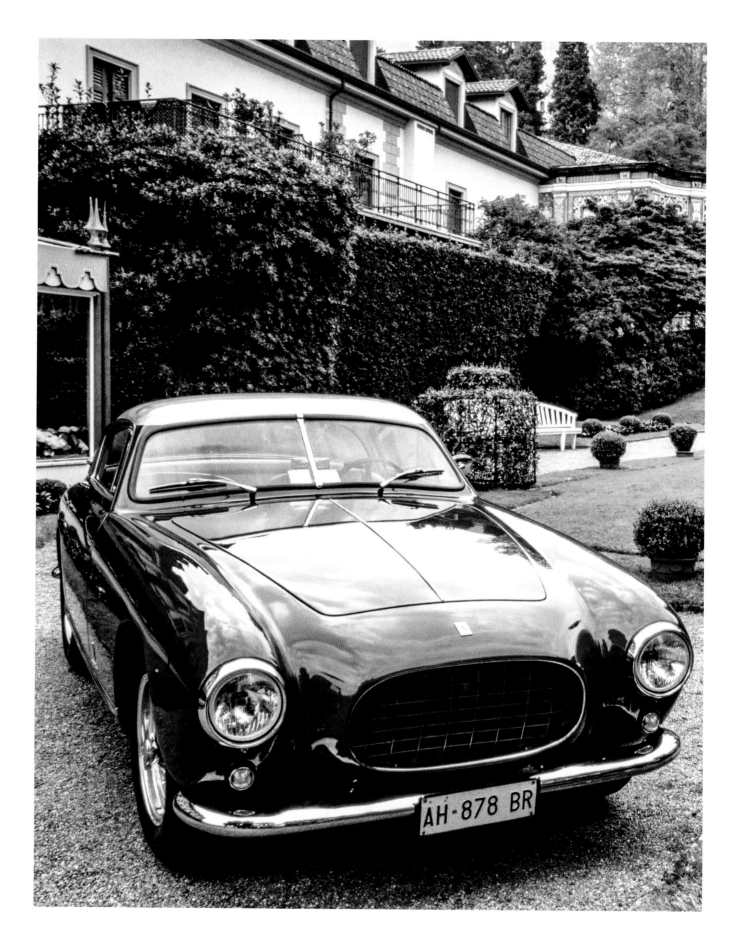

250
Europa GT
1954

ENGINE // 2953CC, V12

POWER // 164KW (220BHP) AT 7000RPM

CHASSIS // STEEL LADDER

GEARBOX // FOUR-SPEED

TOP SPEED // 230KM/H (143MPH)

WEIGHT // 1050KG (2315LB)

The mid-1950s was a period of personal and professional turbulence for Enzo Ferrari as he juggled competing priorities. His son Alfredo (nicknamed "Dino"), whom he was energetically shaping as his successor, had begun to display the symptoms of the Duchenne muscular dystrophy which would claim his life in 1956, aged 24. In a largely separate part of his life, Enzo had a mistress, Lina Lardi, with whom he had a son, Piero, in 1945. There was also the question of how to drive the company forwards, reliant as it was on two main income streams: prize money from motor racing and sales of highly bespoke road and race cars to private individuals.

There were many challenges to operating a manufacturing business in Italy at this time, for it was an era of continued upheaval and unrest. Communist sedition and lightning strikes were rife in Emilia-Romagna and, though Enzo was able to charm his workforce into steadfast labour, materials shortages were common, and third-party ancillary components such as brakes and magnetos were of poor quality. Nevertheless Enzo began to draw up plans to increase road car production with a view to greater sales volumes and profits.

The 250 Europa GT model provided the catalyst for this expansion. Designed by Pinin Farina, the first Ferrari to carry the "GT" badge made a relatively low-key debut at the Paris Motor Show in October 1954. At first glance it appeared little different to the previous 250 Europas finished by Pinin Farina – indeed, Ferrari's own official history offers conflicting accounts of whether the car was initially presented as a 250 Europa or a 250 GT. But the underpinnings of the car were rather different: it was slightly wider in track, and 200mm (7.9in) shorter in the wheelbase, a consequence of swapping from the Lampredi V12 to the most recent 3-litre iteration of the Colombo V12, which had a shorter block.

While this first car enjoyed a racing career, placing first in the 1956 Tour de France with Olivier Gendebien at the wheel, the second chassis had a more sedate destination. The only 250 Europa GT to be Vignale-bodied, with a distinctive American-style windscreen and finned front and rear wings, it was commissioned by Princess Liliane de Réthy of Belgium. Later Pinin Farina bodies evolved the 250 Europa design language with a slightly more pronounced nose and a neater tail treatment; some were built in aluminium rather than steel.

500
Mondial Series II
1955

ENGINE // 1984CC, INLINE-FOUR

POWER // 119KW (160BHP) AT 7000RPM

CHASSIS // STEEL LADDER

GEARBOX // FIVE-SPEED

TOP SPEED // 235KM/H (146MPH)

WEIGHT // 720KG (1587LB)

Ferrari updated the 500 Mondial for 1955 with a stronger chassis frame, using oval tubes rather than round ones, plus a different independent front suspension configuration with individual coil springs rather than a transverse leaf spring. The engine was the updated Tipo 111 version of the 2-litre Lampredi inline-four, driving through a new five-speed transaxle.

Since Pinin Farina was busy expanding its works to facilitate production of the 250 Europa GT, the finishing was entrusted to Scaglietti. Around seven are believed to have been sold, all to privateers – although Scuderia Ferrari entered one, formerly the property of French amateur François Picard, in the 1955 Grand Prix of Venezuela when that country's dictator, Marcos Pérez Jiménez, made Enzo Ferrari an offer he couldn't refuse. In 2018 this car's long-time owner auctioned it for $5 million.

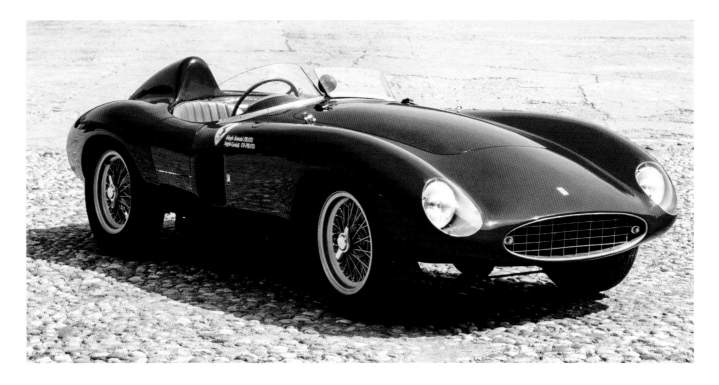

121
LM
1955

ENGINE // 4412CC, INLINE-SIX

POWER // 246KW (330BHP) AT 6000RPM

CHASSIS // STEEL LADDER

GEARBOX // FIVE-SPEED

TOP SPEED // 270KM/H (168MPH)

WEIGHT // 850KG (1874LB)

Ferrari's push to compete with Jaguar and Mercedes in sportscar racing prompted Aurelio Lampredi to evaluate an inline-six engine based on his successful four-cylinder unit (he also went some way down the road with a twin-cylinder unit for short courses). The 3-litre prototype was never raced but did lead Lampredi to develop larger versions, first a 3.7-litre and then, when that proved inadequate to the task, a 4.4-litre.

Eugenio Castellotti went fastest in practice for the 1955 Le Mans 24 Hours in a 121 LM but, while the car offered greater grunt than its rivals, it lacked handling finesse and its drum brakes were no match for Jaguar's pioneering discs. Following the catastrophic events of that race, engine sizes were capped at 2.5-litres so the four 121s were sold into private hands.

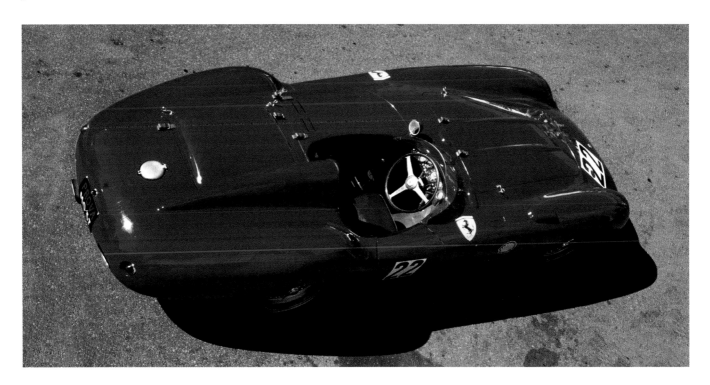

250
GT
1956

ENGINE // 2953CC, V12

POWER // 164KW (220BHP) AT 7000RPM

CHASSIS // STEEL LADDER

GEARBOX // FOUR-SPEED

TOP SPEED // 230KM/H (143MPH)

WEIGHT // 1050KG (2315LB)

A burgeoning order book for the 250 Europa GT encouraged Enzo Ferrari to proceed with his plans for expanded production, if not quite in the same highly mechanized fashion as the great American mass-market manufacturers. Enzo had invested in a new foundry in his factory to expedite production of chassis, but still had no facility to offer complete cars for road use. Thus he approached Pinin Farina to take on a role beyond that of the traditional coachbuilder: series production of bodyshells with less of an element of individual tailoring. From now on, Enzo believed, Ferraris should look like Ferraris.

Welcome to Farina as this opportunity was, he lacked the facilities to fulfil it immediately. So while his son and heir, Sergio, acted as project manager for a new factory just outside Turin, Farina produced a definitive 250 GT design. Production of this would be outsourced until the new facility was ready.

Former Ghia stylist Felice Boano's company fulfilled the first 88 orders before entering a deal with Fiat which required Boano to hand over 250 GT manufacture to Carrozzeria Ellena, owned by his son-in-law. The majority of the Boano-built 250 GTs adhere to the styling template established in one of the final Farina 250 Europa GTs, chassis number 0407GT. For that car, commissioned by a wealthy collector in Rome, Farina had removed the usual "egg-crate" grille in favour of a chromed oval with the Ferrari logo inset, and integral fog lamps. He also removed the bulge ahead of the rear wheel arch to create a single flowing shoulder line to a higher, slightly finned tail with vertical lights.

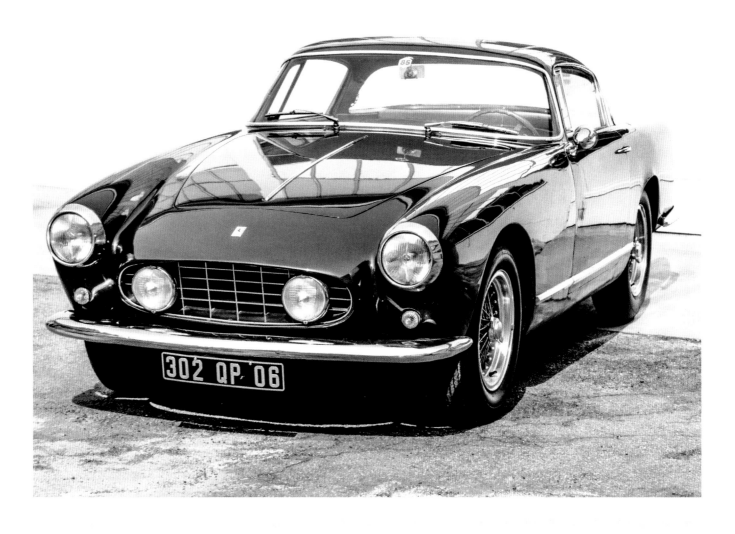

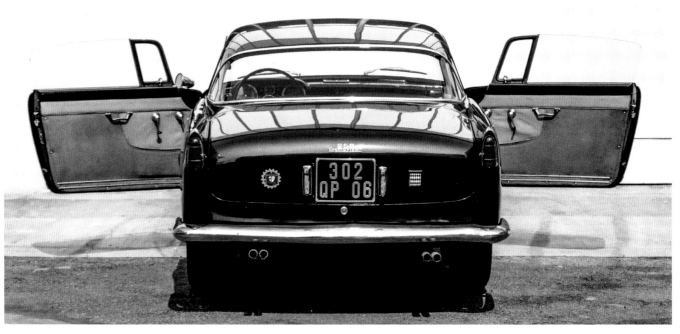

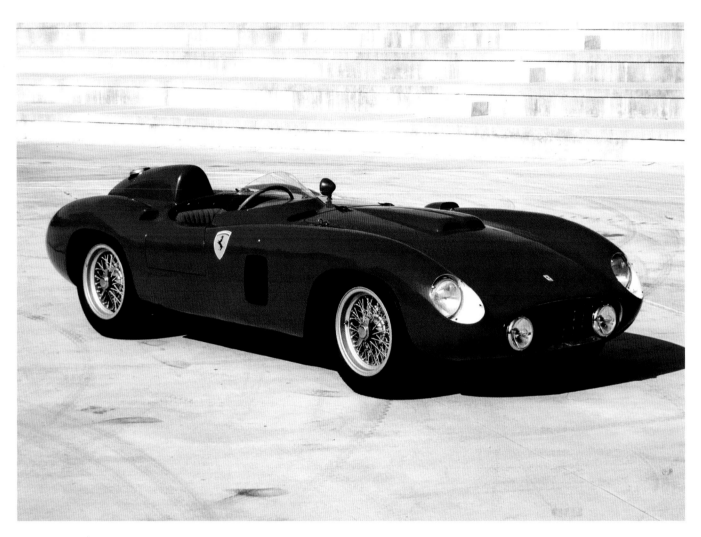

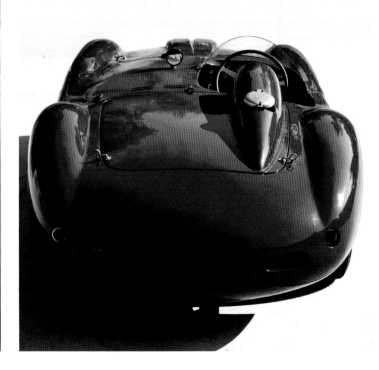

860
Monza
1956

ENGINE // 3431CC, INLINE-FOUR

POWER // 206KW (280BHP) AT 6000RPM

CHASSIS // STEEL LADDER

GEARBOX // FOUR-SPEED

TOP SPEED // 259KM/H (161MPH)

WEIGHT // 860KG (1896LB)

Scuderia Ferrari's 1956 world sportscar championship campaign relied on two models, sharing virtually identical Scaglietti bodies: the 290 MM, powered by a new 3.5-litre V12 designed by Vittorio Jano, who had supplanted Aurelio Lampredi as chief engineer; and the 860 Monza, propelled by the final iteration of the Lampredi inline-four. Enlarging the bore and stroke to 102mm (4in) and 105mm (4.13in) took the overall displacement to 3.4 litres.

In the absence of Mercedes, who had withdrawn from motor racing after the 1955 Le Mans disaster, Ferrari romped to world championship honours. While the three 860 Monzas largely played a supporting role (one was even converted to 290 MM spec), the model enjoyed a victorious debut at the 1956 Sebring 12 Hours when Juan Manuel Fangio and Eugenio Castellotti led home Luigi Musso and Harry Schell in a Ferrari one-two.

250 GT
Berlinetta Competizione
1956

ENGINE // 2953CC, V12

POWER // 191KW (260BHP) AT 7000RPM

CHASSIS // STEEL LADDER

GEARBOX // FOUR-SPEED

TOP SPEED // 249KM/H (155MPH)

WEIGHT // 1000KG (2205LB)

While Ferrari proceeded with series production of the 250 Europa GT, the company continued to build similar race-oriented cars based on the relatively new Tipo 508 chassis design, in which the longitudinal members passed above rather than below the rear axle. Pinin Farina designed a number of prototypes with varying body styles on wheelbases of different lengths, but the majority of extant cars claiming to be 250 GT Competiziones run on the 2600mm (102in) wheelbase used by the production car. Carrozzeria Scaglietti was responsible for the build of several examples in aluminium.

Race car aerodynamics were still in their infancy at this time – certainly in terms of understanding rather than theory – and the Farina cars aimed at a smooth-edged style with a single curving roofline from the tip of the windscreen to the tail, as evaluated on some of the 375 MMs. A number of cars were fitted with plexiglass fairings for the headlights.

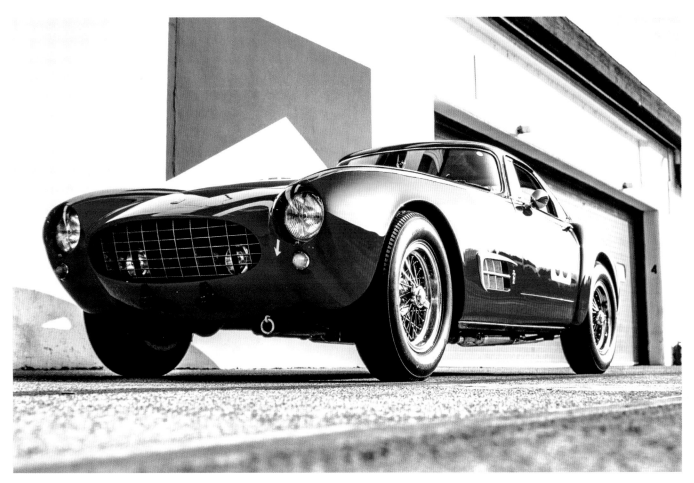

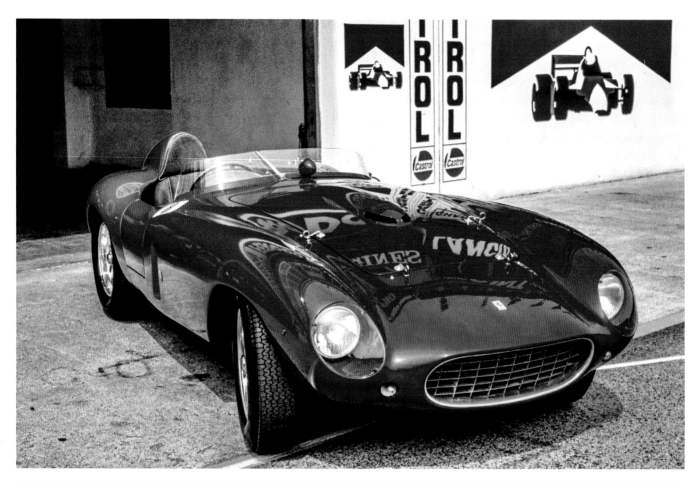

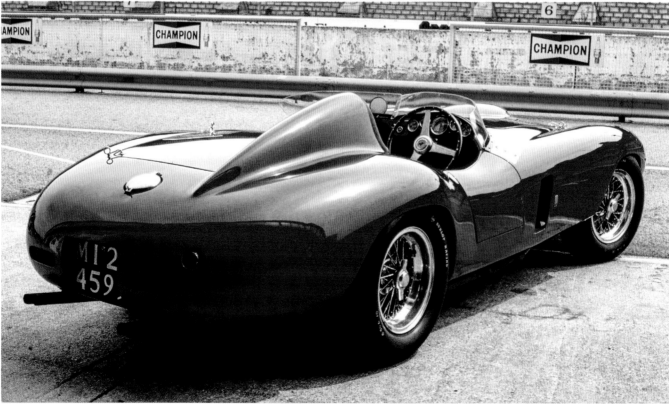

290
Mille Miglia
1956

ENGINE // 3490CC, V12

POWER // 239KW (320BHP) AT 7200RPM

CHASSIS // STEEL LADDER

GEARBOX // FOUR-SPEED

TOP SPEED // 280KM/H (174MPH)

WEIGHT // 880KG (1940LB)

Aurelio Lampredi's time as Ferrari's technical director had come to an end in July 1955, as the company proprietor grew restive over the lack of progress in Formula 1. While Lampredi was still in place Enzo Ferrari had hired the likes of Valerio Colotti and Alberto Massimino to re-engineer the troublesome 553 and 555 F1 cars, to little avail; what sent Lampredi out of the door was the arrival of Lancia's radical D50s and the man who designed them, Vittorio Jano. When the cash-strapped manufacturer withdrew from grand prix racing midway through the year, Fiat magnate Gianni Agnelli negotiated a deal whereby Fiat would pay Ferrari to run the D50s. Along with the transporters carrying the cars and spares came the newly out-of-work Jano.

Having replaced Lampredi, Jano proposed a return to V12 power for the company's flagship sports-prototype racers. Together with Massimino, Andrea Fraschetti and Vittorio Bellentani, Jano created a new engine based on a shorter, wider block than the Lampredi V12, and with revised porting in the twin-spark cylinder heads.

The new engine appeared for the first time in the 290 MM, part of a twin-pronged attack on the sportscar world championship with the 860 Monza. Though the two Scaglietti-bodied cars were outwardly similar, a second exhaust pipe and more aggressive bonnet air scoop distinguished the 290 MM. After an inauspicious debut in the Giro di Sicilia, the new car emerged victorious through particularly foul weather in the Mille Miglia as Eugenio Castellotti led a Ferrari one-two-three-four-five finish – half an hour ahead of the great Juan Manuel Fangio in a sister 290 MM.

500
TR
1956

ENGINE // 1984CC, INLINE-FOUR

POWER // 134KW (180BHP) AT 7000RPM

CHASSIS // STEEL LADDER

GEARBOX // FOUR-SPEED

TOP SPEED // 245KM/H (152MPH)

WEIGHT // 680KG (1499LB)

In 1956 Ferrari replaced the 500 Mondial with the 500 TR – "testa rossa" meaning "red head", as the car's Lampredi inline-four now bore a cylinder head painted red. This was a naming theme Ferrari would return to in the future.

Design changes extended beyond a splash of paint in the engine bay. The Scaglietti-bodied cars now featured independent front suspension by coil springs on each corner rather than a transverse leaf spring, an important step in improving the handling. At the rear, a coil spring and live axle setup replaced the previous longitudinal springs. The five-speed gearbox was dropped in favour of a four-speed, which now boasted synchromesh and a more sophisticated clutch, the better to appeal to amateur racers.

Seventeen 500 TRs were built; the first was sold to Jacques Swaters' Ecurie Francorchamps and later found its way into the hands of Luigi Chinetti's NART organization, who used it to furnish a 17-year-old Pedro Rodríguez with his international race debut in Nassau. Rodríguez would race a 500 TR at Le Mans the following year and go on to win a number of major international races outright with Ferrari, as well as two F1 grand prix wins for Cooper and BRM.

The 500 TR was a sales hit on the international market and a good many found homes in the USA with private race entrants, thanks in part to Chinetti's smart marketing. In July 1956 he leased a 500 TR to John Edgar's race team so rising US star Carroll Shelby could race it during a Sports Car Club of America double-header hill-climb weekend in Pennsylvania, where the future Le Mans winner won both events.

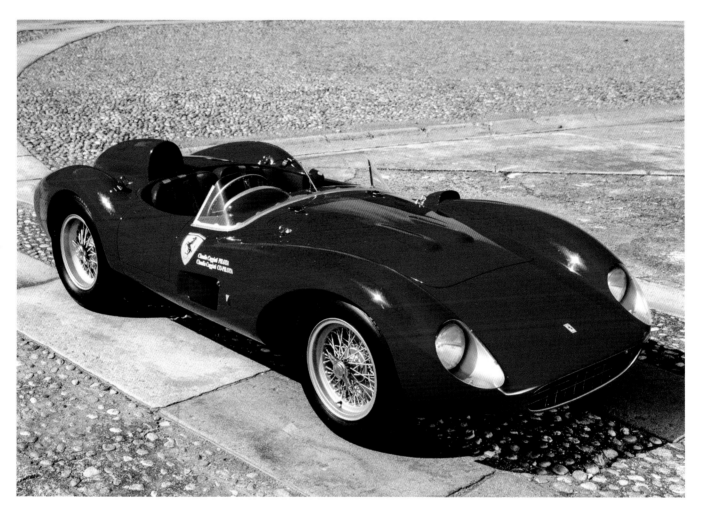

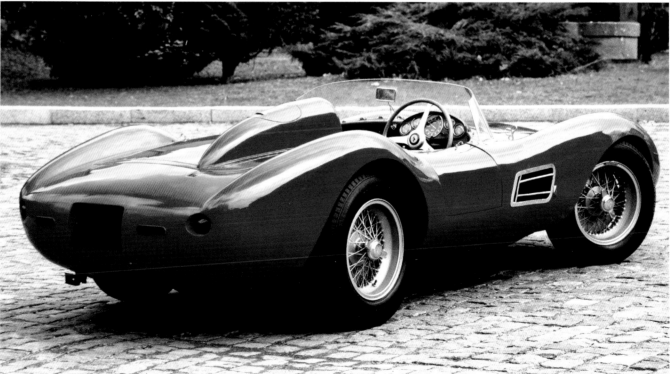

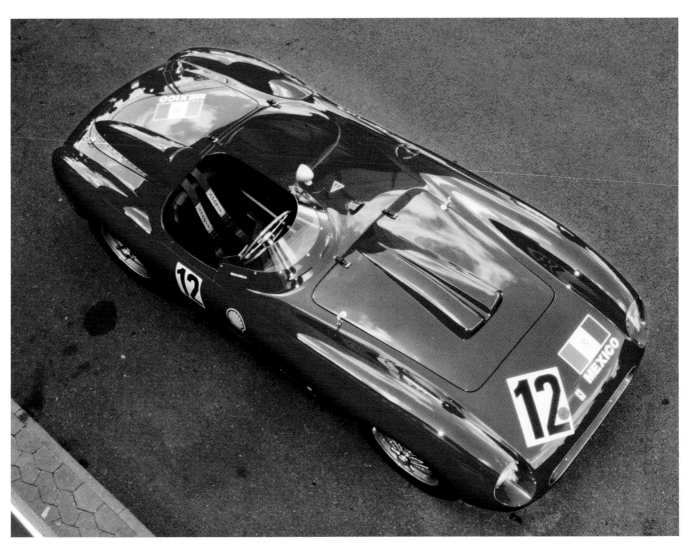

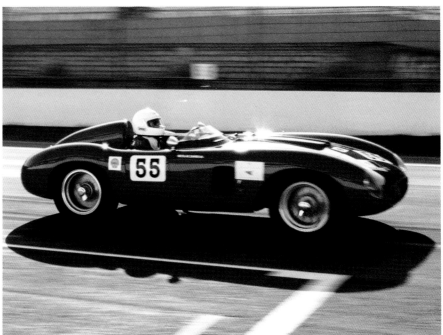

500 TR/625 LM
1956

ENGINE // 2498CC, INLINE-FOUR

POWER // 168KW (225BHP) AT 6200RPM

CHASSIS // STEEL LADDER

GEARBOX // FOUR-SPEED

TOP SPEED // 249KM/H (155MPH)

WEIGHT // 700KG (1543LB)

Since the new 2.5-litre engine limit on so-called prototypes at Le Mans precluded Ferrari from entering the 860 Monza or 290 MM, the factory equipped three 500 TR chassis with 2.5-litre inline-four engines as raced in the 625 Formula 1 car, albeit with a lower compression ratio. Given that the race had been excluded from the world championship there was little incentive to expend resources on an all-new car.

Since Pinin Farina remained busy with other Ferrari projects, Carrozzeria Touring provided the bodywork. The resulting 625 LMs were outgunned in the 24 Hours by Jaguar and Aston Martin, both of whom had managed to persuade the race organizers that their cars had been built in sufficient numbers to qualify as production models rather than protypes. Jaguar's latest D-Type was around 130kg (287lb) lighter than before, handled more nimbly, braked better with its disc setup, and its 3.4-litre fuel-injected inline-six gave 37kw (50bhp) more than Ferrari's smaller engine while working less hard. Just one of the 625 LMs finished, coming home seven laps down on the winning Jaguar.

Later that year US amateur racer Ed Lunken managed to obtain a 625 engine through Luigi Chinetti, and had it installed in his Scaglietti-bodied 500 TR. That car, photographed here, also passed through the hands of brewery heir and sportscar stalwart Augie Pabst, who would later berate himself for selling the car for the same sum he paid for it. It later became a regular feature in historic racing before its owner, a Swiss-domiciled Mexican collector, suffered a fatal accident in one of his other machines.

250 GT
Tour de France
1956

ENGINE // 2953CC, V12

POWER // 194KW (260BHP) AT 7000RPM

CHASSIS // STEEL LADDER

GEARBOX // FOUR-SPEED

TOP SPEED // 249KM/H (155MPH)

WEIGHT // 940KG (2072LB)

Success in the prestigious Tour de France automobile race entitled Ferrari to add that name to a relatively lengthy production run of competition-focused 250 GT berlinettas. Not that Ferrari ever did this officially in period, but owners gladly took it up and the title has become enmeshed in the company history.

Between 75 and 80 so-called Tour de France 250s were built, mostly by Scaglietti to broadly similar body styles which varied in details; today aficionados generally categorize them according to the number of louvres in the sail panel. Standing apart even from these are a number of examples finished in lightweight bodywork by Carrozzeria Zagato.

Ugo Zagato had developed a fascination for aeronautics during his military service in World War I and was a pioneer of aerodynamic experimentation with special-bodied Alfa Romeo race cars in the early 1930s. Sons Elio and Gianni, when they joined the family business, carried on the tradition of adventure, developing the company's distinct "double bubble" roof treatment.

Zagato bodied five 250 GT Coupés in period, all in light alloy with a view to racing. The first, ordered by Vladimiro Galluzzi, president of Scuderia Sant Ambroeus and one of Ferrari's regular customers, was a relatively restrained piece of styling for the coachbuilder, finished in dark blue with the double-bubble roof contrasting in cream. A second, similar car was bought by ex-fighter pilot Camillo Luglio, who sold it on after winning the Italian national championship and ordered another, with a different nose treatment including faired-in lights. The two later cars, one of which was also ordered by Galluzzi, bore faired-in lights and conventional roof profiles.

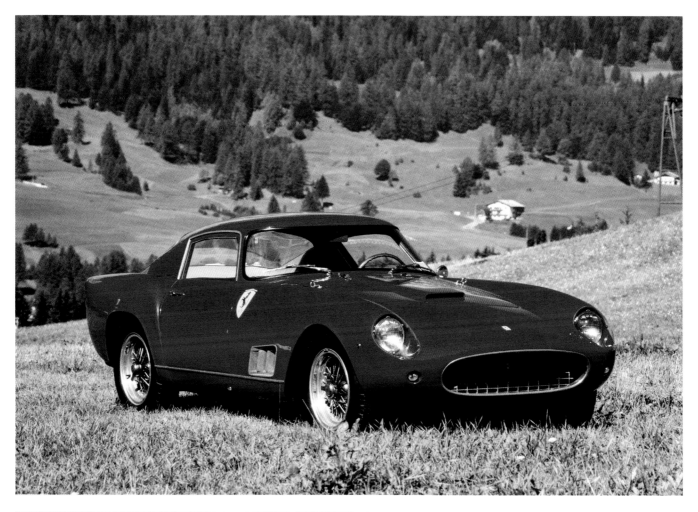

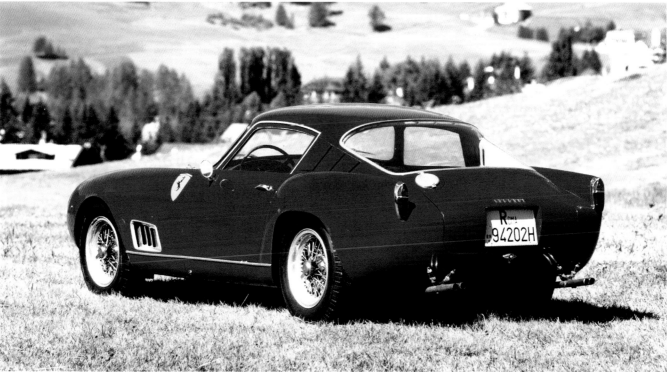

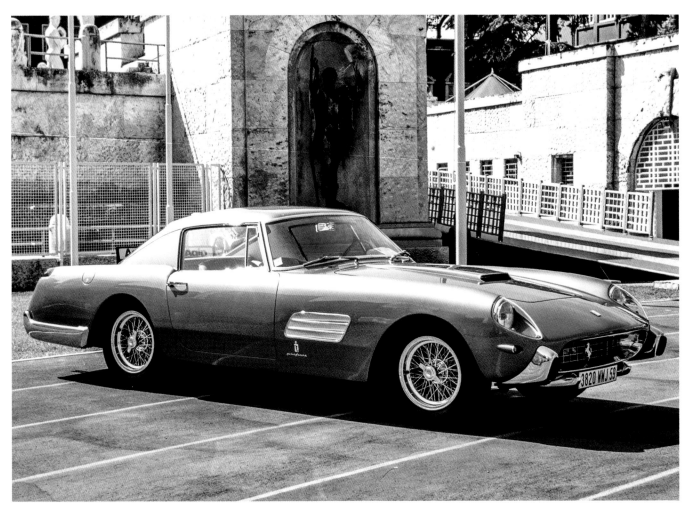

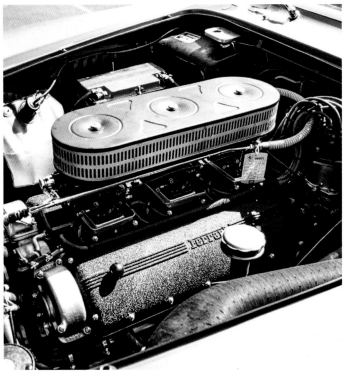

250
GT Speciale
1957

ENGINE // 2953CC, V12

POWER // 164KW (220BHP) AT 7000RPM

CHASSIS // STEEL LADDER

GEARBOX // FOUR-SPEED

TOP SPEED // 230KM/H (143MPH)

WEIGHT // 1050KG (2315LB)

For all that the 250 GT Coupé series represented Ferrari's determination to increase sales volume, the company was still more than willing to entertain significant or high-net-worth customers and their unique requirements. In 1956 four 250 GT Coupé chassis were diverted from Carrozzeria Boano to Pinin Farina, where they were clothed in bodywork closely resembling that of the 410 Superamerica; one of them went to Fiat director Emmanuele Nasi, a member of the Agnelli family.

The following year Pinin Farina received another commission. Princess Lilian de Réthy had married King Leopold III of Belgium in secret while he was under house arrest during World War II; by 1951, accusations of collaboration with the Nazis had rendered Leopold's position untenable and he abdicated in favour of his son, turning his attention to indulging his love of racing and performance cars. The Princess shared this passion and not only acquired a Zagato-bodied 250 GT, she also helped facilitate a supply of tyres from the Belgian company Englebert to Scuderia Ferrari when Pirelli abruptly cut off supplies in mid-1955.

Naturally the Princess's next order received highly preferential treatment. Another Tipo 508 chassis was directed to the Pinin Farina workshops to receive a body which, while unique in itself, incorporated a number of details that would become standard in forthcoming models, such as the faired-in headlamps, split bumpers, chromed side louvres and extended tail.

Nine years later the Princess gifted the car to an American surgeon who had visited a cardiovascular specialist hospital she sponsored; he sold it on to another doctor who fitted larger 15-inch (380mm) wheels and disc brakes.

335 S
1957

ENGINE // 4023CC, V12

POWER // 239KW (320BHP) AT 7400RPM

CHASSIS // STEEL LADDER

GEARBOX // FOUR-SPEED

TOP SPEED // 299KM/H (186MPH)

WEIGHT // 880KG (1940LB)

Under pressure from Maserati's potent 450S, Ferrari responded by upgrading the 290 MM concept. Initially Vittorio Jano and his engineers expanded the V12 to 3.8-litre form, giving a swept volume for each cylinder of 315cc. The resulting unit was mounted into a tubular steel frame similar to the 801 Formula 1 car's and called the 315 S but, after a disappointing maiden appearance at the Sebring 12 Hours in March, Ferrari upgraded the engine again.

Increasing the bore and stroke from 76 x 69.5mm (3 x 2.73in) to 77 x 72mm (3.03 x 2.83in) brought the V12 to just over 4 litres. Two new chassis were built for it and christened the 335 S, while another was installed in the 315 S Peter Collins and Maurice Trintignant had driven to sixth at Sebring. Wolfgang von Trips drove it to second overall on the 1957 Mille Miglia but one of the sister cars, driven by Alfonso de Portago, suffered a tyre blow-out and crashed, killing the occupants and nine spectators. The incident brought denunciation from the Vatican and the end of the Mille Miglia.

Despite the fallout from the accident, Luigi Chinetti saw a potential market for the 335 S on the US club racing scene and, in 1958, persuaded Ferrari to build a fourth car. Scaglietti bodied it in the "pontoon" style made desirable by the 250 Testa Rossa, and Texas rancher and oil magnate Alan Connell Jr acquired the car after seeing it at the New York Motor Show.

In 2016 the ex-Von Trips car changed hands for €32 million in an Artcurial auction at Retromobile Paris.

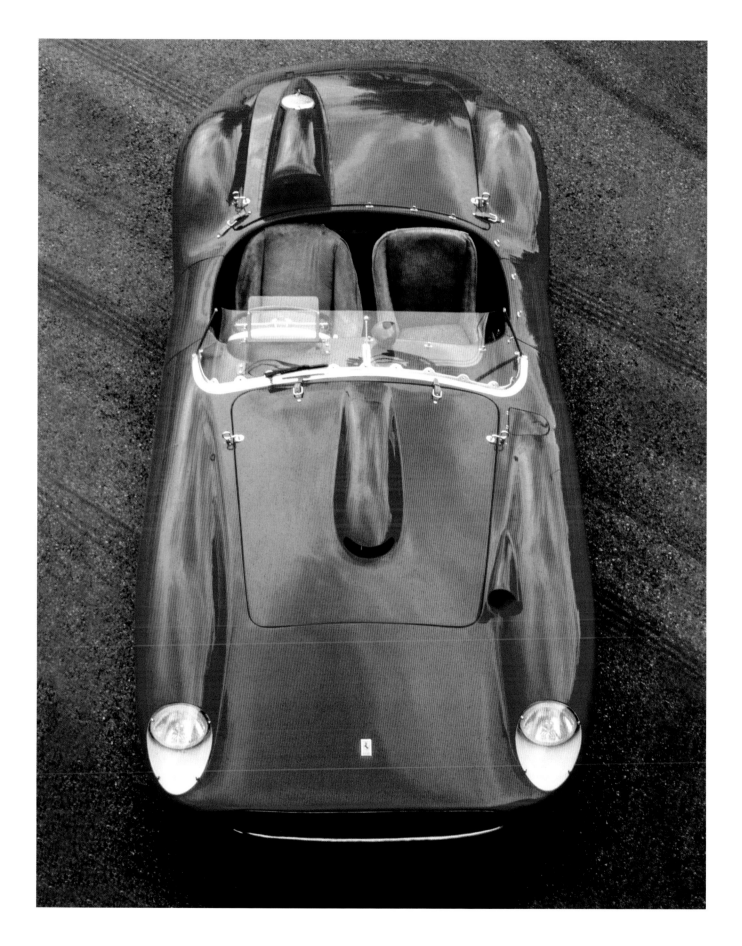

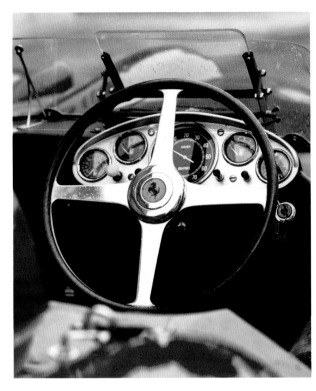

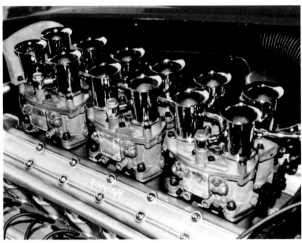

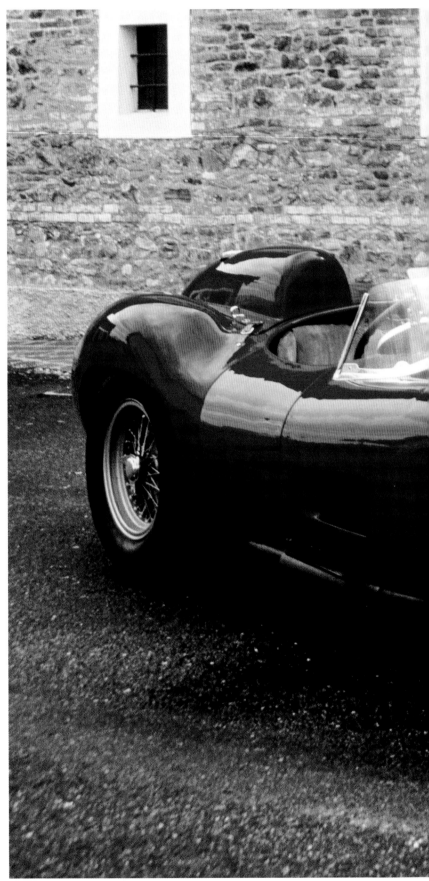

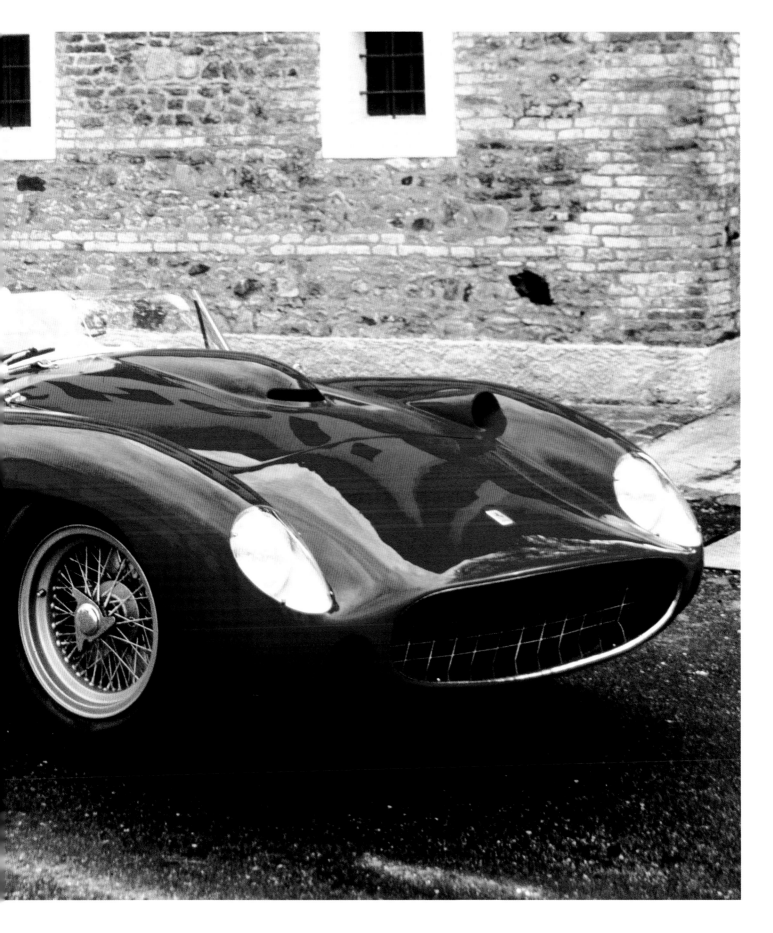

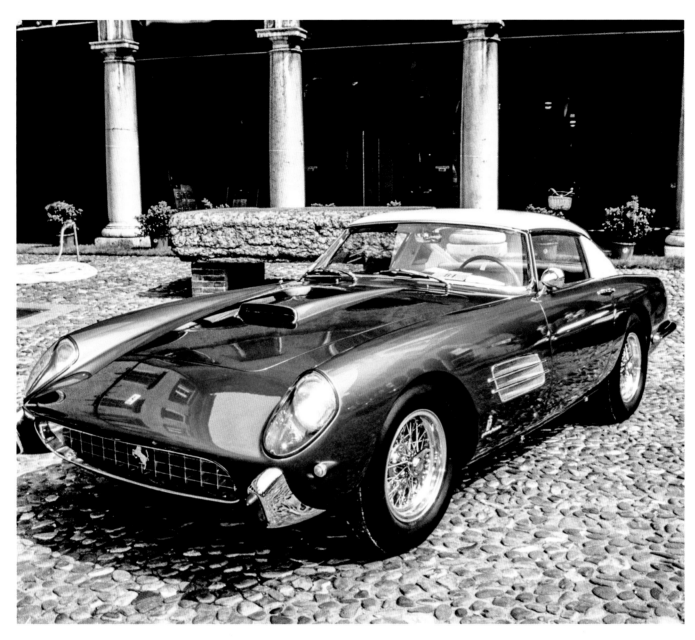

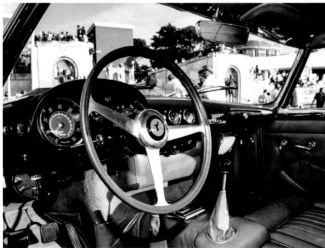

4.9
Superfast
1957

ENGINE // 4962CC, V12

POWER // 283KW (380BHP) AT 6500RPM

CHASSIS // STEEL LADDER

GEARBOX // FOUR-SPEED

TOP SPEED // 259KM/H (161MPH)

WEIGHT // 1200KG (2646LB)

Ferrari's appetite for the American market regularly prompted the company to add to its stock of models catering specifically to the tastes of US customers of the time, lavishly appointed with fins and chrome. In 1956 the 410 Superamerica supplanted the 375 America, featuring a 5-litre version of the Lampredi V12 in a shorter-wheelbase chassis (2600mm/102in). Retaining the artisan style of production for these cars, though, meant they retailed for considerably more than series-built rivals, so the clientele was naturally more rarefied.

For the 1956 Paris Motor Show Pinin Farina built a dramatic one-off variant badged as a 410 "Superfast", powered by a twin-spark version of the V12 and distinguished by dramatically exaggerated Cadillac-style rear fins and a pillarless windscreen. Californian oil magnate William Doheny bought the car but sold it two years later to Hollywood actor Jackie Cooper.

At the 1957 Paris show Farina showed another one-off, similar to the previous example in its front-end treatment but finished in a more sober blue with an off-white roof which swept back into a more restrained tail: here there were no fins, just a neat pair of ridges with "Ferrari 4.9 Superfast" badging on the neatly curved boot lid. After a further appearance at the Turin show the car was sold to the co-founder (with Luigi Chinetti) of the North American Racing Team, US-domiciled Dutch businessman Jan de Vroom. The source of de Vroom's wealth remains the subject of speculation; some time after selling the car he was found dead in his New York home, in a room supposedly locked from the inside. A subsequent owner had the 4.9 Superfast's body repainted green.

250 GT California Spyder
1957

ENGINE // 2953CC, V12

POWER // 209KW (280BHP) AT 7000RPM

CHASSIS // STEEL LADDER

GEARBOX // FOUR-SPEED

TOP SPEED // 174KM/H (108MPH)

WEIGHT // 1000KG (2205LB)

While Luigi Chinetti is a pivotal figure in Ferrari history and led the company's charge into the US market, John von Neumann, an early customer who became Ferrari's agent on the West Coast, is widely credited with sparking the idea for one of the marque's most iconic models. Von Neumann's proposal had an impeccable logic: build an open-top version of the sport-focused 250 GT Berlinetta models, suitable for wind-in-the-hair motoring in sunny California. With Chinetti's backing, Enzo Ferrari was easily convinced.

The first prototype was completed in late 1957, based on a 2600mm-wheelbase (102in) Tipo 508 chassis with a 3-litre Colombo V12 in a similar state of tune to those in the berlinetta models later known as 250 "Tour de France". Ferrari tasked Scaglietti with producing the bodywork. Principally for reasons of cost and production expediency the shell was steel, though the doors, bonnet and boot lid were aluminium. The bumpers, vents, grille and tail lights were identical to the berlinettas. Virginian tobacco magnate George Arents, a keen racer and an investor in Chinetti's North American Racing Team, bought the prototype and immediately shipped it to the US. This car then passed through a number of hands, most recently selling for $6.6 million in 2019 at Gooding & Co's Pebble Beach auction.

Although Ferrari generally used "Spyder" to denote open-top racing cars without a roof, the 250 California also received this name to differentiate it from the 250 GT Cabriolet model. Ultimately 50 were built, some all in aluminium depending on putative owners' wishes, and some with open rather than faired-in headlights. This first production run is now referred to as the "LWB" model, since the next series featured a shorter wheelbase.

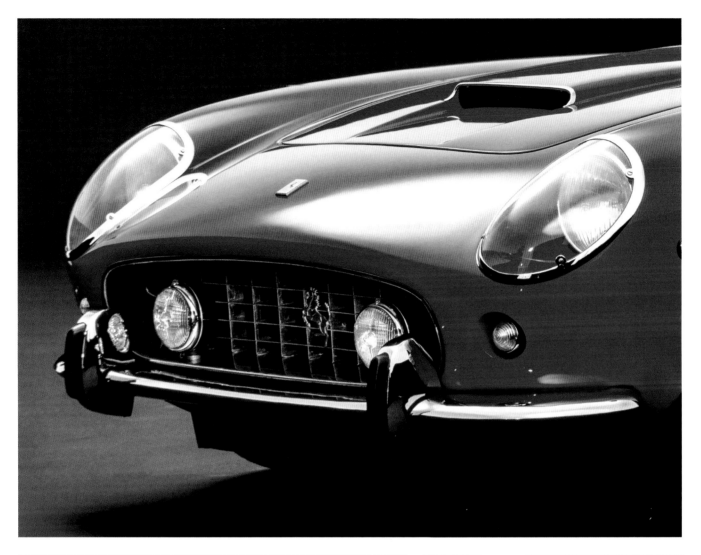

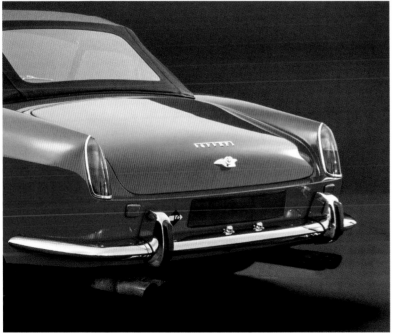

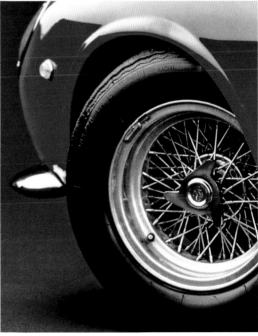

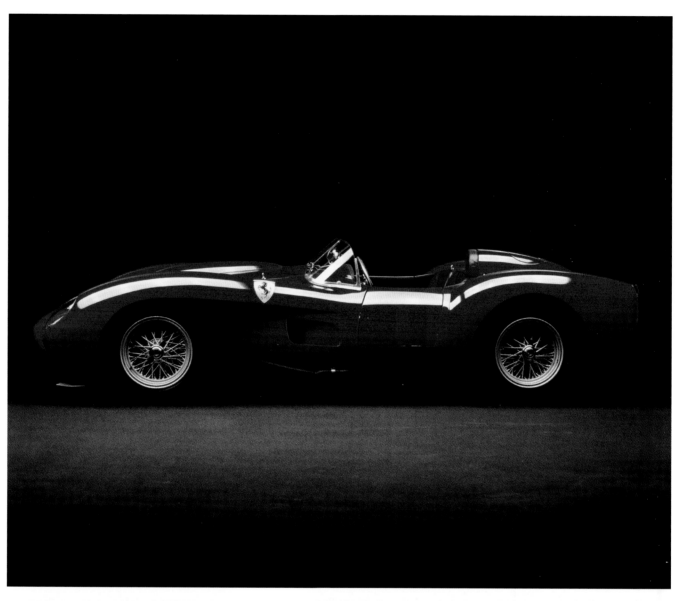

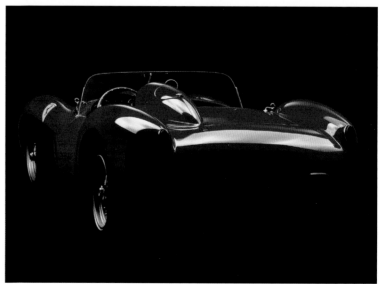

250
Testa Rossa
1957

ENGINE // 2953CC, V12

POWER // 224KW (300BHP) AT 7000RPM

CHASSIS // STEEL LADDER

GEARBOX // FOUR-SPEED

TOP SPEED // 270KM/H (168MPH)

WEIGHT // 800KG (1764LB)

The 500 Testa Rossa gained a big brother in 1957 as Ferrari responded to impending changes in the world sportscar championship, principally the imposition of a 3-litre limit for the 1958 season. The recently arrived Carlo Chiti took charge of development and Enzo Ferrari gave him a stringent brief: essentially the new car was to offer owners of the 500 TRC an upgrade path, offering the same standards of agility but with more power – and unparalleled reliability. This was not a time to experiment.

Chiti's team duly produced a prototype based on a Scaglietti 290 MM body, with an extended version of the new 500 TRC chassis, and powered by a 3-litre Colombo V12 with six carburettors rather than three. The new car was ready in time for the Nürburgring 1000km, weeks after the tragic Mille Miglia; while Scuderia Ferrari contested the event with a 315 S and a 335 S, the 250 TR was a stealth entry in the hands of Colorado oilman Temple Buell's team, driven by up-and-coming US grand prix racer Masten Gregory and Italian amateur Olinto Morolli.

Enzo's dictat regarding experimentation meant the first production 250 TRs of 1958 continued to run with drum brakes rather than discs. To provide additional ventilation for the front brakes Chiti and Scaglietti designed cut-outs between the wings and the nose (so-called "pontoon fenders") and scalloped cut-outs behind the rear wheels, but this proved draggy and was dropped on later cars.

The 250 TR won a number of major international events in 1958, including the Le Mans 24 Hours.

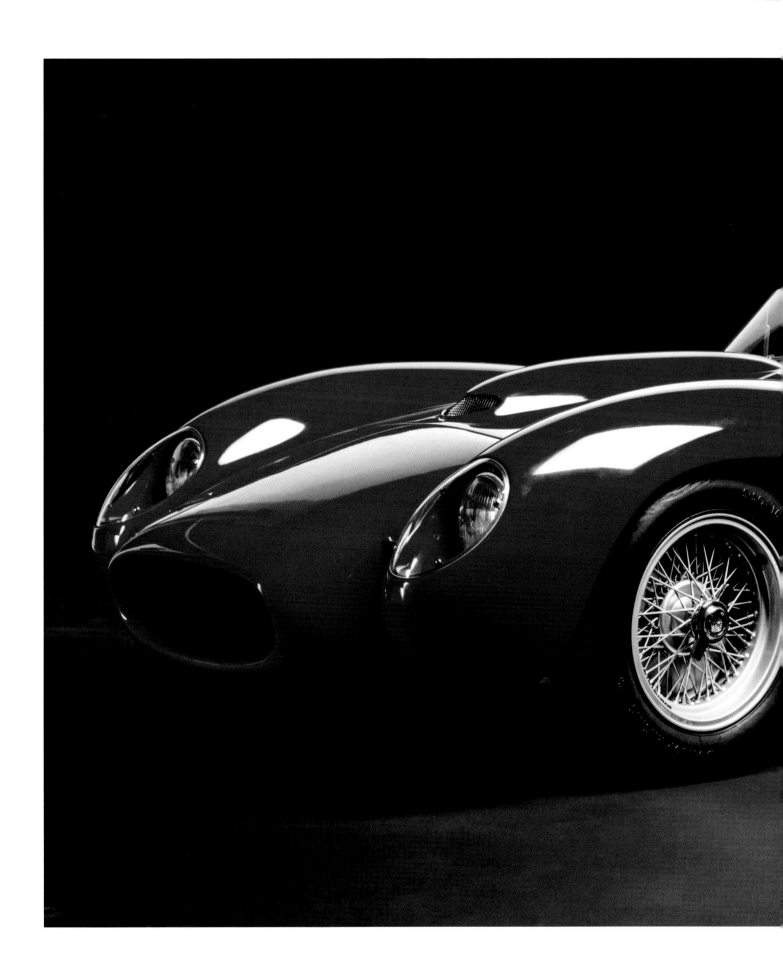

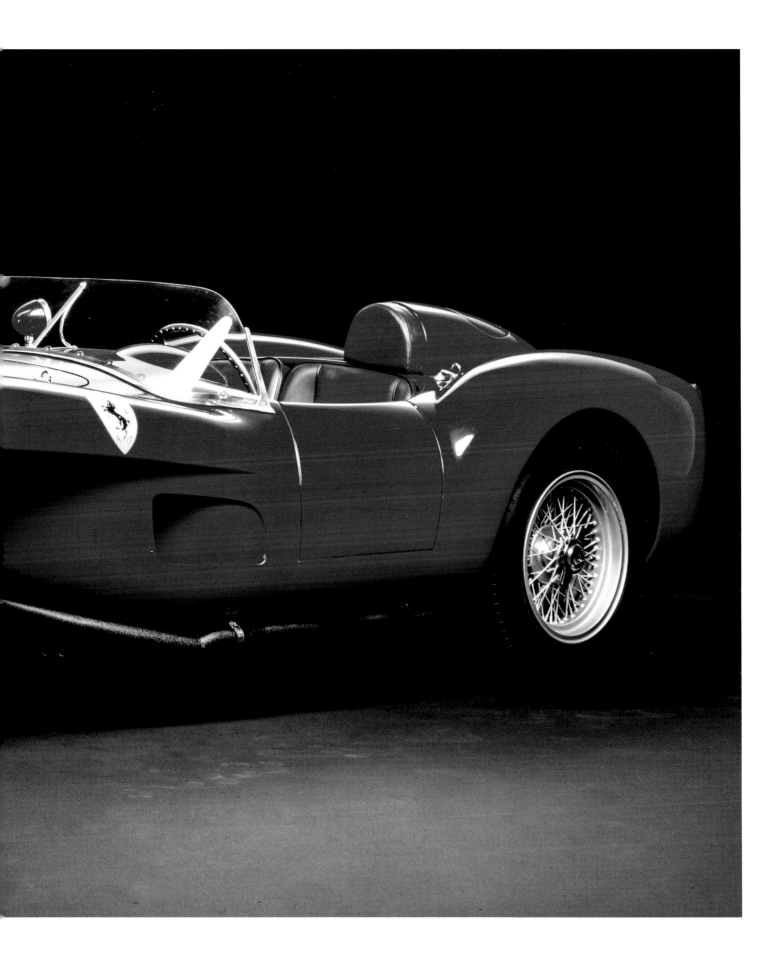

250
GT Cabriolet
1957

ENGINE // 2953CC, V12

POWER // 164KW (220BHP) AT 7000RPM

CHASSIS // STEEL LADDER

GEARBOX // FOUR-SPEED

TOP SPEED // 220KM/H (137MPH)

WEIGHT // 1050KG (2315LB)

Given the popularity of open-top sportscars, it was practically inevitable Ferrari would offer a cabriolet version of the 250 GT and the first prototype, designed and built by Pinin Farina, appeared as a concept car on Ferrari's stand at the 1957 Geneva show. It was later repainted and sold to Peter Collins, one of the works Ferrari drivers (Enzo didn't give his cars away to his contracted drivers, but he was prepared to move a little on the price).

Before series-style production got underway as per the mainstream model, the 250 GT Cabriolet was built to order artisan-style; the fourth example built was a commission for the Aga Khan and featured a precious stone set in the dashboard. While the prototype featured Dunlop disc brakes, production 250 GT Cabriolets reverted to drum brakes all round. Farina also mildly restyled the tail with less pronounced "fins".

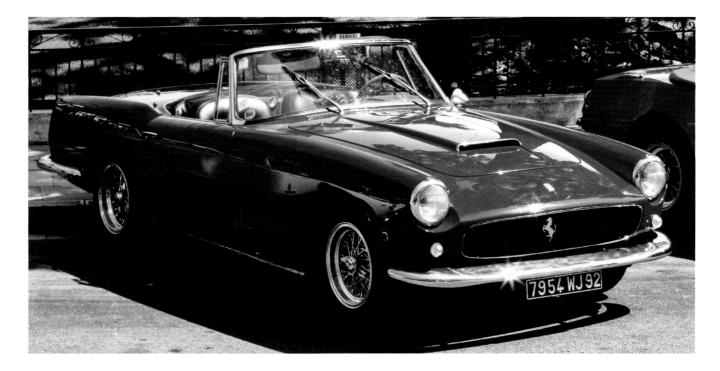

500 Testa Rossa Competizione
1957

ENGINE // 1984CC, INLINE-FOUR

POWER // 134KW (180BHP) AT 7000RPM

CHASSIS // STEEL LADDER

GEARBOX // FOUR-SPEED

TOP SPEED // 245KM/H (152MPH)

WEIGHT // 680KG (1499LB)

The FIA's sporting commission brought in new regulations for 1957 which required the 500 Testa Rossa design to change. The revised Appendix C gave a minimum cockpit width for cars of this class and required them to have space for a passenger, plus a full-width windscreen, functioning doors and a folding top. Carrozzeria Scaglietti took the opportunity to revise the car's shape slightly, leading with a lower and more tapering nose shape, broader cut-outs behind the front wheels, plus a lower bonnet line – enabled by mounting the Lampredi inline-four lower in the chassis.

Nineteen examples were built, the majority either acquired directly by US customers or being sold on to American hands after racing in Europe. Richie Ginther, Howard Hively and Windy Morton scored a class win, 10th overall, at the 1957 Sebring 12 Hours in the first chassis completed.

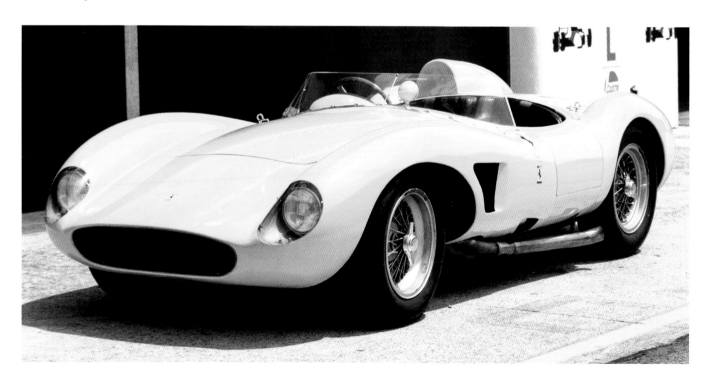

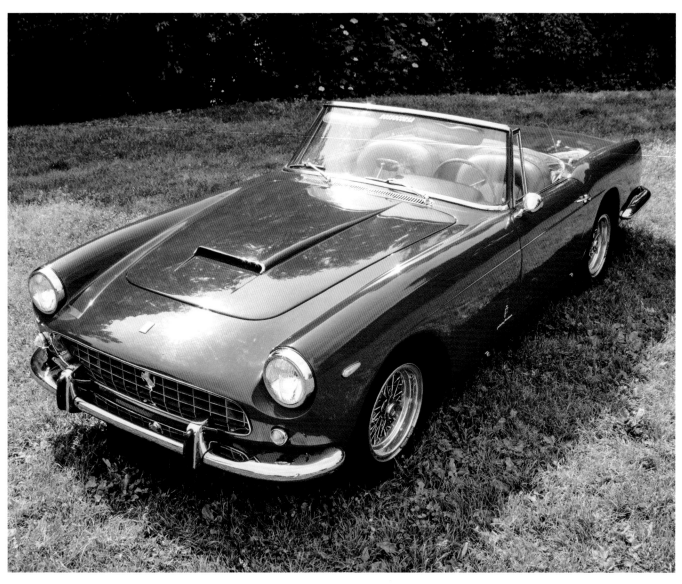

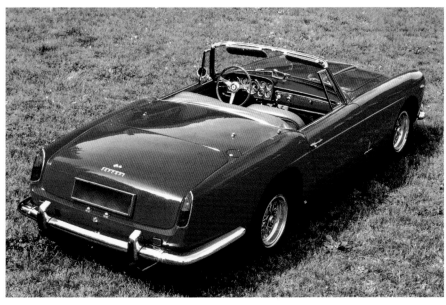

250 GT
Cabriolet Series II
1959

ENGINE // 2953CC, V12

POWER // 179KW (240BHP) AT 7000RPM

CHASSIS // STEEL LADDER

GEARBOX // FOUR-SPEED

TOP SPEED // 249KM/H (155MPH)

WEIGHT // 1200KG (2645LB)

For 1959 Ferrari updated the 250 GT Cabriolet to differentiate it further from the edgier, more performance-focused berlinetta-style models. A more rounded nose treatment with open rather than Plexiglass-faired headlights, generous but not too over-the-top applications of chrome, a discreet swage line running between the top of the front and rear wheel arches, and a less steeply raked windscreen marked out the exterior. Inside, the new car was far more luxuriously trimmed than before and slightly more spacious, as was the boot.

Mechanical changes included a sharper steering rack, disc brakes, and the new Tipo 128F version of the Colombo engine, which featured a new cylinder head design boasting revised porting and conventional valve springs rather than the hairpin type used previously. The renewed emphasis on durability and long-legged comfort was successful: around 200 were built.

250
GT SWB
1959

ENGINE // 2953CC, V12

POWER // 209KW (280BHP) AT 7000RPM

CHASSIS // STEEL LADDER

GEARBOX // FOUR-SPEED

TOP SPEED // 267KM/H (166MPH)

WEIGHT // ALUMINIUM BODY 960KG (2116LB); STEEL BODY 1100KG (2425LB)

First introduced as a pure racing model at the 1959 Paris Motor Show, the short-wheelbase evolution of the 250 GT reinvigorated the model and rendered the "Interim" version obsolete at a stroke. Reducing the wheelbase by 200mm (7.9in) to 2400mm (94.5in) improved agility and Pinin Farina subtly restyled the aluminium body into a more aerodynamic form, with a less bluff nose, lower bonnet and roof line, and more neatly resolved details around the rear wheel arches and tail. Under the skin, disc brakes featured on a production Ferrari for the first time.

As with the 250 GT Cabriolet Series II, the new model featured the latest Tipo 128F iteration of the Colombo V12, in which the spark plugs had been relocated from the inside to the outside of the "vee" to improve combustion at high revs. Changing from hairpin to coil-spring valve actuation enabled Ferrari to locate the cylinder head with four studs per cylinder rather than the previous three, reducing the likelihood of blown gaskets.

Among the team working on the 250 GT SWB under Carlo Chiti was Mauro Forghieri, a recent graduate of Bologna University. Forghieri's father Reclus was a long-time associate of Enzo Ferrari; the two had worked together when Ferrari was running Alfa Romeo's racing team in the 1930s. Now Enzo offered young Mauro an internship and persuaded him to put on hiatus his plans to work in the US aviation industry.

While a softer-edged "Lusso" ("luxury") model was launched in 1960, with a steel bodyshell, it's as a race car the 250 GT SWB is most memorable. Homologated just before the 1960 Le Mans 24 Hours, it took the top four positions in class and went on to claim further victories in prominent international events.

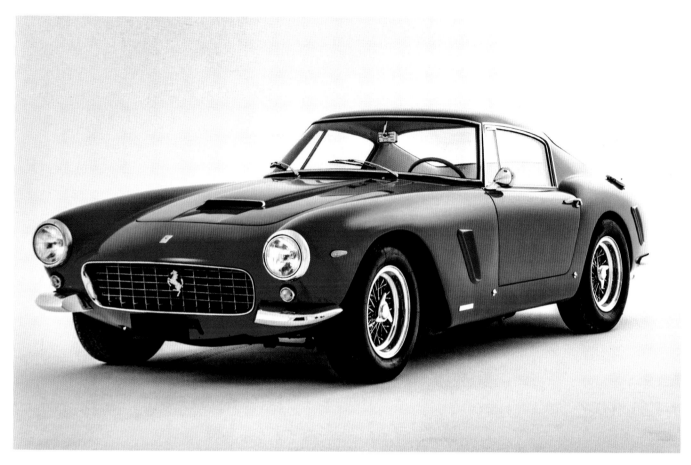

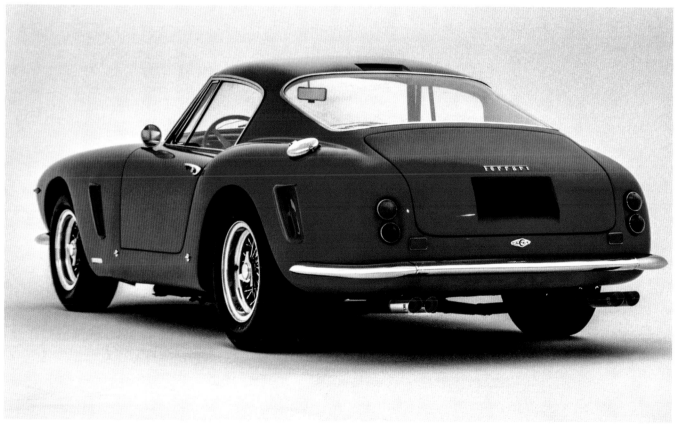

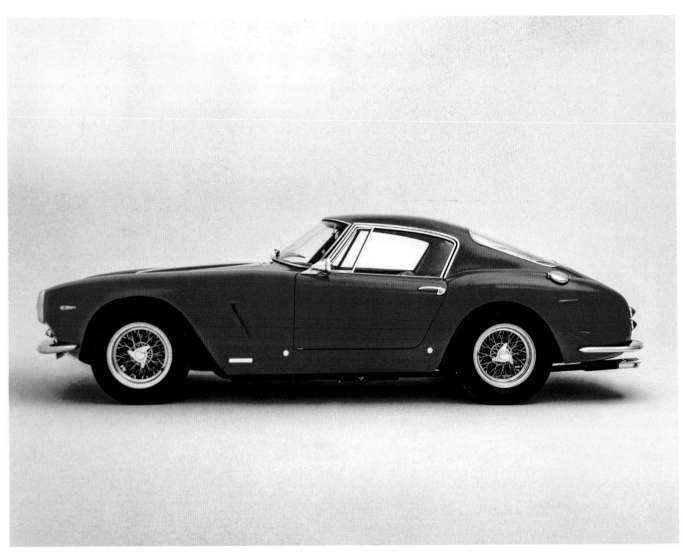

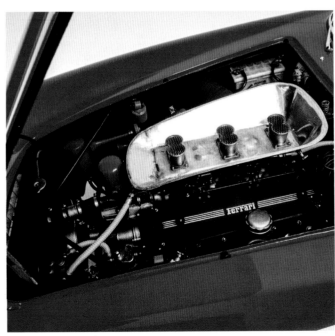

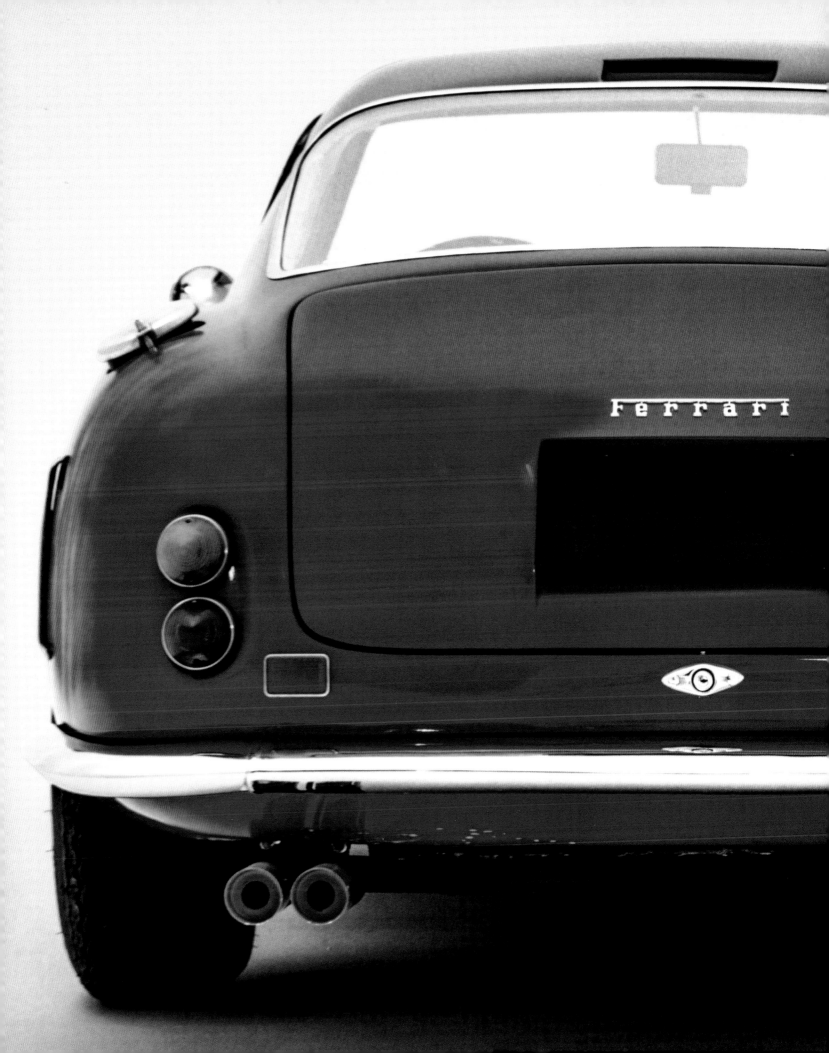

- 250 TR 59/60
- 400 SUPERAMERICA
- 250 GT CALIFORNIA SWB SPYDER
- 250 TRI 61
- 250 GT SPERIMENTALE
- 250 GTO
- 250 GT DROGO
- 250 GTO "BREADVAN"
- 250 GT LUSSO
- 330 LMB
- 250 GTE 2+2
- 330 AMERICA
- 330 GT 2+2
- 275 P
- 330 P
- ASA 1100 GT
- 250 GTO 64
- 250 LM
- 275 GTS/2
- 275 GTS/2 TRE POSTI
- 275 GTB/2
- 330 P2
- 365 P2/3
- 412P
- 275 GTB4
- DINO 206 S
- 330 GTC
- 330 GT
- DINO 206 S PININFARINA COMPETIZIONE
- 365 GT 2+2
- 275 GTS NART
- 330 GT 2+2 SHOOTING BRAKE
- 365 GTB4
- 365 GTC
- 365 GTS4
- DINO 246 GT

1960s

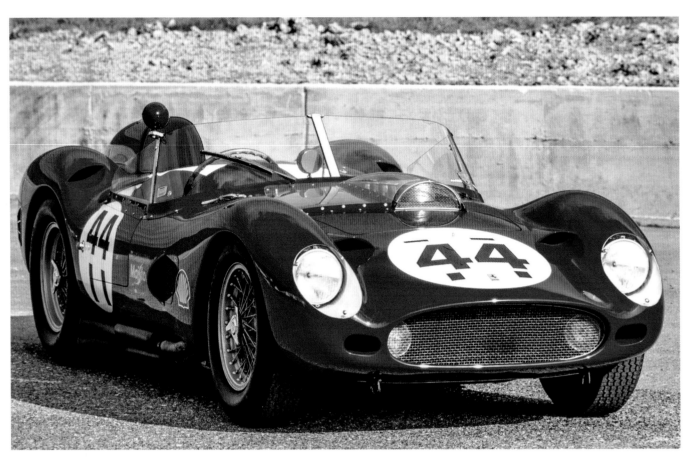

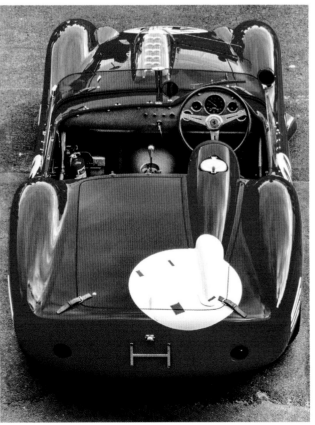

250
TR 59/60
1960

ENGINE // 2953CC, V12

POWER // 209KW (280BHP) AT 7200RPM

CHASSIS // TUBULAR STEEL

GEARBOX // FIVE-SPEED

TOP SPEED // 259KM/H (161MPH)

WEIGHT // 750KG (1654LB)

While the "pontoon fender" front-end treatment of the original 250 Testa Rossa became iconic, in period it was quickly recognized as a liability and dropped in favour of a conventional nose; moving from drum brakes to Dunlop discs for the 1959 season removed the need for the (theoretically) greater amount of cooling the pontoons offered. But despite adopting these upgrades, along with a lighter, shorter chassis and a new five-speed gearbox, Ferrari was still frustrated in the 1959 world sportscar championship.

Having lost the title to Aston Martin – a company which, just over a decade earlier, had been sold through the classified advertisements section of *The Times* newspaper – Enzo sanctioned further developments of the 250 TR concept. Dry-sumping the engine enabled it to be mounted lower in the tubular steel chassis frame, improving handling and aerodynamics – although gains in the latter were offset by a new rule requiring windscreens to have a minimum vertical height of 250mm (9.84in). Testing would uncover drag and turbulence issues which would not be resolved until 1961.

Two new cars were built with Fantuzzi bodywork and featuring independent rear suspension, while three of the 1959 chassis were converted with the new bodywork and engine but retaining a De Dion rear axle. Ferrari won the first round of the 1960 championship season, but then withdrew from the Sebring 12 Hours in a dispute over fuel imposed on them by the race organizers. This, and defeats by Porsche and Maserati in two subsequent rounds, left them needing to win at Le Mans. There, despite the aerodynamic issues, Ferrari claimed a one-two finish with Olivier Gendebien and Paul Frère leading in the car photographed here.

400 Superamerica
1960

ENGINE // 3967CC, V12

POWER // 254KW (340BHP) AT 7000RPM

CHASSIS // STEEL LADDER

GEARBOX // FOUR-SPEED

TOP SPEED // 266KM/H (165MPH)

WEIGHT // 1280KG (2822LB)

While embracing series production with the 250 GT range, Ferrari continued to offer artisan-style construction to a more rarefied clientele. The 400-series grand tourer (named after the 4-litre V12's total displacement rather than the volume of a single cylinder) supplanted the low-volume 410 in 1960, previewed by a one-off coupé designed for Fiat magnate Gianni Agnelli and displayed at the Turin Motor Show in October 1959. This car bore a stronger American styling influence than the examples to come, leading with twinned headlights and a protruding squared-off grille; Pinin Farina would refine the style slightly ahead of a subsequent appearance in Geneva in 1960 before Agnelli took delivery.

A two-seater 400 Superamerica cabriolet bearing a familial resemblance to the 250 GT appeared at the Brussels show in January 1960, but it was not until November that year, at the Turin show, that something approaching the definitive overall shape of the coupé would be revealed. Badged as the Superfast II, the car was elegantly streamlined from the pop-up headlights in its sloping nose to its elongated, tapering tail. Farina would present the car on two more occasions in reworked form as the Superfast III and IV.

Production examples followed a similar styling template but with fixed rather than pop-up headlights; customers could specify a California-style treatment with Plexiglass fairings. It is believed around 17 coupés were built, with a price tag which guaranteed scarcity. Some were sold to European dignitaries such as Count Giovanni Volpi di Misurata but the majority went to America, where customers included the likes of Las Vegas casino pioneer William Fisk Harrah and oil magnate John Mecom Jr.

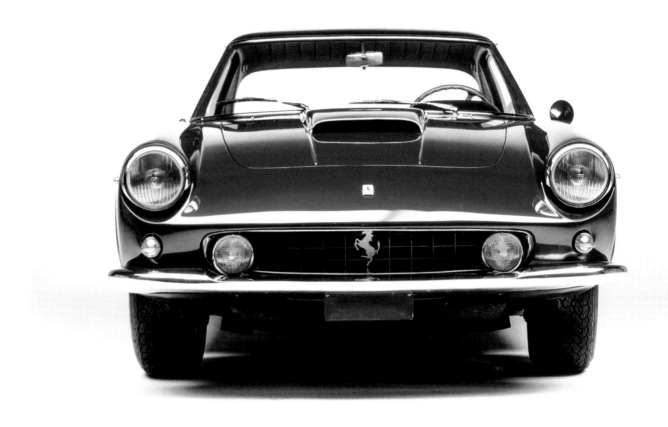

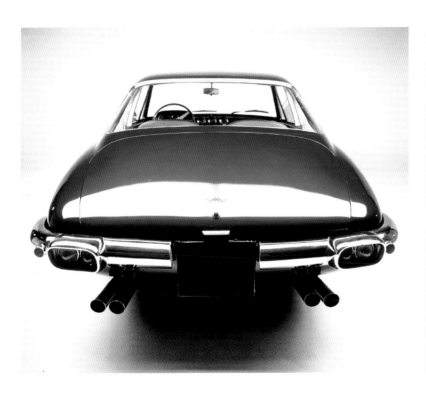

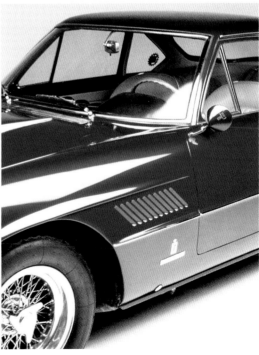

250 GT
California SWB Spyder
1960

ENGINE // 2953CC, V12

POWER // 209KW (280BHP) AT 7000RPM

CHASSIS // STEEL LADDER

GEARBOX // FOUR-SPEED

TOP SPEED // 230KM/H (143MPH)

WEIGHT // 1020KG (2249LB)

In 1959 Scaglietti mildly restyled the 250 GT California with a different bonnet scoop profile, chromed vents in each wing, plus chromed headlight surrounds on those sold without Plexiglass fairings. These examples also benefitted from Dunlop disc brakes. But the bigger change came in 1960 when Ferrari swapped the car to the new short-wheelbase wide-track chassis which underpinned the 250 GT SWB berlinettas. Telescopic shock absorbers replaced the previous setup of Houdaille rotary dampers acting via rocker arms. Under the bonnet, the new Tipo 168 engine breathed through a new cylinder head design featuring larger valves.

This latest version of the car inked in Ferrari's popularity with the Hollywood set; buyers included Bob Hope, Alain Delon, Barbara Hershey and Roger Vadim. Iconic French singer Johnny Hallyday was another notable owner.

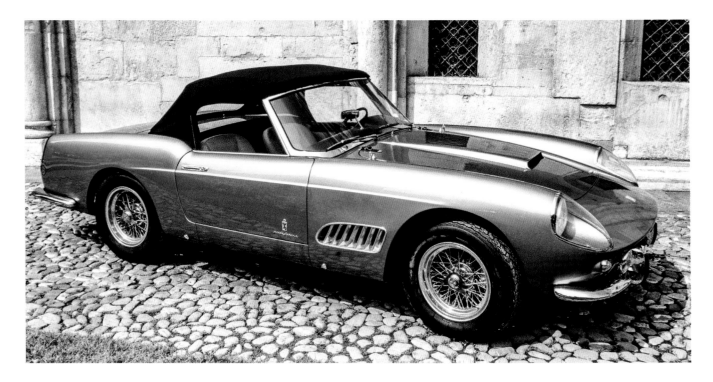

250 TRI 61
1961

ENGINE // 2953CC, V12

POWER // 235KW (315BHP) AT 7500RPM

CHASSIS // TUBULAR STEEL

GEARBOX // FIVE-SPEED

TOP SPEED // 270KM/H (168MPH)

WEIGHT // 685KG (1510LB)

To resolve the drag and turbulence issues generated by the 1960-spec 250 TR bodyshells, Carlo Chiti's engineers wind tunnel-tested a bold new shape distinguished at the front by a twin-nostril treatment. The Perspex windscreen was less aggressively angled and now wrapped around the cockpit sides; but the key developments were at the rear, which was higher than before and cut off abruptly in a so-called Kamm-tail profile. During track testing of a TRI 60 chassis adapted with the new bodywork, Ferrari added a small lip to the top of the trailing edge.

Two TRI 61s were built, by Fantuzzi; Olivier Gendebien and Phil Hill won the Sebring 12 Hours in the first but its engine failed at Le Mans, where it was driven by Pedro and Ricardo Rodríguez. Gendebien and Hill won in the second car.

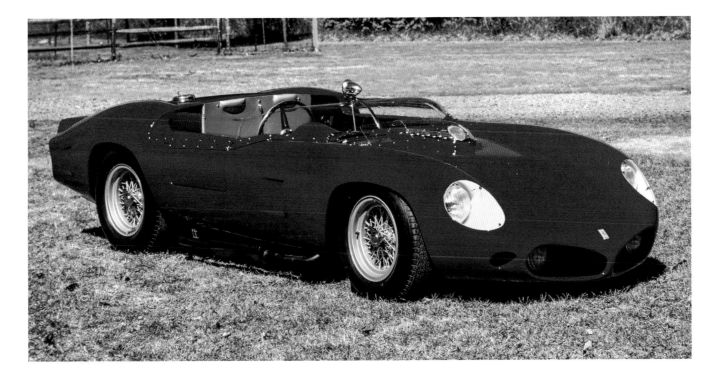

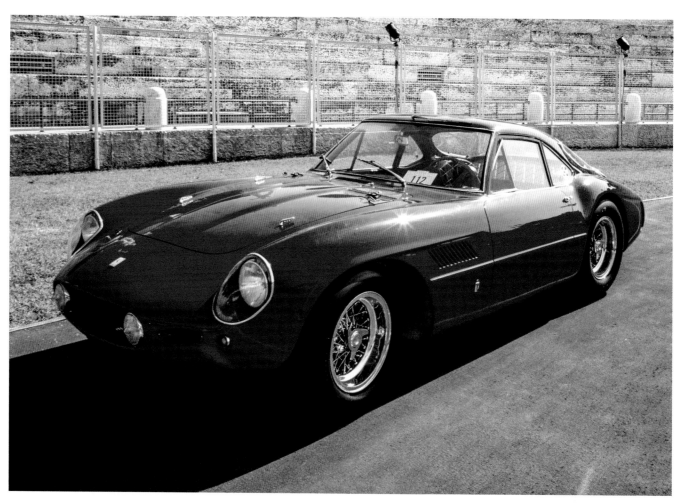

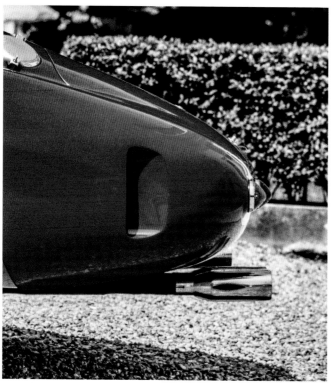

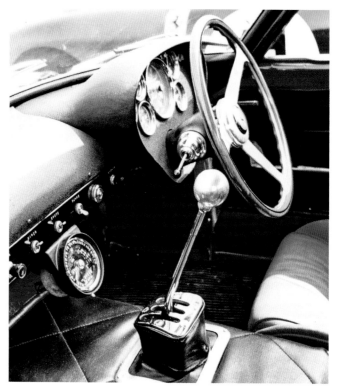

250
GT Sperimentale
1961

ENGINE // 2953CC, V12

POWER // 224KW (300BHP) AT 7200RPM

CHASSIS // STEEL LADDER

GEARBOX // FOUR-SPEED

TOP SPEED // 274KM/H (170MPH)

WEIGHT // 1000KG (2205LB)

When racing's governing body announced that from 1962 only so-called "Group 3" grand touring cars rather than sports-prototypes would be eligible for points in the world sportscar championship, Ferrari put the 250 GT through an urgent development programme led by Giotto Bizzarrini. To arrive at a definitive spec which could then be homologated, the team evaluated a number of aluminium-bodied "Sperimentales" with the primary aim of solving the 250 GT's main issue, which was high-speed drag.

 One 250 GT chassis, number 2643 – photographed here – was rebodied with a Superamerica-style shell and fitted with the Tipo 168 six-carb competition version of the Colombo V12, recently victorious at Le Mans. While the car, driven by Giancarlo Baghetti and Fernand Tavano, retired with engine failure at Le Mans in June 1961, it is now regarded as a significant step towards the evolution of the legendary 250 GTO.

250
GTO
1962

ENGINE // 2953CC, V12

POWER // 224KW (300BHP) AT 7200RPM

CHASSIS // STEEL LADDER

GEARBOX // FIVE-SPEED

TOP SPEED // 280KM/H (174MPH)

WEIGHT // 880KG (1940LB)

Ferrari describes the 250 GTO as "perhaps the last dual-purpose road/race car", a fittingly imprecise term for what is now among the most desirable and valuable sports cars ever created, but one whose creation is cloaked in myth.

Ferrari in mid-1961 was a company in tumult – though this was a relative concept in an organization presided over by Enzo Ferrari, the self-confessed "agitator of men". Scuderia Ferrari was winning again in Formula 1, though chiefly through being better-prepared for the switch to 1.5-litre engines than rivals. Engine grunt was keeping Ferrari on top at Le Mans, too, but the company's technical proposition was becoming increasingly outdated.

The "O" stands for "Omologato" (homologated), and expresses the very point of the car: a forthcoming rule would require 100 examples to be built before a car was approved for racing. Fortunately, as was often the case at this time, the application of this rule was less than diligent: Ferrari only made 39 (this is the official figure; opinions vary as to its accuracy).

Even the identity of the donor car used to create the prototype is unclear: Bizzarrini has said it was a "Boano", number 0523GT; others claim it was an SWB, number 2053GT; Ferrari say "internal factory records" reveal it to be 1791GT, which had been used as a hill-climb racer until its owner, Elio Lenza, crashed it in 1960. Whatever the car, Bizzarrini replaced its engine with the dry-sump Tipo 168 V12 and mounted it lower down and closer to the driver than in the regular 250 GT. Wind tunnel research at the University of Pisa dictated a shape which was denigrated by journalists present at the first test in August 1961 as "Il Mostro" (the monster).

Development was then overtaken by events. Ferrari F1 driver Wolfgang von Trips was killed in the Italian Grand Prix, along with 14 spectators, and Enzo virtually went into hiding. Tensions accumulated and in November eight key employees, including Bizzarrini and Carlo Chiti, departed after a bust-up over the conduct of Enzo's wife Laura.

The task of completing work on the 250 GTO fell to Mauro Forghieri, then 24 years old. Scaglietti revised the bodyshell, while Forghieri refined the (still crude) chassis, and a 250 GTO finished second overall – behind a 250 TR – on its maiden appearance in the 1962 Sebring 12 Hours. The car remained competitive for class wins and high overall placings until mid-engined machinery rendered it obsolete, and surviving examples are hugely prized – one was sold for a reported $70 million in 2018.

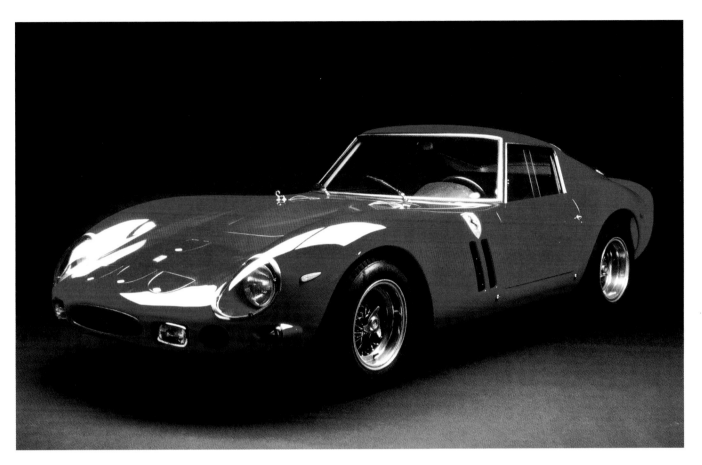

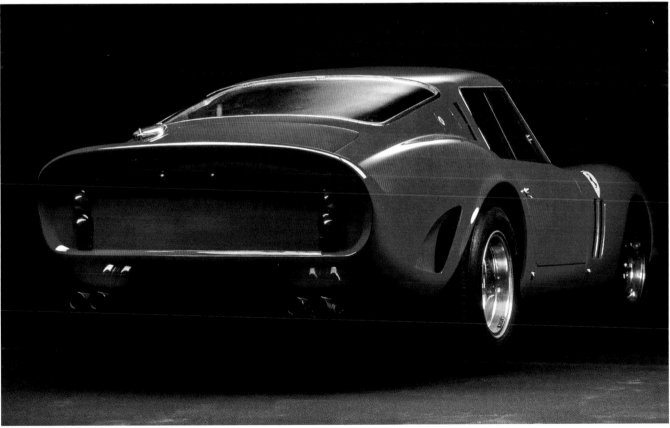

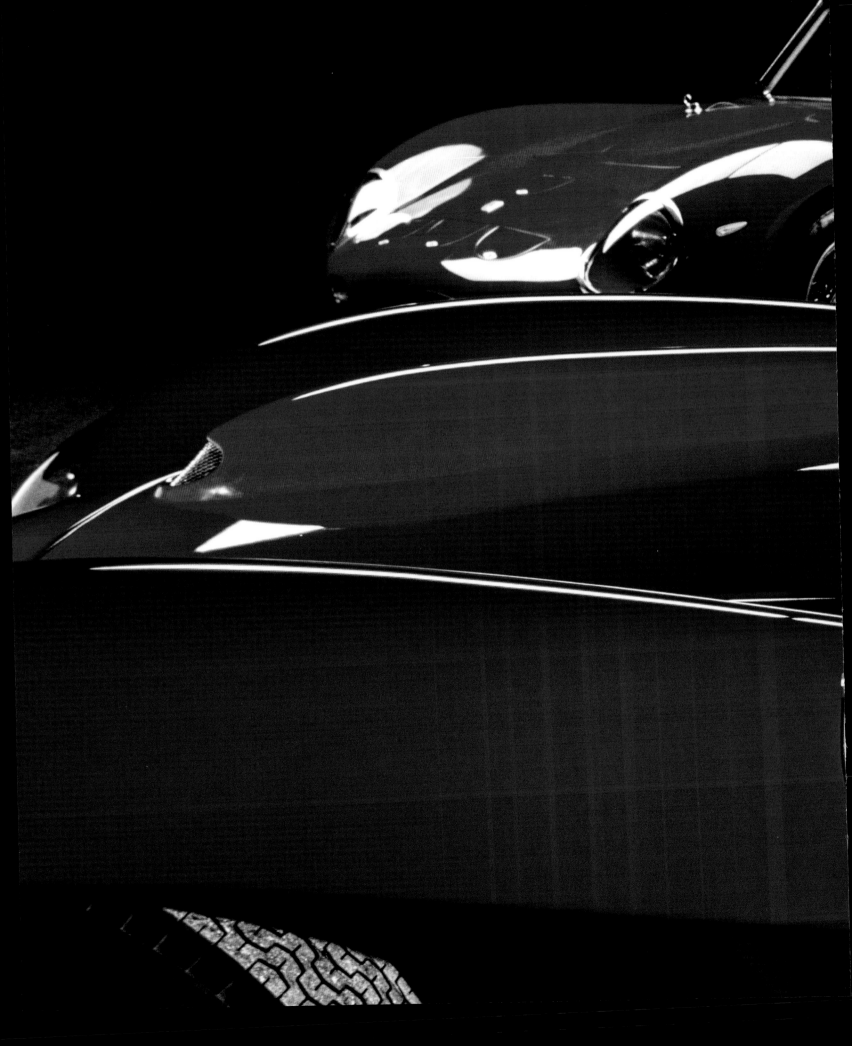

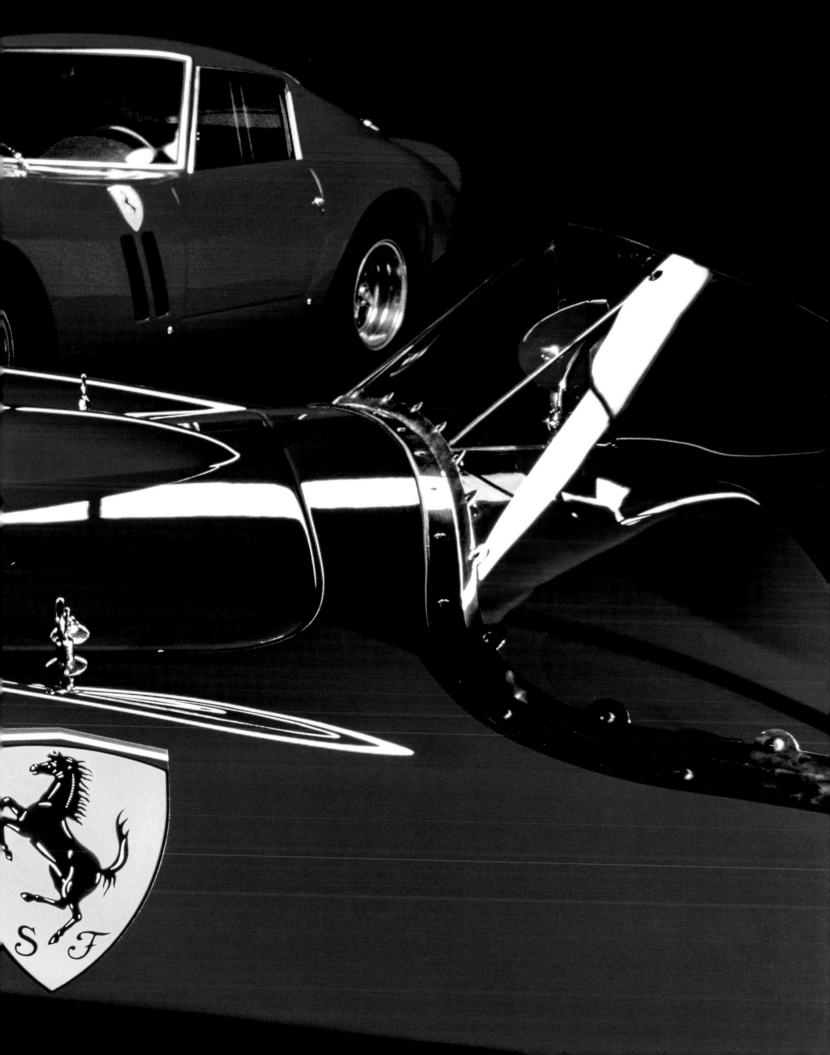

250
GT Drogo
1962

ENGINE // 2953CC, V12

POWER // 179KW (240BHP) AT 7200RPM

CHASSIS // STEEL LADDER

GEARBOX // FOUR-SPEED

TOP SPEED // 249KM/H (155MPH)

WEIGHT // 1145KG (2524LB)

Piero Drogo's Carrozzeria Sports Cars bodied several of Ferrari's successful sports-prototype race cars during the 1960s but was also responsible for a handful of bespoke 250 GT-style Ferraris. The exact number remains indefinite thanks to the vagaries of record-keeping in the era, the tendency of chassis numbers to be swapped between cars to facilitate import/export paperwork, and the fact that at least one bodyshell migrated to another chassis after being crashed.

It is believed the first two were built in 1962–63, one from the chassis of an Ecurie Francorchamps 250 GT SWB which had been damaged in a crash at Le Mans; Hollywood actor James Coburn then bought it. Another was built from an ex-works 250 TR chassis which had been crashed in Brazil. Its owner later sent another to Drogo for the same treatment. Swedish racer Ulf Norinder also had his racing 250 GTO rebodied by Drogo and outfitted as a road car.

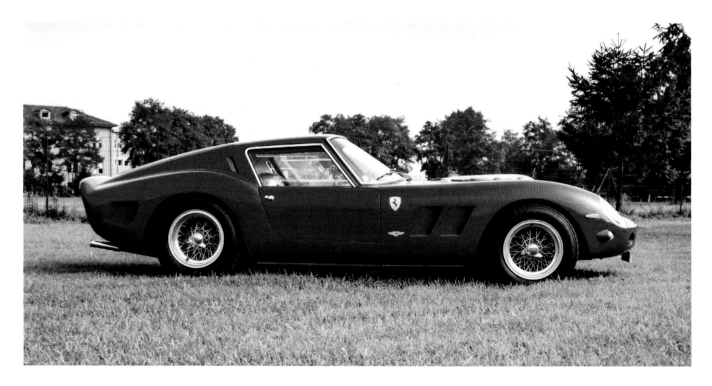

250 GTO "Breadvan"
1962

ENGINE // 2953CC, V12

POWER // 224KW (300BHP) AT 7000RPM

CHASSIS // TUBULAR STEEL

GEARBOX // FOUR-SPEED

TOP SPEED // 280KM/H (174MPH)

WEIGHT // 935KG (2061LB)

Count Volpi was one of Ferrari's preferred customers, but he lost that status in 1962 when Enzo discovered the Count had sponsored the ATS organization, co-founded by Ferrari "rebels" Carlo Chiti and Giotto Bizzarrini. Enzo cancelled the Count's order for a pair of 250 GTOs but he had reckoned without the young nobleman's determination.

Using a 250 GT SWB Volpi had acquired from Olivier Gendebien as a donor, Bizzarrini worked with Piero Drogo's Carrozzeria Sports Cars to design a new shell with a lower bodyline than the GTO's, featuring a full-length roofline which cut off in a Kamm tail. He dry-sumped the engine so it could be fitted lower in the chassis and doubled the number of carburettors. Nicknamed "The Breadvan" by British journalists, the car was running ahead of the five GTOs entered at Le Mans when it retired with a driveshaft failure.

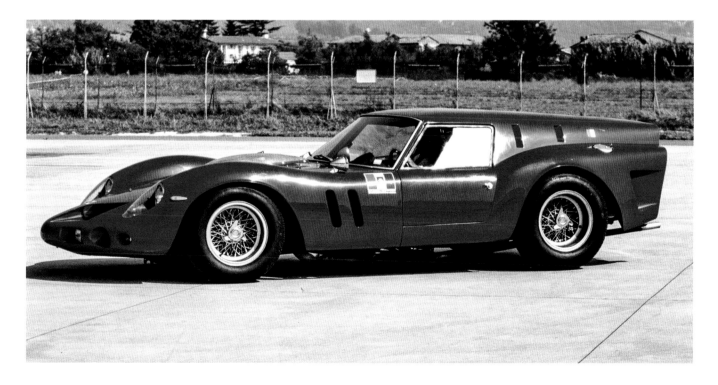

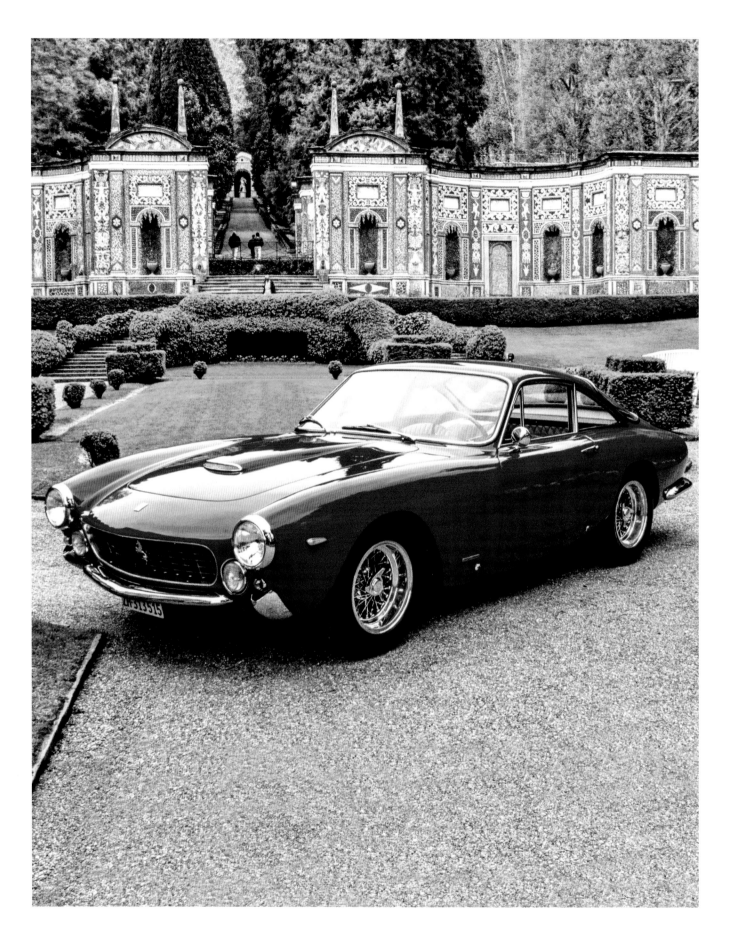

250
GT Lusso
1962

ENGINE // 2953CC, V12

POWER // 179KW (240BHP) AT 7500RPM

CHASSIS // STEEL LADDER

GEARBOX // FOUR-SPEED

TOP SPEED // 240KM/H (149MPH)

WEIGHT // 1310KG (2888LB)

A small but significant step in the evolution of Ferrari's road car offering came in the form of the 250 GT Lusso, presented for the first time at the Paris Motor Show in 1962. Ferrari continued to live largely hand-to-mouth based on earnings from racing and the sale of customer race cars; Enzo was beginning a dance with Ford which would ultimately lead to an offer from the Blue Oval to buy the company. Meanwhile Battista "Pinin" Farina was also looking to the future, changing his family name as well as that of his prestigious carrozzeria to Pininfarina and handing control to his son, Sergio.

While there had already been a "Lusso" ("luxury") version of the 250 GT SWB, this was essentially a racing car with a steel body and more pleasant trimmings, not greatly endowed with cabin or boot space. Ferrari's aim with the new model was to eke more life out of the ageing and rather crude 250 GT underpinnings (still essentially a ladder-frame chassis, albeit with round tubes and additional bracing) while scoring a hit in the more mainstream market.

Pininfarina created an elegant and restrained body style whose unadorned curves directly referenced Ferrari's racing heritage, but the retention of the short-wheelbase chassis meant space was still limited, even if the cabin was more luxuriously trimmed than before. Premature valve-guide wear, which caused the cars to emit copious amounts of smoke under hard acceleration, proved a bugbear for owners who liked to cover distances in their GT Lussos; one such was Steve McQueen, who sold his on after tiring of the bills for engine rebuilds. Still, the car was a success: Ferrari claim to have sold 350 over the two-year production run.

330
LMB
1963

ENGINE // 3967CC, V12

POWER // 298KW (400BHP) AT 7500RPM

CHASSIS // STEEL LADDER

GEARBOX // FIVE-SPEED

TOP SPEED // 280KM/H (174MPH)

WEIGHT // 950KG (2094LB)

Conceived as a "big brother" to the 250 GTO, the 330 LMB took advantage of a relaxation of the rules which had capped engine displacements for GT and sports-prototypes at 3 litres. The governing body's sweeping changes for the 1962 sportscar world championship format had sat ill with the organizers of the Le Mans 24 Hours, and the revised format represented a form of compromise. It also coincided with another expansion of the calendar.

Stretching the wheelbase by 100mm (3.94in) enabled Ferrari to accommodate a 4-litre version of the V12 engine, while the suspension – independent by wishbones at the front, with a live axle at the rear – was similar to the 250 GTO's. Just four 330 LMBs were built and the model was quickly retired as Ferrari pivoted towards mid-engined designs.

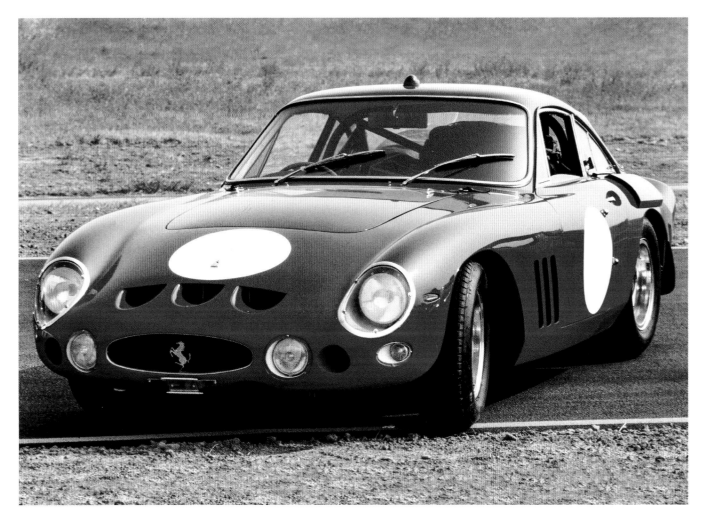

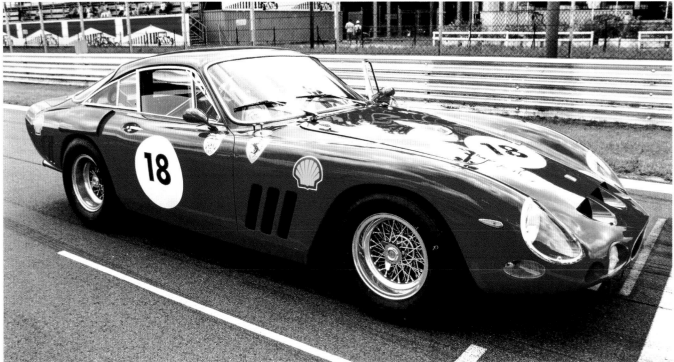

250
GTE 2+2
1963

ENGINE // 2953CC, V12

POWER // 179KW (240BHP) AT 7000RPM

CHASSIS // STEEL LADDER

GEARBOX // FOUR-SPEED

TOP SPEED // 230KM/H (143MPH)

WEIGHT // 1280KG (2822LB)

While its styling was undeniably restrained, Ferrari's first series-produced luxury grand tourer proved enduringly successful: 953 GTE 2+2s were delivered in three series from 1960 to 1963. The final Series III models from 1963 are distinguished by the location of the front fog lights below the headlights, and a different rear-end treatment in which the slightly fussy-looking stack of three individual lights on each side are replaced with a single cluster.

Based on the long-wheelbase 250 GT chassis, the 250 GTE (which took its name from the Tipo 128E engine and 508E chassis) theoretically offered room for four occupants. While the rear seats were perhaps not the last word in space and luxury for those customers who employed a chauffeur, they were more accommodating than the vestigial benches found in some other 2+2s. Seen for the first time as the course marshal's car at Le Mans in 1960, the 250 GTE 2+2 quickly proved it offered performance which belied its stately appearance.

In comparison to the 250 GT LWB, the engine was mounted further forwards in the frame and the roofline lengthened, both to facilitate more space. Wider front and rear tracks also afforded greater cabin and boot volume while benefitting ride quality.

It's possible the success of the 250 GTE 2+2 contributed to Enzo feeling able to rebuff, in 1963, the offer from Henry Ford II to acquire Ferrari; although the potential loss of autonomy over his racing division is believed to have been the greater trigger. The model certainly etched itself on the national consciousness, especially after the government commissioned two to be supplied to Rome police's flying squad.

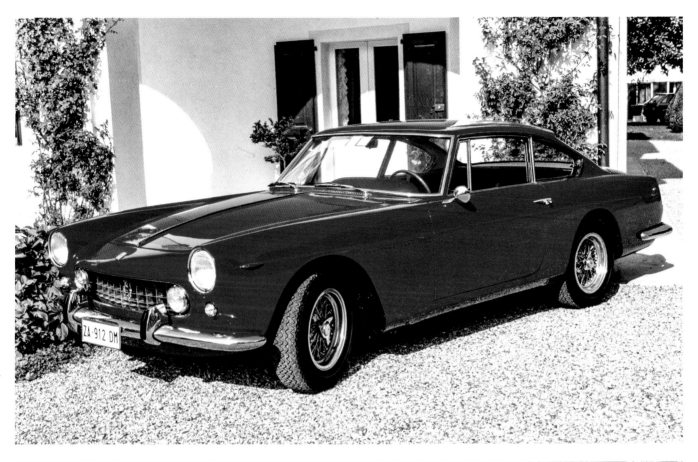

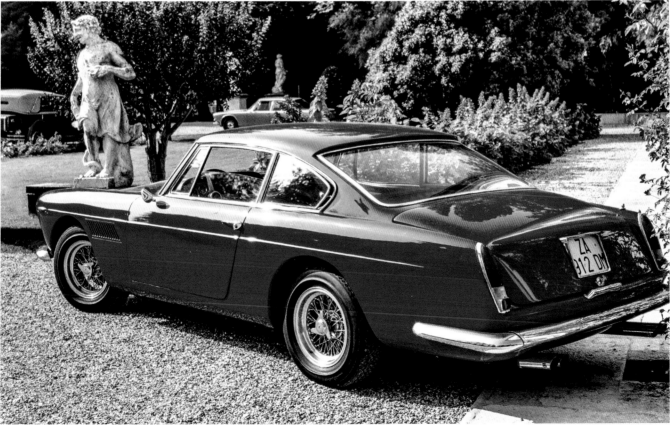

330
America
1963

ENGINE // 3967CC, V12

POWER // 224KW (300BHP) AT 6500RPM

CHASSIS // STEEL LADDER

GEARBOX // FOUR-SPEED

TOP SPEED // 240KM/H (149MPH)

WEIGHT // 1310KG (2888LB)

Between the end of production of the 250 GTE 2+2 and the introduction of the larger 330 GTE 2+2, Ferrari built a short run of what was essentially an interim model. Named 330 after the volume of a single cylinder in the new 4-litre Tipo 209 V12 engine, the car was virtually identical to the outgoing 250 GTE 2+2 model and based on the same chassis. The new engine differed from the Tipo 163 previously used in the 400 Superamerica in having a longer block which permitted the bores to be more widely spaced.

Precedent dictated that large-engined Ferraris were branded "America" models and the majority of the 50 examples produced carried this badging in chrome on the boot lid. Appropriately enough, many of the cars made the Atlantic crossing to be sold by Luigi Chinetti.

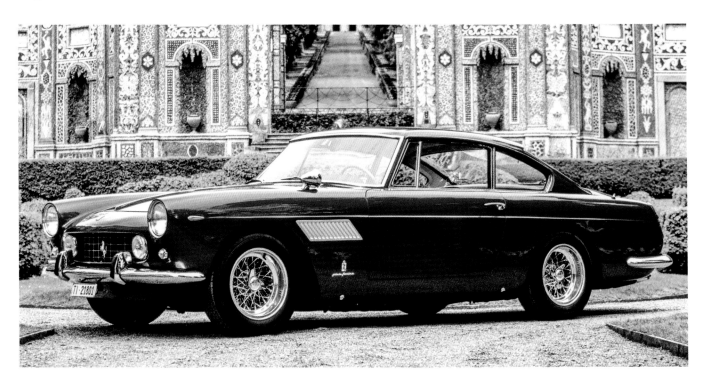

330
GT 2+2
1964

ENGINE // 3967CC, V12

POWER // 224KW (300BHP) AT 6500RPM

CHASSIS // STEEL LADDER

GEARBOX // FOUR-SPEED

TOP SPEED // 240KM/H (149MPH)

WEIGHT // 1380KG (3042LB)

Although the "America" badging would be dropped from Ferrari's next 330 grand touring model, that continent was very much on Enzo Ferrari's mind when he planned it. A wheelbase 50mm (2in) longer than the 330 America enabled Ferrari to offer more cabin space and, for the exterior design, Detroit-born Tom Tjaarda – recently hired by Pininfarina from Ghia – took charge.

Quad headlamps were on trend in the US at the time, so Tjaarda sculpted the front end to accommodate a pair of lights each side, the innermost ones of a slightly smaller diameter. The wing louvres and rear-end treatment also marked a clear departure from the 250 GTE 2+2's appearance. Later Series I models also gained a five-speed gearbox rather than a four-speed plus overdrive. Officially 625 Series I models were built.

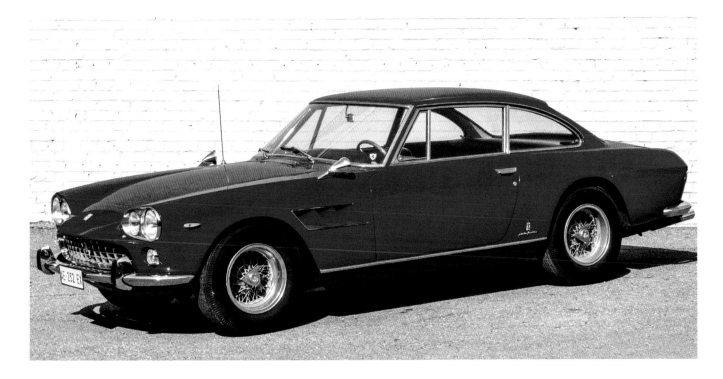

275 P
1964

ENGINE // 3286CC, V12

POWER // 239KW (320BHP) AT 7700RPM

CHASSIS // TUBULAR STEEL

GEARBOX // FIVE-SPEED

TOP SPEED // 299KM/H (186MPH)

WEIGHT // 755KG (1664LB)

Having successfully adopted the mid-engined chassis philosophy in a sports prototype with the 1963 250 P, which won three of the four races (including Le Mans) that counted for the International Trophy for GT Prototypes, Ferrari couldn't afford to rest. Henry Ford II, furious that his offer to buy the company had been spurned at the last moment, was gunning for Ferrari at the top level.

To combat the threat of Ford's imminent new prototype, Ferrari crafted three new mid-engined rivals. Two were similar to the 250 P but armed with larger engines – in the case of the 275 P, a 3286cc version of the short-block Colombo V12 with a unitary displacement of 274cc. The 275 P was an immediate winner, scoring a one-two in the Sebring 12 Hours as well as victory in the Nürburgring 1000km and at Le Mans.

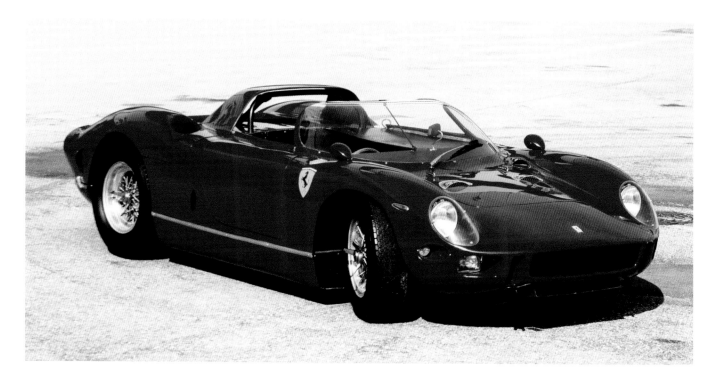

330 P
1964

ENGINE // 3967CC, V12

POWER // 276KW (370BHP) AT 7300RPM

CHASSIS // TUBULAR STEEL

GEARBOX // FIVE-SPEED

TOP SPEED // 299KM/H (186MPH)

WEIGHT // 785KG (1730LB)

Another element of Ferrari's multi-pronged assault on sports-prototype racing in 1964 was the 330 P, essentially a sister car to the 275 P but with a larger engine. Indeed, the early examples of both were built on modified 250 P chassis with revised bodywork by Fantuzzi and engines could be swapped between cars, so their identities were equally interchangeable.

In 4-litre form, as used in the Superamerica, the Colombo engine had a longer stroke which benefitted torque as well as delivering 37kw (50bhp) greater peak power – but it weighed 30kg (66lb) more, which made on-the-limit handling edgier than the 275 P. Reliability was also less good: at Le Mans in June the 330 Ps were faster on track but one blew a gasket and the others spent more time in the pits than the winning 275 P, finishing second and third.

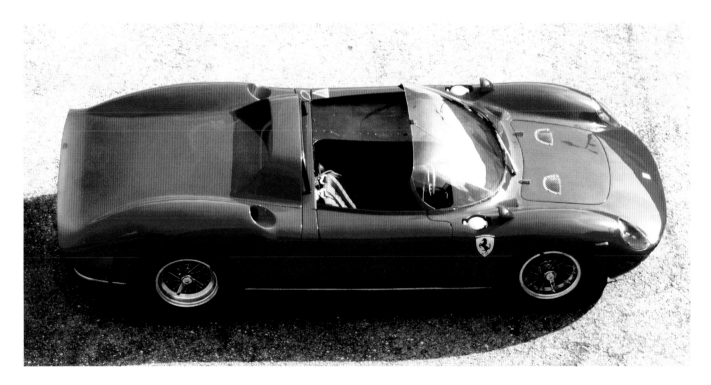

ASA
1100 GT
1964

ENGINE // 1092CC, INLINE-FOUR
POWER // 78KW (104BHP) AT 7800RPM
CHASSIS // STEEL LADDER
GEARBOX // FOUR-SPEED
TOP SPEED // 190KM/H (118MPH)
WEIGHT // 780KG (1720LB)

As early as 1959, Enzo Ferrari had given consideration to building a small high-performance
car with an inline-four engine based on a cut-down cylinder bank from the Colombo V12. Giotto
Bizzarrini designed the chassis while Bertone was commissioned to create a coupé bodyshell;
the shape is believed to be one of the earliest works by Giorgetto Giugiaro.

Ferrari pulled back from producing the car under his own name and, after a number of false
starts, reached a deal for Milanese entrepreneur Oronzio de Nora to build them via a new
company, Autocostruzioni Società per Azioni. Though the car was launched in 1962, production
did not get underway properly until two years later. The 1000 GT was rather expensive for what
it was, and even the subsequent arrival of an 1100cc model failed to entice buyers.

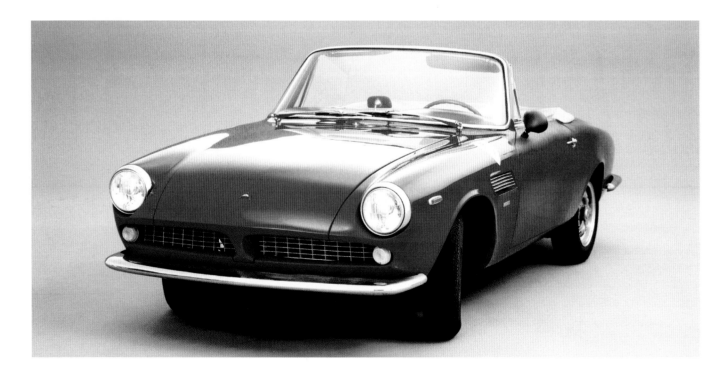

250
GTO 64
1964

ENGINE // 2953CC, V12

POWER // 224KW (300BHP) AT 7500RPM

CHASSIS // STEEL LADDER

GEARBOX // FIVE-SPEED

TOP SPEED // 280KM/H (174MPH)

WEIGHT // 900KG (1984LB)

While reluctantly accepting the competitive necessity of building mid-engined racing cars, Enzo Ferrari clung on to his belief that the horse should pull the cart rather than push it. Even the declining sales of the 250 GTO could not dissuade him from sanctioning one more upgrade to the front-engined Berlinetta.

 In effect the 250 GTO 64 was a re-skin sitting on a slightly wider track. Pininfarina designed a new shell (built by Scaglietti) with a more aggressive nose and a longer slope to the windscreen. Like the 250 LM also under development, the roofline cut off sharply to reach the downward-sloping rear deck. Just seven examples were built, three on modified 250 GTO chassis while four later cars were rebodied Series I GTOs.

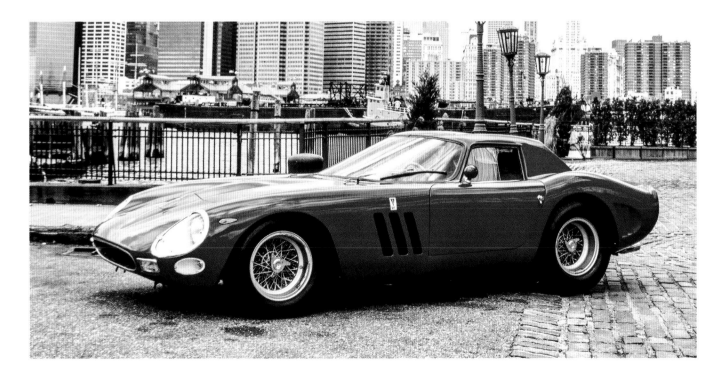

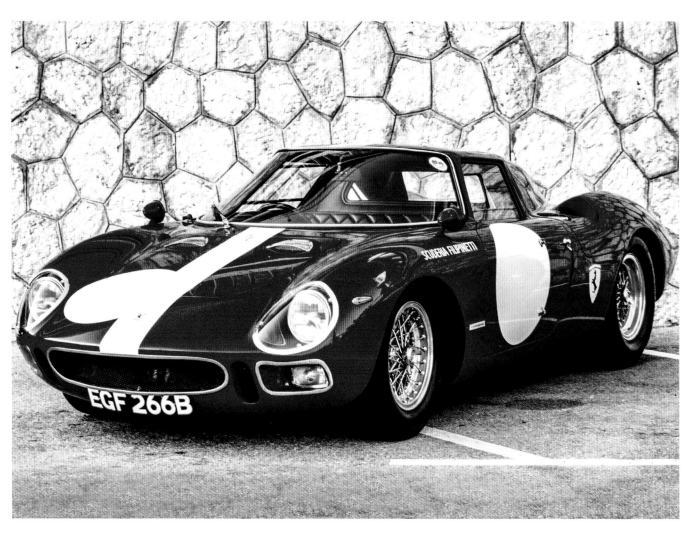

250
LM
1964

ENGINE // 3285CC, V12

POWER // 239KW (320BHP) AT 7500RPM

CHASSIS // TUBULAR STEEL

GEARBOX // FIVE-SPEED

TOP SPEED // 290KM/H (180MPH)

WEIGHT // 820KG (1808LB)

Having successfully hoodwinked delegates from racing's governing body into believing their homologation requirements had been met by the 250 GTO, Enzo Ferrari tried again with the car he viewed as the GTO's successor. Since only GT cars counted for points in the world championship, the plan for the 250 LM was to create a GT version of the mid-engined, spaceframe-chassis sports-prototypes Ferrari was beginning to build.

Shown for the first time at the 1963 Paris Motor Show, the 250 LM had more in common with that year's sports-prototype Ferrari, the 250 P, than the 250 GTO it ostensibly replaced. In fact it was essentially the same car but with a roof, and thicker-gauge steel in the tubular spaceframe chassis – a structure which bore little resemblance to that which underpinned the GTO. The fact that it was powered by the same 3-litre V12 fooled nobody. Resolve stiffened by years of complaints about the GTO from other competitors, the inspectors were unmoved by claims Ferrari could build the necessary 100 examples – or that it was but an update to the GTO and therefore didn't need to reach that bar anyway.

Even the car's nomenclature was misleading. Production examples – around 32 were built – received the "275" 3.3-litre engine in the hope that it would be more competitive in the prototype class to which it had been consigned. Against expectations the car chalked up a number of victories through 1964; in 1965 it was believed to be outgunned by the improved Ford GT40s at Le Mans, so Masten Gregory and Jochen Rindt decided to wring the neck of their NART-entered 250 LM and enjoy themselves before it broke. It didn't and they recorded Ferrari's final outright victory at the legendary enduro.

275
GTS/2
1964

ENGINE // 3286CC, V12

POWER // 191KW (256BHP) AT 7000RPM

CHASSIS // STEEL LADDER

GEARBOX // FIVE-SPEED

TOP SPEED // 241KM/H (150MPH)

WEIGHT // 1120KG (2469LB)

At the 1964 Paris Motor Show Ferrari revealed the replacements for the 250 GT Lusso and 250 GT Spider – but this was no mere cosmetic upgrade, albeit with a larger and more powerful V12 engine. Beneath the elegantly Pininfarina-styled bodies lay more sophisticated suspension and transmission.

Both the 275 GTB (Berlinetta coupé) and 275 GTS (Spider) now featured independent rear suspension rather than a live axle and, in tandem with this, a new five-speed drivetrain in which the gearbox and differential were combined to offer better mechanical balance. The styling of the GTS was less racy than the GTB, with a recessed grille and chrome bumpers framing open headlights, a crease line running from front to rear, and less macho rear wings. Borrani wire wheels offered a more delicate alternative to the alloys on the GTB.

275 GTS/2 tre posti
1964

ENGINE // 3286CC, V12

POWER // 191KW (256BHP) AT 7000RPM

CHASSIS // STEEL LADDER

GEARBOX // FIVE-SPEED

TOP SPEED // 241KM/H (150MPH)

WEIGHT // 1120KG (2469LB)

While 200 examples of the 275 GTS are believed to have been built, all by Pininfarina – the GTBs were bodied and trimmed by Scaglietti – four of them carry a unique and peculiar feature: room for three in the front seats. It is unclear who was responsible for the idea: in essence the Connolly-leather-trimmed passenger seat was wider than standard and theoretically offered space for two.

One theory is that it was a Pininfarina-sourced flight of fancy, since the 1964 Paris Motor Show car had this seating arrangement. The build of the 275 GTS was logistically complicated, involving the chassis being shipped to Pininfarina's Turin works to be bodied and trimmed, then back to Maranello for the engine and transmission to be installed. US buyers didn't engage with the three-seat look and it was quickly dropped.

275
GTB/2
1964

ENGINE // 3286CC, V12
POWER // 209KW (280BHP) AT 7500RPM
CHASSIS // STEEL LADDER
GEARBOX // FIVE-SPEED
TOP SPEED // 257KM/H (160MPH)
WEIGHT // 1100KG (2425LB)

Unveiled alongside its spider sibling at the Paris show in 1964, the Pininfarina-designed, Scaglietti-built 275 GTB wore its racing influences boldly, from the faired-in headlights and snub nose to the aggressive-looking side vents, sloping windscreen, muscular bulges around the rear wheels and cut-off tail. Like the GTS it was never referred to as a "/2" in period but has subsequently been categorized as such to differentiate it from later models with double-camshaft cylinder heads.

Though the coupé's Tipo 213 version of the Colombo V12 was in a perkier state of tune than that in the GTS, and the overall effect of the styling was sportier, both cars imported their manners from the racetrack. The first iteration of the all-round independent suspension was crude and the nose of the GTB prone to aerodynamic lift, despite development work undertaken by contracted Ferrari race driver Michael Parkes.

One criticism of the early models was that they lacked finesse as well as being unstable at high speed. Thin rubber engine and transaxle bushes and a fixed driveshaft which was solidly attached to the transaxle (rather than having a universal joint) and mounted with a single central bearing, magnified noise and vibration from the drivetrain and sent it upwards into the cabin to disagreeable effect. Later in the series-one production run Ferrari added constant-velocity joints to the driveshaft setup, reducing the issues.

For the second series of the GTB in 1966 Ferrari lengthened the nose to reduce lift, and revised the drivetrain once more with new mountings for the engine and transaxle. The addition of a torque tube (not fitted to the GTS) between the engine and transaxle did much to refine the driving experience.

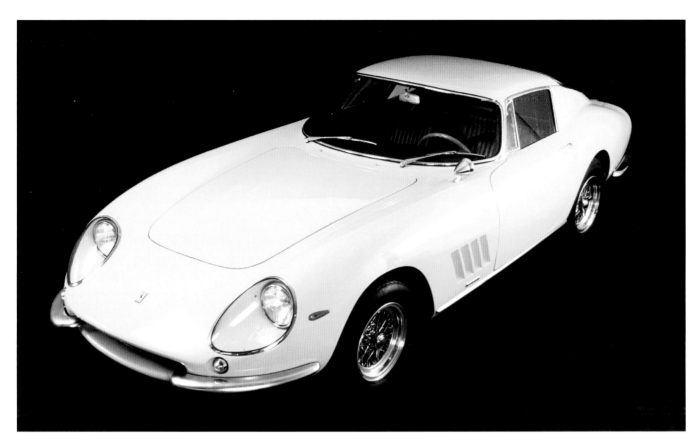

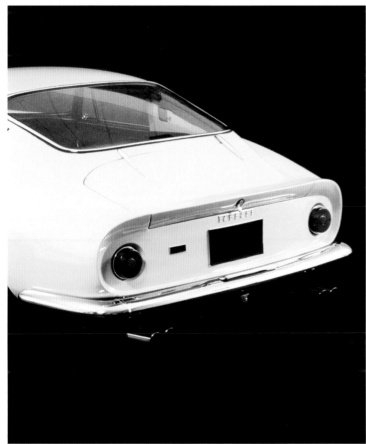

330
P2
1965

ENGINE // 3967CC, V12

POWER // 306KW (410BHP) AT 8000RPM

CHASSIS // STEEL SEMI-MONOCOQUE

GEARBOX // FIVE-SPEED

TOP SPEED // 299KM/H (186MPH)

WEIGHT // 820KG (1807LB)

Although Ford's challenge to Ferrari in the 1964 Le Mans 24 Hours faded when the new GT40s failed mid-race, the potential of the new cars had registered in the corridors of Maranello. When control of the GT40 project was transferred to Carroll Shelby's workshops late in '64, urgent action was required.

Ferrari's response was to redevelop the P-series prototypes almost from the ground up, integrating lessons from the Formula 1 programme, which was recovering from a brief slump in competitiveness as Mauro Forghieri re-engineered the cars. For much of the 1963 racing season, Forghieri had laboured to emulate the monocoque chassis designs introduced by British rivals in which the outer bodywork contributed to the stiffness of the overall structure. The 156 "Aero" introduced at the Italian Grand Prix that year, while not a true monocoque, would influence racing Ferraris for years to come and lead to the 1964 championship-winning 158.

Lessons from that car would inform the structure of the P2 series, in which the spaceframe was replaced by a network of thinner tubes augmented by riveted aluminium sheets. Much of the suspension concept was also ported over from the 158, with unequal-length wishbones at the front and a reversed lower wishbone with upper radius arms at the rear. The track was widened by 50mm (1.97in) at the front and 30mm (1.18in) at the rear. The factory cars retained the 275 and 330 short-block Colombo V12s, but these now featured double overhead camshafts on each cylinder bank and twin spark plugs per cylinder.

Ferrari won the Nürburgring 1000km with a 330 P2 but the cars failed at Le Mans.

365 P2/3
1965

ENGINE // 4390CC, V12

POWER // 291KW (390BHP) AT 7200RPM

CHASSIS // STEEL SEMI-MONOCOQUE

GEARBOX // FIVE-SPEED

TOP SPEED // 299KM/H (186MPH)

WEIGHT // 820KG (1807LB)

As a complement to the factory racing programme in 1965, Ferrari created an ostensibly simpler version of the P2 for customers, powered by a 4.4-litre engine with a single camshaft per cylinder bank and single plugs, and a unitary capacity of 365.9cc. Only one was supplied with a brand new chassis frame while a further five had seen race action in 275 and 375 P2 form, including the 1965 Monza 1000km winner. This car was fitted with the 4.4-litre engine and sold to British racer David Piper as a 365 P2.

Two 365 P2s, including Piper's, were later rebodied by Piero Drogo and raced as 365 P2/3s. Piper's retained the open-top body while the other, damaged in a crash at Sebring, gained a roof and an elongated tail in the hope of achieving higher top speeds at Le Mans.

412P
1966

ENGINE // 3967CC, V12

POWER // 313KW (420BHP) AT 8000RPM

CHASSIS // STEEL SEMI-MONOCOQUE

GEARBOX // FIVE-SPEED

TOP SPEED // 311KM/H (193MPH)

WEIGHT // 820KG (1807LB)

The unexpected victory of the NART-entered 250 LM at Le Mans in 1965 enabled Ferrari to regroup and address some of the P2's shortcomings in relation to Ford's consistently improving GT40. Lacking the resources to build an engine as large as Ford's 4.7-litre V8 (and potentially aware an even bigger one was coming), Ferrari focused on squeezing more power out of the existing 330 engine and lightening the bodywork, while exploiting the removal of the rule stipulating a minimum width for the windscreen.

Measuring 90mm (3.54in) lower than the P2 and featuring more extensive use of fibreglass in the bodywork, the Drogo-designed 330 P3 theoretically offered an aerodynamic advantage as well as being lighter. Factory-entered examples featured fuel injection for the first time on a Ferrari but customer models were sold as 412Ps and retained carburettors.

275
GTB4
1966

ENGINE // 3286CC, V12

POWER // 224KW (300BHP) AT 8000RPM

CHASSIS // STEEL LADDER

GEARBOX // FIVE-SPEED

TOP SPEED // 257KM/H (160MPH)

WEIGHT // 1100KG (2425LB)

There was little outwardly to distinguish the latest generation of the 275 GTB when it was launched at the 1966 Paris Motor Show, save for neatly chromed exterior boot hinges – to improve space within – and a bulge in the bonnet which alluded to the major changes beneath. Comprehensive re-engineering of the car had delivered more power while considerably reducing noise, vibration, and harshness through the drivetrain and a tendency for oil pressure to flutter during hard cornering.

Benefitting from the experience with Ferrari's prototype racers, the new Tipo 226 version of the Colombo V12 featured two camshafts per cylinder bank, a first for a Ferrari road car. Six Weber 40 DCN carburettors accounted for the bonnet bulge. A dry-sump lubrication system aimed to cure the pressure fluctuations under high cornering forces.

As with late models of the single-cam generation, the engine and transaxle were joined by a torque-tube arrangement that enabled them to be rigidly connected while the prop shaft spun within, benefitting chassis rigidity while reducing the transmission of vibrations through to the cabin.

While the 275 GTB/4 was offered in steel as standard, an aluminium bodyshell was available as an option – desirable not only for its reduced weight, but also because the poor quality of Italian steel at the time made it prone to rust. Ferrari's records claim 331 GTB/4s were built, of which 16 were aluminium.

New emissions regulations in the US, Ferrari's key market for the GTB, would bring the 275 series to the end of the line in 1968. Limits for hydrocarbons and carbon monoxide previously enacted for domestic models in California were adopted country-wide and applied to imports as well.

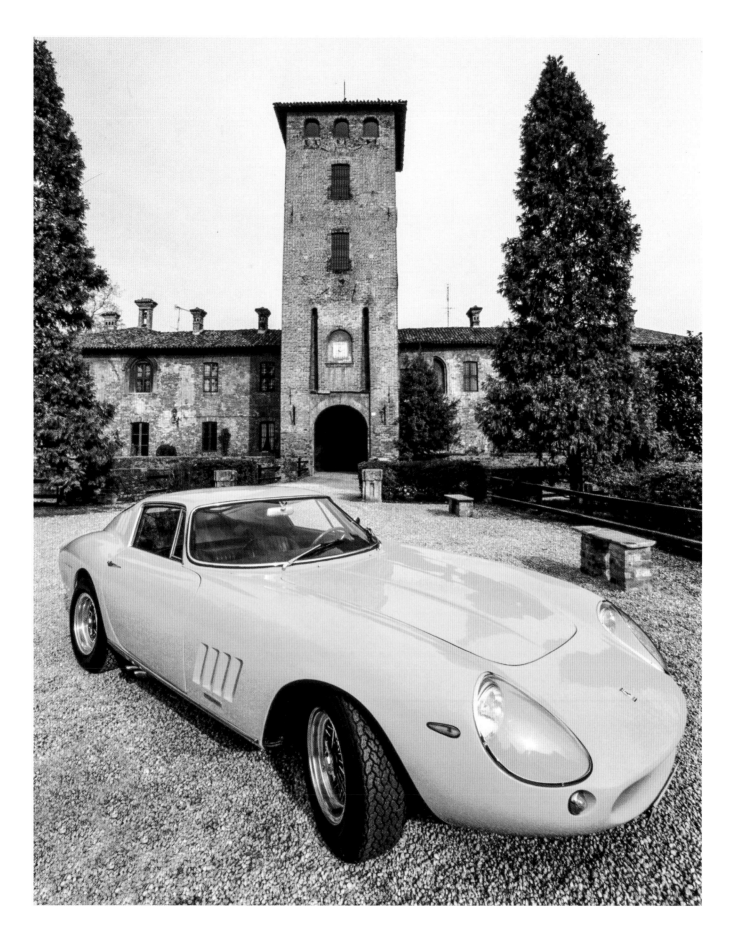

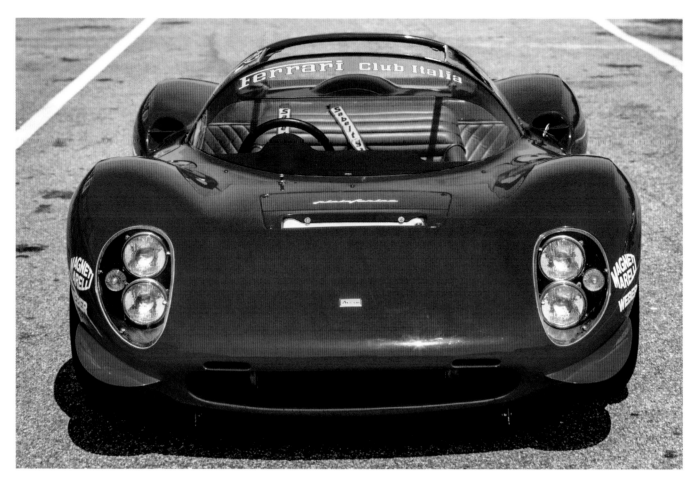

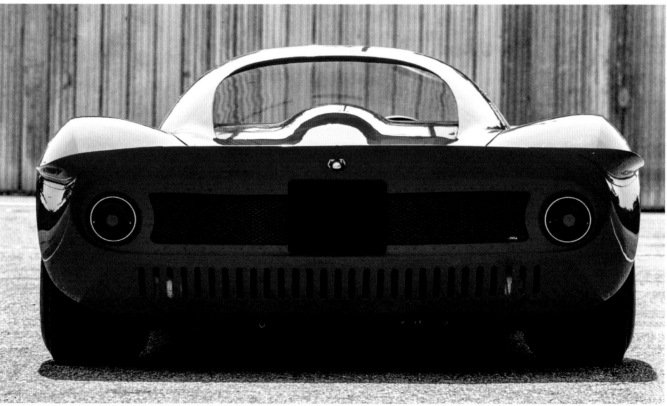

Dino
206 S
1966

ENGINE // 1987CC, V6

POWER // 164KW (220BHP) AT 9000RPM

CHASSIS // STEEL SEMI-MONOCOQUE

GEARBOX // FIVE-SPEED

TOP SPEED // 261KM/H (162MPH)

WEIGHT // 580KG (1279LB)

For 1966, racing's governing body revised the Appendix J regulations governing sportscar racing yet again. There was no cap on engine displacement for the top Group 6 prototypes, enabling Ford to install a 7-litre V8 in the GT40, and the smaller Group 4 Sport class was sub-divided into categories of over and under 2 litres. Ferrari decided to create a car for this class which could be run by the factory team but also supplied to private entrants, targeting a production run of 50 examples which would satisfy the homologation requirements.

Ferrari had already revived the "Dino" name for a small V6-powered sports-racer in 1965. Enzo had a sentimental attachment to the title because his son Alfredo had proposed a V6 engine before his untimely death. The resulting project, which powered the Dino 246 Formula 1 car, had delivered Mike Hawthorn to the world championship in 1958. A 1.5-litre, 65-degree V6 carried Phil Hill to the title in 1961 and Franco Rocchi enlarged this to 1.6 litres for the new "baby" sportscar launched in 1965, the 166 SP. This was deemed successful enough to be revamped to suit the latest regulations in 1966, with the engine taken out to 2 litres.

Launched alongside the 330 P3, the Dino 206 S looked almost like a scale model of its larger sibling and it, too, was based on a semi-monocoque chassis and clothed in bodywork sculpted by Piero Drogo's Carrozzeria Sports Cars. Unfortunately, owing to a combination of industrial strife and lukewarm interest from customers, fewer than 20 were built, which meant it had to compete in Group 6 as a prototype.

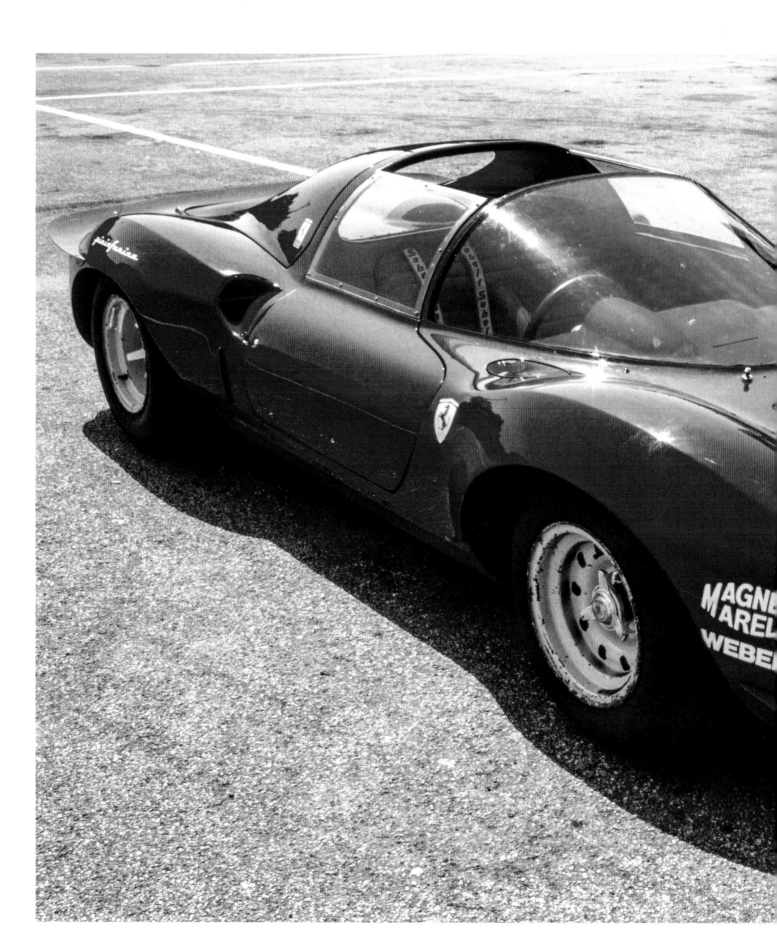

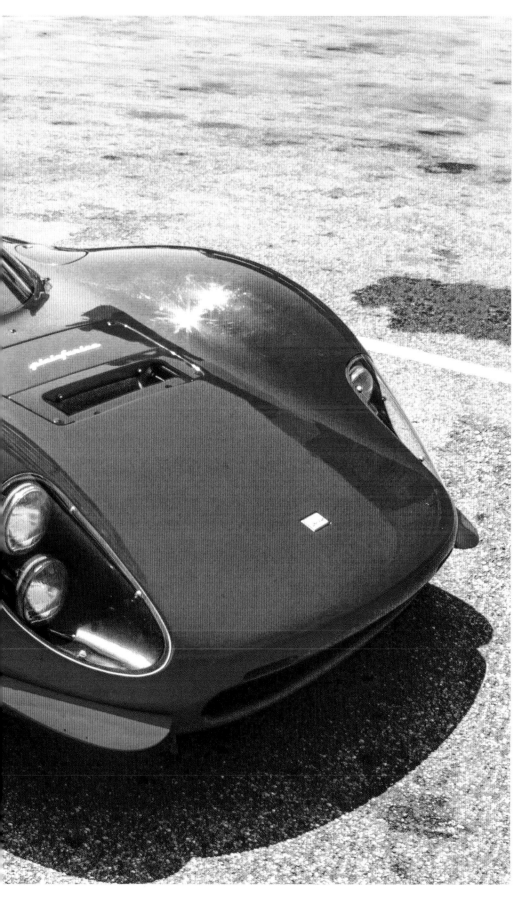
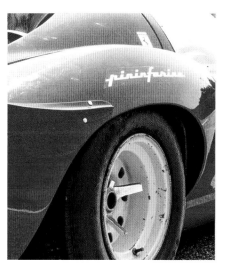
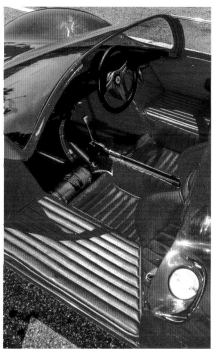
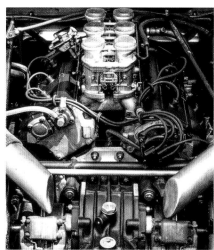

330 GTC
1966

ENGINE // 3967CC, V12

POWER // 224KW (300BHP) AT 7000RPM

CHASSIS // STEEL LADDER

GEARBOX // FIVE-SPEED

TOP SPEED // 245KM/H (152MPH)

WEIGHT // 1300KG (2866LB)

Unveiled to the public at the Geneva Motor Show in 1966, the 330 GTC complemented the 275 GTB, offering a larger engine in the same chassis for customers who wanted some of the refinements of the 330 GT 2+2 but had no need for the extra seats. Though Pininfarina never divulged such details in period, the restrained styling has subsequently been credited to lead designer Aldo Brovarone, who combined his previous works to great effect: a front end similar to the 400 Superamerica flows neatly into the tail of the 275 GTS, despite the addition of a roof.

The 330 GTC proved vastly more popular than its more expensive drop-top sibling which was introduced later that year, outselling it sixfold – 600 to 99.

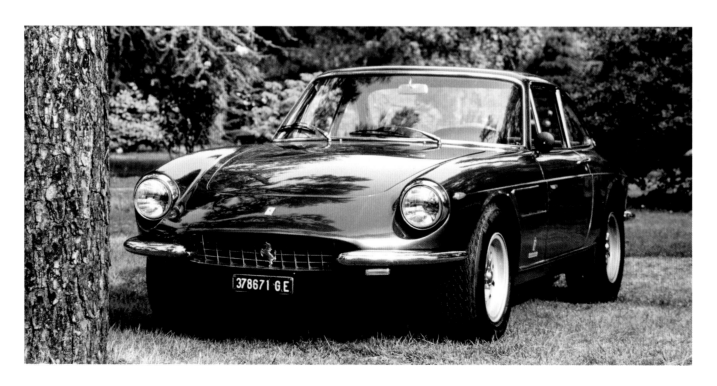

330 GT
1966

ENGINE // 3967CC, V12

POWER // 224KW (300BHP) AT 7000RPM

CHASSIS // STEEL LADDER

GEARBOX // FIVE-SPEED

TOP SPEED // 235KM/H (146MPH)

WEIGHT // 1200KG (2646LB)

In 1966, one Pietro Capocaccia of Genoa took delivery of a new Ferrari 330 GT with the serial number 8733. The car's history from this point is patchy but it's understood a later owner crashed it before another individual had another body fitted entirely.

Rewind to 1963. The billionaire pharmaceutical heir Pasqualino Alecce bought one of the moribund 330 LMBs and asked Carrozzeria Fantuzzi to rebody it as a street car, but in a sports-prototype style. Dubious, Fantuzzi consulted the Ferrari factory and were told Mr Alecce's money was good. The car, painted gold, would also feature in three feature films, most notably in the horror anthology, *Spirits of the Dead,* starring Terence Stamp.

A later owner of the car had it restored to its original shape and the one-off body was transferred to 8733 and repainted red.

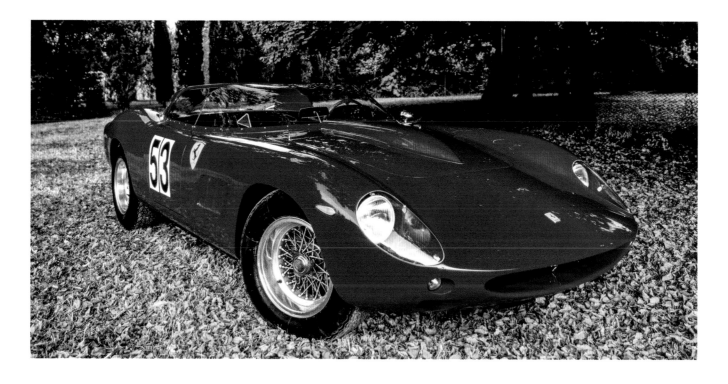

Dino 206 S
Pininfarina Competizione
1967

ENGINE // 1987CC, V6

POWER // 164KW (220BHP) AT 9000RPM

CHASSIS // STEEL SEMI-MONOCOQUE

GEARBOX // FIVE-SPEED

TOP SPEED // 261KM/H (162MPH)

WEIGHT // 636KG (1402LB)

When the Dino 206 S production fell well short of the 50 examples required for homologation, Ferrari released three unsold chassis to Pininfarina to transform into concept cars. The first, chassis 034, was displayed at the Frankfurt Motor Show in 1967 as the 206 S Pininfarina Competizione.

The car was the first Pininfarina work by former Bertone apprentice Paolo Martin, who provided an original spin on the Dino's proportions with an adventurous bowl-style glasshouse, gullwing doors, and large, ovoid headlamp enclosures. The adjustable front and rear wings seemed superfluous at the time and Martin has subsequently said these were the work of Pininfarina MD Renzo Carli. Although a working prototype, it remained on display in the company's museum for many years before its acquisition by US entrepreneur and B-movie producer/director James Glickenhaus.

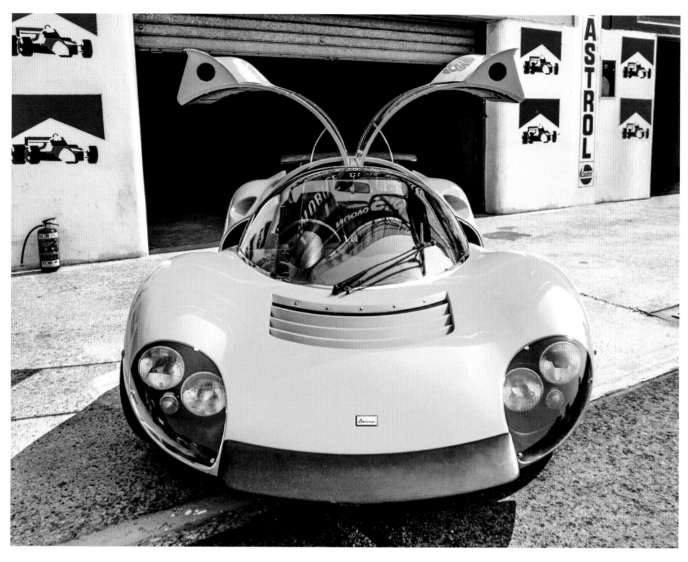

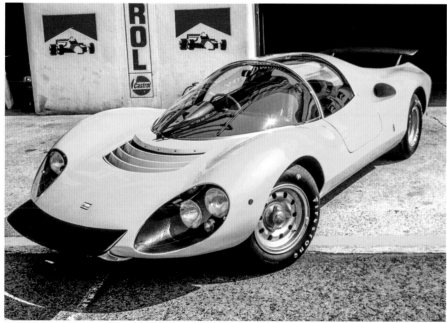

365
GT 2+2
1967

ENGINE // 4390CC, V12

POWER // 239KW (320BHP) AT 6600RPM

CHASSIS // STEEL LADDER

GEARBOX // FIVE-SPEED

TOP SPEED // 245KM/H (152MPH)

WEIGHT // 1480KG (3263LB)

New US emissions regulations prompted Ferrari to rethink engine options for one of the company's largest export markets and begin a thorough revamp of one of their most popular models. When the 330 GT 2+2 was retired it would be replaced by a model which not only featured a larger engine, more easily adaptable to comply with US laws, but which would also be the largest Ferrari road car yet.

Shown for the first time at the 1967 Paris Salon, the 365 GT 2+2 rode on the same chassis type as the 330 GTC, with a 2650mm (104.3in) wheelbase, although its prodigious overhangs brought the total length to nearly 5 metres (16ft). *Road & Track* magazine later nicknamed it "The Queen Mary", after the recently retired Cunard ocean liner now permanently moored in Long Beach harbour. The single-cam version of the 4.4-litre V12 was tuned to deliver its peak power of 239kw (320bhp) at a relatively relaxed 6600rpm and, even though performance remained potent, Ferrari placed much emphasis on mechanical refinement. Not only did this car feature independent rear suspension for the first time in a Ferrari four-seater, it was a self-levelling hydropneumatic system devised by Koni.

Designer Aldo Brovarone incorporated a familial resemblance to his 500 Superfast at the front, while the roofline and rear windows echoed the shape of the flying-buttress profile Pininfarina had created for a one-off 330 GTC commissioned by Belgium's Princess Lilian de Réthy. Unlike that car, though, the rear window extended across the full width of the rear pillars to facilitate rear-seat headroom. Power steering and air conditioning came as standard.

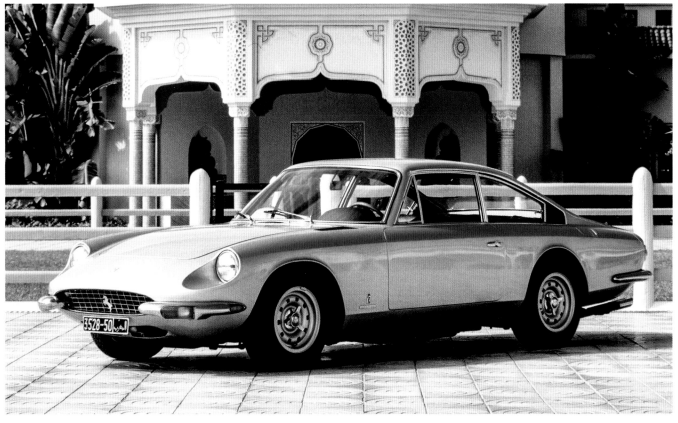

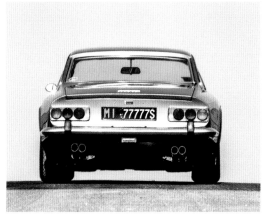

275
GTS NART
1967

ENGINE // 3286CC, V12

POWER // 224KW (300BHP) AT 8000RPM

CHASSIS // STEEL LADDER

GEARBOX // FIVE-SPEED

TOP SPEED // 249KM/H (155MPH)

WEIGHT // 1115KG (2458LB)

Two decades after his pivotal encounter (if the company's origin story is to be believed) with Enzo Ferrari, Luigi Chinetti remained an influential figure in the marque's business. Scuderia Ferrari had even raced its Formula 1 cars in the colours of Chinetti's NART organization when John Surtees claimed the world title in 1964, after Enzo's falling-out with the Italian national automobile club. A keen salesman as well as a skilled race driver in his time, Chinetti identified a gap in the model range – at least so far as US customers were concerned.

Believing the 330 GTS was too sedate and overly expensive, and the 275 GTB4 too hard-edged, Chinetti successfully pitched Enzo the concept of a model whose demeanour and performance envelope would sit somewhere between the two. Sadly his predictions of the US market's appetite for such a car would be proved incorrect, although the new emissions regulations would play a part: 25 examples were planned but just 10 orders were ultimately received. All were built by Scaglietti to a Pininfarina design alongside the 275 GTB4 berlinettas.

Chinetti shipped the first completed car immediately to the US and entered it in the 1967 Sebring 12 Hours, where Denise McCluggage and Pinky Rollo guided it to 17th place overall and second in class. Repainted in burgundy, it then appeared in *The Thomas Crown Affair*, driven by Steve McQueen, thence to *Road & Track* magazine for a laudatory cover feature. Still the car did not gain traction in the US, though jazz musician Miles Davis bought one, as did McQueen. In 2013 a pristine example fetched $27.5 million at auction.

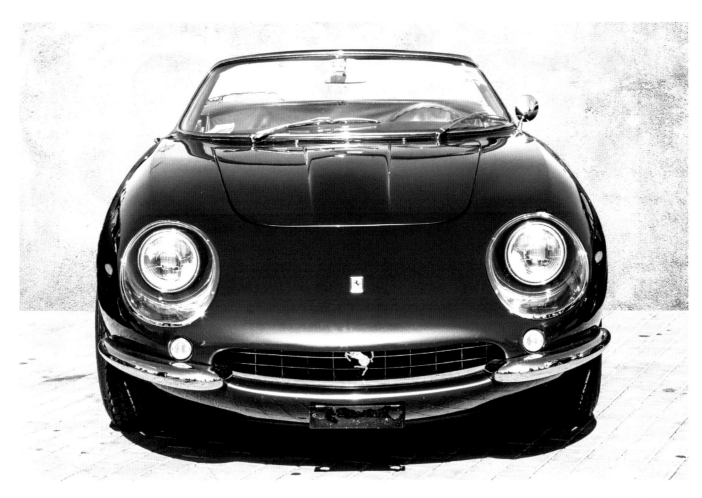

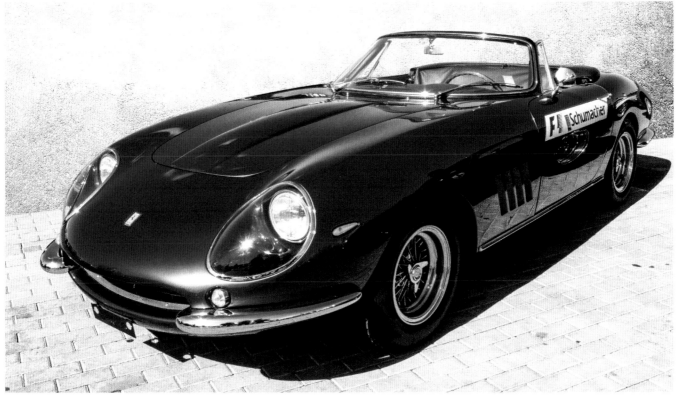

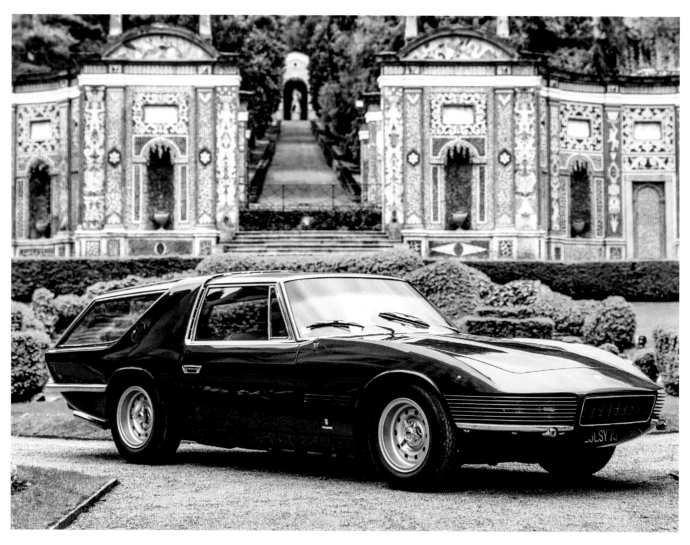

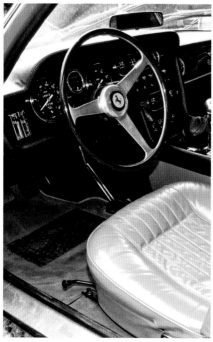

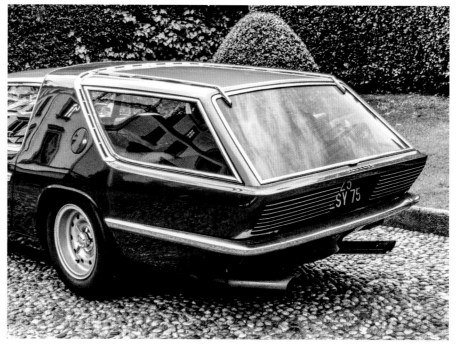

330 GT
2+2 Shooting Brake
1967

ENGINE // 3967CC, V12

POWER // 221KW (296BHP) AT 6600RPM

CHASSIS // STEEL LADDER

GEARBOX // FIVE-SPEED

TOP SPEED // N/A

WEIGHT // N/A

Among the more peculiar one-offs in the Carrozzeria Vignale canon is a "wagon" version of the 330 GT 2+2. The car started life as a standard US export model finished in red with beige leather interior trim, sold by Chinetti Motors in 1965. Two years later Luigi Chinetti Jr acquired the car and returned it to Italy, where Vignale rebodied it according to a design by commercial illustrator Bob Peak, best known at that time for his work in ad campaigns and on movie posters for the likes of *West Side Story* and *My Fair Lady*.

 The finished car had no panels in common with the original and took pride of place on Vignale's stand at the 1968 Turin Motor Show. The car passed through several hands, including those of musician Jay Kay; after various unsuccessful auction placings which valued it at around £1 million, it sold for $313,000 in Los Angeles in 2018.

365
GTB4
1968

ENGINE // 4390CC, V12
POWER // 262KW (352BHP) AT 7500RPM
CHASSIS // STEEL LADDER
GEARBOX // FIVE-SPEED
TOP SPEED // 280KM/H (174MPH)
WEIGHT // 1280KG (2822LB)

Semi-unofficially known as the Daytona, the successor to the 275 GTB4 represented a turning point for Ferrari's design language, if not for the time-honoured means of construction. Styled by Leonardo Fioravanti at Pininfarina, it was built by Scaglietti; in-house assembly lines lay some way over the horizon for Ferrari.

The origin of the Daytona name is unclear. Ferrari now claim it was confected by the press in honour of the famous one-two-three finish in the 1967 Daytona 24 Hours, where Scuderia Ferrari vanquished Ford after a troubled '66 racing season. Since Ferrari was considerably more excited about this than the motoring press, it's more likely the company has stepped back from it over the years to avoid potential litigation, since Daytona is owned by the powerful and commercially savvy France family.

At a time when rival sports car makers were relocating the engine behind the cabin, Ferrari stubbornly kept faith with the philosophy that the horse should pull the cart rather than push it. The latest 4.4-litre quad-cam version of the venerable Colombo V12, dry-sumped and breathing through six Weber carburettors, produced a claimed 262kw (352bhp) – enabling the 365 GTB4 to nail the 0–96km/h (0–60mph) acceleration benchmark in just over five seconds.

Fioravanti's rejection of previous styling tropes began at the front, with a wide, sharply creased nose, slimline bumpers, and a recessed radiator grille. The earliest examples featured four round headlights behind Plexiglass panels; these are now the rarest and among the most highly prized by collectors. US legislation banning covered headlights led Ferrari to replace them with pop-up items which maintained the original shape of the nose until activated. The top edge of the front wings was angled rather than gently curved, although the line of them flowed neatly into the A-pillar in profile, tracing a gentle sweep across the side window lines. A semi-circular groove ran between the wheel arches and continued towards the angular tail.

For the European market the 365 GTB4 came with five-spoke alloys as standard, mounted via a central Rudge knock-off hub. Borrani wire wheels were optional. While initial models were bodied in steel with aluminium doors, bonnet and boot lid, during production Ferrari adopted steel doors with internal bracing in response to US legislation. In fact, the relentless pace of American regulatory requirements with regards to emissions and safety features meant this car would be the last Ferrari to be offered for sale in the USA until the 1980s.

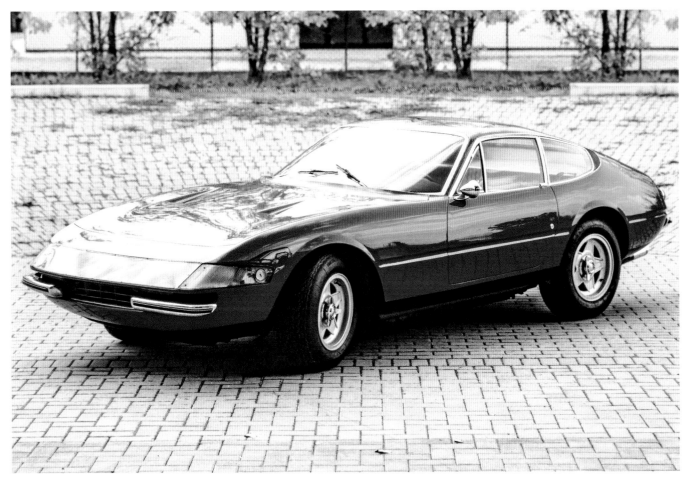

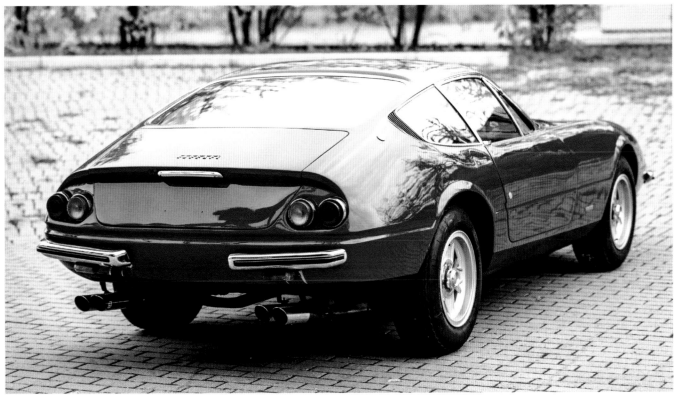

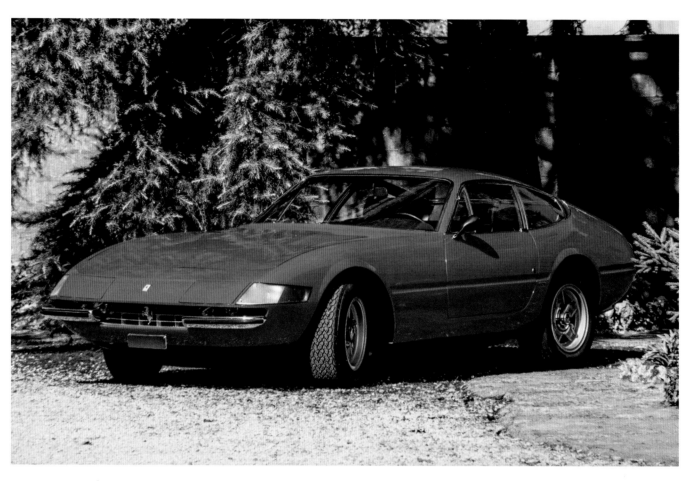

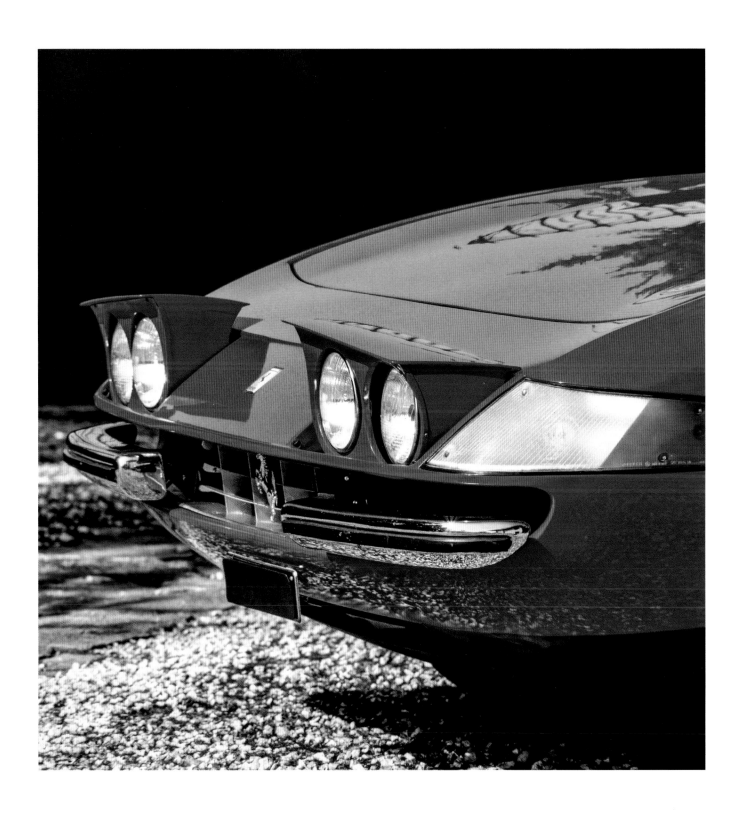

365
GTC
1969

ENGINE // 4390CC, V12

POWER // 239KW (320BHP) AT 6600RPM

CHASSIS // STEEL LADDER

GEARBOX // FIVE-SPEED

TOP SPEED // 245KM/H (152MPH)

WEIGHT // 1350KG (2976LB)

In late 1968 Ferrari quietly supplanted the 330 GTC with the 365 GTC, and it would take a practised eye to distinguish the two models on first acquaintance. Based on the same 2400mm-wheelbase (94.5in) chassis as the 330 GTC, the 365 GTC scarcely deviated from the Superamerica-derived styling of the earlier model, with its discreetly jutting oval grille framed by split chromed bumpers. Indeed, designer Aldo Brovarone had been busy elsewhere; his Peugeot 504 saloon was launched with somewhat greater fanfare at the Paris show that October.

This was a Ferrari aimed at a more mature clientele than the thrustingly forward-looking 365 GTB4 and naturally more conservative. Hot air outlets at the rear of the bonnet rather than behind the wheel arches were the only outward indicator of the larger engine within, for Ferrari had also eliminated the model designation from the boot lid. Close examination with a tape measure would reveal the 365 GTC to be wider and taller by a matter of millimetres. The convertible GTS model which appeared at the same time also closely resembled its predecessor, except for a more pronounced lip on the boot lid.

The 4.4-litre V12 was identical to the specification already being rolled out in the 365 GT 2+2 model, featuring wet-sump lubrication and single camshafts per cylinder bank. Though it developed greater power – especially in the mid-range – than the 330 engine, this powerplant was less racy than its quad-cam sibling in the "Daytona".

While the 330 had been relatively successful, the 365 GTC resonated far less with customers and just 168 GTCs were sold (according to Ferrari's figures) before production ended in 1970.

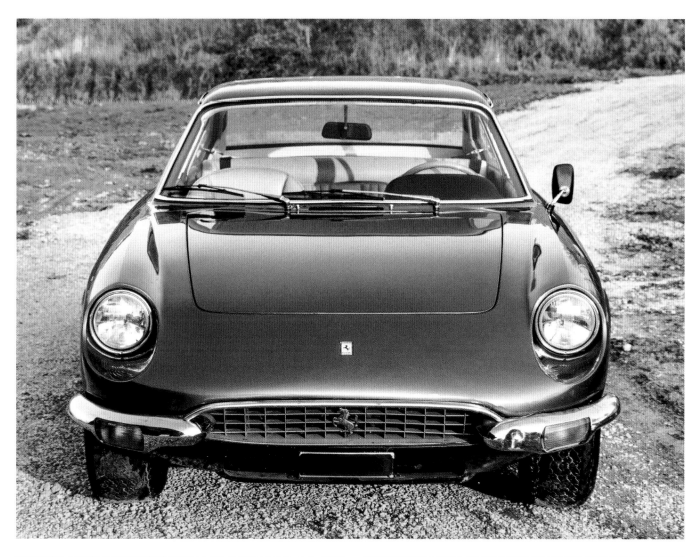

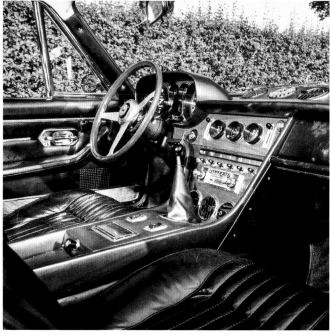

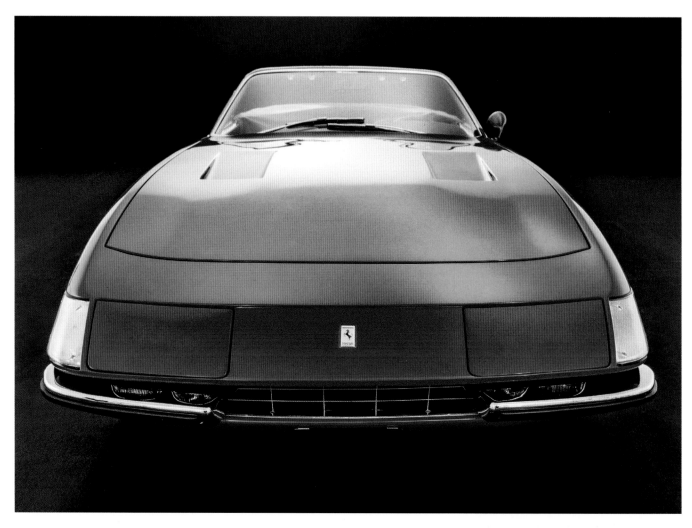

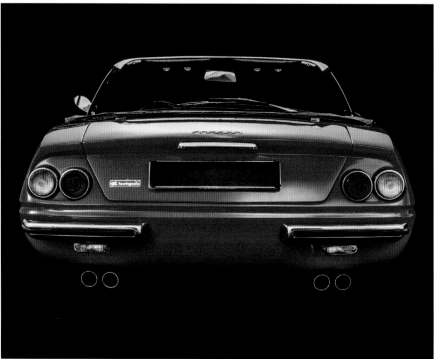

365 GTS4
1969

ENGINE // 4390CC, V12

POWER // 261KW (350BHP) AT 7500RPM

CHASSIS // STEEL LADDER

GEARBOX // FIVE-SPEED

TOP SPEED // 261KM/H (162MPH)

WEIGHT // 1200KG (2646LB)

Ferrari completed the counter-strike against the upstart Lamborghini marque's startling Miura with a drop-top derivative of the 365 "Daytona", launched at the Frankfurt Motor Show in September 1969. US importer Luigi Chinetti's influence on the project was clear to see, for the new car was resplendent in "Giallo Fly" – a bright yellow Chinetti often used on his race cars, claiming that he had once lost the Le Mans 24 Hours on account of a timekeeper failing to spot him passing the pits at the wheel of a car in a less startling shade. Enzo Ferrari never liked the colour, saying, "Chinetti, you've built a taxi…"

Though the 365 GTB4 had been initially created as a stopgap while Enzo dragged his heels over the notion of transitioning his road car range to the mid-engined concept, the order book was filling and Chinetti felt a cabriolet version would augment sales further. The new model had proved a remarkable success given that Leonardo Fioravanti's first designs, based on a naked 330 GTC chassis he had seen in the Pininfarina works, were purely speculative.

At the Paris Motor Show which opened on 10 October, Pininfarina's stand featured the 365 GTS4 Speciale, a fascinating one-off based on an early production GTS. Rather than having a completely open top, the car featured two-tone bodywork in which a white fixed roof panel crowned a satin-finish steel roll-over hoop and deep blue bodywork, with a removable rear window.

While the era of hand-built "specials" was coming to a close, in future years the 365 GTS4 would become so desirable that many GTB4 owners converted their cars to open-top spec.

Dino 246 GT

1969

ENGINE // 2419CC, V6

POWER // 145KW (195BHP) AT 8000RPM

CHASSIS // STEEL SEMI-MONOCOQUE

GEARBOX // FIVE-SPEED

TOP SPEED // 245KM/H (152MPH)

WEIGHT // 1080KG (2381LB)

Against some expectations – notably those of Enzo Ferrari himself – the mid-engined Dino 206 had received favourable notices in the motoring press and sold in reasonable if not extraordinary numbers. One thing the critics agreed on, though, was that it lacked power, even though the car itself was small and lightweight. So, while it remained expedient for Ferrari to maintain some distance from the mechanical layout and V6 engine – the cars would continue to be marketed as Dinos rather than Ferraris, although the UK importer cheekily added a prancing horse logo – the 246 was revealed at the 1969 Geneva show.

While the 246's bodyshell appeared virtually identical to the one drawn by Aldo Brovarone and Leonardo Fioravanti for the 206, it was slightly longer, both overall (by 85mm/3.35in) and in the wheelbase (by 60mm/2.36in), and 20mm (0.79in) taller, giving slightly different proportions. Detail-minded observers could also note the fuel cap's relocation to a recess behind a round, flush-fit panel. The body also differed invisibly in that it was now made from steel rather than aluminium, apart from the bonnet.

The original engine's racing origins were manifest in its short stroke, which gave little torque and required the driver to keep the revs high to access meaningful grunt. Recast in iron with an alloy head rather than all-aluminium, and with greater bore and stroke to give an overall displacement of 2.4 litres, the revised V6 was both more powerful and delivered more peak torque at lower revs.

These changes swung potential customers: around 2500 were reported sold over a five-year production run, along with 1300 of the targa-top GTS model introduced in 1972.

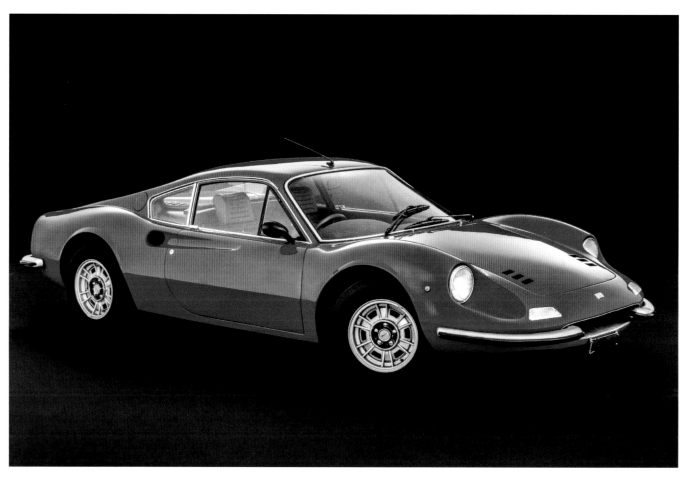

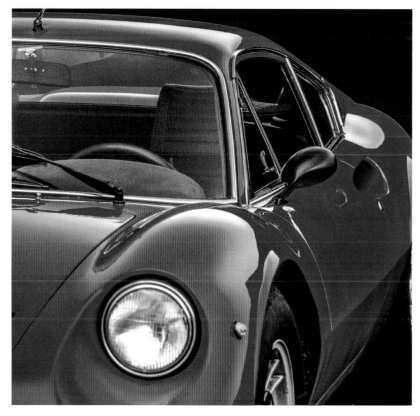

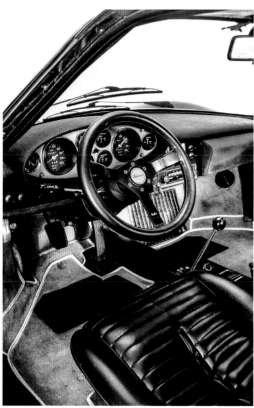

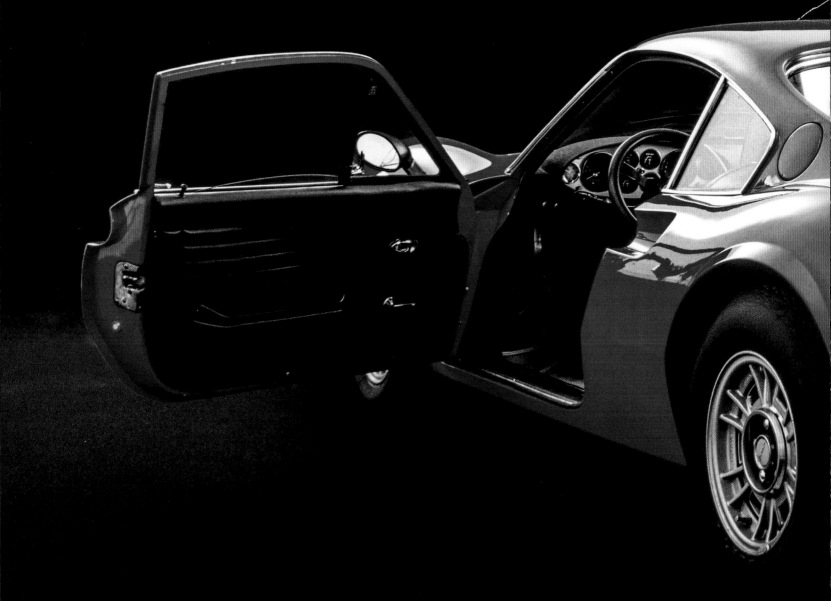

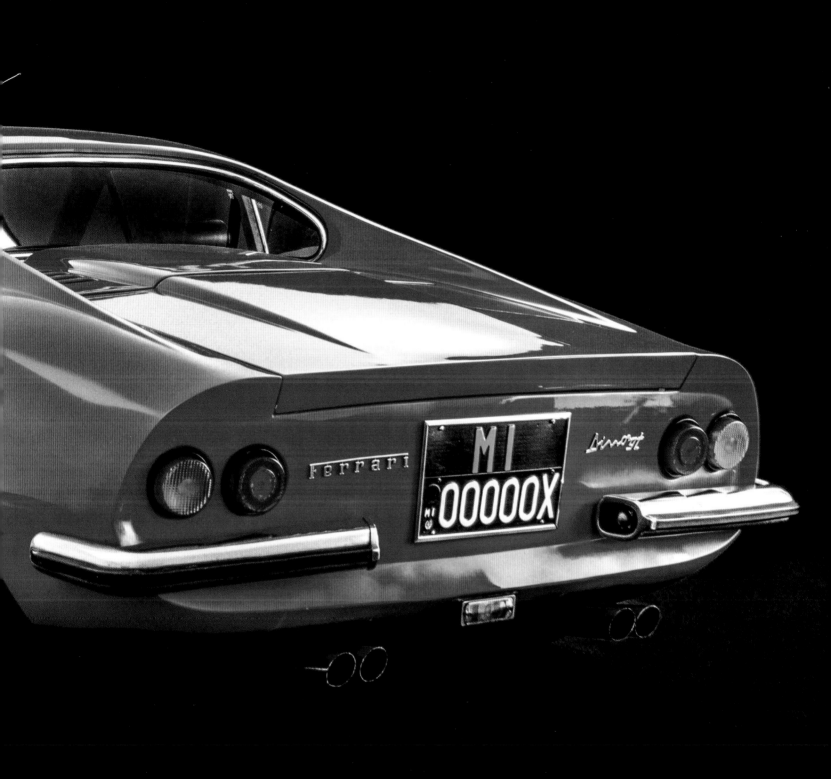

- 512 MODULO PININFARINA
- 512 S
- 512 M
- 712 CAN-AM
- 3Z SPIDER
- 365 GTC4
- 365 GT4 2+2
- 365 GT4 BB
- DINO 308 GT4
- 308 GTB
- 512 BB
- 308 GT RAINBOW
- 400 AUTOMATIC
- 400 CABRIOLET
- 308 GTS
- STUDIO AERODINAMICA
- 512 BB LE MANS

1970s

512
Modulo Pininfarina
1970

ENGINE // 4994CC, V12

POWER // 410KW (550BHP) AT 8000RPM

CHASSIS // STEEL SEMI-MONOCOQUE

GEARBOX // FIVE-SPEED

TOP SPEED // N/A

WEIGHT // N/A

While visitors to motor shows would become wearily familiar with ever-more wedge-shaped concept cars during the 1970s, one of the originals remains among the most extreme and most striking. At the turn of the decade Pininfarina demonstrated the profoundly influential 512 Modulo, a project which – according to its designer at least – had been at least two years in the making. After drawing the Dino Competizione show car, Paulo Martin sketched out an even more outlandish design, one which was almost symmetrical in profile as well as in plan view.

Martin would later claim the idea came to him while he was designing elements of the Rolls-Royce Camargue. Despite the lack of enthusiasm from Pininfarina management, Martin built a scale model out of polystyrene blocks which he cut and shaved into shape – but this, too, was supposedly met with disdain and consigned to a dusty corner.

Salvation came in the form of an unused 512 S race car chassis which had been built to conform with homologation requirements for prototype racing in 1970. Named the "Modulo" as a nod to the design conceit of the car looking like two half-shells pressed together, the finished vehicle pre-empted the "one box" themes which would become fashionable in the coming decades. Appearing for the first time at the Geneva show, it toured the world for a number of years as Pininfarina demonstrated it – in a different colour each time – at locations as diverse as Mexico City and Expo 70 in Osaka, Japan.

While the 512 Modulo had an engine and drivetrain from its donor, it didn't run under its own power until after US entrepreneur James Glickenhaus acquired it in 2014.

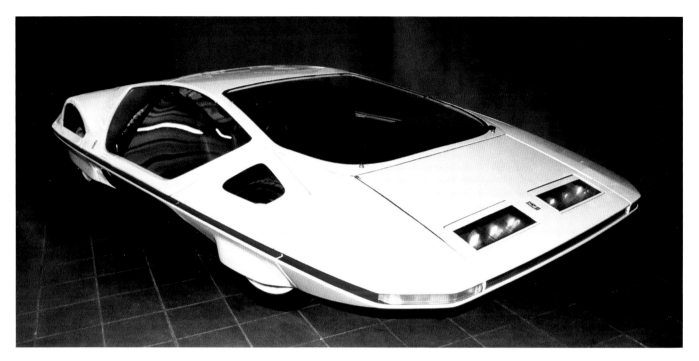

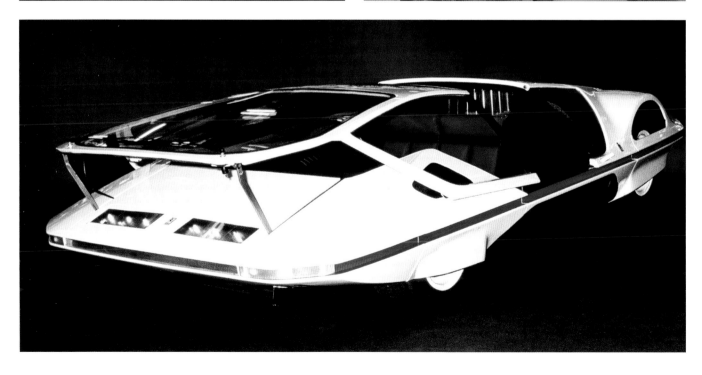

512 S
1970

ENGINE // 4994CC, V12

POWER // 410KW (550BHP) AT 8000RPM

CHASSIS // STEEL SEMI-MONOCOQUE

GEARBOX // FIVE-SPEED

TOP SPEED // 340KM/H (211MPH)

WEIGHT // 840KG (1852LB)

The increasing demands of prototype sportscar racing, plus the revolving door of technical regulations, had prompted Ferrari to sit out the 1968 season, focusing on Formula 1 and the relatively unrestricted Can-Am series instead. High on Enzo Ferrari's list of dislikes was the 3-litre engine limit imposed on Group 6 cars, a move he believed to be weighted in favour of Porsche, while Group 4 (which permitted 5-litre cars) continued with the onerous 50-car homologation minimum. A concession by the governing body followed in '68 when it cut the homologation requirement in half, though few in the racing industry believed any manufacturer would have the appetite to design a new Group 4 car.

The wake-up call arrived shortly after Ferrari unveiled a new 3-litre Group 6 car in December 1968, the 312P, conceived to compete with Porsche's 908. At the Geneva show the following March, Porsche revealed the 917 – a 5-litre Group 4 prototype. By April, Porsche had assembled 25 examples and posed them outside the factory for a photograph. Whether they all ran was open to question, but homologation was granted anyway.

Come June, Enzo had secured the investment to revitalize his ailing F1 and sportscar programmes – by selling 50 per cent of his company to Fiat under a deal in which he remained in control. Enzo then tasked Mauro Forghieri with designing a response to the 917. Working quickly, Forghieri focused on the engine, developing a new Tipo 261 derivative of the F1 V12 displacing 5 litres, with quad-cam multivalve cylinder heads. Slotted into a development of the P4 chassis it was first shown in Pininfarina concept-car form at Turin in October '69, then raced in definitive fibreglass bodywork designed by aerodynamicist Giacomo Caliri. Ferrari scraped through the homologation process by showing inspectors 17 complete cars along with components for a further eight.

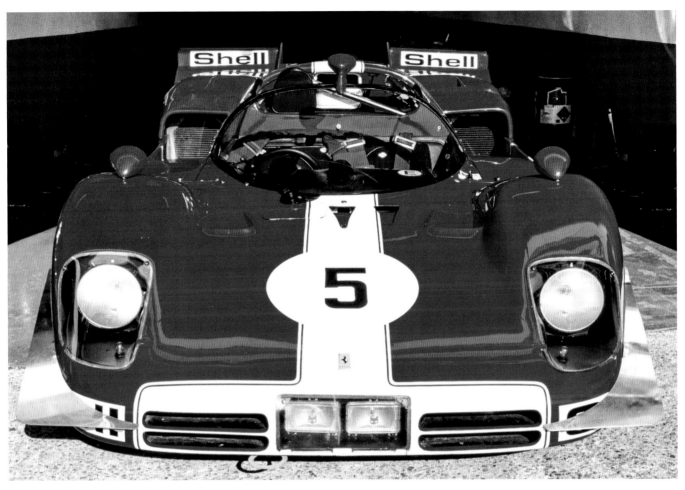

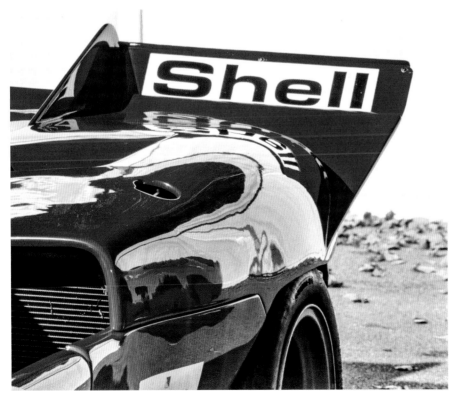

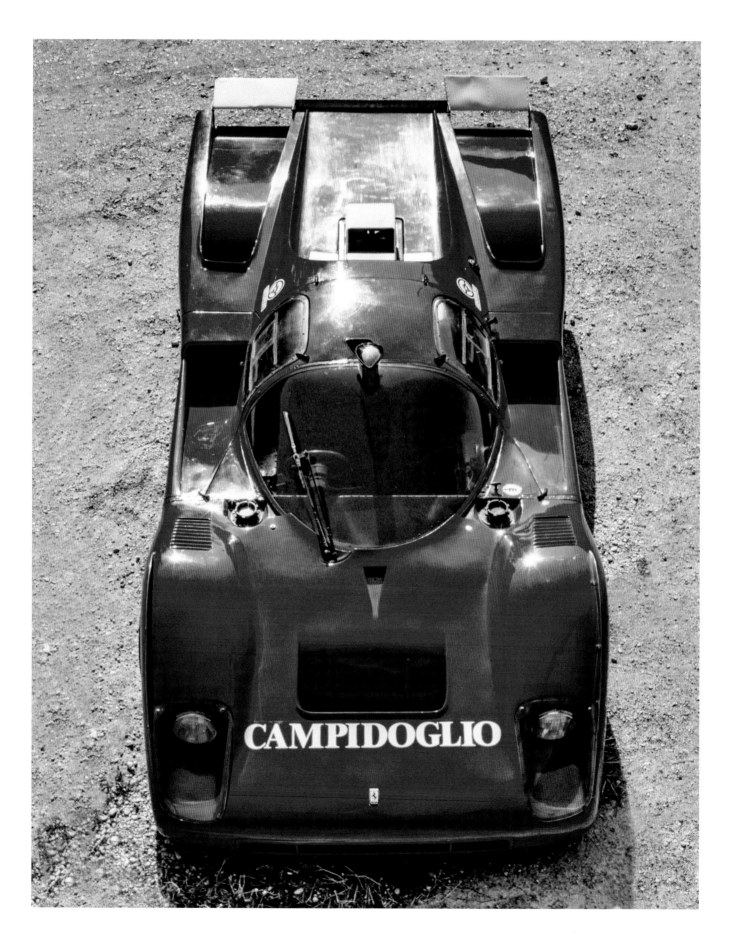

512 M
1970

ENGINE // 4994CC, V12

POWER // 455KW (610BHP) AT 9000RPM

CHASSIS // STEEL SEMI-MONOCOQUE

GEARBOX // FIVE-SPEED

TOP SPEED // 346KM/H (215MPH)

WEIGHT // 815KG (1799LB)

The rushed development cycle of the 512 S, combined with poor weather in Europe during the winter of 1969–70, resulted in a car which was overweight in comparison with Porsche's gas-filled alloy-spaceframe 917, and poorly sorted ahead of its racing debut in the Daytona 24 Hours at the end of January. Mario Andretti, Jacky Ickx and Arturo Merzario finished third behind a pair of 917s – but 48 laps down on the leader. Over the coming months Mauro Forghieri would look to shave weight from the car and tweak its aerodynamics to suit particular circuits, adding dive planes to the front and changing the length of the rear deck.

Problems for the 917s in the Sebring 12 Hours set up a memorable finish in which Andretti chased down a 908 shared by Peter Revson and Steve McQueen (who was preparing for his vanity-project *Le Mans* movie) for the win. But at a dramatic and largely wet Le Mans 24 Hours, where a camera car was circulating to capture footage for McQueen's film, Porsche's development work in taming the 917's wayward handling told – and none of the works Ferraris finished.

In the wake of the Le Mans disappointment, Ferrari sanctioned further development which resulted in the 512 M (for "modificato"), which was made available to customers as an upgrade package to the existing chassis after its first race outing at the Österreichring in October. With sleeker bodywork including a ram-air scoop for the engine, a lighter chassis and revised suspension, and a lighter and more powerful V12, the 512 M achieved respectable if not outstanding results through 1971 in the hands of experienced private teams such as NART and Penske.

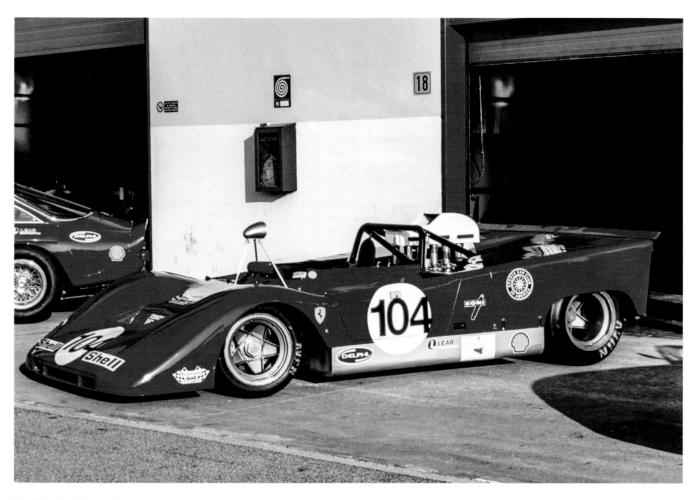

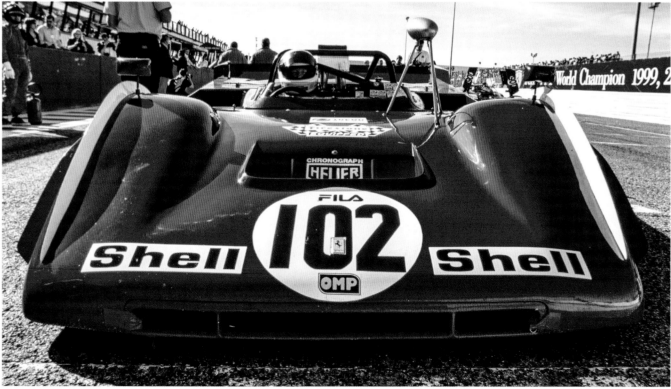

712
Can-Am
1971

ENGINE // 6860CC, V12

POWER // 582KW (780BHP) AT 8000RPM

CHASSIS // STEEL SEMI-MONOCOQUE

GEARBOX // FOUR-SPEED

TOP SPEED // 340KM/H (211MPH)

WEIGHT // 680KG (1499LB)

By 1971 the Can-Am series, a championship held on the North American continent for sports-prototypes of unlimited engine size, had become an exceedingly profitable pursuit. The McLaren team had been criss-crossing the Atlantic from their UK base since 1966, dovetailing Can-Am dominance with an increasingly successful Formula 1 campaign, so why not Ferrari?

Maranello had dabbled in Can-Am before, supplying a pair of modified 330 P3s with spyder bodywork and 4.1-litre V12s to Luigi Chinetti's NART organization in 1967. Ferrari then followed it up with a larger version of the Tipo 237 engine, now stretched to 6.2 litres, in the 612P, which appeared for the first time in the '68 season closer at Stardust Raceway in Las Vegas. Chris Amon retired on the opening lap.

The 612P appeared a handful of times in 1969 and claimed a podium finish in Amon's hands, but this was Ferrari's racing annus horribilis, in which lack of money and slow progress on the new flat-12 F1 engine stymied racing activities.

The redundancy of the 512 project enabled Ferrari to have a final fling in Can-Am – just as Porsche was weighing in with a spyder version of the 917. The first 512 chassis to have been converted to "Modificato" spec, number 1010, was tweaked again with open cockpit bodywork and Ferrari's biggest-ever racing engine – 6.9 litres – installed. Ferrari claim it won in this form in an Interserie race at Imola in May 1971, but photographs show it in 512M bodywork.

Mario Andretti qualified fifth and finished fourth on the car's US debut as the 712 at Watkins Glen, but Ferrari then shuttered the project before selling the car to NART.

3Z Spider
1971

ENGINE // 2953CC, V12
POWER // 179KW (240BHP) AT 7000RPM
CHASSIS // STEEL LADDER
GEARBOX // FOUR-SPEED
TOP SPEED // N/A
WEIGHT // N/A

Although rising costs were beginning to push individually coachbuilt cars out of reach of all but the wealthiest collectors by the turn of the 1970s, the likes of Carrozzeria Zagato remained successful within this niche, often producing one-offs for display. One such was the 3Z Spider, which appeared in public for the first time at the Turin Motor Show in October 1971, a year later than originally intended.

The donor car had departed the Maranello works in 1961 as a left-hand-drive 250 GT SWB California before it was acquired from its Italian owner by Luigi Chinetti in 1969 and delivered direct to Zagato's Turin workshop. Chinetti maintained a constant dialogue with Elio and Gianni Zagato as well as Giuseppe Mittino, who had taken over from Ercole Spada as chief designer. There is a lack of consensus as to the reasons for the delay in completing work on the car, but it's believed Chinetti – like many clients – underwent several changes of mind as to what he wanted. He was also embroiled in a project to create a Cadillac-based, Zagato-built mid-engined car for the high-end US market, to be badged as a NART. Through this he hoped to be able to circumvent the emissions regulations which were threatening his Ferrari import business.

Following its appearance on the show circuit the 3Z Spider was imported to the US and sold into private hands. In September 2013 the car appeared at Salon Privé in Syon Park, London, rebodied back to its original California spec with faired-in headlamps. It's believed the current owner has retained the Zagato body for display elsewhere in their collection.

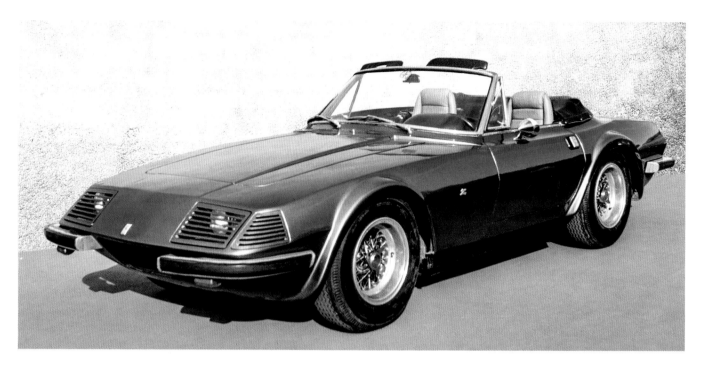

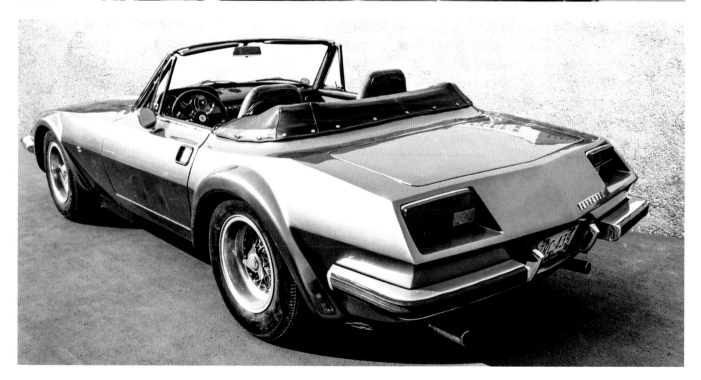

365
GTC4
1971

ENGINE // 4390CC, V12

POWER // 254KW (340BHP) AT 6200RPM

CHASSIS // STEEL LADDER

GEARBOX // FIVE-SPEED

TOP SPEED // 261KM/H (162MPH)

WEIGHT // 1450KG (3197LB)

Dismissed rather unfairly by the Italian motoring media as "il gobbone" (the hunchback) and likened to a banana in other territories, the 365 GTC4 met with a surprisingly tepid reaction when it was unveiled at the 1971 Geneva Motor Show. One of Filippo Sapino's last works for Pininfarina before he was poached to head up Ford's new European design studio, the car was a bold attempt to integrate traditional Ferrari design cues with the increasingly fashionable wedge profile. Sapino also succeeded where many of his contemporaries were failing: new US safety regulations demanded substantial bumpers which were challenging to incorporate, especially on a sportscar.

Ostensibly replacing the 365 GTC but bearing no outward resemblance to it, the GTC4 was based on the proven underpinnings of its predecessors, a tubular steel ladder frame setup augmented by additional cross-bracing. A 100mm (3.94in) wheelbase extension over its predecessor granted extra cabin space for the two occasional seats behind the front occupants, as well as a relatively generous boot. Adopting side-draught Weber 38DCOE carburettors – six in all – enabled a low bonnet line as the profile of the car traced a gentle waveform towards the rear wings and tail lights. The bumpers meshed neatly with the GTC4's slightly understated styling, tracing a wide oval around the driving lights and indicators at the front, and underlining the horizontal array of rear lights. As with several other Ferraris of this era, the body was formed in steel with an aluminium bonnet and boot lid.

A traditional gearbox arrangement rather than a transaxle made for a less challenging driving experience and suited the detuned engine's more relaxed power delivery, but buyers preferred Ferrari's spicier offerings and just 500 examples were sold.

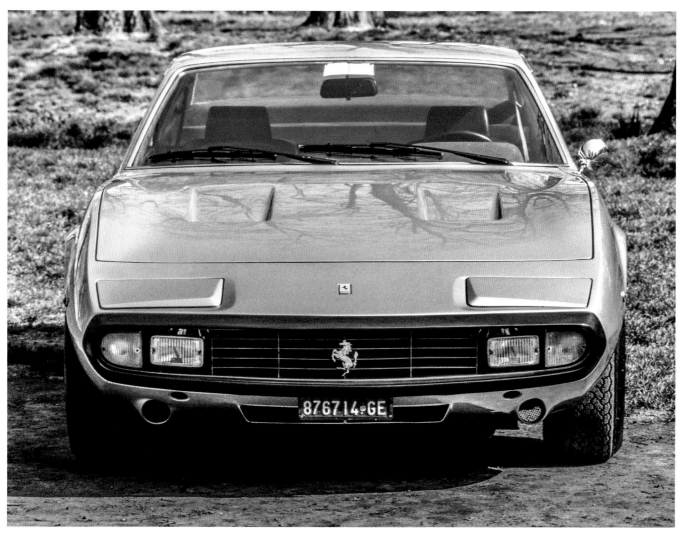

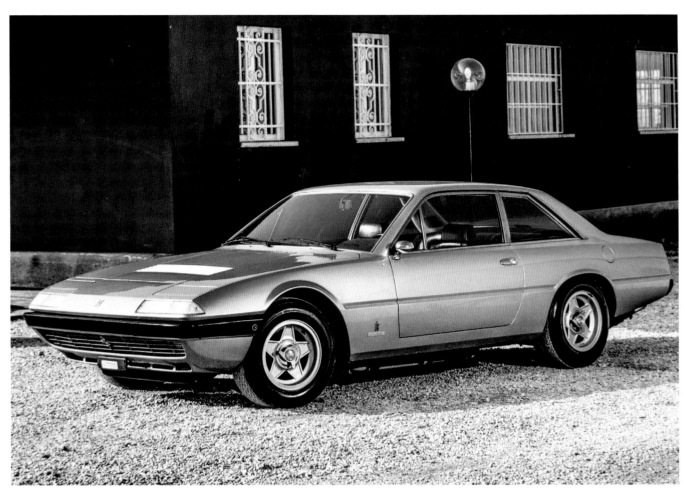

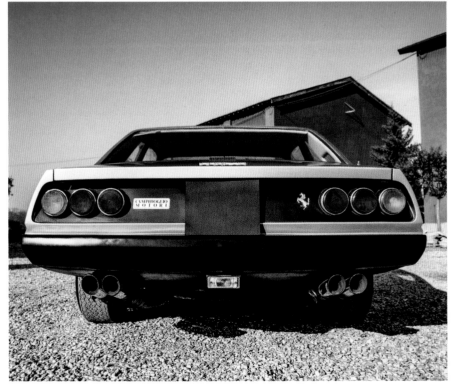

365 GT4 2+2
1972

ENGINE // 4390CC, V12

POWER // 254KW (340BHP) AT 6200RPM

CHASSIS // STEEL LADDER

GEARBOX // FIVE-SPEED

TOP SPEED // 245KM/H (152MPH)

WEIGHT // 1500KG (3307LB)

Stung by the critical response to the 365 GTC4 and consumer apathy to the model, Ferrari swiftly began development of a new model which was launched at the Paris Motor Show in October 1972. The GT4 2+2 represented a definitive break from mainstream Ferraris past, with more emphatic use of straight lines; in profile Leonardo Fioravanti's design recalled the *outré* 512 Modulo concept car in its suggestion of two almost symmetrical shells pushed together, and the indented belt line was a clear nod to the successful 365 GTB4 "Daytona".

There was cleverness even in a front end which lacked ostentation: a substantial one-piece moulded resin bumper neatly complied with new safety regulations while feeding cool air to the radiator. Perhaps more significant was the extended cabin and glasshouse, facilitated by a chassis 200mm (7.87in) longer in the wheelbase. More than any Ferrari which had gone before, this model resembled a three-box saloon more than a coupé.

While the exterior was minimalist, the interior was luxurious and cosseting. Only the instrument panel resembled the GT4 2+2's predecessor in layout: there was proper room for four passengers to travel in comfort.

Ferrari left the engine untouched from the GTC4, save for upgrading the ignition system from a single-coil distributor to a twin-coil setup. While the bumpers might have complied with US regulations, Ferrari decided against offering the GT4 2+2 in this market, figuring that the costs involved in achieving compliance elsewhere – particularly emissions – wouldn't be justified in a low-volume model.

Indeed, Ferrari had reached an acceptance that this flagship model would have a niche audience: sales remained steady (just over 520) but the GT4 2+2 lived on until 1976.

365
GT4 BB
1973

ENGINE // 4390CC, FLAT-12

POWER // 283KW (380BHP) AT 7200RPM

CHASSIS // STEEL SEMI-MONOCOQUE

GEARBOX // FIVE-SPEED

TOP SPEED // 303KM/H (188MPH)

WEIGHT // 1445KG (3186LB)

How to replace the iconic and popular 365 GTB4? Carefully. By degrees Enzo Ferrari came to accept that his road car range would have to include a V12 mid-engined model in response to Lamborghini moving in on his turf. The questions, as 1970s car style developed in the direction of the wedge, were what would such a Ferrari look like? And how would the engine be packaged?

While the Lamborghini Miura featured a relatively tall, transversely mounted V12 behind the driver, Ferrari engine boss Giuliano de Angelis felt a lower rear deck could be achieved through the traditional longitudinal engine configuration, but with the gearbox mounted below what was essentially a flattened-out V12. As with Ferrari's 312 Formula 1 engine – and despite the GT4's generally accepted nomenclature as "Berlinetta Boxer" – it's incorrect to describe the flat-12 as a "boxer" since the opposed pistons share crankpins and have a different firing order.

By the time Ferrari had shown the first concept model of the BB, at the Turin show in October 1971, it was known Lamborghini was working on a new and even more radical supercar. Ferrari's near neighbours had brought that March's Geneva show to a standstill with the startling LP5000 concept car, which became the Countach.

The definitive 365 GT4 BB was ready for launch in autumn 1973. Leonardo Fioravanti's gently flowing lines incorporated the now-familiar Pininfarina "twin shell" motif. Air vents on the rear deck enabled the engine to be on display, a feature already seen on the Lamborghinis.

While the global oil crisis harmed sales, the 365 GT4 BB remains a turning point in Ferrari history.

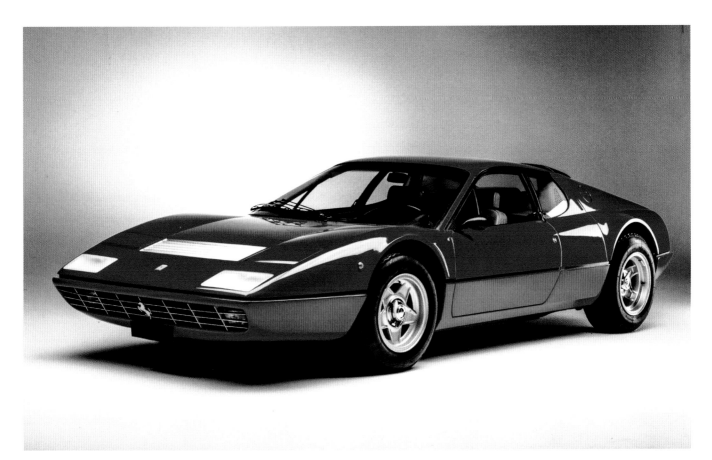

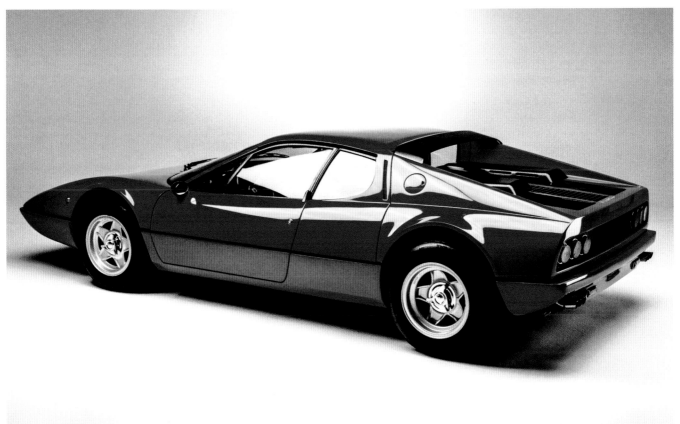

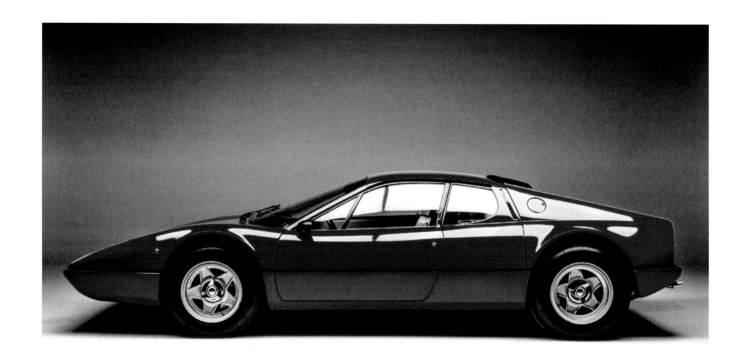

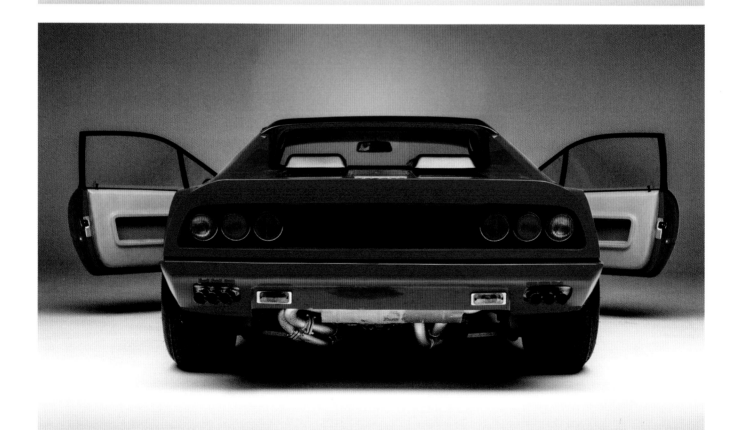

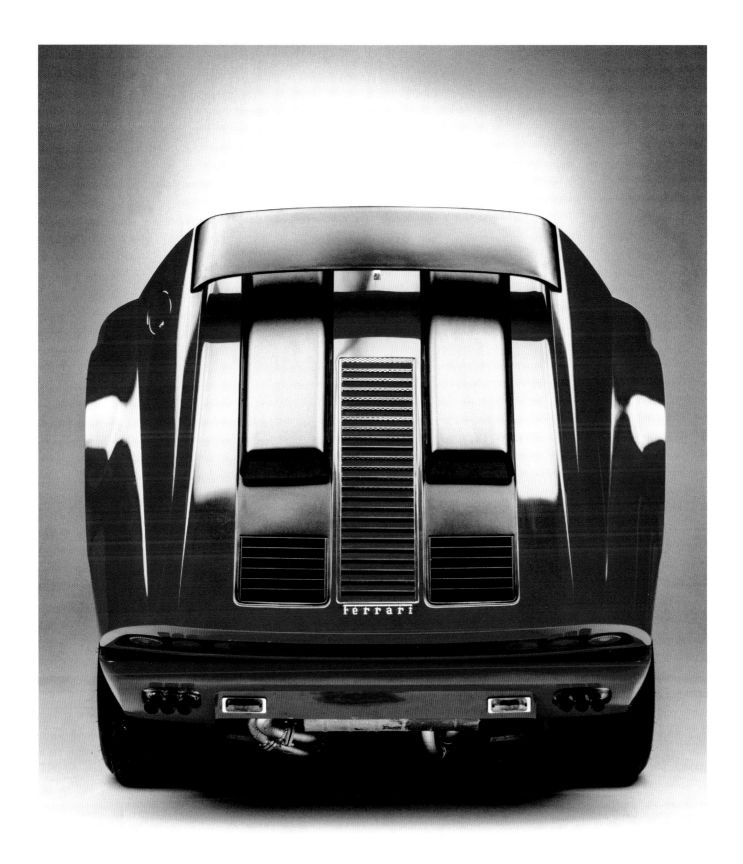

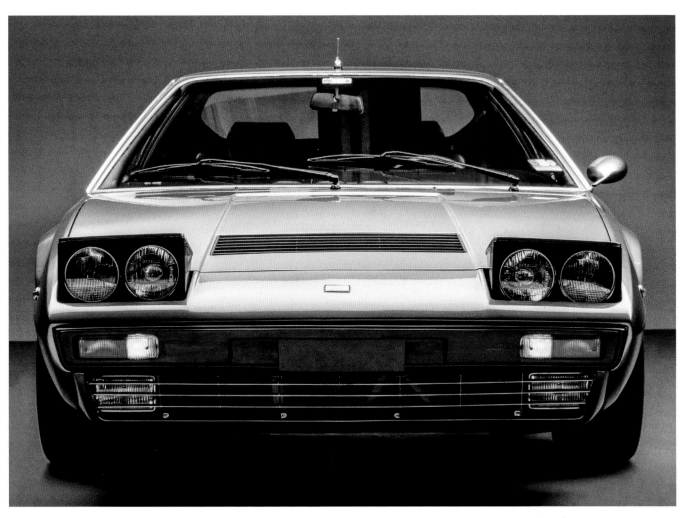

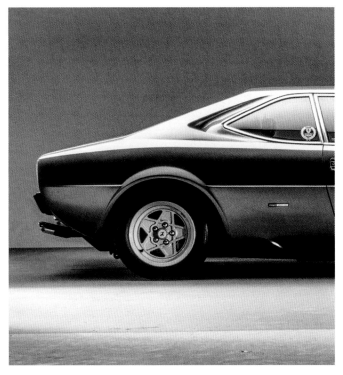

Dino
308 GT4
1974

ENGINE // 2927CC, V8

POWER // 190KW (255BHP) AT 7700RPM

CHASSIS // STEEL SEMI-MONOCOQUE

GEARBOX // FIVE-SPEED

TOP SPEED // 249KM/H (155MPH)

WEIGHT // 1150KG (2535LB)

Fiat's influence on Maranello matters became manifest for the first time at the 1973 Paris Motor Show. There Ferrari launched their first production model in two decades to have been designed outside the walls of Pininfarina. It's widely claimed that Fiat lobbied hard for Bertone to be handed the task of styling the new car; the Grugliasco-based coachbuilder's work for Lamborghini was considered to be genre-defining.

So it must have come as a disappointment to the Fiat executives when the Dino 308 GT4 met with an underwhelming initial response. Though its fashionably wedgy lines flowed from the pen of Miura designer Marcello Gandini, the car was disconcertingly similar to another work from the Italian stylist's back catalogue, the slow-selling Lamborghini Urraco. Posterity, though, has been kinder to the Dino 308 GT4 – collectors favour the Ferrari on account of its slightly shorter overhangs and less fussy C-pillar area, yielding more pleasing proportions.

Slightly wider than its predecessor, the Dino 308 GT4 was based around a development of the Dino 246 GT's tubular steel chassis with the wheelbase extended by 210mm (8.27in) to 2550mm (100.4in). For the first time since the 1.5-litre Formula 1 era, Ferrari built a V8 engine and, despite the 90-degree vee, was able to mount the 3-litre quad-cam unit transversely and leave room for two occasional seats behind the front passengers. The intention was to compete with Porsche's 911.

Ferrari could also convert it relatively painlessly to comply with US emissions laws; new Italian tax laws also moved the company to offer a 2-litre model for the domestic market. In 1976 Ferrari added the prancing horse badge to stimulate sales in the US; Elvis Presley bought one shortly before his death.

308
GTB
1975

ENGINE // 2927CC, V8

POWER // 190KW (255BHP) AT 7700RPM

CHASSIS // STEEL SEMI-MONOCOQUE

GEARBOX // FIVE-SPEED

TOP SPEED // 249KM/H (155MPH)

WEIGHT // 1250–1400KG (2756–3086LB)

By the mid-1970s Enzo Ferrari had become reconciled to the commercial reality that he could no longer reserve his surname and the prancing horse motif solely for models powered by 12-cylinder engines. The year before the "Dino" brand was quietly phased out on the 308 GT4, the replacement for the Dino 246 GT arrived resplendent in Ferrari branding.

The new 308 GTB, launched at the 1975 Paris Motor Show, would also represent a return to Ferrari's preferred stylist, Pininfarina, after the lukewarm reception afforded to the Bertone-designed Dino 308 GT4. While the 308 GTB was not without sharp creases, Leonardo Fioravanti's shape incorporated gently flowing lines which referenced both the Dino 246 GT and the 365 GT4 BB. The scalloped air intakes on the flanks, buttressed C-pillars, concave rear screen, and circular rear lights brought the essence of the 246 GT's design language into an overall shape which was definitively modern – and informed by research in Pininfarina's wind tunnel.

As with several other Pininfarina-designed Ferraris, construction was subcontracted to Carrozzeria Scaglietti and the earliest cars were built with fibreglass shells and aluminium bonnet, a first for Ferrari. Dialling the wheelbase of the semi-monocoque back to 2340mm (92.1in) enabled Ferrari to achieve a compact shape, albeit with a smaller cabin than the 308 GT4. The transverse V8 engine and five-speed transmission were carried over but dry-sumped in order to be mounted lower and to resist the effects of oil surge during hard cornering. Models for certain overseas markets including the US retained the wet-sump setup and featured a second ignition system in order to meet emissions standards.

While many road testers and customers were enthused by the performance inherent in such a light and powerful car, certain elements of the marketplace were less convinced about the quality, durability, and tactility of fibreglass. Series production in composite also proved challenging for Scaglietti. In 1977 Ferrari swapped to pressed steel for the bodies, saving costs on the production line but adding around 150kg (331lb) to the complete package. From a distance the two can only be differentiated by the presence of indentations where the A-pillars meet the roof on fibreglass models which – owing to their comparative rarity (just over 800 were built) – are now the most valuable examples.

The 308 GTB range would last until the 1980s and become Ferrari's biggest-selling model yet.

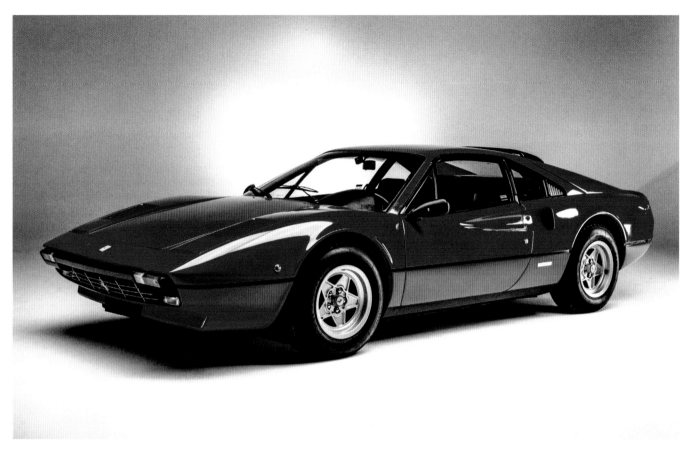

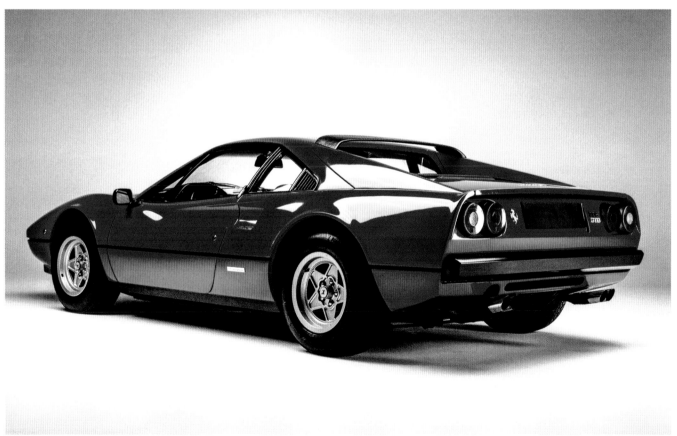

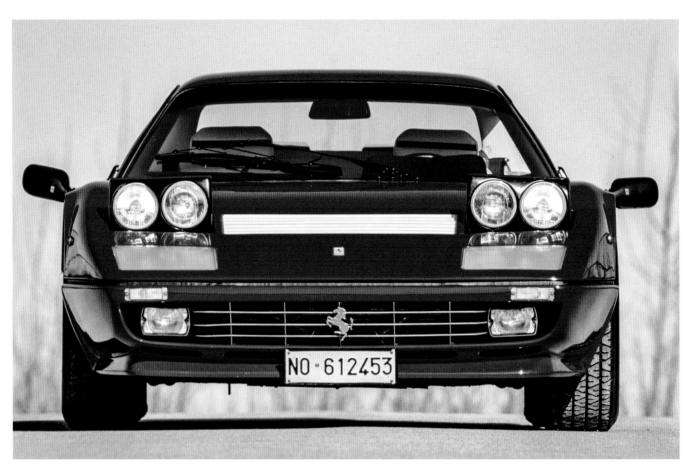

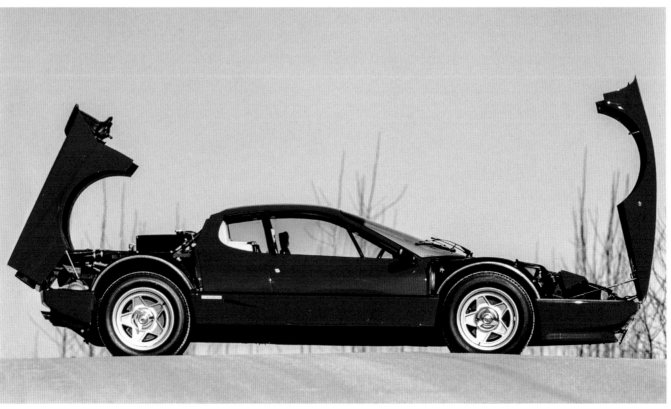

512 BB
1976

ENGINE // 4943CC, FLAT-12

POWER // 268KW (360BHP) AT 6800RPM

CHASSIS // STEEL SEMI-MONOCOQUE

GEARBOX // FIVE-SPEED

TOP SPEED // 303KM/H (188MPH)

WEIGHT // 1515KG (3340LB)

In 1976 Ferrari replaced the 365 GT4 BB with a larger-engined model while following the company's gradual transition to a new naming convention which had begun with the Dino range: rather than the number reflecting the swept volume of a single cylinder, it was a combination of engine size and the number of cylinders. Now the car boasted a 5-litre flat-12 – but outright power was not the target. By raising the bore by a lower ratio than the stroke – from 81 x 71mm (3.19 x 2.79in) to 82 x 78mm (3.23 x 3.07in) – and upping the compression ratio from 8.8:1 to 9.2:1, Ferrari liberated 10 per cent more torque even though peak power dropped by 15kw (20bhp). A hydraulic clutch complemented the approach of improving the powertrain's driveability.

Packaging the larger engine required a change to dry-sump lubrication but otherwise the mechanical layout of the 512 BB was identical, based on the same semi-monocoque chassis with a load-bearing central cell augmented by tubular steel extrusions. Externally the key differences came in the form of a subtle full-width chin spoiler, NACA ducts in the rear flanks to provide exhaust cooling, twinned rear lights and exhausts, and a wider rear track with larger wheels.

Despite the lower power output, the 512 BB's relatively high centre of gravity meant it retained its predecessor's penchant for lift-off oversteer. When Formula 1 driver Carlos Reutemann tested a 512 BB for the Italian magazine *Quattroruote*, he described it as "a car for the few", and he was not referring solely to its price tag. Although expensive in its day, the car was a good investment: the first 512 BB off the line sold at auction in 2017 for €425,000.

308
GT Rainbow
1976

ENGINE // 2927CC, V8

POWER // 190KW (255BHP) AT 7700RPM

CHASSIS // STEEL SEMI-MONOCOQUE

GEARBOX // FIVE-SPEED

TOP SPEED // N/A

WEIGHT // N/A

Though sales came steadily rather than in an impassioned torrent, the 308 GT4 would remain in production until the end of the decade – and its polarizing design did not dissuade Ferrari from collaborating with Bertone again. Indeed, Nuccio Bertone was determined to be bolder with the concept car his company would present at the 1976 Turin show, feeling that the problem with the 308 GT4 was the limitations of the brief – chiefly, the need to accommodate four in the cabin.

Accordingly, Bertone obtained a 308 GT4 chassis, shortened the wheelbase by 100mm (3.94in), and let Marcello Gandini have more or less free rein – with the stipulation the car included Bertone's patented new "Rainbow" retractable targa roof. If the car did not lead to further commissions from Ferrari it would at least act as a shop window for this new twist in wind-in-the-hair motoring.

The 308 GT Rainbow revisited several Gandini styling tics and previewed several more. Its abundance of creases and straight lines clearly had its roots in Gandini's mid-engined Fiat X1/9 and Jaguar XJS Ascot concept, though more exaggerated here. The squared-off wheel arches would be seen later on Gandini works as diverse as the Lamborghini Silhouette and the Citroën BX.

Perhaps sensibly, Bertone eschewed electrical or hydraulic actuation for the roof mechanism: the driver simply released a catch at the leading edge of the targa lid to unlock it, then pushed it upwards to where it could pivot and slide into a space behind the front seats. But, while the concept car excited much attention on the show circuit, it failed to persuade Ferrari to engage Bertone in shaping the 308 GT4's replacement.

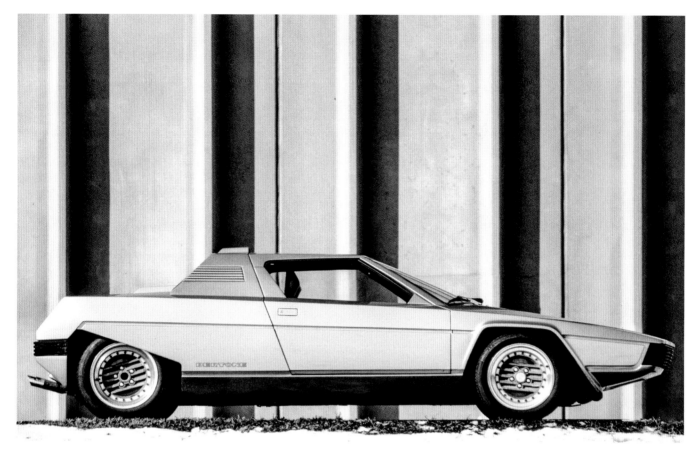

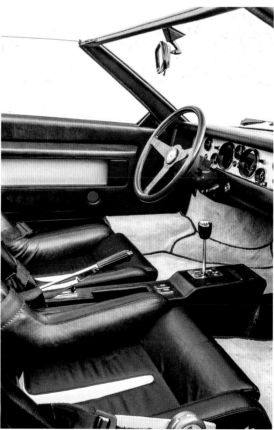

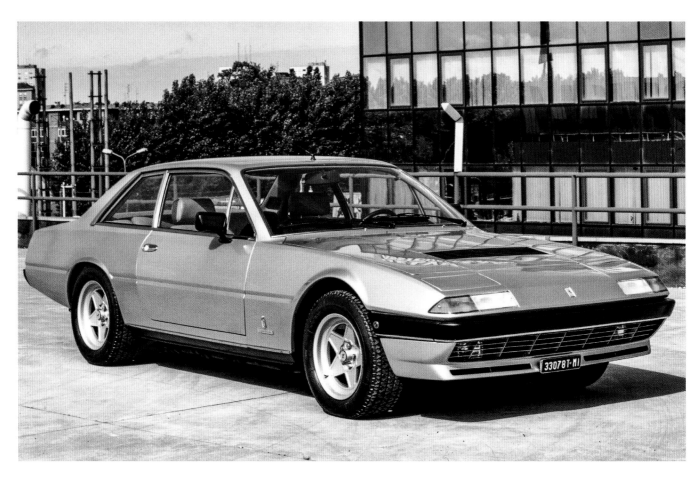

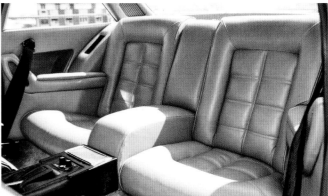

400
Automatic
1976

ENGINE // 4823CC, V12

POWER // 254KW (340BHP) AT 6500RPM

CHASSIS // STEEL LADDER

GEARBOX // FIVE-SPEED

TOP SPEED // 249KM/H (155MPH)

WEIGHT // 1600KG (3527LB)

In replacing the 365 GT4 2+2, Ferrari simplified the car's nomenclature while remaining true to the company's traditional naming conventions: with the engine now enlarged to 4.8 litres, the swept volume of each cylinder was 400cc. The changes to the rest of the car were rather less extensive, for this remained a relatively niche model aimed at a particular clientele: older, moneyed, and keen to transport more than two people without undue ostentation.

The 400's elegantly understated styling appealed to those who did not wish to flaunt their wealth, particularly in Italy, where social unrest in the 1970s had prompted a rash of kidnappings by organizations such as the Red Brigades as well as impromptu acts of petty criminality. Famous cases such as the kidnapping of John Paul Getty III and industrialist Vallarino Gancia provided an incentive to travel in a car whose demeanour and internal appointments befitted a person's station in life without turning too many heads.

Externally the 400 differed from its predecessor only in details such as the chin spoiler, twinned rear lights, and five-stud alloy wheels. The interior was mildly facelifted while remaining a paragon of leather-lined elegance.

Beneath the skin, the tubular steel chassis with self-levelling rear suspension remained the same, while the enlargement of the engine was achieved by lengthening the stroke by 7mm (0.27in) to 78mm (3.07in). The 400's most noteworthy new feature was the arrival on the options list of an automatic gearbox, a first for Ferrari. Rather than develop a bespoke unit, Maranello installed the well-proved General Motors-designed Turbo Hydra-Matic three-speed transmission. Though heavy, it appealed to the target audience: only one in three 400s sold was a manual.

400
Cabriolet
1977

ENGINE // 4823CC, V12

POWER // 254KW (340BHP) AT 6500RPM

CHASSIS // STEEL LADDER

GEARBOX // FIVE-SPEED

TOP SPEED // 241KM/H (150MPH)

WEIGHT // 1650KG (3638LB)

Though never officially offered for sale in the US – even though the later fuel-injected version
would have been readily adaptable to suit emissions regulations – the 400 gained a presence
there through the "grey import" market. This was still insufficient for Ferrari to consider
manufacturing a drop-top version of the model.

 Nevertheless there was demand for such a vehicle, both in the US and Europe, and individual
coachbuilding companies could fulfil that for discerning clients. Richard Straman Coachworks
of Costa Mesa, California, and Milan-based Carrozzeria Pavesi were responsible for the majority,
although AC Cars completed a number of conversions on behalf of UK customers. Given the
expense – labour costs could run to near the original price of the car itself – the clientele was
appropriately rarefied. Libyan president Muammar Gaddafi was among the famous owners.

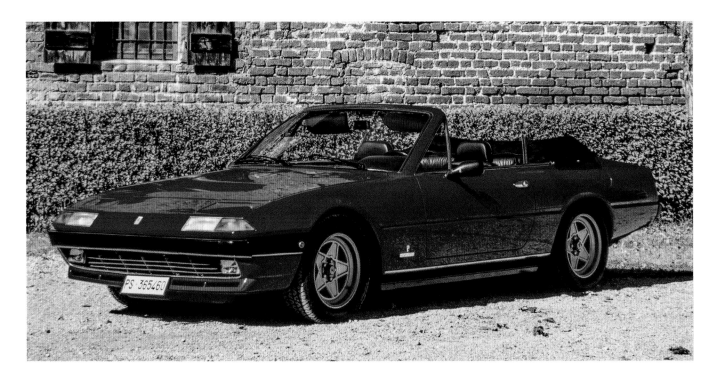

308
GTS
1977

ENGINE // 2927CC, V8

POWER // 179KW (240BHP) AT 7000RPM

CHASSIS // STEEL SEMI-MONOCOQUE

GEARBOX // FIVE-SPEED

TOP SPEED // 249KM/H (155MPH)

WEIGHT // 1400KG (3086LB)

Predictably, given the demand, Ferrari revealed an open-top version of the 308 at the 1977 Frankfurt Motor Show. Rather than being a cabriolet, it featured a manually removeable fibreglass targa roof that could be stowed in a recess behind the seats. In almost all other respects the GTS was mechanically identical to the GTB, though beefing up the structure to make up for the absence of a fixed roof required a change to wet-sump lubrication.

The GTS ensnared great mainstream attention. In the 1980 *Car & Driver* essay "Ferrari Reinvents Manifest Destiny", P.J. O'Rourke described an eventful drive across America to deliver a 308 to Los Angeles, where it was due for onward shipment to Hawaii to appear in the pilot episode of the TV show *Magnum, PI.* In the following years the 308 GTS would become iconic.

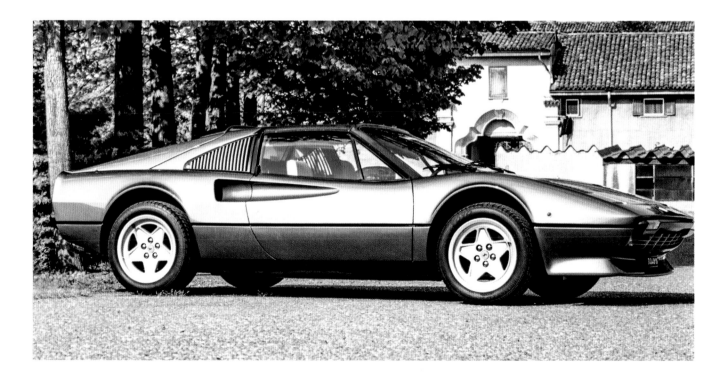

308
Studio Aerodinamica
1977

ENGINE // 2927CC, V8

POWER // 190KW (255BHP) AT 7700RPM

CHASSIS // STEEL SEMI-MONOCOQUE

GEARBOX // FIVE-SPEED

TOP SPEED // 249KM/H (155MPH)

WEIGHT // 1400KG (3086LB)

Since the late 1960s Pininfarina had been keen to showcase their aerodynamic expertise, both in the form of concept cars and much-publicized work with Ferrari's Formula 1 team. At the Geneva show in 1977 the company demonstrated a so-called "aerodynamic study" based on the 308 GTB, though it was rapidly dubbed the "Millechiodi" (thousand rivets).

Pininfarina's aim was to show how the popular wedge shape could be finessed to reduce aerodynamic lift and drag, and how the trend towards larger wheels with low-profile tyres could be incorporated into the design language. During this period many tyre manufacturers were beginning to follow Michelin's lead in adopting radial construction rather than the traditional cross-ply. Radials have less rigid sidewalls, dictating that sports cars targeting high cornering speeds need low-profile radials to avoid instability.

The areas of difference were so subtle that Pininfarina chose to accentuate them by leaving them unpainted on the finished car: a front bumper assembly including a chin spoiler, a wraparound spoiler on the rear deck, and flared wheel arches enclosing the Michelin TRX tyres and larger wheels. Inside, the show car differed from a standard 308 GTB only in the fascia panel, which was adapted from that used in the 512 BB and finished in black. A number of these features made their way on to production examples in subsequent years.

Opinions differ as to the fate of the show car. A period photograph shows it sitting in the Ferrari yard, shorn of spare parts. Some claim it was bought and restored by a collector, others believe it was scrapped and the car claiming its identity is a replica.

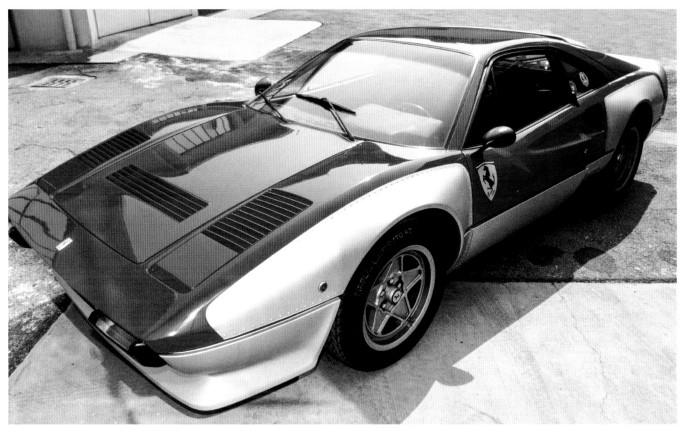

512
BB Le Mans
1978

ENGINE // 4943CC, FLAT-12

POWER // 350KW (470BHP) AT 7250RPM

CHASSIS // STEEL SEMI-MONOCOQUE

GEARBOX // FIVE-SPEED

TOP SPEED // 320KM/H (199MPH)

WEIGHT // 1050KG (2315LB)

While Ferrari had stepped back from sportscar competition to focus on Formula 1, and been rewarded with three more world championships, Luigi Chinetti's NART organization had continued to represent the marque in sportscars – often without much in the way of factory support. Having campaigned at Le Mans and elsewhere with a hotch-potch of machinery, including a Michelotti-built spyder and a modified 365 GT4 BB as well as several 365 GTB4s in "standard" competizione form, Chinetti lobbied Ferrari for help with a racing 512 BB.

Other prolific Ferrari customers Jacques Swaters and Charles Pozzi lent their weight to the argument and the result was a not-quite-official race programme ("some dealers prepared a number of examples according to factory instructions" is how Ferrari now rather primly puts it). A tuned version of the flat-12 engine was mated to a heavy-duty cooling system more suitable for endurance racing. Apart from race-style suspension fittings, changes to the body were limited to lightweighting measures and the addition of wings and wheel arch blisters.

Unfortunately by 1978, when these cars competed at Le Mans for the first time, Porsche had perfected the Group 5 racing version of the 911, the 935 – and was supplying it in numbers to private customers. None of four 512 BB LMs lasted the distance while four 935s finished inside the overall top 10.

Despite this failure there was sufficient appetite from customers to go again, and the next two iterations of the 512 BB LM were far more racy, featuring all-new silhouette-style bodyshells shaped in the Pininfarina wind tunnel. One of these finished fifth overall at Le Mans in 1981.

- PININ
- MONDIAL
- 208 GTS
- 308 GTBi
- 308 GTS QV
- 308 GTB GROUP 4
- 308 GT/M
- 288 GTO
- TESTAROSSA
- 328 GTS
- 412
- MONDIAL 3.2
- GTB/GTS TURBO
- TESTAROSSA SPIDER
- 288 GTO EVOLUZIONE
- 412 VENTOROSSO
- F40
- MONDIAL T
- MONDIAL T CONVERTIBLE
- F40 LM
- 348 TB

1980s

Pinin
1980

ENGINE // 4943CC, FLAT-12
POWER // 268KW (360BHP) AT 6800RPM
CHASSIS // STEEL LADDER
GEARBOX // FIVE-SPEED
TOP SPEED // N/A
WEIGHT // N/A

Pininfarina's 50th birthday present to itself came in a suitably extravagant form. Harking back to the nickname of company founder Battista Farina this revolutionary concept vehicle was, in the words of design director Leonardo Fioravanti, a car Farina "had always dreamed of… but had never built".

That might have been the case but the real impetus came from Battista's son, Sergio Pininfarina, who had read the market and believed the time was right for Ferrari to create a four-door saloon. Maserati had recently launched a third-generation Quattroporte, styled by Giorgetto Giugiaro. Ranged against this was Enzo Ferrari's long-standing reluctance to building a four-door car.

Sergio Pininfarina was determined to prove a point and mark the company's half-century in business – and got his way in the form of a concept vehicle carrying the Ferrari badge. The Pinin promised genteel but genre-defining style and utmost comfort for three rear-seat passengers – while delivering all the performance expected of a Ferrari. In fact, though it had a 512 BB-sourced flat-12 mounted longitudinally and ahead of the cabin, with a chassis and drivetrain adapted from the 400, the prototype was unable to run under its own power.

Word got out ahead of the 1980 Turin Motor Show that Pininfarina was working on something special, and the reality justified the gossip. Styled by Diego Ottina, superintended by Fioravanti, the Pinin proved to be a genuine show-stopper – even displayed alongside the coachbuilder's "greatest hits" collection.

While the Pinin never got the go-ahead for production, a subsequent owner hired a "retired" Mauro Forghieri to restore and re-engineer it as a working vehicle.

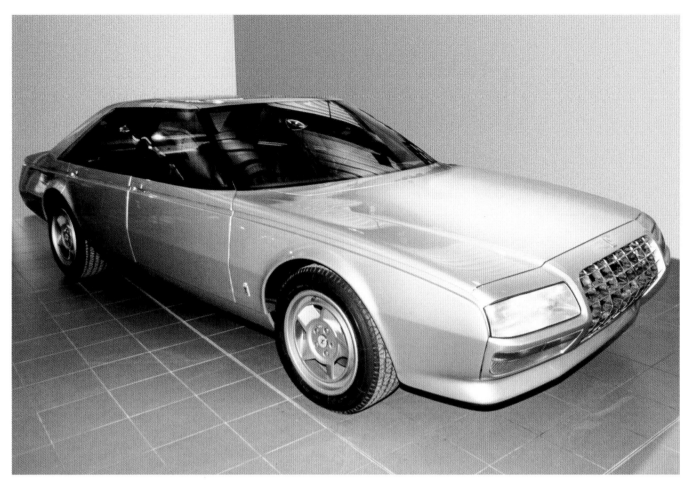

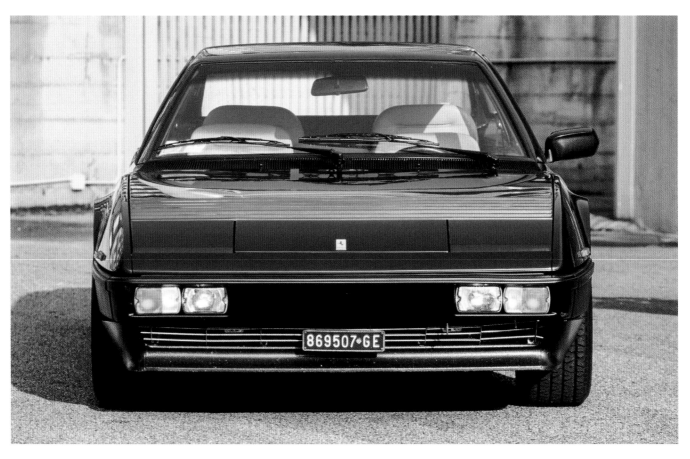

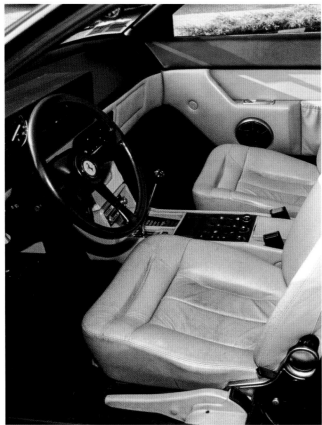

Mondial
1980·

ENGINE // 2927CC, V8

POWER // 160KW (214BHP) AT 6600RPM

CHASSIS // STEEL SEMI-MONOCOQUE

GEARBOX // FIVE-SPEED

TOP SPEED // 230KM/H (143MPH)

WEIGHT // 1585KG (3494LB)

Few Ferraris have the power to polarize quite so effectively as the Mondial, a car derided (with some justification) almost as much as it has been lauded. Power being one of the points of contention: the newly fuel-injected V8's grunt was considered somewhat insipid in the two-seat 308 GTB, let alone in a four-seater introduced as the replacement for the 308 GT4.

Thus the Mondial regularly appears in automotive media "listicles" lambasting history's least impressive supercars. It even warranted an entry in *Time* magazine's "50 Worst Cars Of All Time", a piece composed by no less an eminence than Dan Neil, the only journalist to win a Pulitzer prize for writing about cars. "This large and relatively heavy 2+2 coupé had a mere [160kw] 214 hp on tap from its transversely mounted, mid-engine V8, and its transistor-based electronics had more bugs than a Barstow motel rollaway," he sneered. "It hasn't helped the Mondial reputation that it was one of the 'cheap' Ferraris, within reach of a reasonably successful orthodontist. Mondials eventually got much better. They could hardly get worse."

And yet, like it or not, the Mondial is a significant car in Ferrari history, one that established a precedent for the four-seater models which provide a profitable backbone for the company's line-up to this day. Though its soft-edged personality was not considered a virtue on launch in 1980, in the coming decades buyer perceptions would shift. Now there is a clear divide between so-called "hypercars", where mechanical rawness is tolerated in the name of ultra-high performance, and supercars, which are expected to be civilized enough for everyday use.

From the moment the Mondial was unveiled at the Geneva Motor Show in March 1980 it was obvious Pininfarina had, like Bertone with the 308 GT4, struggled to reconcile the various elements of the brief. A 100mm (3.94in) wheelbase extension facilitated more cockpit space, and it was both taller and slightly wider than its predecessor too. But despite sharing certain stylistic flourishes with the two-seater 308 GTB/GTS, the Mondial looked ill-proportioned and uneasy with itself: the cabin looked too big, and the plain side surfaces clashed with the sportier details lifted from the GTB/GTS. The straked air intakes on each side looked cheap and poorly integrated, particularly on the early examples where they were painted black.

The arrival of the 16-valve engine in 1982, followed by a cabriolet in 1983, did much to address the criticisms.

208
GTS
1980

ENGINE // 1991CC, V8
POWER // 116KW (155BHP) AT 6800RPM
CHASSIS // STEEL SEMI-MONOCOQUE
GEARBOX // FIVE-SPEED
TOP SPEED // 216KM/H (134MPH)
WEIGHT // 1232KG (2716LB)

In response to the oil crisis of the early 1970s, the Italian government had imposed stringent taxes on cars with engines displacing over 2 litres. Among Ferrari's responses had been the development of a 2-litre version of the V8 engine introduced in the Dino 308 GT4. Having sold over 800 examples of the domestic-market 208 GT4 between 1974 and 1980, Ferrari thought it prudent to offer a similar package in the bigger-selling two-seater GTB and GTS.

Here lay an additional challenge. In its new fuel-injected form (to comply with international emissions regulations) the 3-litre V8 in the forthcoming 308 GTBi made 30kw (40bhp) less than the previous four-carburettor spec. A 2-litre version would offer at best 97kw (130bhp). Since Italian regulations were less stringent on emissions, Ferrari could spec four carburettors and produce a relatively respectable 116kw (155bhp) – with acceleration assisted by shorter gear ratios. A four-pipe exhaust like the 308's was on the options list.

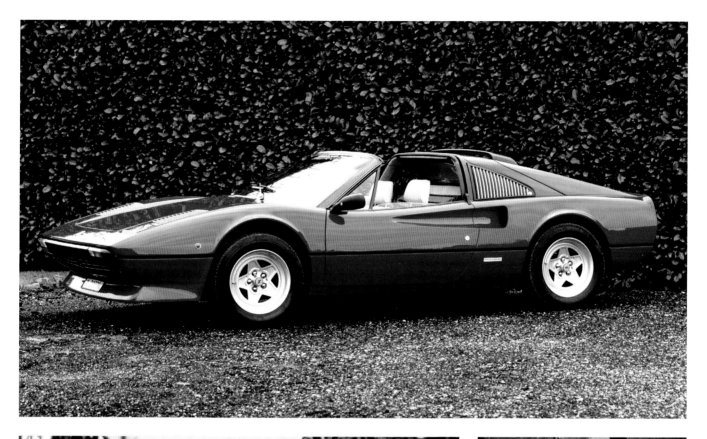

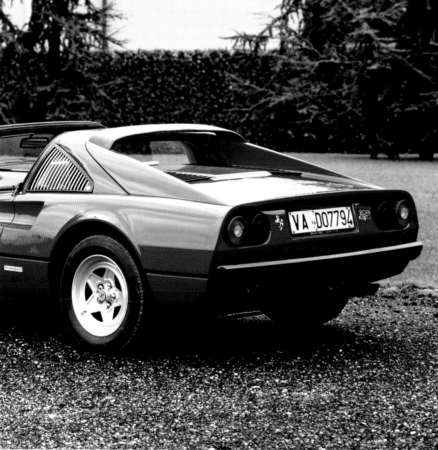

308
GTBi
1980·

ENGINE // 2927CC, V8

POWER // 160KW (214BHP) AT 6600RPM

CHASSIS // STEEL SEMI-MONOCOQUE

GEARBOX // FIVE-SPEED

TOP SPEED // 240KM/H (149MPH)

WEIGHT // 1400KG (3086LB)

The strong-selling 308 GTB/GTS range received a mild refresh in 1980, with an updated interior design centred around the driver: behind a new-look steering wheel the instrument binnacle had been redesigned for better visibility of key instrumentation. This was transferred to later examples of the 208 GTB/GTS. Outwardly the car retained unchanged the popular Pininfarina-styled lines, but with new wheels as Ferrari adopted metric-sized Michelin TRX radial. Buyers could still specify Imperial options on 14-inch and 16-inch wheels.

Greater change lay in the engine bay, where a Bosch K Jetronic fuel injection system replaced the quadruple-carb Weber setup, and the GTB joined the GTS in having wet-sump lubrication. While adding refinement and enabling Ferrari to comply with emissions tests in international markets, the fuel injection cut power to 160kw (214bhp). Measures for the more demanding US cut this figure to 153kw (205bhp).

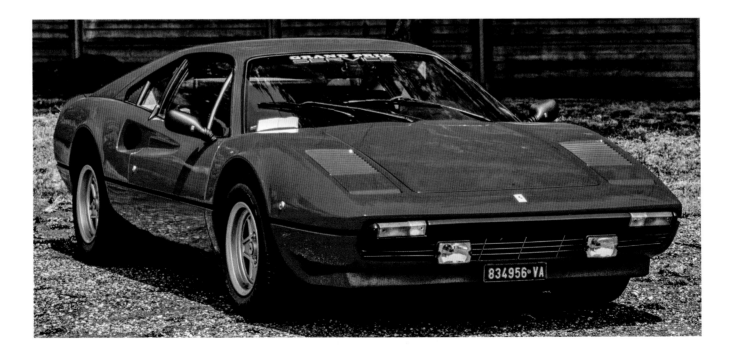

308 GTS QV
1982

ENGINE // 2927CC, V8

POWER // 179KW (240BHP) AT 7000RPM

CHASSIS // STEEL SEMI-MONOCOQUE

GEARBOX // FIVE-SPEED

TOP SPEED // 254KM/H (158MPH)

WEIGHT // 1400KG (3086LB)

The reduction in power caused by adopting fuel injection on the 308 in 1980 did not go unremarked upon by the motoring media and potential customers. In October 1982 Ferrari revealed a further update to the 308 family at the Paris Motor Show. Externally the differences were relatively minor – new fog lights set in the grille, a more extensively louvred bonnet, side repeater indicators (now a legal requirement in many markets), plus a vinyl wrap for the GTS's targa top.

Behind the passenger compartment, the engine bore the stamp of change on its red air filter box: Quattrovalvole. Four-valve cylinder heads were just the headline news in a package of refinements which included a new piston crown profile, a higher compression ratio, and Nikasil rather than cast iron liners. The result was more power and a greater appetite for revs again.

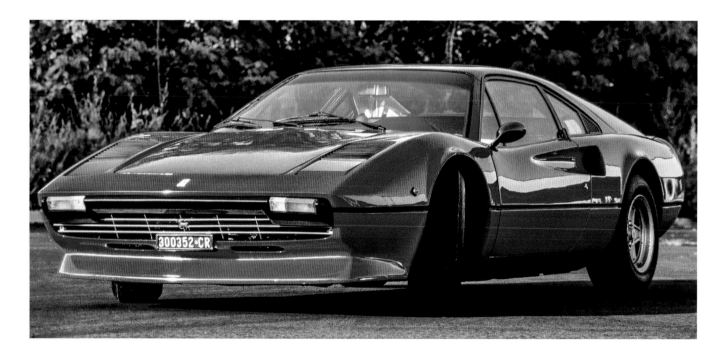

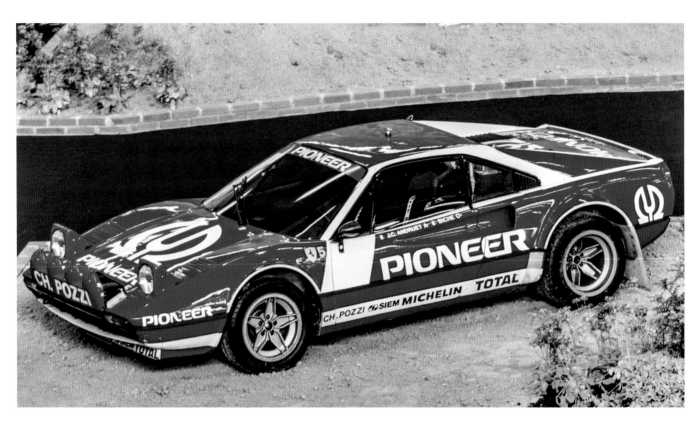

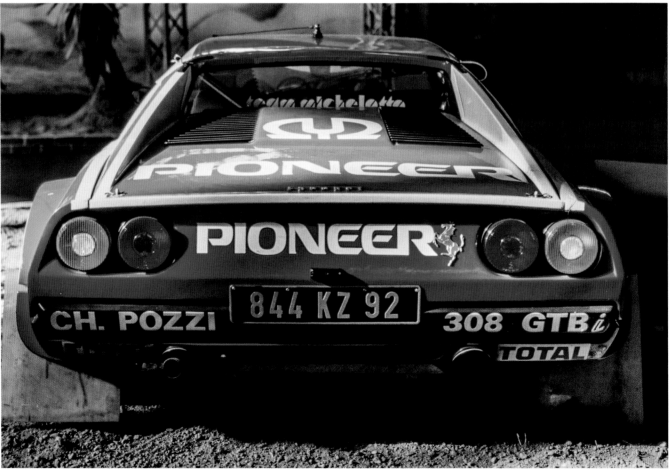

308
GTB Group 4
1982

ENGINE // 2927CC, V8

POWER // 235KW (315BHP) AT 8000RPM

CHASSIS // STEEL AND TITANIUM SEMI-MONOCOQUE

GEARBOX // FIVE-SPEED

TOP SPEED // 274KM/H (170MPH)

WEIGHT // 960KG (2116LB)

While the Ferrari name might not be synonymous with rallying, the marque enjoyed a brief sojourn in that motorsport niche during the late 1970s and early '80s – albeit via the back door of the factory. As early as 1976 Ferrari's Assistenza Clienti, managed by Gaetano Florini, built a prototype racing version of the 308 GTB with a view to establishing a supply to customers. The prototype, based on a stripped-down production 308 GTB with a modified engine and chassis, was shaken down at Ferrari's Fiorano race track – some claim by F1 world champion Niki Lauda – and homologated for competition before Ferrari abandoned the idea of building it in-house.

Separately the race modification specialist Giuliano Michelotto, architect of the Group 4 Lancia Stratos which had won the world rally championship for three consecutive seasons in the mid-70s, approached Ferrari to suggest a new project: a rallying 308 GTB. The chief obstacle to this proposal was that Ferrari, as part of the Fiat Group, could not be seen to be competing directly with Lancia, another part of the empire. But if it was customers racing under their own auspices, using cars prepared by a third-party company, internal politics became less of an issue.

Michelotto's first chassis failed to finish the 1978 Targa Florio rally in the hands of Roberto Liviero, but the following year Raffaele Pinto won the Monza Rally in it and other potential customers took notice, notably French Ferrari dealer Charles Pozzi, and ultimately 11 were sold. Notably, Jean-Claude Andruet finished second in the Tour de Corse, a WRC event, in 1982; Michelotto then built a further four GTBs to the new Group B spec.

308
GT/M
1984

ENGINE // 2927CC, V8

POWER // 271KW (363BHP) AT 8500RPM

CHASSIS // STEEL SEMI-MONOCOQUE

GEARBOX // FIVE-SPEED

TOP SPEED // N/A

WEIGHT // 840KG (1852LB)

Customers pleased with the competitiveness of the 308 adapted by Michelotto to Group 4 rally regulations began to approach the Padua-based tuner to prepare examples to the new and (theoretically) less restrictive Group B spec. But the homologation requirements represented an obstacle: to produce a car which exploited the full reach of the regulations, Michelotto would have to build at least 20 – beyond the company's relatively humble means. Such Group B cars which did leave the shop, therefore, featured stock body panels on top of a modified chassis and drivetrain.

Michelotto got as far as building three "evolution" prototypes with the quiet involvement of the Ferrari factory. Rather than being a heavily adapted road car the GT/M was essentially a new vehicle bearing only a vague resemblance to the parent model: the chassis was a bespoke design in which the quattrovalvole engine was mounted longitudinally rather than transversely, the better to facilitate access at the service parks, where facilities were often basic. Lightened internals and a customized fuel injection system raised power to 271kw (363bhp), transmitted via a Hewland racing gearbox. Suspension components were derived from the wider Ferrari parts stock in order to introduce the Mondial's anti-dive geometry.

The GT/M's composite bodywork closely resembled the aerodynamically optimized shape drawn by Pininfarina for the final, most extreme 512 BB Le Mans, but with much shorter overhangs, especially at the front.

Development delays meant the GT/M wasn't ready until 1984, by which time the dominance of Audi's four-wheel drive Quattro had sapped Ferrari's appetite for the rallying world.

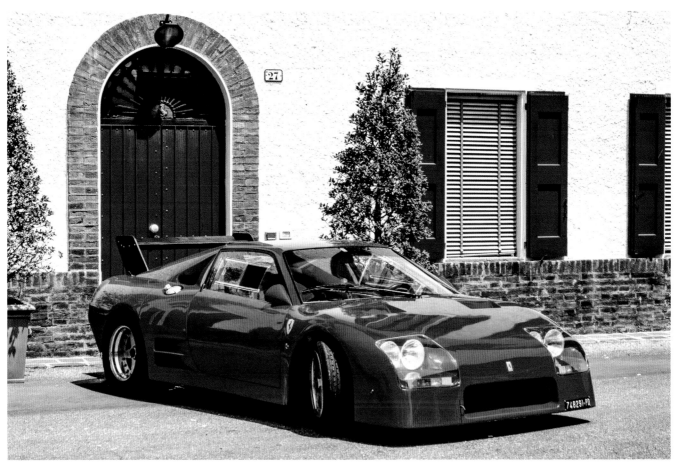

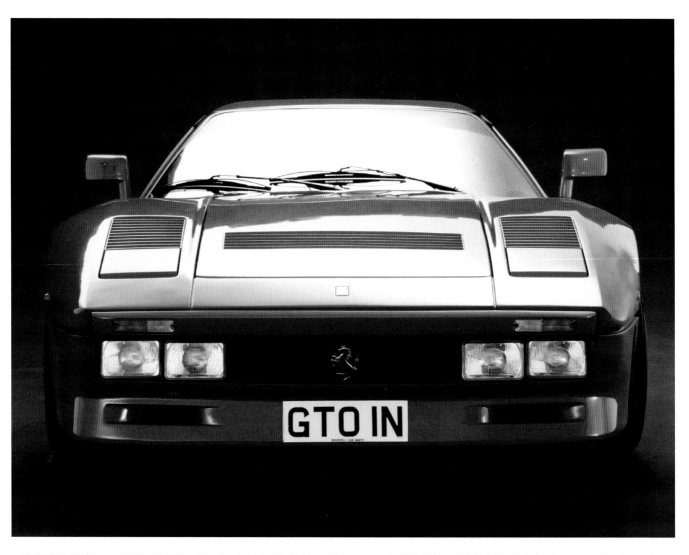

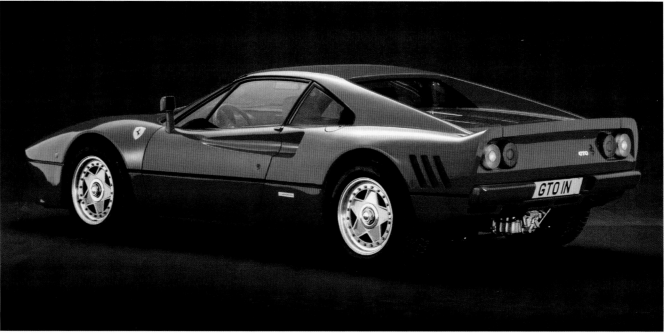

288 GTO
1984

ENGINE // 2855CC, TWIN-TURBO V8

POWER // 298KW (400BHP) AT 7000RPM

CHASSIS // STEEL AND COMPOSITE SEMI-MONOCOQUE

GEARBOX // FIVE-SPEED

TOP SPEED // 306KM/H (190MPH)

WEIGHT // 1160KG (2557LB)

The FIA's light-touch Group B regulations were intended to provide a common framework encompassing both rallying and circuit racing. While not quite "anything goes", it is little exaggeration to say the resulting race cars bore only a passing resemblance to what you could buy in the showroom. Sadly it was short-lived, as there was insufficient interest from the world of sportscar racing for it to take root there. But it did set the stage for some of the most exciting and evocative Ferraris ever made.

The 288 GTO – reviving the Gran Turismo Omologato name from the iconic 250 GTO – endured a protracted conceptual phase owing to the byzantine internal politics of the time. While Enzo Ferrari was keen to see such a vehicle spice up the company's increasingly conservative range and provide the platform for a Group B racer, his hands were tied to an extent by the terms of his deal with Fiat. Enzo retained control of Ferrari's racing activities but the production car division was the bailiwick of Fiat suits unwilling to take expensive risks.

Though Audi's dominance of rallying prompted Ferrari to abandon the 308 GT/M developed in partnership with Michelotto, work proceeded in-house on the 288 GTO, leaning on expertise from two recent recruits to Ferrari's Formula 1 programme: Dr Harvey Postlethwaite and Nicola Materazzi. Pininfarina's Leonardo Fioravanti provided the styling – heavily influenced by the company's 308 Millechiodi concept – for a chassis based on the existing 308's but with an extended wheelbase and a rear bulkhead made in aluminium honeycomb sandwiched by layers of Kevlar. Only the windscreen and doors were shared with the 308 GTB; the rest of the body was a Kevlar/fibreglass composite.

Ostensibly sourced from the 308 Quattrovalvole, the V8 was extensively reworked by Materazzi using the latest knowledge gleaned from F1, sleeved down to 2855cc (to pass the FIA's equivalency formula for turbo cars) and breathing through a pair of water-cooled IHI turbochargers. In the GTO it was mounted longitudinally rather than transversely and driving directly through a five-speed transaxle gearbox.

Though the 288 GTO never raced, Ferrari had no difficulties selling the 272 examples they built. It made for a curious, if exhilarating, road car experience if not the last word in comfort: joining a British customer to collect his from Maranello, *Car* magazine's Gavin Green wryly recounted finding a blanking plate where they expected the radio to be.

"'A radio cassette player is an option', explained the Ferrari man. 'Although we do fit the speakers and wiring as standard.'"

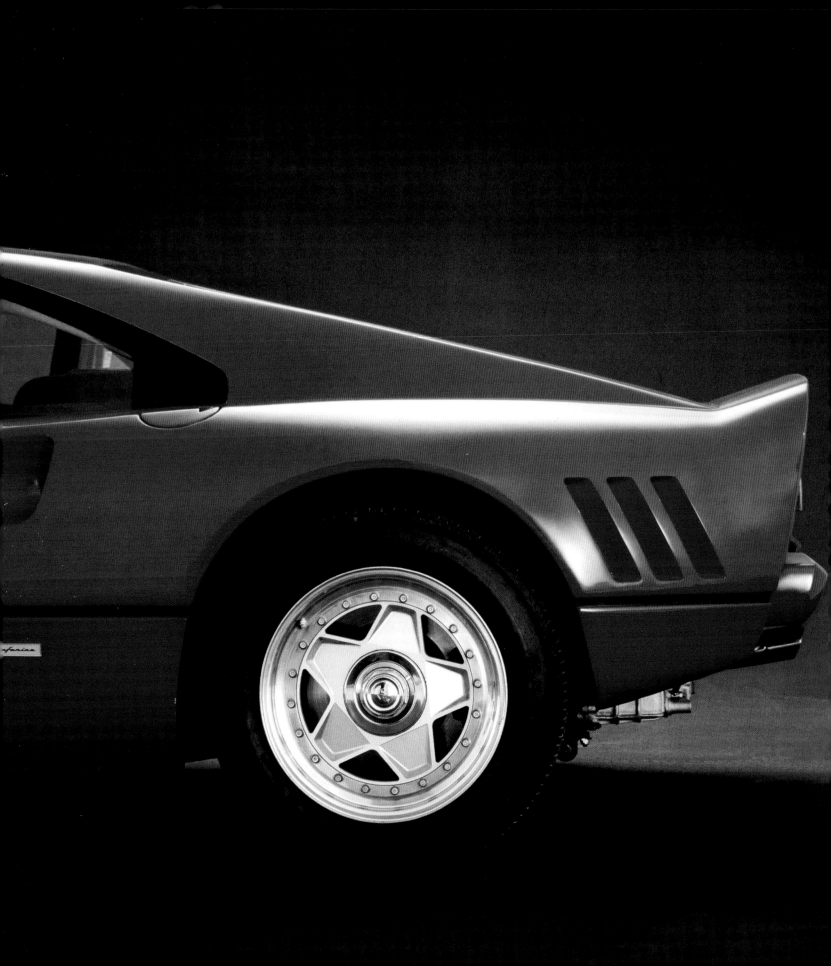

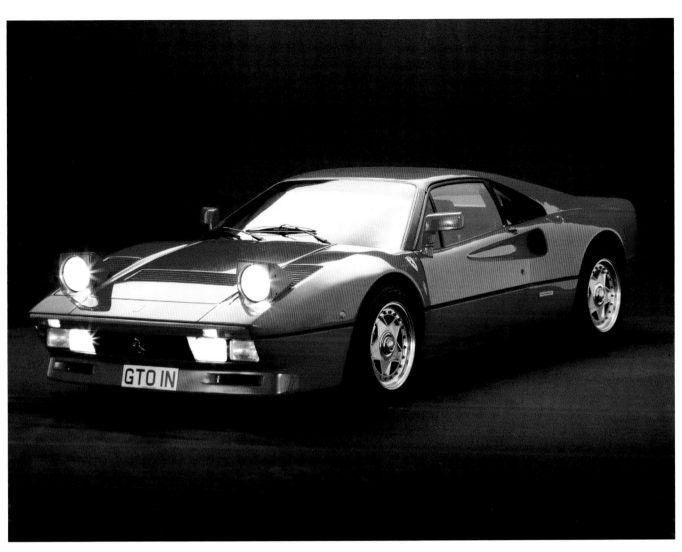

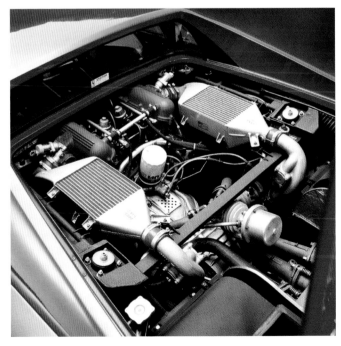

Testarossa

1984

ENGINE // 4943CC, FLAT-12

POWER // 291KW (390BHP) AT 6300RPM

CHASSIS // STEEL SEMI-MONOCOQUE

GEARBOX // FIVE-SPEED

TOP SPEED // 290KM/H (180MPH)

WEIGHT // 1630KG (3594LB)

2 October 1984. The day before the opening of the Paris Motor Show, the world at large got its first glimpse of a car which would become a Ferrari legend. Lowered from the ceiling of the Lido nightclub on the Champs-Élysées, a spotlight playing evocatively along its sculptured red flanks, the Testarossa arrived in a style to which it would become accustomed.

It had been six years in the making, a car over which management at Ferrari, Fiat and Pininfarina had sweated and fretted. Initial plans to replace the 512 BB series cheaply via a facelift – the preferred option of the bean-counters – foundered. Curing that car's known shortcomings, particularly its non-compliance with US safety and emissions laws, made a new model more desirable once the requirement for greater performance was factored in.

Nicola Materazzi's engine department developed the Type F113A flat-12, larger than its predecessor and with four valves per cylinder. To resolve the issue of heat soak into the cockpit from the engine's plumbing, Ferrari mounted radiators laterally, beside the engine, rather than having a single unit in the nose. This dictated substantial air intakes would be required on each side.

Wrapping a "modern" shape around these requirements, plus a much broader rear track, challenged Pininfarina's design team. Emmanuele Nicosia's proposal, which accentuated these engineering features rather than attempting to disguise them, won out.

The Testarossa's aggressive flamboyance meshed perfectly with the thrustingly aspirational sensibilities of the age, rapidly permeating popular culture. No teenager's bedroom was complete without an Athena poster of a Testarossa to complement the black ash furniture. And what other car could have occupied centre stage in *Miami Vice*? The Testarossa was perfectly at home in the glamorous TV cop drama's world of graduated tints and pastel-shaded linen jackets with rolled-up sleeves.

Ferrari's high-profile involvement in the fictionalized world of Miami's seedy underbelly actually represented a thawing of relations between the company and the programme makers. For the first two seasons Don Johnson's character "Sonny" Crockett drove a 365 GTB4 Spider, actually a fibreglass replica, inviting a cease-and-desist letter from Ferrari North America. However, it transpired Enzo was a fan of the show, ultimately resulting in the delivery of a genuine Testarossa – which producer Michael Mann insisted be white "to fit in with the Miami palette". The 365 replica met an explosive demise on screen at the hands of an arms dealer demonstrating a Stinger missile.

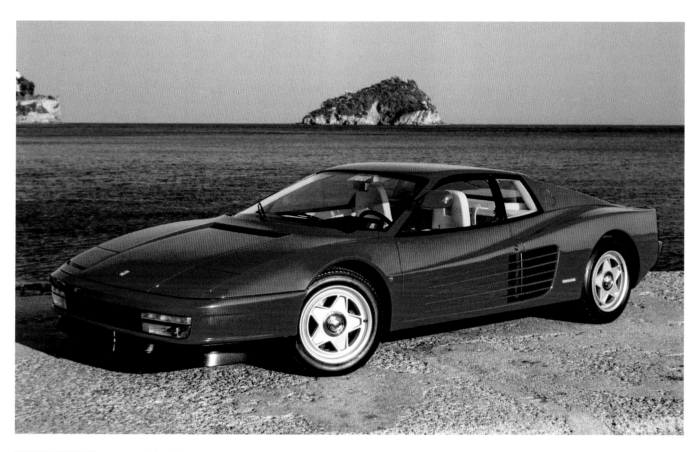

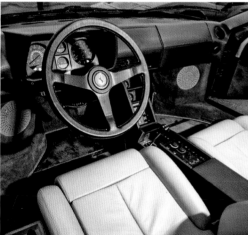

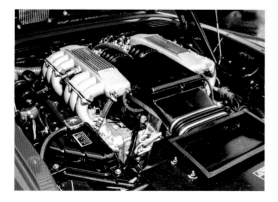

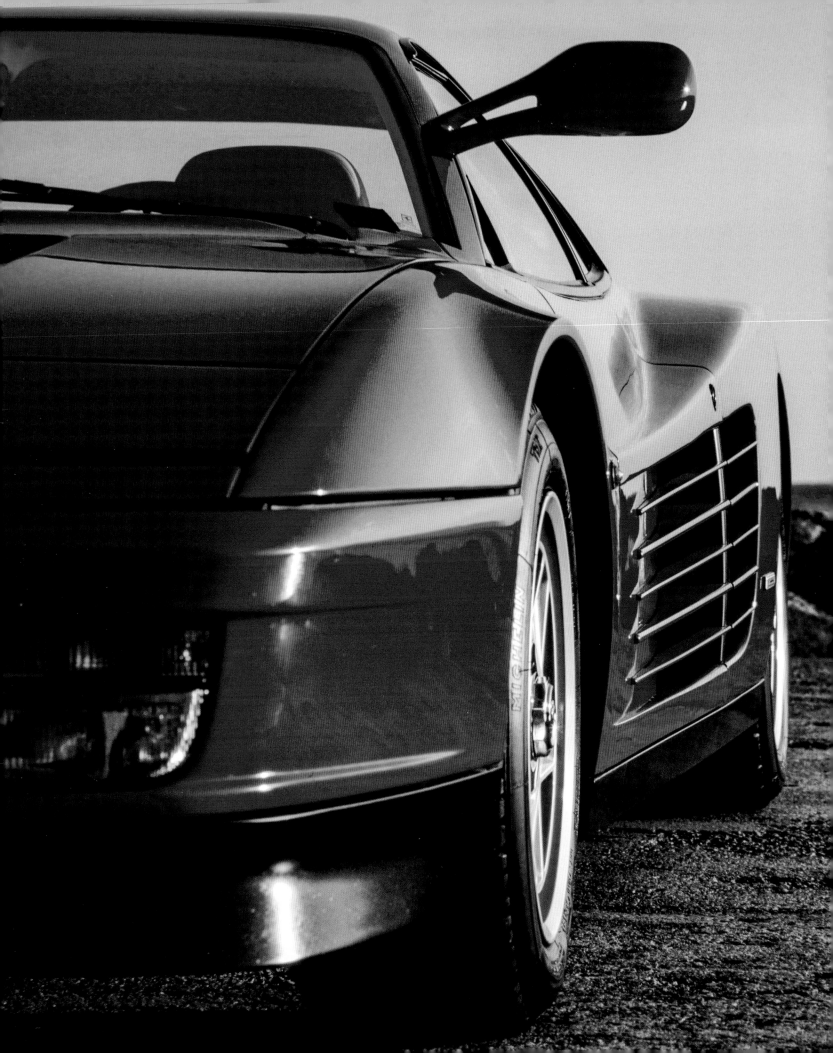

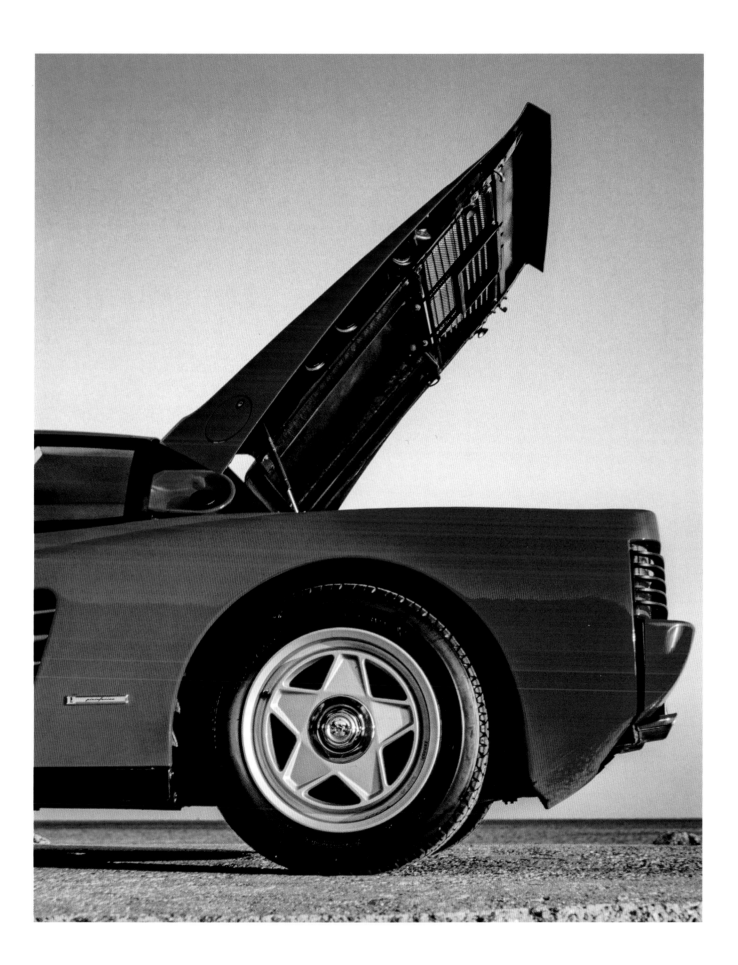

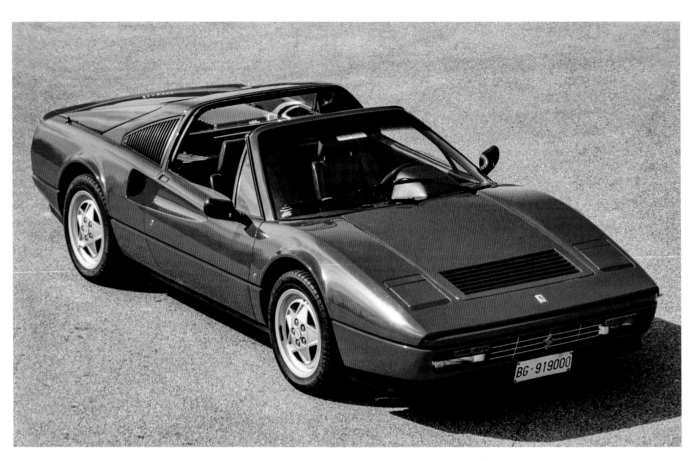

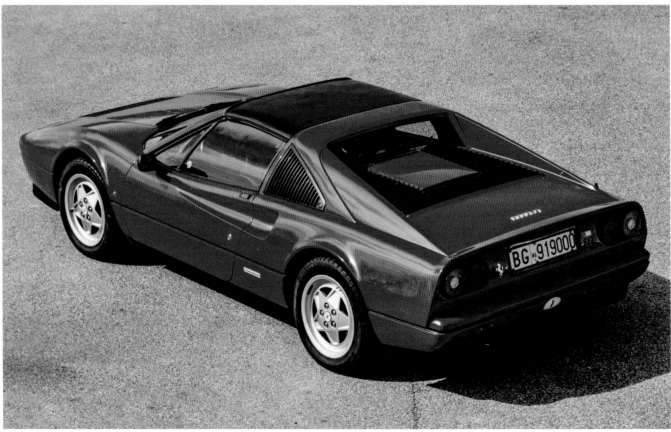

328 GTS
1985

ENGINE // 3186CC, V8

POWER // 201KW (270BHP) AT 7000RPM

CHASSIS // STEEL SEMI-MONOCOQUE

GEARBOX // FIVE-SPEED

TOP SPEED // 262KM/H (163MPH)

WEIGHT // 1273KG (2806LB)

The fact that a decade passed between the introduction of the 308 and the arrival of its successor alluded to the sheer popularity of the model, but it was also evidence of the stagnation which had crept into Ferrari's line-up as the company's ageing founder devoted rather too much attention to his growing role as power-broker between warring political factions in Formula 1. Fiat, too, had shifted focus away from Maranello under the leadership of Vittorio Ghidella, putting most energy into beating fractious trade unions and bringing profitable high-volume small cars to market.

Although every body panel was different, Leonardo Fioravanti's revised shape was familiar in style and proportion, marked chiefly by being softer-edged and more wave-like in profile. Body-coloured bumpers and recessed front lights brought the nose and tail into stylistic harmony with the Mondial 3.2; in the 1980s it was fashionable for the majority of models in a manufacturer's line-up to share the same "face". Inside, Ferrari took the opportunity to update the switchgear and instruments to reflect contemporary tastes as well as revising the upholstery.

To enlarge the quad-cam V8 to 3.2 litres, Ferrari widened the bore and lengthened the stroke in the same proportions, adding a new Magnetti Marelli electronic ignition system for reliability as well as performance reasons. The revised engine's greater power output was complemented by a bodyshell which was lighter than the 308's despite the adoption of galvanized steel as a rust-prevention measure.

While a cabriolet version was evaluated, to avoid poaching sales from the Mondial Ferrari elected to continue with a targa roof on the GTS.

412
1985

ENGINE // 4943CC, V12

POWER // 254KW (340BHP) AT 6000RPM

CHASSIS // STEEL SEMI-MONOCOQUE

GEARBOX // FIVE-SPEED MANUAL/THREE-SPEED AUTO

TOP SPEED // 245KM/H (152MPH)

WEIGHT // 1805KG (3979LB)

While the 400 range had long been a target for cheap invective, and would continue to be so after this facelift (motoring journalist Jeremy Clarkson described it as "awful in every way", while the BBC *Top Gear* book *Crap Cars* listed this "abject exercise in large-scale origami" between the Austin Ambassador and Daihatsu Applause), Ferrari resisted the temptation to demand extensive changes to Leonardo Fioravanti's gently maturing design. The "new" 412 gained body-coloured bumpers in line with the rest of the range, along with more prominent front driving lights which matched the corporate "face" of the 328 and Mondial, and a chin spoiler in matt black. A slightly raised boot line facilitated even more boot space.

Inside, Ferrari extensively revised the instrumentation and switchgear in a way which was both more visually appealing and ergonomically superior to the outgoing model. Two-zone air conditioning, central locking and more extensive use of leather added to a feeling of discreet opulence.

Increasing the cylinder bore by a millimetre took the V12 engine to just under 5 litres. Now equipped with Magnetti Marelli microplex electronic ignition and the latest Bosch K-Jetronic fuel injection, it was more powerful, more refined and more reliable than its predecessor. Anti-lock braking, appearing for the first time on a Ferrari, was the only other addition to the mechanical spec.

Not all motoring media reviled Ferrari's flagship 2+2. *Fast Lane* magazine featured the 412 on its cover, describing it as "the forgotten supercar". Editor Peter Dron committed to print his belief that the 412 was more enjoyable to conduct at speed than the Testarossa.

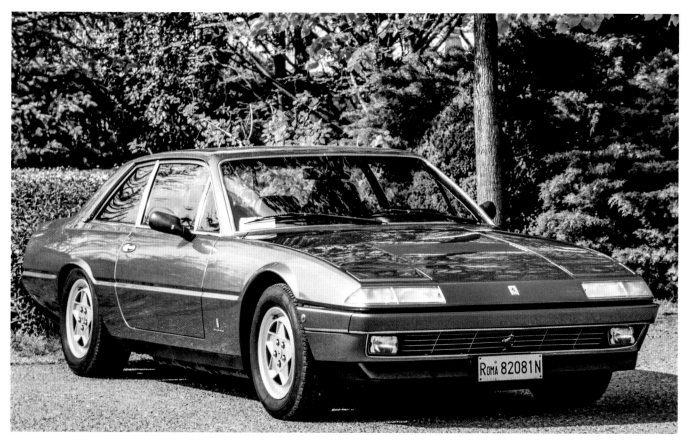

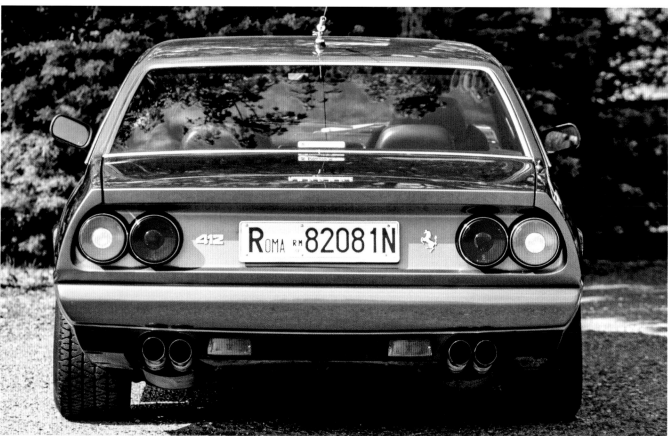

Mondial 3.2
1985

ENGINE // 3186CC, V8

POWER // 201KW (270BHP) AT 7000RPM

CHASSIS // STEEL SEMI-MONOCOQUE

GEARBOX // FIVE-SPEED

TOP SPEED // 249KM/H (155MPH)

WEIGHT // 1410KG (3109LB)

It was third time lucky for the Mondial as Ferrari revealed "take three" at the 1985 Frankfurt Motor Show. While the company had deemed it too early for a cosmetic facelift when the Quattrovalvole V8 supplanted the eight-valve in 1982, as the decade reached the halfway point the Mondial received body-coloured bumpers, new front lights and a mildly revised tail treatment, along with new-look alloy wheels.

 The most notable changes were under the skin, where Ferrari narrowed the rear track slightly while widening the front, and specced a new steering rack with fewer turns from lock to lock. This would have made the car a sportier and more engaging steer even without the revised 3.2-litre V8 which it shared with the new 328. In this form the Mondial would live on unchanged, except for additions to the options list, until the Mondial T arrived in 1989.

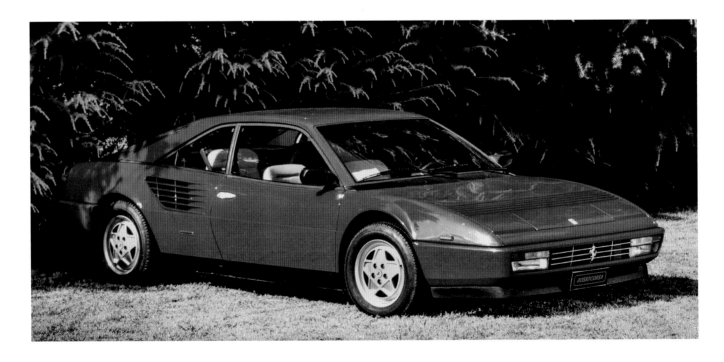

GTB/GTS Turbo

1986

ENGINE // 1991CC, TURBOCHARGED V8

POWER // 189KW (254BHP) AT 6500RPM

CHASSIS // STEEL SEMI-MONOCOQUE

GEARBOX // FIVE-SPEED

TOP SPEED // 253KM/H (157MPH)

WEIGHT // 1280KG (2822LB)

To comply with onerous sales taxes on cars above 2 litres, Ferrari had offered a smaller-displacement version of its 308 models for the domestic market. Although performance was weak, in 1982 Ferrari augmented it using turbocharging expertise gleaned from the Formula 1 programme.

In 1986 the company launched a new version based on the 328 GTB/GTS series bodyshell and interior. A new IHI turbocharger running 1.05bar (15.23psi) boost (replacing a KKK unit at 0.6bar/8.7psi) brought peak power to 189kw (254bhp) while delivering maximum torque at lower revs than before. Here there were further parallels with the F1 project, where development had done much to reduce turbo "lag" and improve driveability while maintaining high outputs. Assuredly the smaller-displacement cars were no longer the poor relations of their naturally aspirated siblings.

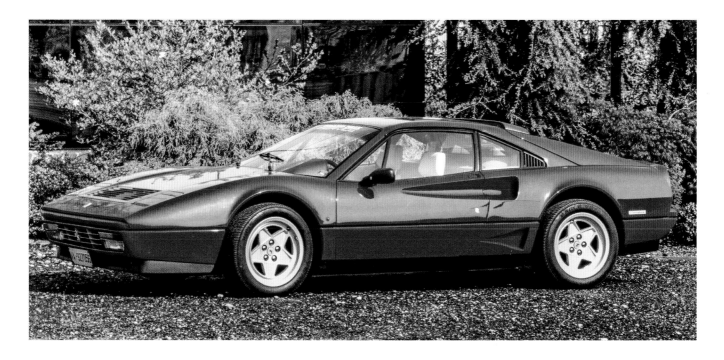

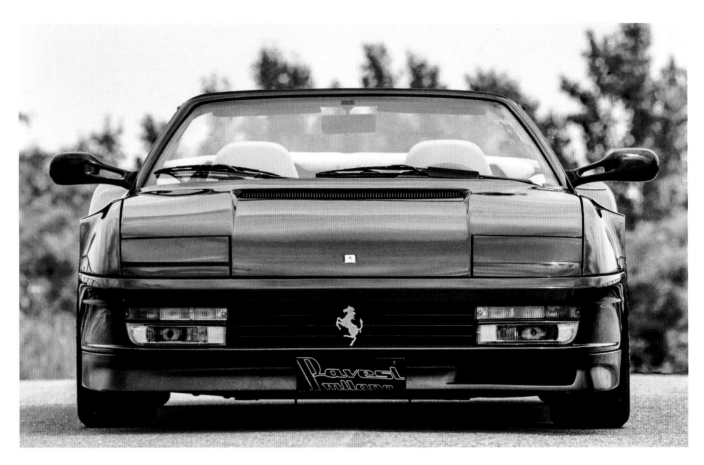

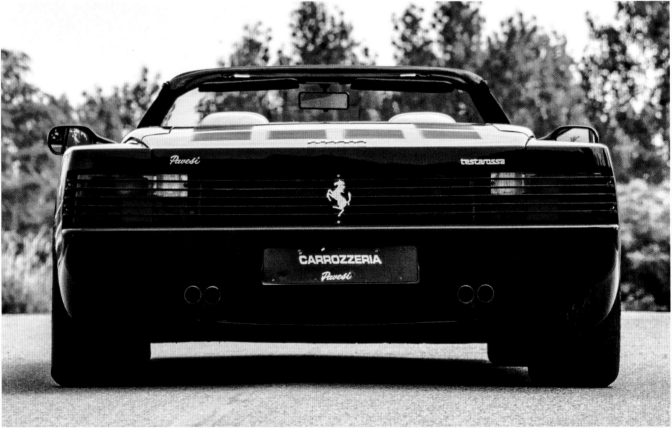

Testarossa Spider
1986

ENGINE // 4943CC, FLAT-12

POWER // 291KW (390BHP) AT 6300RPM

CHASSIS // STEEL SEMI-MONOCOQUE

GEARBOX // FIVE-SPEED

TOP SPEED // 274KM/H (170MPH)

WEIGHT // 1630KG (3594LB)

In an era of conspicuous consumption, the flamboyant styling of the Testarossa perfectly embodied the zeitgeist. For those who wished to elevate themselves beyond the aspirational crowd there was the world of specialist conversions. Ferrari never offered a convertible version of the Testarossa for general sale although they did build one as a special commission for Fiat magnate Gianni Agnelli, to mark the 20th anniversary of him assuming the reins of the group. The Agnelli dynasty was hugely influential in Italian politics and business and this was far from Gianni's first bespoke Ferrari – although previous examples had been built before the time Ferrari abandoned artisan production methods.

Beyond the specifics of re-engineering the shell to maintain rigidity once shorn of its roof, Ferrari left the mechanicals intact save for the installation of a Valeo button-operated electronic clutch – a specific touch for Agnelli, who had a weak left leg owing to an old injury. The folding roof was also a bespoke item.

Third parties stepped in to take advantage of demand, including the well-established California-based Richard Straman (whose spider conversion featured in a Pepsi ad, driven by Michael Jackson) and newcomers including German company Lorenz & Rankl, who also converted a number of 400s. Munich tuner Koenig Specials concocted a supercharged version which they offered in convertible form via Lorenz & Rankl. In Belgium, Ernst Berg's EBS company produced a one-off targa-roofed variant. A Testarossa spider also featured in the video game *Out Run*.

Milanese coachbuilder Pavesi, whose work is seen here, is believed to have converted at least two Testarossa spiders.

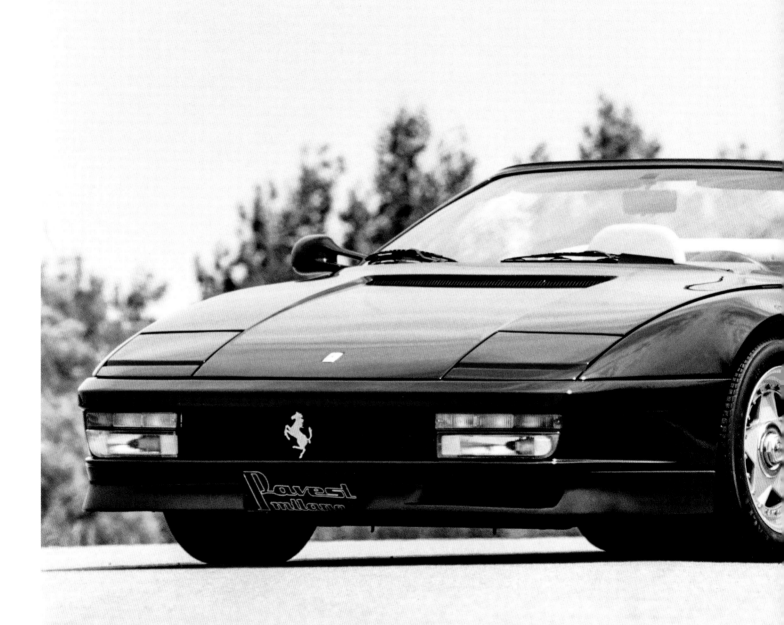

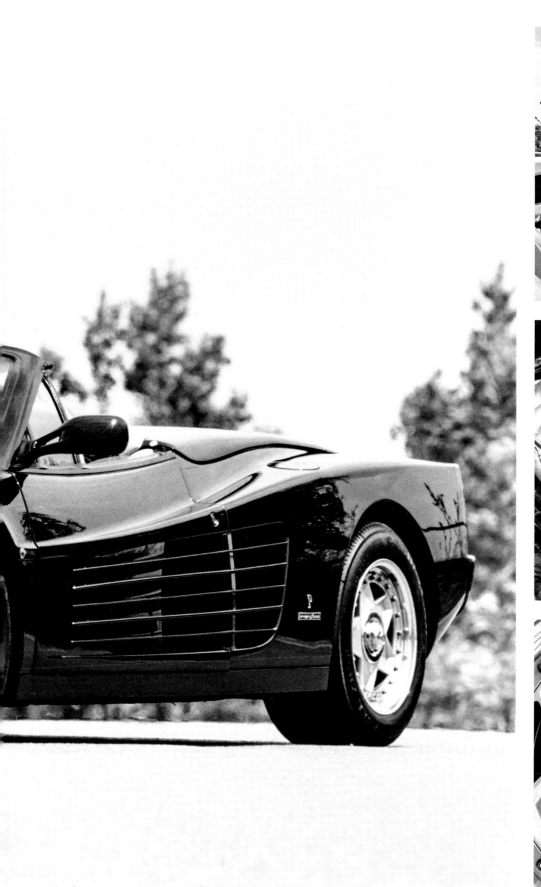
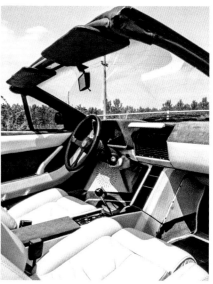
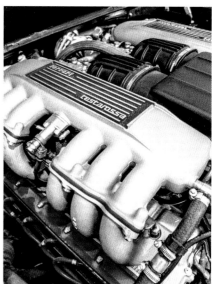

288
GTO Evoluzione
1986

ENGINE // 2855CC, TWIN-TURBO V8

POWER // 298KW (400BHP) AT 7000RPM

CHASSIS // STEEL AND COMPOSITE SEMI-MONOCOQUE

GEARBOX // FIVE-SPEED

TOP SPEED // 369KM/H (229MPH)

WEIGHT // 940KG (2072LB)

Having sold well over the 200 examples of the 288 GTO which enabled the car to pass the homologation threshold for competition, Ferrari developed an "evolution" version for Group B. To be eligible, 20 examples would have to be built – less of a stretch for Ferrari than it would have been for a tuning company such as Michelotto.

Working with Michelotto again, Ferrari engineer Nicola Materazzi developed a new, stiffer chassis and two engine variants with different power and torque curves to suit the differing requirements of rallying and circuit racing. For the prototypes Materazzi retained the twin-IHI turbo setup although KKK compressors would likely have been used on production models, since Honda had exclusive rights to IHI turbos in racing. Pininfarina's wind tunnel helped shape a new race-focused bodyshell, garlanded with wings and dive planes, which was fabricated in Kevlar and fibreglass composite.

While not driving through all four wheels like its potential rivals, the Audi Quattro and Porsche 959, the 288 GTO Evoluzione outgunned them in terms of peak power. It would have been fascinating to see how the competition transpired; sadly, though, a string of high-profile accidents, including the death of Lancia's Henri Toivonen and co-driver Sergio Cresto on the 1986 Tour de Corse, prompted racing's governing body to terminate Group B for the 1987 season.

Thus the 288 GTO Evoluzione project ended with just five prototypes built. Three of these made their way into private hands including, almost inevitably, the Sultan of Brunei. Ferrari retained two for onward development. Having been delighted by sales of the 288 GTO, Enzo was keen to make another lucrative race car for the road…

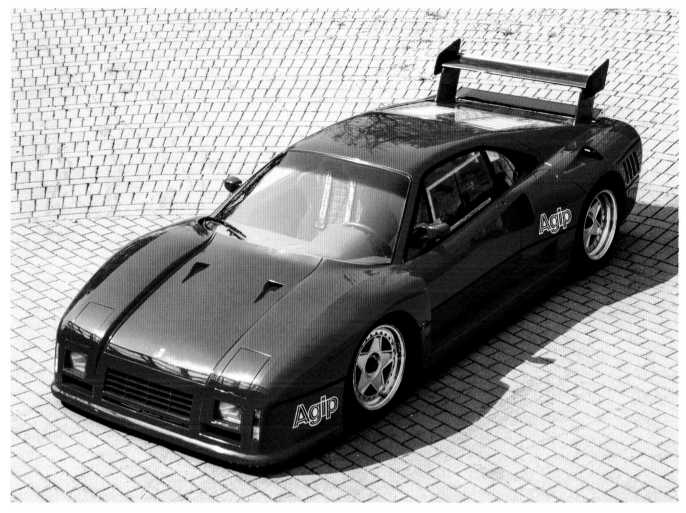

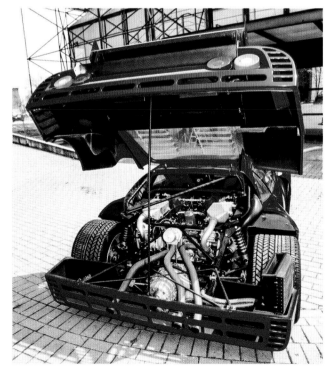

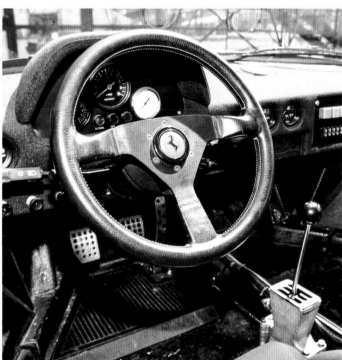

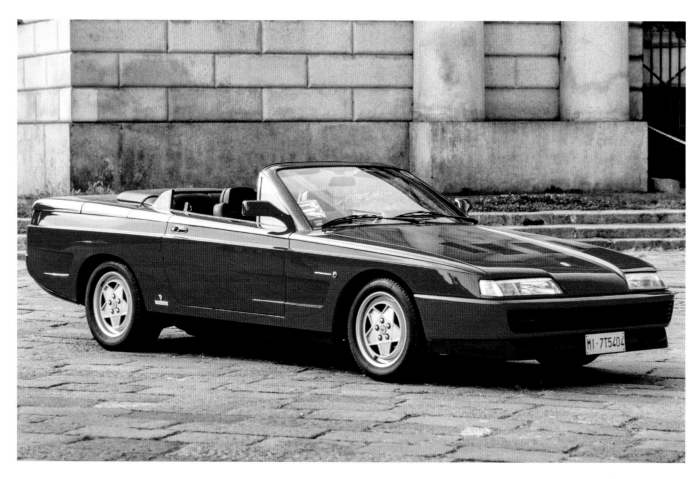

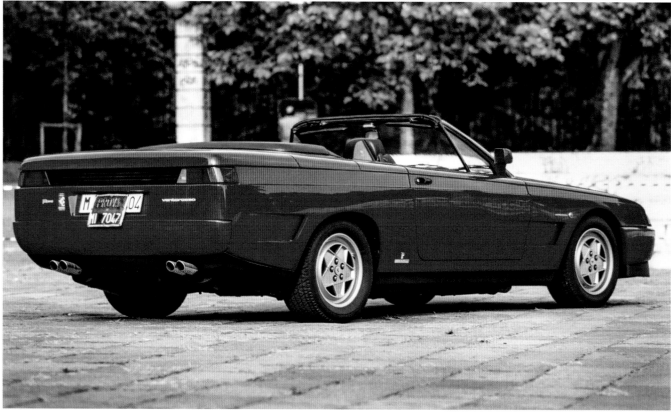

412 Ventorosso
1988

ENGINE // 4943CC, V12

POWER // 254KW (340BHP) AT 6000RPM

CHASSIS // STEEL SEMI-MONOCOQUE

GEARBOX // FIVE-SPEED

TOP SPEED // 240KM/H (149MPH)

WEIGHT // 1810KG (3990LB)

Throughout the 1980s the Milanese coachbuilder Pavesi was among a small group of specialists offering open-top conversions of sportscars and armour-plating for limousines, usually to high-net-worth clients and celebrities who could well afford the costs. But Pavesi's original business had been in complete-car customizations and, like many such craft-oriented companies, they had struggled to maintain a niche in the era of mass production.

In 1989 the company acquired a second-hand 412 on which to perform a showcase conversion to act as a mobile shop window for their skills. The Ventorosso ("red wind") was a bespoke in-house design requiring the donor car to be stripped to a rolling chassis, which was then augmented to retain structural integrity without a roof once the new body panels (to a Pavesi design) were applied.

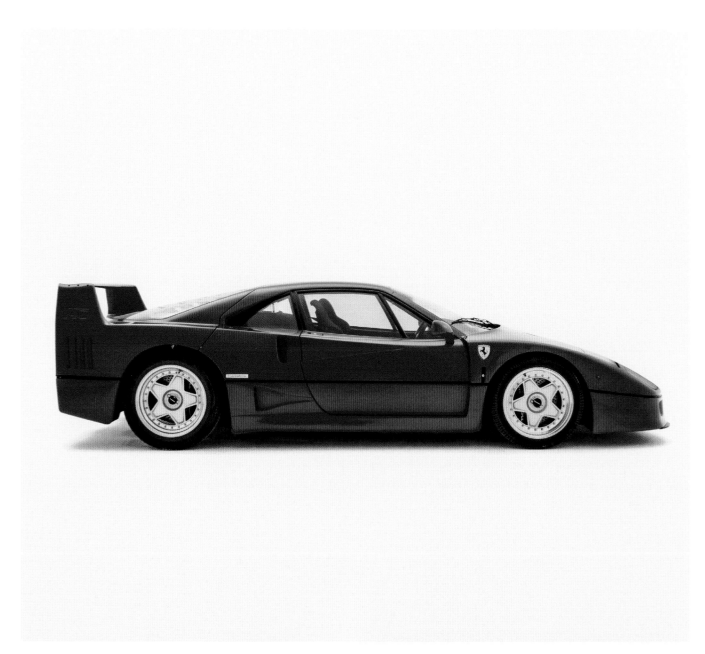

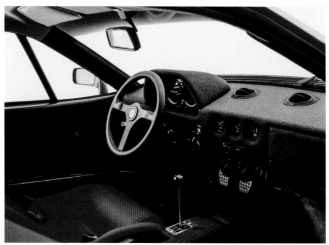

F40
1988

ENGINE // 2936CC, TWIN-TURBO V8

POWER // 350KW (470BHP) AT 7000RPM

CHASSIS // STEEL AND COMPOSITE SEMI-MONOCOQUE

GEARBOX // FIVE-SPEED

TOP SPEED // 320KM/H (199MPH)

WEIGHT // 1254KG (2765LB)

"The sign-off of the F40 was, for me, one of the last decisions taken directly by Enzo Ferrari." So said the car's chief engineer, Nicola Materazzi, in a 2019 interview in *Enzo* magazine. The company founder delighted in maintaining a cloak of myth about his life, so it is fitting that one of his final acts should be to sanction an utterly outrageous machine to celebrate Ferrari's 40 years of car manufacture. Development work proceeded in utmost secrecy, the majority of it carried out by Michelotto, the engineering firm that was being quietly rewarded for productive and harmonious relations with Ferrari and Materazzi in previous projects.

Strong customer interest in the supposedly rarefied 288 GTO had moved Ferrari to approve another race car for the road, away from the interference of the Fiat functionaries who now predominantly called the shots in the road car business. Two of the 288 GTO Evoluzione prototypes became the test beds for what would become the F40 over a remarkably short – 13 months – development period.

Styling was chiefly the work of Pietro Camardella, who had joined Pininfarina as an intern under Aldo Brovarone and Leonardo Fioravanti. The soon-to-retire Brovarone is credited with adding what is perhaps the F40's signature feature: the bold, right-angled rear wing. Despite the extensive testing in Pininfarina's wind tunnel, Michelotto made a number of practical changes to the bodyshell in the name of improvements. The styling house chafed at this and demanded their name be taken off the project, only to change their mind later.

Ferrari installed a small final assembly line at Maranello so the intricate production process would not interfere with other models. The raw components were predominantly subcontracted: the tubular steel spaceframe was sourced from preferred Ferrari supplier Vaccari of Modena but Scaglietti took responsibility for bonding in the composite sections. The composite bodyshell was the work of Dino Cognolato, a neighbour of Michelotto in Padua. Models for the US market featured slightly different chassis, with additional front, side, and rear impact structures, as well as prominent rubber "bumper strips" front and rear.

The prototypes and early production models featured race-style sliding side windows; interior trimmings were spartan (not even the wiring for a radio, as with the 288 GTO). The interior door-pulls were fabric strips.

Performance was electrifying, sales incredible, despite a list price more than double the Testarossa. Having planned to build 400, Ferrari sold 1315.

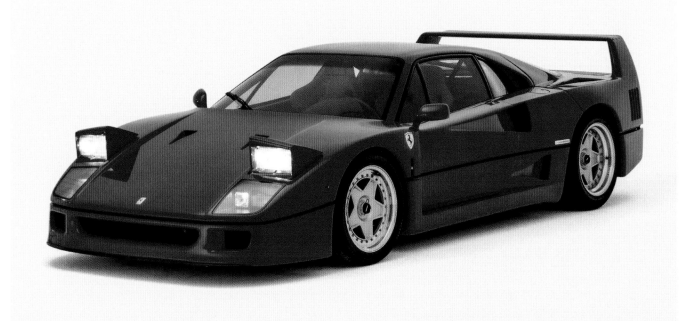

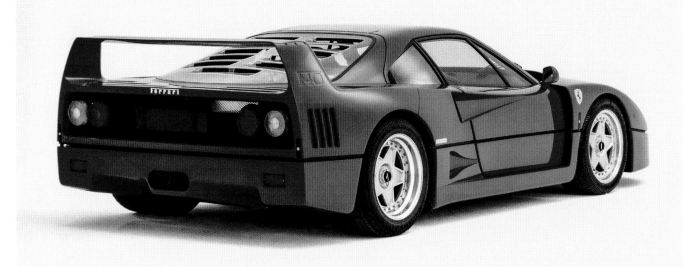

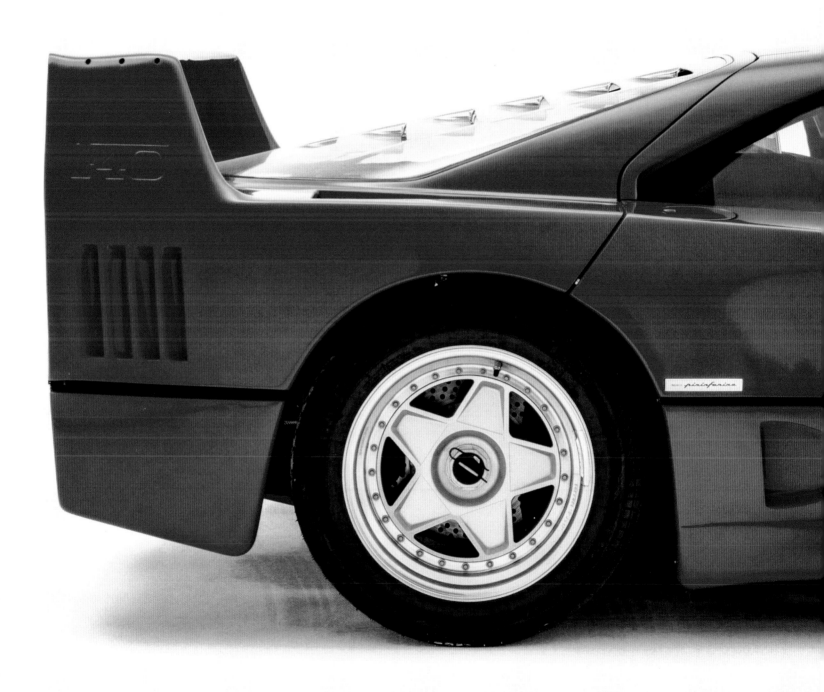

Mondial T
1989

ENGINE // 3405CC, V8

POWER // 224KW (300BHP) AT 7200RPM

CHASSIS // STEEL SEMI-MONOCOQUE

GEARBOX // FIVE-SPEED

TOP SPEED // 254KM/H (158MPH)

WEIGHT // 1426KG (3144LB)

Plans to develop an all-new Mondial got as far as a styling exercise by Pininfarina's Pietro Camardella before Ferrari scaled back the project. New headlights and flush-fit door handles amounted to a neatening rather than a wholesale restyle, as did the adoption of a rectangular rather than trapezoidal outline for the straked air intakes on the rear wings.

 In the engine bay, Ferrari rotated the V8 by 90 degrees so it was now longitudinally mounted, but driving through a new transverse gearbox. The engine itself had a wider bore and longer stroke, bringing it to 3.4 litres. This, along with new Bosch M2.5 electronic fuel injection, brought power output to a claimed 224kw (300bhp). While the new transmission layout delivered better handling balance, access was difficult, adding to the expense of servicing.

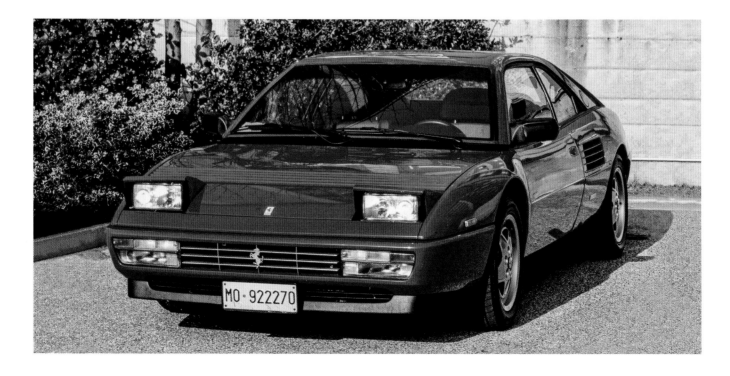

Mondial T Convertible
1989

ENGINE // 3405CC, V8

POWER // 224KW (300BHP) AT 7200RPM

CHASSIS // STEEL SEMI-MONOCOQUE

GEARBOX // FIVE-SPEED

TOP SPEED // 254KM/H (158MPH)

WEIGHT // 1468KG (3236LB)

The open-top Mondial evolved into the "T" via the same path as the berlinetta, with the new engine layout and mild restyling package. As with the closed-top model, front and rear track were widened slightly (by 2mm/0.08in and 50mm/1.97in) and the rear wheel arches enlarged to suggest a more muscular presence. The backrests of the rear seats could be folded forwards to turn the space into a luggage enclosure.

Production continued until 1993, by which time Ferrari had added the option on both models of a Valeo electronic clutch, a forerunner of the semi-automatic gearboxes of today, and adopted Bosch's M2.7 injection system when catalytic converters became mandatory in Europe. The final Mondial cabriolet outsold the berlinetta by 1010 to 842, according to Ferrari's records.

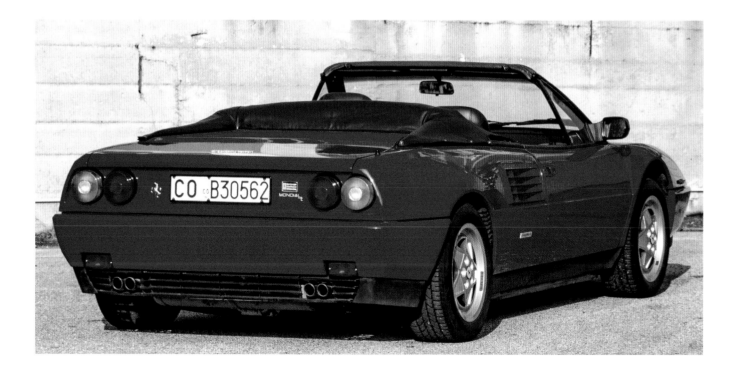

F40 LM
1989

ENGINE // 2936CC, TWIN-TURBO V8
POWER // 537KW (720BHP) AT 7500RPM
CHASSIS // STEEL AND COMPOSITE SEMI-MONOCOQUE
GEARBOX // FIVE-SPEED
TOP SPEED // 335KM/H (208MPH)
WEIGHT // 1050KG (2315LB)

Although Luigi Chinetti had long since shuttered NART, French Ferrari importer Charles Pozzi maintained the tradition of advocating Ferrari's involvement in sportscar racing. As he had with the 512 BB and 308, Pozzi, via his lieutenant Daniel Marin (a handy racer in his time), pushed for a full-on racing version of the F40.

Vigonza-based Dino Cognolato worked with Michelotto to lighten and strengthen the structure of two F40s for Pozzi while modifying the suspension and drivetrain for the rigours of racing. While the plan was to compete in the world sportscar championship's GTC category, the absence of other takers caused that idea to be shelved in favour of competing in the US-based IMSA championship. Thus Michelotto had to add ballast and suffer the indignity of fitting restrictor plates to the inlet plenums to comply with IMSA's performance-balancing regime.

Pozzi appointed former Renault F1 sporting director Jean Sage to manage the racing programme and it took on a distinct French flavour, with grand prix winner Jean-Pierre Jabouille acting as development driver as well as Ferrari's chief tester Dario Benuzzi. Future F1 star Jean Alesi also tested the prototype chassis at Monza in June 1989, ahead of the F40 LM's race debut at Laguna Seca in October, where Alesi placed third behind a pair of Audi quattros driven by Hans-Joachim Stuck and Hurley Haywood. Jabouille failed to finish the next race at Del Mar but Pozzi was able to attract sufficient sponsorship for a two-car entry the following season, claiming four podium finishes. When the sponsors did not renew, the programme ended, but Pozzi retained the cars in his private collection for several years.

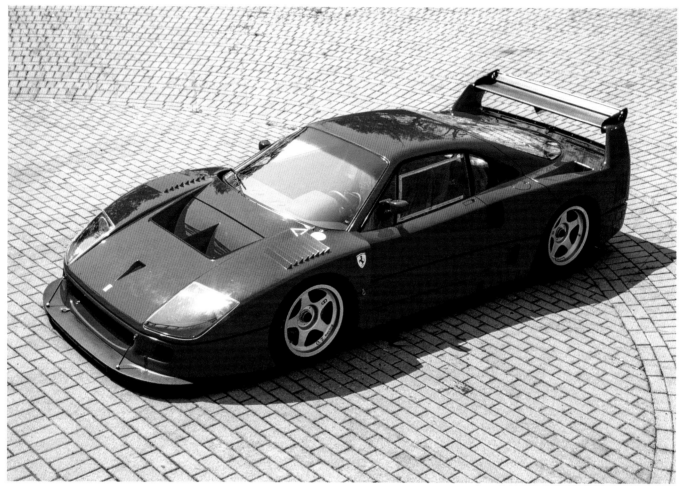

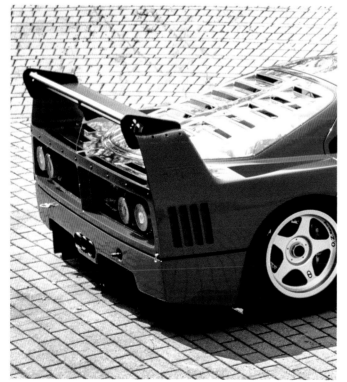

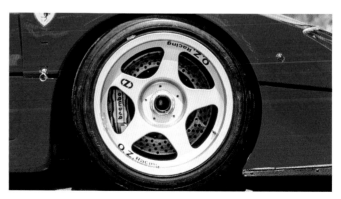

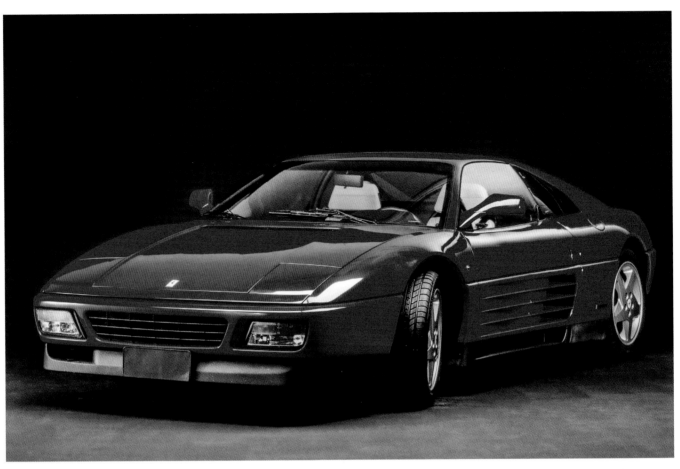

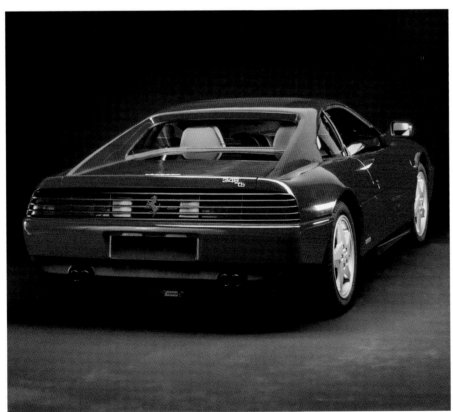

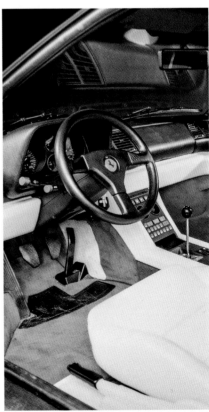

348 TB
1989

ENGINE // 3405CC, V8

POWER // 224KW (300BHP) AT 7200RPM

CHASSIS // STEEL UNIBODY

GEARBOX // FIVE-SPEED

TOP SPEED // 280KM/H (174MPH)

WEIGHT // 1393KG (3071LB)

Models as enduringly popular as the 308 and 328 would always be difficult to follow but the 348, which was unveiled at 1989 Frankfurt Motor Show, failed to hit the mark despite being an advance on many fronts. This was a turning point in Ferrari history: the last mid-engined V8 to have been developed during Enzo Ferrari's lifetime, the last Ferrari to be designed under the direction of Leonardo Fioravanti at Pininfarina, and the first Ferrari to feature modern steel unibody construction rather than a spaceframe-based semi-monocoque.

Adopted to comply with modern crash-testing regulations, the chassis also featured a 100mm (3.94in) longer wheelbase than the outgoing 328. As with the refreshed Mondial T, the enlarged and dry-sumped V8 engine was mounted longitudinally within the structure, driving through the transverse gearbox whose presence was honoured in the model's name.

The 348 TB certainly looked right (for its time), seamlessly blending the Ferrari corporate face with styling cues from its predecessor and the Testarossa. No mid-engined car was visually complete at the time without an array of full-length straked air intakes.

Where the new model fell short, particularly in the context of new rivals such as Honda's NSX, was in its on-the-limit handling manners. Although the dry-sump setup enabled the engine to be mounted low, while cornering under duress it still felt very high in the frame. Neither was the 348 especially fast; Luca di Montezemolo, recruited as Ferrari president in 1991 after his role in organizing the 1990 football World Cup, complained that a Golf GTi could beat it away from a set of traffic lights.

- 456 GT
- 348 SPIDER
- 328 CONCISO
- 512M
- F355 BERLINETTA
- 333 SP
- F355 SPIDER
- F355 GTS
- F355 CHALLENGE
- F50
- 550 MARANELLO
- 456M
- 360 MODENA
- 360 MODENA CHALLENGE

1990s

456 GT
1992

ENGINE // 5474CC, V12
POWER // 330KW (442BHP) AT 6250RPM
CHASSIS // STEEL SEMI-MONOCOQUE
GEARBOX // SIX-SPEED
TOP SPEED // 314KM/H (195MPH)
WEIGHT // 1690KG (3726LB)

When Ferrari revealed the 456 GT at the 1992 Paris Motor Show, Luca di Montezemolo said "It has been 20 years since we had a car like this at Ferrari." With its elegant yet muscular lines, four round rear lights, and a V12 engine sitting ahead of the passenger compartment, it was nothing less than a modern evocation of the classic 365 GTB4 Daytona – with two extra seats.

While Montezemolo could not claim the entire credit for the car – he was appointed president just a year before launch – his fingerprints are on the final product and cars such as the 456 GT would come to define his reign. Under him, Ferrari would modernize and transform from a debt-ridden corner of the Ferrari empire into an engine of profit.

Montezemolo's vision for the 456 GT and forthcoming models was that they should be practical and reliable as well as establish new performance benchmarks. For too long the balance sheet had been propped up by niche high-margin cars which appealed chiefly to collectors and speculators.

Although there had been a changing of the guard at Pininfarina, following the retirement of Aldo Brovarone and Leonardo Fioravanti's recruitment to head up Fiat's Centro Stile, new design chief Lorenzo Ramaciotti had been with the company since 1972. Ramaciotti retained the tradition of inviting designers to submit competing proposals and F40 designer Pietro Camardella's won out.

While the chassis was an old-fashioned steel tube-based semi-monocoque, everything else was new – including the all-alloy V12, now angled at 65 degrees instead of 60. A variable-rate steering rack, self-levelling rear suspension and electronically adjustable dampers, in combination with neutral weight distribution, helped make this 2+2 one of Ferrari's best-handling new cars in years.

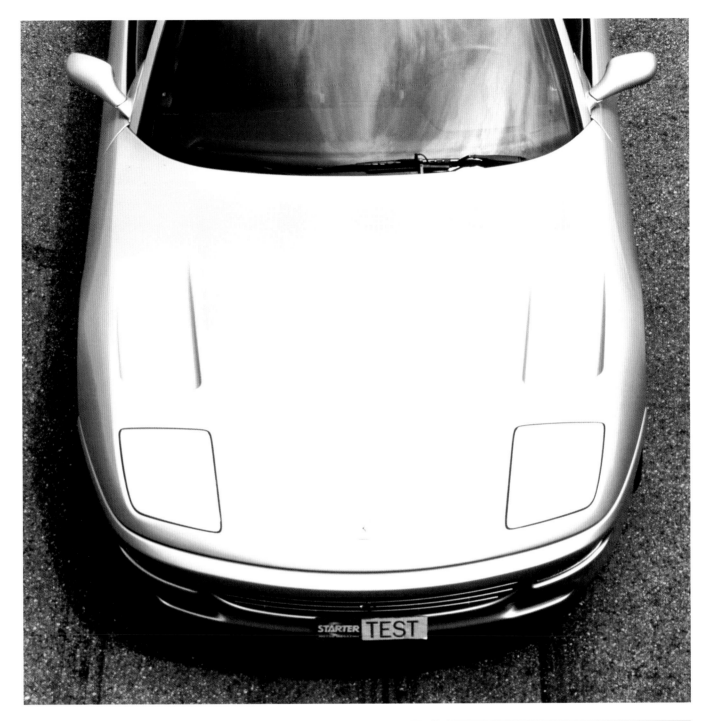

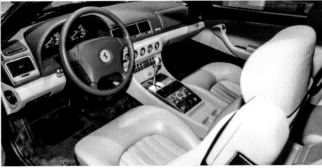

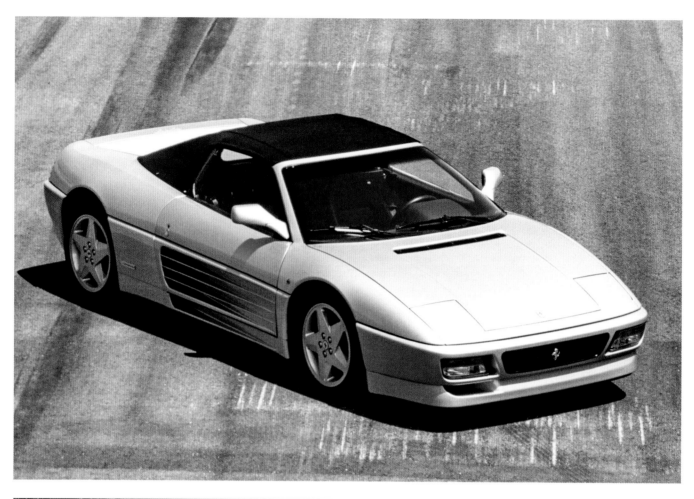

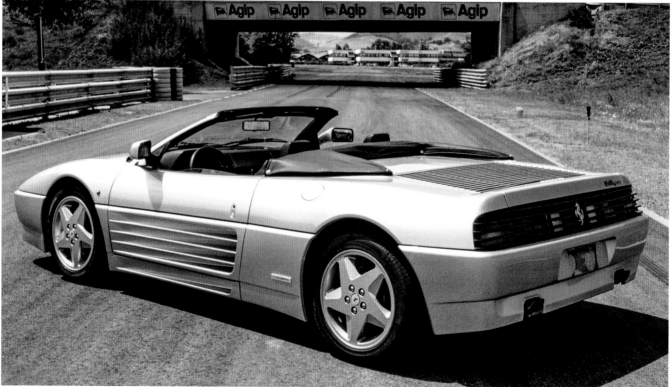

348
Spider
1993

ENGINE // 3405CC, V8

POWER // 239KW (320BHP) AT 7200RPM

CHASSIS // STEEL UNIBODY

GEARBOX // FIVE-SPEED

TOP SPEED // 280KM/H (174MPH)

WEIGHT // 1370KG (3020LB)

Ferrari responded quickly to the 348's lukewarm reception by quietly introducing in 1990 a package of engine management updates and adjusting the suspension settings, as well as changing practices on the production line to improve the build quality. What it could not do was significantly alter one of the principal reasons for its snappy on-the-limit behaviour: insufficient torsional stiffness in the bodyshell, expensive to remedy in a unibody chassis.

Ahead of a soft relaunch in 1993, Ferrari relocated the battery and shaved seven litres from the fuel tank capacity to make space for a stronger structure. Combined with a further package of suspension changes and a revised engine with different camshaft profiles, a higher compression ratio and longer inlet plenums, this did much to address the 348's major shortcomings. A new gearbox with shorter ratios and less truculent shifting manners cleverly complemented the V8's additional grunt.

The changes were rolled out first in the new Spider before being applied to the berlinetta and targa-top models. Aside from its neatly executed folding roof, the Spider differed visually from the launch models in details: the front spoiler and skirts were now body-coloured rather than matt black. On top of the measures introduced in the revised body-in-white, the Spider featured bracing along the chassis and around the windscreen to bolster rigidity.

Since the Spider was aimed chiefly at the American market, Ferrari paid special attention to the slickness of the folding hood mechanism. Though manual (electric operation was soon to become a must-have), it was neatly executed and required just two handles to unlock and stow out of sight.

328
Conciso
1993

ENGINE // 3186CC, V8

POWER // 198KW (266BHP) AT 7000RPM

CHASSIS // STEEL SEMI-MONOCOQUE

GEARBOX // FIVE-SPEED

TOP SPEED // 278KM/H (173MPH)

WEIGHT // 889KG (1960LB)

At the Frankfurt and Geneva motor shows in 1989 the German company Michalak Design, previously best known for executing convertible versions of mass-market road cars, exhibited a full-scale mock-up for an open-top two-seat sports car called the Cilindro. Four years later the company returned to the show circuit with a similar-looking vehicle, albeit based on real running gear: the Conciso. The minimalist aluminium bodyshell was based on Ferrari 328 underpinnings and, said creator Bernd Michalak, was driven by his philosophy that sportscars should look "athletic" and carry "not an extra ounce" in weight.

Although Michalak drew the Conciso, intending it as a calling card for future design work, the conversion of the donor car was outsourced to Bastiglia-based coachbuilders and car restorers Bacchelli & Villa. This was a company steeped in Ferrari tradition: Robert Villa had been a modeller at Scaglietti, Franco Bacchelli an apprentice at Piero Drogo's Carrozzeria Sports Cars.

The Conciso therefore represents a small-scale revival of the grand Italian coachbuilding tradition: Bacchelli & Villa stripped a 1989 328 GTS down to the rolling chassis and replaced the body with an aluminium shell hand-crafted to Michalak's designs. Since it has no proper windscreen or roll bar, the Conciso's occupants must wear crash helmets; bespoke compartments are provided for these within the luxuriously appointed cabin.

Although the Conciso won second prize at the 1994 Eurosign Design Awards, no more were produced. Despite the historic connections with Bacchelli & Villa, Ferrari would not have permitted such a car to retail with the prancing horse logo. The show car fetched €109,250 at auction in Monaco in 2018.

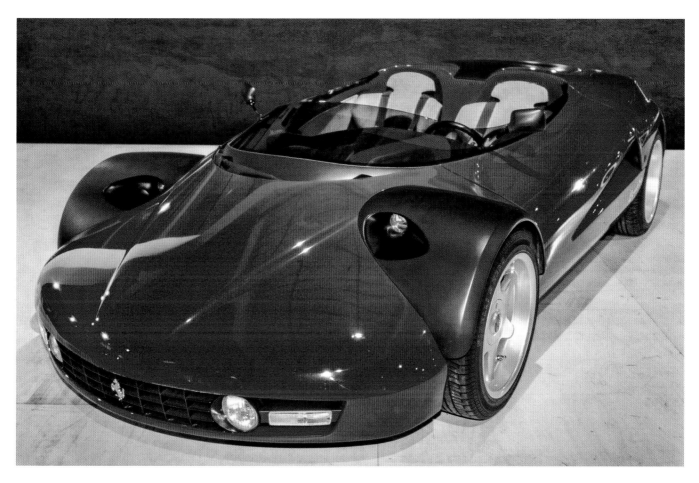

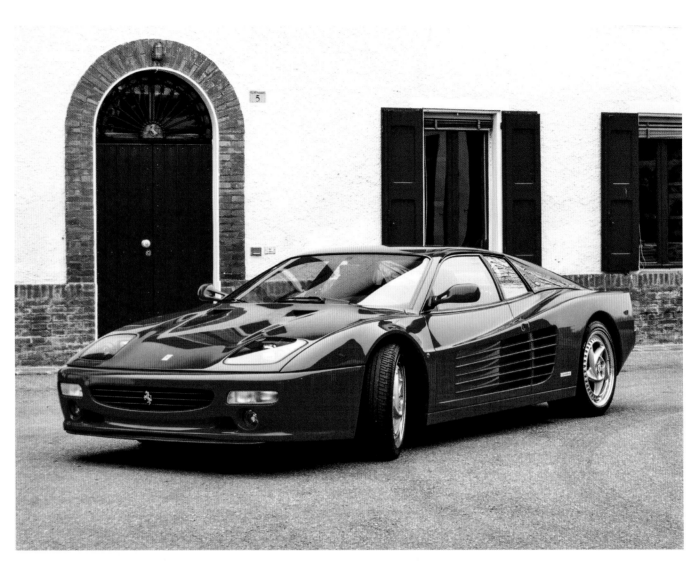

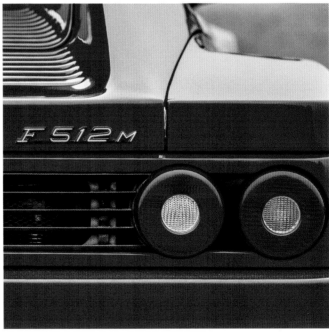

512M
1994

ENGINE // 4943CC, FLAT-12

POWER // 328KW (440BHP) AT 6750RPM

CHASSIS // STEEL SEMI-MONOCOQUE

GEARBOX // FIVE-SPEED

TOP SPEED // 315KM/H (196MPH)

WEIGHT // 1455KG (3208LB)

As Ferrari developed the third iteration of the iconic Testarossa, the decision had already been taken that this would be the end of the line. Sales of a car so strongly associated with the 1980s were in decline, not helped by a global economy recovering only slowly from recessional pressures at the turn of the decade.

Chiefly the revamp was a cosmetic one since demand did not warrant significant investment. Pininfarina facelifted the nose and tail, adding four rear lights and deleting the black horizontal slats at the rear. Above a new, restyled front bumper a pair of fixed inset headlights on each side replaced the previous pop-up items. It was a visually incongruous but supposedly necessary measure to comply with new laws in several markets, though Ferrari continued to offer models with pop-up lights. Split-rim five-spoke alloy wheels of a new design came as standard.

Beyond the visual changes, the engine benefitted from a new crank, a higher compression ratio and titanium conrods, plus a new low back-pressure exhaust.

In 1995 *Car* magazine borrowed a 512M and drove it to Morocco for a blast through the Sahara desert; the headline ran, unapologetically, "Because it's there". In years past, Ferrari would hardly have countenanced a motoring magazine attempting such a feature. Then again, in years past very few Ferraris would have survived an itinerary which included being driven through Italy, France, and Spain to Algeciras, thence by ferry to Tangier and a partial disassembly by Moroccan customs officers convinced drugs are on board. The 512M barely missed a beat throughout; further evidence that Ferraris were no longer temperamental beasts.

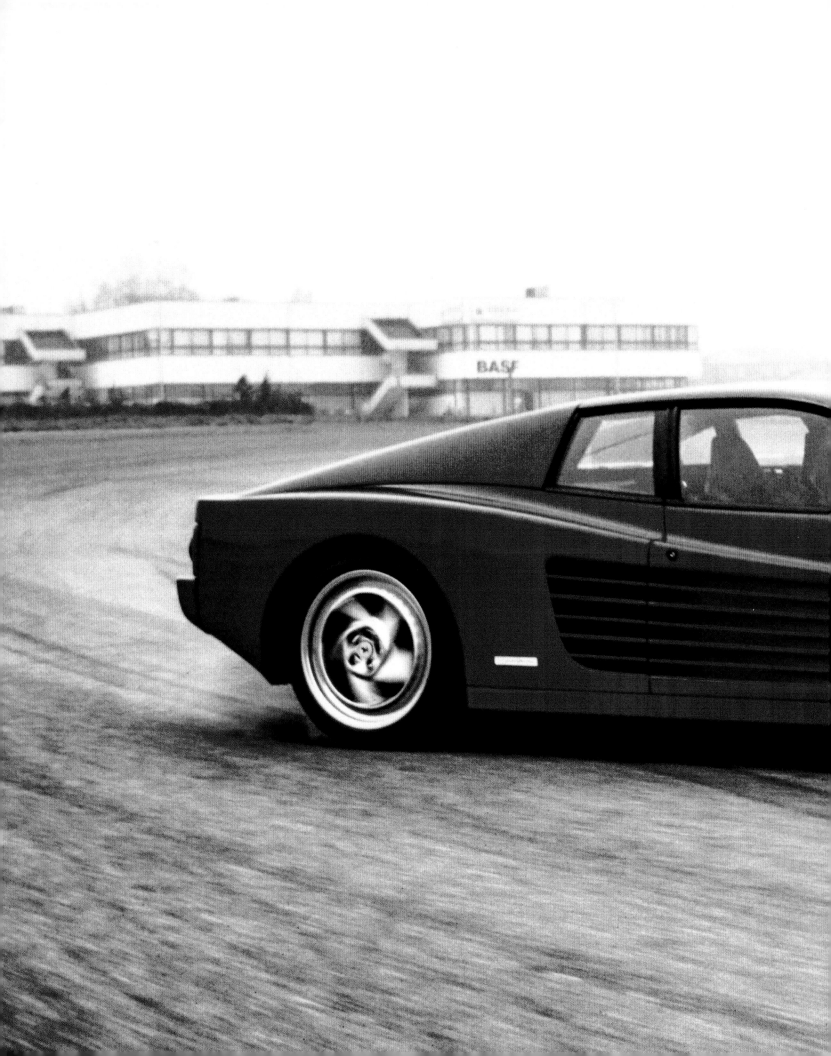

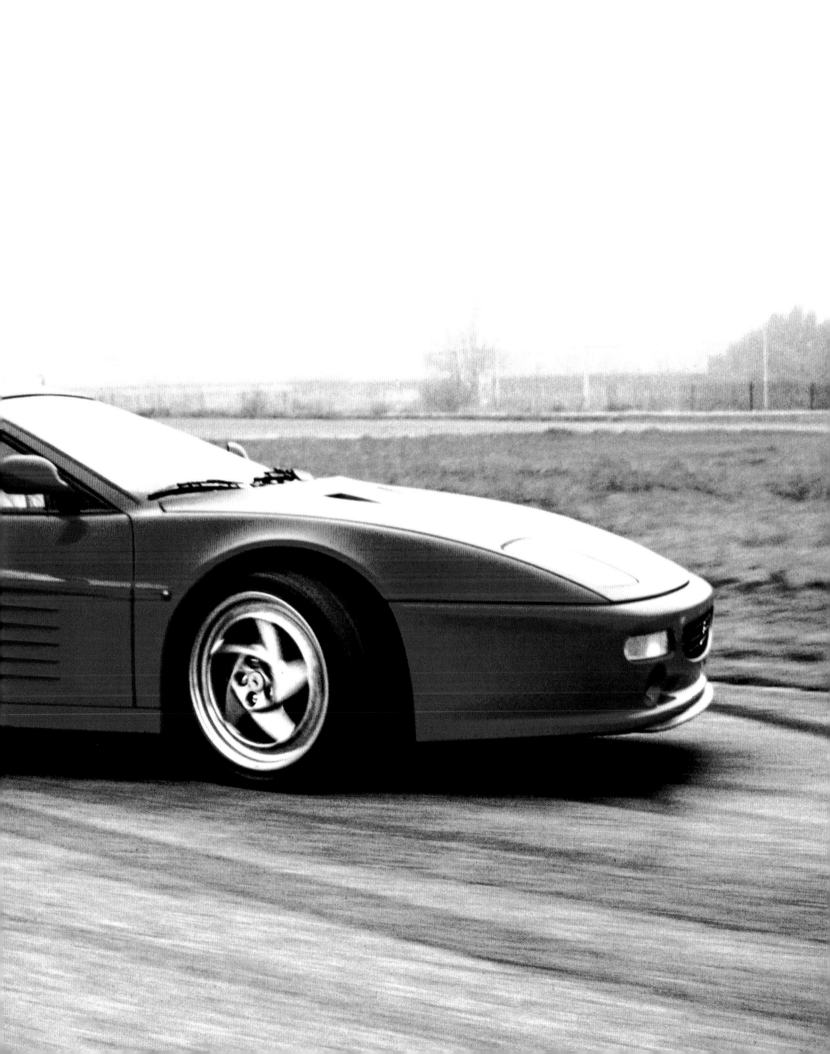

F355
Berlinetta
1994

ENGINE // 3496CC, V8

POWER // 283KW (380BHP) AT 8250RPM

CHASSIS // STEEL UNIBODY

GEARBOX // SIX-SPEED

TOP SPEED // 295KM/H (183MPH)

WEIGHT // 1350KG (2976LB)

While the 1993 revamp of the 348 had done much to ameliorate the car's issues, in the court of public opinion (and, perhaps most significantly, that of company president Luca di Montezemolo) the 348 had already been condemned and development of a replacement was underway. That this project was completed with management's finger on the fast-forward button is evinced by the nature of the roll-out: while the F355 Berlinetta was launched at the 1994 Frankfurt Motor Show, the targa-top and convertible versions did not follow until later.

While the F355 retained the 348's essential layout of pressed steel unitary bodyshell with a removable rear steel-tube subframe cradling the engine, gearbox and rear suspension, Ferrari had redesigned the entire assembly to achieve greater torsional stiffness. New suspension geometry supported larger alloy wheels and incorporated two-stage electronic dampers.

In its new F129B spec the V8 now breathed through five valves per cylinder. A 2mm (0.08in) bore increase took overall capacity to 3496cc and titanium conrods helped enable Ferrari to reach a rev ceiling of 8500rpm. At launch, Bosch 2.7 Motronic fuel injection was standard but for the following model year this would be upgraded to 5.2 Motronic, partially to achieve smoother power delivery but chiefly to meet US emissions regulations.

Styling was the work of Maurizio Corbi at Pininfarina and, while bearing a respectful familial resemblance with the 348, the F355 benefitted from substantial work in the wind tunnel. A flat bottom reduced drag while the aero-optimized shape of the lateral air intakes enabled them to do without the now-passé strakes.

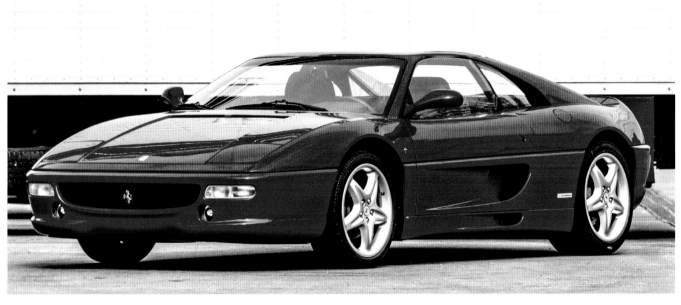

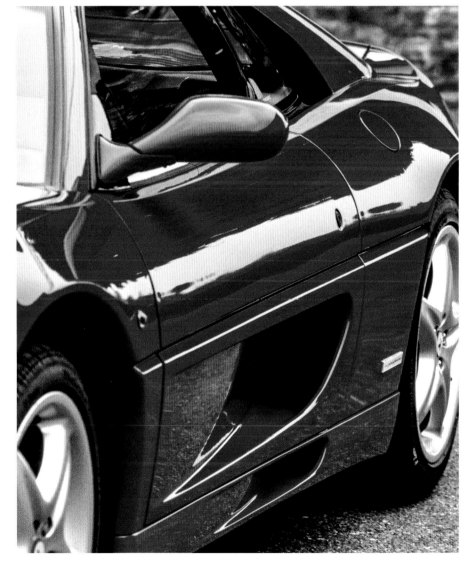

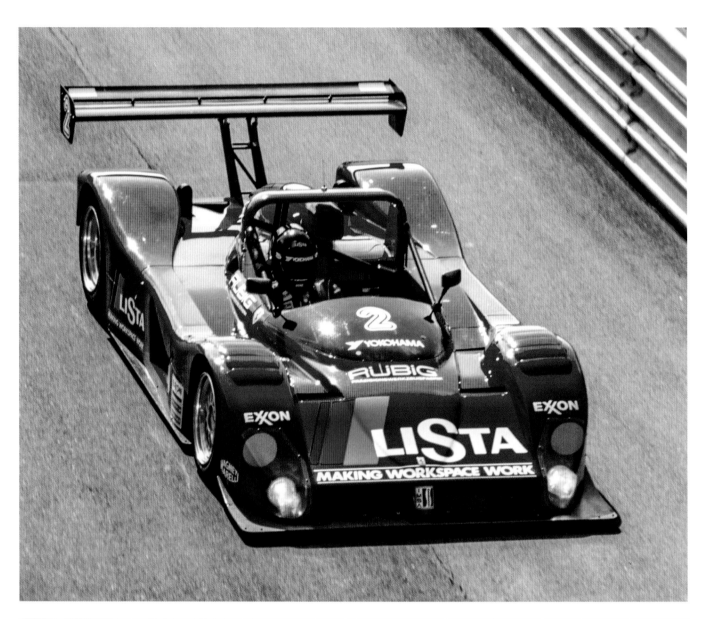

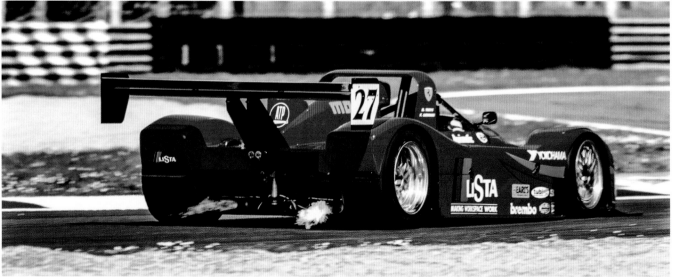

333 SP
1994

ENGINE // 3997CC, V12

POWER // 485KW (650BHP) AT 11000RPM

CHASSIS // CARBON-ALUMINIUM HONEYCOMB MONOCOQUE

GEARBOX // FIVE-SPEED

TOP SPEED // 369KM/H (229MPH)

WEIGHT // 860KG (1896LB)

Thirty years after forsaking the world of sports-prototype racing Ferrari made an unexpected return, though not quite in the way many racing fans would have anticipated. The demise of the GTP category in the US-based IMSA series created the opportunity: global recession had nibbled away at racing budgets and manufacturer enthusiasm for racing, prompting the rule-makers to formulate a new category which would in theory be cheaper and allow more road-based technology. Spec aerodynamic elements would also control costs, while mandatory open cockpits aimed to connect the audience with the spectacle, enabling fans to see the drivers at work.

The new World Sports Car regulations would not have been enough to engage Ferrari but for pressure from elsewhere. Expatriate Italian Gianpiero Moretti, founder of the Momo wheels empire, became the prime mover behind the project; it's said he persuaded Piero Lardi Ferrari, Enzo's surviving (if illegitimate) son, that a WSC car could be produced relatively cheaply and with little effort from Ferrari if design were outsourced to the specialist race car constructor Dallara. All Ferrari had to do was bless the project publicly and provide a badge and some ex-F1 engines.

Gian Paolo Dallara was perhaps more closely associated in the public mind with Lamborghini, having engineered the Miura, but nevertheless Luca di Montezemolo was persuaded to sign off and work began. The prolific British sportscar and Formula 1 designer Tony Southgate joined as a consultant and the car took shape around a composite-augmented aluminium honeycomb monocoque. Despite some resistance from the Americans the car was permitted to compete – and in 1998 enabled Moretti to achieve his ambition of winning the Daytona 24 Hours. The 333 SP remained in competition until 2002.

F355
Spider
1995

ENGINE // 3496CC, V8

POWER // 283KW (380BHP) AT 8250RPM

CHASSIS // STEEL UNIBODY

GEARBOX // SIX-SPEED

TOP SPEED // 295KM/H (183MPH)

WEIGHT // 1365KG (3009LB)

Maurizio Corbi's beautiful and purposeful F355 design had established a clear dividing line between the new generation of Ferraris and the ostentatious brashness of their 1980s forebears. Removing its roof and flying-buttress three-quarters contrived to make the shape still more elegant.

The F355 Spider weighed just a little more than the Berlinetta, on account of the additional bracing required to compensate for removing the roof. Pininfarina had engineered the folding hood to closely mimic the berlinetta's roofline while up; and, in response to mixed reviews of the 348 Spider's manual hood setup and to keep on trend, the canvas top now featured an automatic mechanism. All the driver had to do was release a single latch on the roof and press a button in the centre console – everything else, including a brief shimmy forward of the seats as it traced an arc behind them, was handled by electric motors.

As with the berlinetta, the Spider's gearshift was actuated by rods rather than cables and a coolant heat exchanger expedited the gearbox oil's progress to optimal temperature after start-up. It provided a marked improvement upon the 348's notchy action across the gate.

"The perfect sports car just got better," enthused the US magazine *Motor Trend*. "A morning of testing at Sears Point International Raceway followed by an afternoon of hightailing it to various Northern California wine-country photo locations left us laughing in a giddy hysteria, weak from the repeated adrenaline surges, and proud of the best use of fossil fuel since our '96 Porsche 911 Turbo flog."

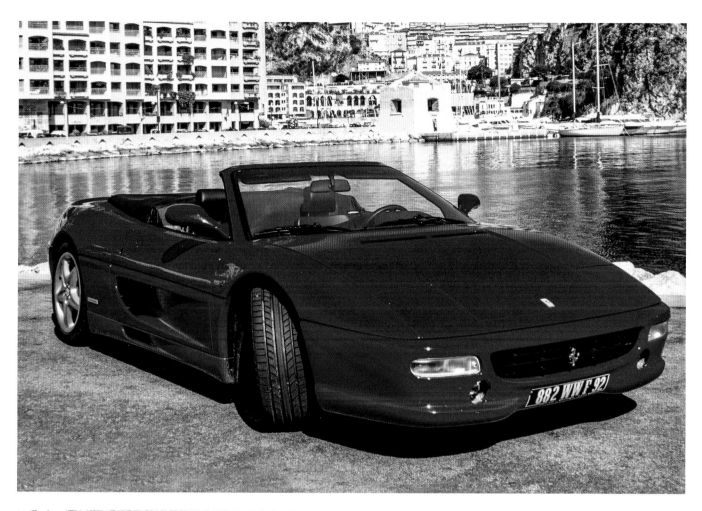

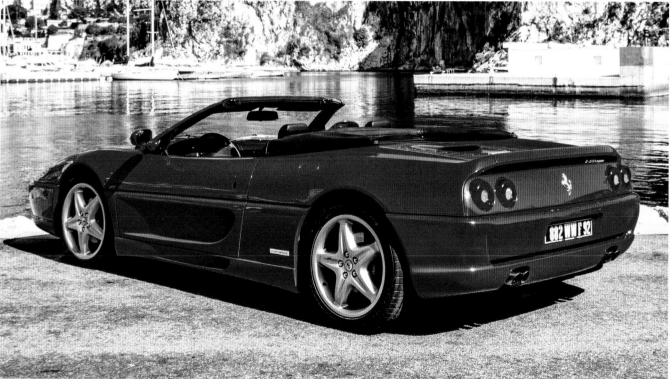

F355
GTS
1995

ENGINE // 3496CC, V8

POWER // 283KW (380BHP) AT 8250RPM

CHASSIS // STEEL UNIBODY

GEARBOX // SIX-SPEED

TOP SPEED // 295KM/H (183MPH)

WEIGHT // 1350KG (2976LB)

The targa-top F355 GTS model offered the best of both worlds: wind-in-the-hair motoring with little effort, and the convenience (and noise-proofing) of a fixed roof. Since the raw mechanical sound of the flat-plane-crank V8 was among the most pleasing attractions of Ferrari's mid-engined two-seaters, it is hard to countenance why anyone would wish to shut it out.

For the 1997 model year Ferrari introduced a new transmission option across all models. The so-called "F1" gearbox exploited Ferrari's role as the pioneer of the semi-automatic gearbox in Formula 1, although in this application it is better described as a robotized manual version of the existing gearbox. Paddle switches mounted behind the steering wheel enabled the driver to shift up and down the gears while electronics handled the clutch action.

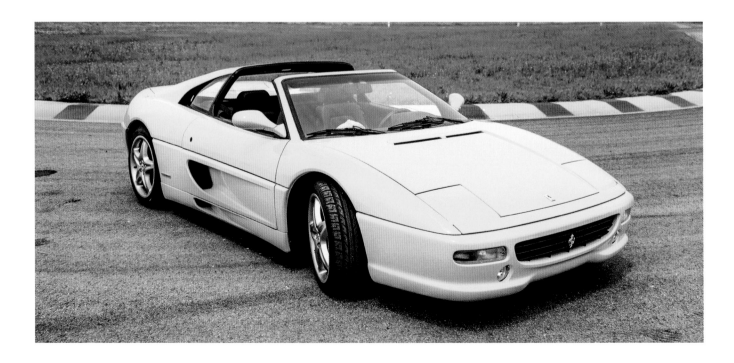

F355 Challenge
1995

ENGINE // 3496CC, V8

POWER // 283KW (380BHP) AT 8250RPM

CHASSIS // STEEL UNIBODY

GEARBOX // SIX-SPEED

TOP SPEED // 295KM/H (183MPH)

WEIGHT // 1350KG (2976LB)

By 1995 the Ferrari Challenge series was expanding its reach across most continents and major sports car markets, so it was inevitable that Ferrari would produce a Challenge kit for the F355, the 348's replacement, offering a similar package of light-touch modifications. Service for customers was also the same, as the F355 supplanted the 348 as the premier category in the arrive-and-drive race format. In 1997 Ferrari dropped the 348 from the series entirely, much to the chagrin of many owners.

By 1998 Ferrari had decided to scrap the system of selling kits to be fitted by dealers and began assembling complete F355 Challenges at the Maranello factory. By doing so it ensured greater consistency while ensuring the flow of profit went straight into the company coffers.

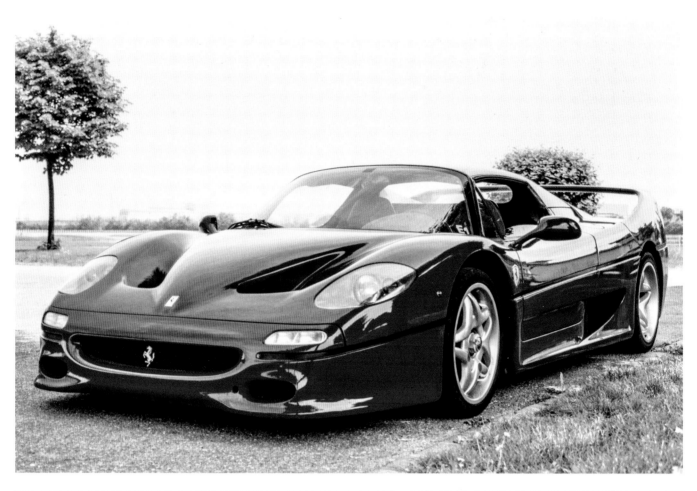

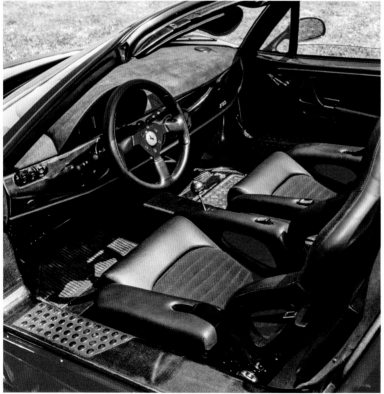

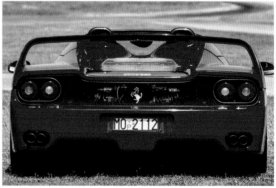

F50
1995

ENGINE // 4699CC, V12

POWER // 388KW (520BHP) AT 8500RPM

CHASSIS // CARBON FIBRE MONOCOQUE

GEARBOX // SIX-SPEED

TOP SPEED // 325KM/H (202MPH)

WEIGHT // 1230KG (2712LB)

Formula 1 technology for the road was what Ferrari promised with this slightly premature 50th anniversary car. And that, for the most part, was what it delivered, though a semi-automatic gearbox would be a notable omission.

The 4.7-litre V12 could trace its architecture back to the Tipo 036 engine used in Ferrari's 641 F1 racer – the car in which Alain Prost might have won the 1990 world championship had he not been bundled off the track by his bitter rival Ayrton Senna in a moment of sheer madness at the Japanese Grand Prix. Ferrari's choice of cast iron for the block was a matter of curiosity at the time, both externally and internally (Nicola Materazzi cited the reversion to iron blocks in racing engines as one of the growing catalogue of misgivings about the company's direction which led to him leaving in 1988). In Tipo F130 form the engine's stroke was extended to enlarge its displacement and increase torque, and lighter materials were used elsewhere: aluminium alloy for the Mahle pistons and five-valve cylinder heads, and titanium for the conrods. Magnesium housings for the oil and water pumps also helped minimize weight. A 4-litre version had already been used in the 333 SP sports-prototype.

Concerns about the F50's viability in the US market, with new emissions regulations due to come into force shortly, was what prompted Ferrari to bring forward its 50th birthday celebration. The F50's existence also solved another problem in the US: complaints from rival IMSA competitors about the 333 SP's engine not being derived from a road car. Ferrari's US racing clients were able to make the case that a closely related unit was indeed being used in the company's road range, adhering in a way to the letter of the law while blatantly circumventing its spirit.

Since the engine's progenitor had been designed to act as a stressed element of an F1 chassis, Ferrari was able to follow that construction principle through in the F50, forming the passenger cell as a carbon fibre monocoque with the V12 mounted directly to it. Movement of the rose-jointed wishbones all round was controlled via electronic adaptive dampers.

Pietro Camardella describes the F50 as his "unfinished" project since he left Pininfarina during development; the final design had input from others, including Lorenzo Ramaciotti and Ferrari management, hence a certain lack of purity compared with the F40. A total of 349 were built, the majority in Rosso Corsa.

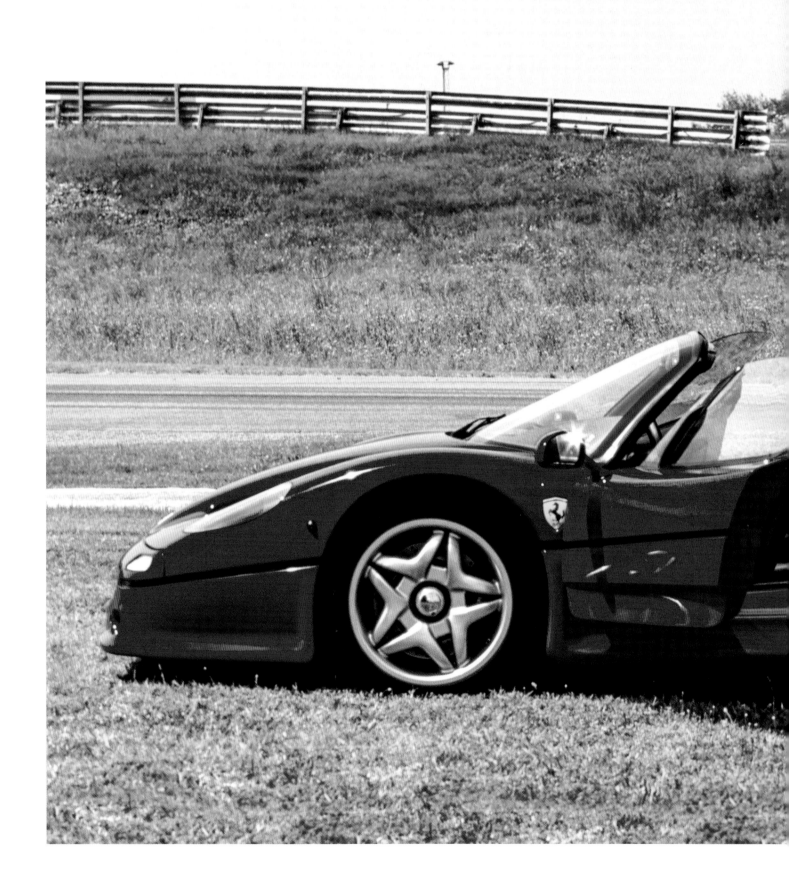

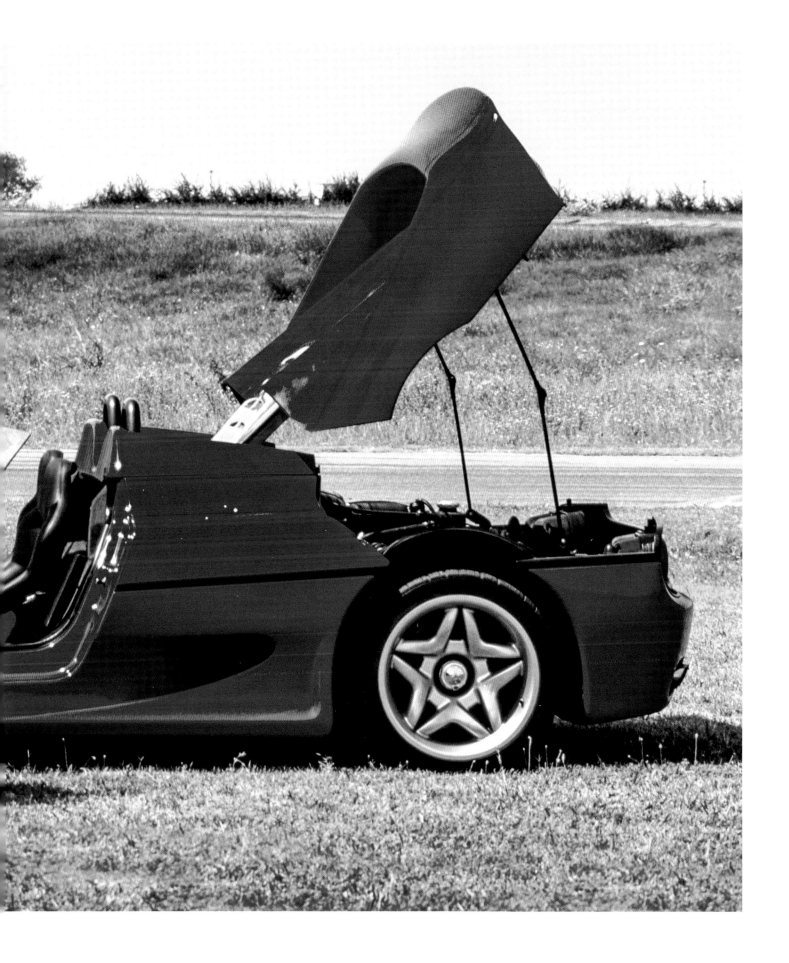

550 Maranello
1996

ENGINE // 5474CC, V12

POWER // 362KW (485BHP) AT 7000RPM

CHASSIS // STEEL SEMI-MONOCOQUE

GEARBOX // SIX-SPEED

TOP SPEED // 320KM/H (199MPH)

WEIGHT // 1690KG (3726LB)

Montezemolo-era Ferrari returned to the theme of the classic 365 GTB4 in the mid-1990s, turning back the clock on 23 years of mid-engined two-seaters powered by 12-cylinder engines. Evoking Enzo Ferrari's abiding principle that the horse should pull the cart, as well as establishing a clear break from antecedents now viewed as slightly naff products of their time, the company returned to market with a two-seat grand tourer powered by a V12 sitting ahead of the passenger compartment.

Two and a half years in development, the 550 Maranello arrived with a mission to prove that front-engined GTs could handle with the fluidity of those with the engine positioned amidships. Traction control, anti-lock brakes, and stability control offered an electronic safety net, but Ferrari's engineers carefully attended to the car's primary balance, specifying a six-speed manual transaxle. Magnesium wheels and brake callipers minimized unsprung weight while the car's structure and outer bodyshell was a combination of steel and aluminium, like the 456 GT. Ferrari was confident enough in the car's prowess to arrange its press launch at the Nürburgring circuit.

Pininfarina's Elvio D'Aprile styled the bodywork under Lorenzo Ramaciotti's supervision, with a mandate to channel the spirit of the iconic Daytona. The completed work was a remarkable achievement, seamlessly meshing visual cues from classic Ferraris including the 365 GTB4 – gill-style air outlets in the front wings, a swooping bonnet line, four round rear lights set in a neatly resolved tail – without becoming a pastiche.

The Tipo F133A V12 engine was a development of the one originally seen in the 456 GT. In this application the quad-cam, 48-valve cylinder heads were redesigned and mated to a new variable-tract induction system featuring what Ferrari described as "resonance effect". Power was abundant.

But it was the car's poise, balance, and manners which impressed as much as its sonorous V12. In the run-up to launch, influential figures in the motoring press had questioned Montezemolo's wisdom in dictating a return to mounting the engine up front. The 550 Maranello dispelled those doubts. *Autocar* magazine summed up the new car's achievement: "For all its speed and beauty, it [the 365 GTB4] showed that a mid-engined successor was necessary. The 550 shows that it is not."

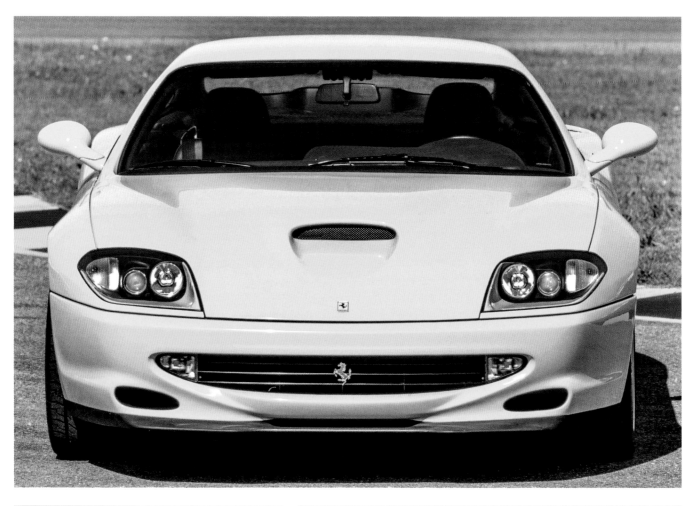

456M
1998

ENGINE // 4943CC, V12

POWER // 330KW (442BHP) AT 6250RPM

CHASSIS // STEEL SEMI-MONOCOQUE

GEARBOX // SIX-SPEED

TOP SPEED // 314KM/H (195MPH)

WEIGHT // 1690KG (3726LB)

The final step in the 456's evolution came with the unveiling of the M – for Modificata – at the 1998 Geneva Motor Show. Outwardly there were few discernible differences – small round foglights now sat in a neater and more aerodynamically optimized nose treatment, and the rear undertray had also been reconfigured – but the underpinnings benefitted from the latest technology.

Production of the 456 bodyshell had already transferred from Pininfarina's plant to Fiat-owned Scaglietti's works in Modena, part of a largely amicable long-term "conscious uncoupling" between Ferrari and the Torinese coachbuilder. Burgeoning profitability meant Ferrari was now stable enough to move towards manufacturing all its cars on its ever-expanding Maranello campus. A four-speed automatic gearbox was also now an option, though most buyers preferred the manual.

Underneath, a number of non-structural panels were now fabricated in composite materials, chiefly for corrosion resistance. The front suspension geometry was revised to resist dive – necessary given the larger front brake discs – while the on-board electronics received an upgrade including a new traction-control system. The latest Tipo F116C engine had a revised firing order for the sake of improved refinement.

While these detail changes contributed to the 456M's increased appeal, the new interior was perhaps the biggest draw: more plush front seats complemented a new and much neater fascia with more tactile switchgear and a new three-spoke steering wheel.

The 456M is seen as the most desirable of the models and used values have recovered in recent years after falling sharply in the 2008 global recession.

360
Modena
1999

ENGINE // 3586CC, V8

POWER // 298KW (400BHP) AT 8500RPM

CHASSIS // ALUMINIUM SPACEFRAME

GEARBOX // SIX-SPEED

TOP SPEED // 295KM/H (183MPH)

WEIGHT // 1400KG (3086LB)

The F355 was the backbone of Ferrari's sales renaissance in the 1990s, moving over 10,000 examples during its five-year lifespan. But the sportscar market never ceased its forward momentum and, with the memory of the 348's embarrassment at the hands of Honda's NSX still fresh, Ferrari knew the F355's replacement would need to move the game on again. Lamborghini had been bought by Audi and was readying a "baby supercar", but Maranello was brimming with confidence wrought from burgeoning sales of its road cars and increasing success on the track as the F1 programme transformed under new management.

Thus it was no surprise the new car looked nothing like the old when the covers came off at the 1999 Geneva Motor Show. Goran Popović's bold design was curvaceous rather than angular while cleverly integrating several familiar Ferrari design cues such as the sculpted air intakes. The 360 was bigger and wider than its predecessor, more spacious and comfortable inside, more aerodynamic outside, and a step more refined to drive.

In partnership with the US company Alcoa, Ferrari built the 360 in aluminium, using rigorous fine-element analysis to focus the density of the welded sections in areas subject to highest stress, while specifying thinner, bonded metal elsewhere. Despite its larger size the 360 was only a little heavier than the F355.

The enlarged V8 now boasted variable valve timing and a new throttle trumpet design which made the most of the aerodynamically optimized air inlets. Fly-by-wire throttle, a first for Ferrari, added further refinement.

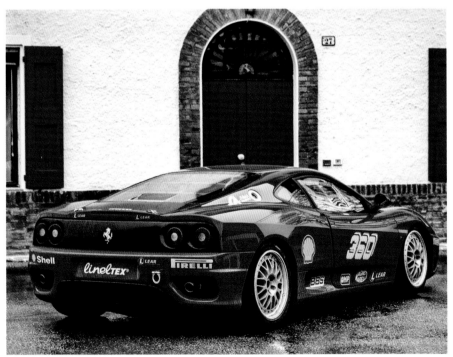

360
Modena Challenge
1999

ENGINE // 3586CC, V8

POWER // 306KW (410BHP) AT 8500RPM

CHASSIS // ALUMINIUM SPACEFRAME

GEARBOX // SIX-SPEED

TOP SPEED // 298KM/H (185MPH)

WEIGHT // 1169KG (2577LB)

The ongoing success of the global network of Ferrari Challenge series naturally led to Ferrari launching a race-ready Challenge spec of the 360 Modena within months of unveiling the new model. By now the Challenge cars had evolved beyond the relatively humble origins of the series machinery. As with the final iteration of the F355 Challenge, the new cars were built to order in Challenge spec at Maranello; nothing was left to dealers or owners.

To cut weight from the base car and give a properly racy feel, Ferrari stripped out the cosseting elements: air conditioning, in-car entertainment, the instrument panel (replaced by a Magnetti Marelli LCD display) airbags, electric windows, the central locking mechanism, the soundproofing, and the electrically adjustable seats. Lexan side windows replaced glass in doors now built from carbon fibre. A lightweight straight-through exhaust contributed further reductions but, apart from this, the engine remained untouched.

An FIA-homologated roll cage ensured legality along with bucket seats, multi-point harnesses, and a fire extinguisher system. BBS spoked alloy wheels with visible gold-coloured Brembo racing brake callipers and slick racing rubber completed the race-ready look. A Bosch ASR anti-lock-braking and traction-control system was on hand to spare the blushes of those owners whose enthusiasm and commitment exceeded their competence and judgement.

The "F1" robotized gearbox was a standard feature, though the paddles were enlarged for easier operation. While some in the media were mildly critical of the presence of electronic driver aids, the 360 Challenge's customer base adopted them with due enthusiasm.

- 360 SPIDER
- ROSSA
- 550 BARCHETTA PININFARINA
- 575M
- ENZO
- SCAGLIETTI
- 599 GTB FIORANO

2000s

360
Spider
2000

ENGINE // 3586CC, V8

POWER // 298KW (400BHP) AT 8500RPM

CHASSIS // ALUMINIUM SPACEFRAME

GEARBOX // SIX-SPEED

TOP SPEED // 290KM/H (180MPH)

WEIGHT // 1350KG (2976LB)

While the 360 Modena had received glowing reviews for the most part, some voices lamented its more rounded appearance and slightly softer-edged demeanour ("Dare I suggest that in Ferrari's endless quest to keep the signs of age at bay, they've gone a face-lift too far and created Zsa Zsa Gabor in aluminium," complained Jeremy Clarkson in *Top Gear* magazine. "A 360 in its 'sport' setting feels exactly the same as the 355 in 'comfort'"). The Spider version successfully swayed many if not all the doubters.

Ferrari had designed the 360's spaceframe with an open-top variant in mind, so the structure required little in the way of additional metal bracing around the rear bulkhead – and could accommodate a larger roof aperture than previous mid-engined drop-top Ferraris. Pininfarina therefore had a much freer hand in styling the shoulders and rear deck, resulting in neatly integrated aerodynamic "blisters" with accompanying leather-trimmed roll-over hoops. The electrically operated hood could deploy in around 20 seconds and retracted fully within the flush-fitting deck when not in use. It was costly to engineer, though, and this expense was naturally reflected in the retail price.

In the summer of 2000 Luca di Montezemolo got married and, as a wedding present, Fiat magnate Gianni Agnelli commissioned a silver 360 Spider customized by Pininfarina with a low-profile fixed windscreen among other unique features. It was a fitting gift for the individual who had transformed the company's fortunes and whose restructure of the F1 team had finally delivered on track: in 1999 Scuderia Ferrari had won the constructors' title for the first time since 1983.

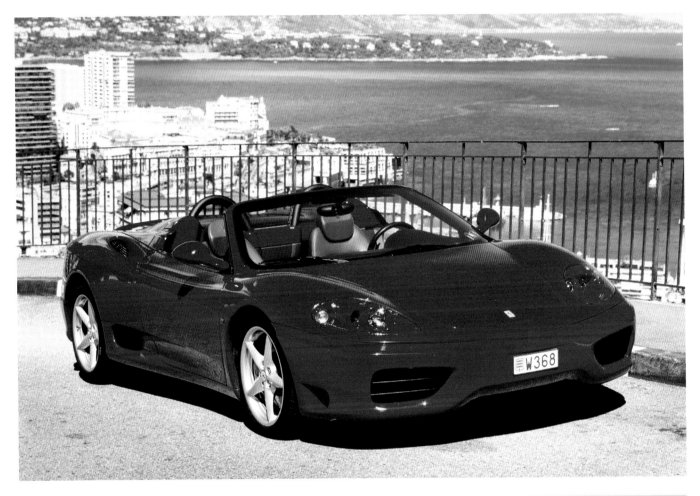

Rossa

2000

ENGINE // 5474CC, V12

POWER // 362KW (485BHP) AT 7000RPM

CHASSIS // STEEL SEMI-MONOCOQUE

GEARBOX // SIX-SPEED

TOP SPEED // N/A

WEIGHT // N/A

Once again Pininfarina celebrated a notable birthday in the form of a car, this time a model to commemorate 70 years in the coachbuilding trade and nearly 50 years of working with Ferrari. The concept car's name explicitly referenced Maranello's racing colours while its shape and details was akin to a "greatest hits" collection of Pininfarina–Ferrari styling cues. While the 1950s-style ovoid "egg-crate" grille looked slightly uncomfortable flanked by air intakes like those of the contemporary 360 Modena, the modern interpretation of the original racing Testarossa's pontoon fenders was highly successful.

The ultra-low bonnet line enabled the stylists to cut away a portion around a decorative engine cover, a modern take on the bonnet scoops of Ferrari's 1950s racers. A low wrap-around windscreen was a clear nod to the Le Mans-winning sports-prototypes of the '50s and '60s.

At the rear, the shoulder line flowed around the base of aerodynamically shaped roll-over bars towards a cut-off tail crowned by four inset round lights. This treatment would be adopted on later Ferrari road models.

Other less immediately obvious details were the absence of door handles – these were concealed within the cockpit – and rear-view mirrors. A camera behind the occupants transmitted pictures to a screen mounted ahead of the gearshift, itself a decorative feature mounted in an elevated position with a polished metal gate. Bucket-style non-adjustable seats completed the race-ready effect.

The running gear was based on the 550 Maranello, specifically one of the prototypes for the 550 Barchetta. After its appearance at Turin the Rossa was placed on permanent display at the Pininfarina museum.

550
Barchetta Pininfarina
2000

ENGINE // 5474CC, V12

POWER // 362KW (485BHP) AT 7000RPM

CHASSIS // STEEL SEMI-MONOCOQUE

GEARBOX // SIX-SPEED

TOP SPEED // 299KM/H (186MPH)

WEIGHT // 1690KG (3726LB)

Ferrari marked Pininfarina's 70th anniversary with a lucrative limited-edition 550 which celebrated the barchetta-style racers of the 1950s. While not as extreme as Pininfarina's own 70th birthday present to itself, the Rossa, this 550 derivative really was a barchetta rather than a convertible: it had no folding roof. Ferrari supplied a rudimentary cover – very basic, considering the rarefied nature of the car – which could be erected like a tent over the cockpit to protect it from the elements while at rest. Buyers were advised not to exceed 113km/h (70mph) with it in place.

The cockpit cover also served to exaggerate the 550 Barchetta Pininfarina's only stylistic shortcoming, namely that the roll-over hoops behind the occupants' heads were slightly taller than the windscreen, a consequence of complying with crash-protection regulations. The windscreen had been lowered, supposedly for aerodynamic reasons and to provide a visual connection to the low-screened racing barchettas of the 1950s. Another compelling reason for truncating it was the presence of thick-gauge steel tubing within, the better to resist crushing forces in the event of a roll.

Every car featured a plaque signed by Sergio Pininfarina mounted on the centre console. Upon launch at the 2000 Paris Motor Show it was made explicit that production would be limited, and Ferrari composed a list which admitted only the best customers. This in itself was something of a return to tradition: in Enzo Ferrari's pomp, he would be the final arbiter of whether he sold you a car or not. 460 550 Barchetta Pininfarinas were built, of which 12 were pre-production prototypes.

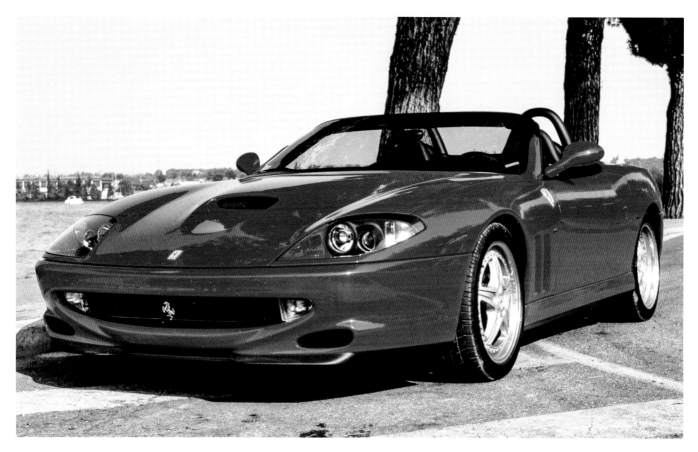

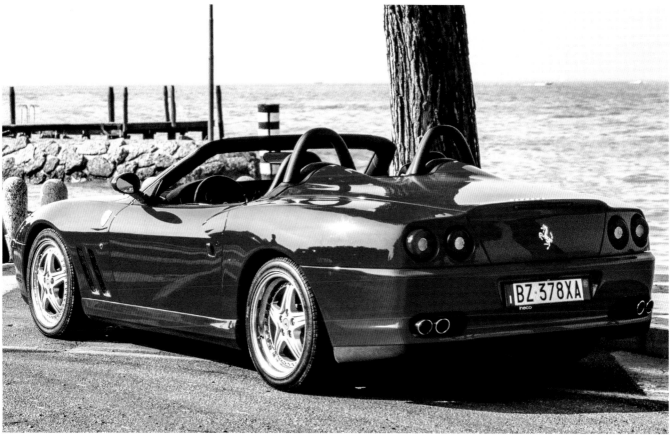

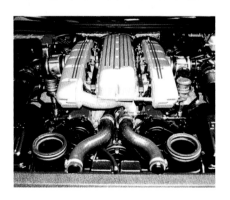

575M
2002

ENGINE // 5748CC, V12

POWER // 379KW (508BHP) AT 7250RPM

CHASSIS // STEEL SEMI-MONOCOQUE

GEARBOX // SIX-SPEED

TOP SPEED // 325KM/H (202MPH)

WEIGHT // 1730KG (3814LB)

When Ferrari came to refresh the successful 550 Maranello for the new decade it seemed pointless to change too much about what was a particularly harmonious and elegant design. But, with a larger engine to accommodate, the breathing requirements also increased. Pininfarina tweaked the car's front bumper design to feature a taller and slightly narrower radiator aperture, with the bonnet crowned by a much more protuberant air scoop. Xenon headlights replaced traditional bulbs and the 575M also came with a new five-spoke alloy wheel design.

Under the skin, changes were more extensive as the 575M adopted Ferrari's "F1" paddle-shift automated manual gearbox; when the car was launched at Geneva in 2002, Michael Schumacher had just delivered Ferrari's second F1 drivers' title and the company's involvement in top-level motor racing was no longer the source of puzzlement.

Enlarging the V12 to 5.7 litres delivered a 17kw (23bhp) boost as well as greater torque, marshalled by an improved array of electronic driver-assistance systems and adaptively damped suspension.

Initial feedback from road testers suggested that the greater power occasionally overwhelmed the 575M's ability to contain it, resulting in a less fluent driving experience than the 550 Maranello. Within months Ferrari launched a "Fiorano" handling pack which lowered the suspension by 10mm (0.39in) and swapped in tighter anti-roll bars and a quicker steering rack. The company then quietly made this spec standard on later production models.

A further "GTC" performance package comprised new 19-inch wheels with Pirelli P Zero Corsa tyres, suspension and exhaust upgrades, and a carbon-ceramic brake setup.

Enzo

2002

ENGINE // 5998CC, V12

POWER // 485KW (650BHP) AT 7800RPM

CHASSIS // CARBON FIBRE–ALUMINIUM HONEYCOMB MONOCOQUE

GEARBOX // SIX-SPEED

TOP SPEED // 349KM/H (217MPH)

WEIGHT // 1480KG (3263LB)

"The closest you can get to the F1 experience in a road car" was Ferrari's promise and, when the car most pundits expected to be badged the F60 was revealed, it was certainly a supreme evocation of form following function. Few bar the most obsessive Ferrari fans would describe the Enzo as conventionally pretty, but it wore its Formula 1 influences in plain sight.

In 2002 Ferrari's F1 team were reaching the height of their powers. By the time the Enzo was unveiled at the Paris Motor Show in late September, Michael Schumacher had long since put the world championships beyond doubt, scoring enough points to win the drivers' title at the French Grand Prix in July – with six rounds remaining. Trickle-down technology to the Enzo included an F1-derived carbon fibre and aluminium honeycomb monocoque chassis with the engine mounted directly to the tub, a paddle-shift gearbox, pushrod-actuated dampers, and carbon-ceramic brakes.

The aerodynamics were also far more closely related to a racing car's than anything Ferrari had yet built for the road. Crude spoilers and dive planes were absent, though an extendable plane would rise from the rear deck at speed to aid stability. The Enzo traded off downforce against drag similarly to an F1 car: with sharply angled surfaces at the front, a flat floor, and a diffuser between the rear wheels which generated negative pressure with rising ground speeds.

Ferrari's new Tipo F140 V12 set the record for the world's most powerful naturally aspirated road car engine, producing 485kw (650bhp). While the paddle-shift six-speed gearbox was a development of the previous robotized manual transmission, Ferrari had revised it extensively to speed up shift times. As with an F1 car, switches on the steering wheel enabled the driver to move between the many different driving modes (although, of course, in F1 such niceties as the Enzo's adaptive damping, stability control, ABS, and traction control were outlawed). Shift lights on top of the steering wheel indicated when the engine was about to hit its rev limiter, though anyone attempting to reach this point on the road would require supreme commitment and friends in the right places.

Evo magazine summed up the Enzo experience perfectly: "Anyone who climbed out of an Enzo and said it wasn't fast enough was either a liar or Michael Schumacher."

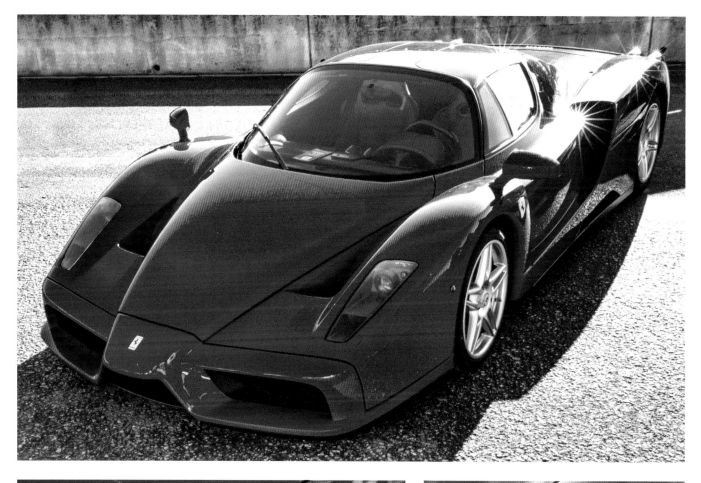

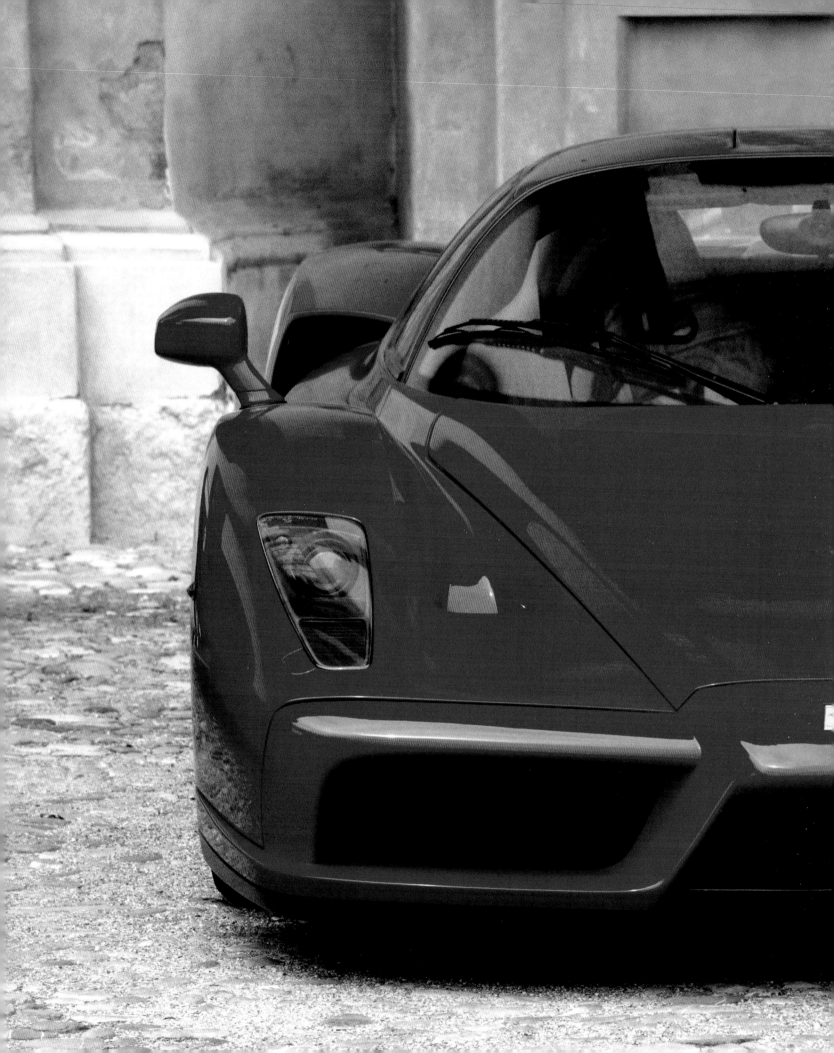

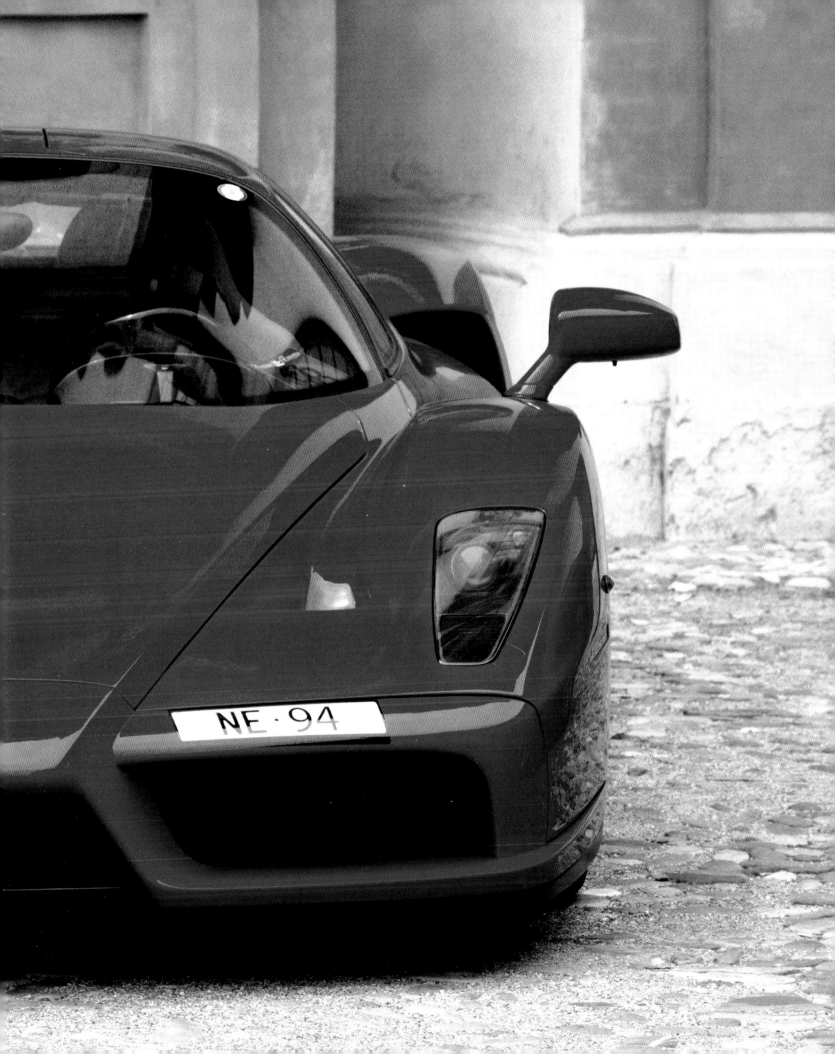

Scaglietti
2004

ENGINE // 5748CC, V12
POWER // 403KW (540BHP) AT 7250RPM
CHASSIS // STEEL SEMI-MONOCOQUE
GEARBOX // FIVE-SPEED
TOP SPEED // N/A
WEIGHT // 1840KG (4057LB)

Raiding Ferrari's past for evocative names and concepts was another of Luca di Montezemolo's initiatives and the 612 Scaglietti offered two in one package. Even before the car was revealed at the Detroit Motor Show in January 2004, Ferrari had made it known that not only would the car be named in honour of master coachbuilder Sergio Scaglietti, its styling would ape that of the "Speciale" 375 MM commissioned by film director Roberto Rossellini for his muse, Ingrid Bergman, in 1954. The company had also formulated a shade of grey paint matching the original, which it made available on the options list as Grigio Ingrid.

Like the Enzo the 612 Scaglietti was the work of Ken Okuyama at Pininfarina; it would be his last production Ferrari before he left to set up his own design consultancy. Longer and higher than the 456 GT it replaced, the 612 offered perceptibly more interior space and permitted easier access for rear-seat passengers. The aluminium spaceframe chassis – clad with aluminium panels – adopted lessons from the mid-engined 360 Modena series although the long nose gave away the V12's location. As with the 599 GTB which would follow, the engine was located as far behind the front axle line as possible to offer better primary balance.

Appropriately enough, the body panels and chassis were made in the former Scaglietti plant on Via Emilia Est, Modena. At the time, the 612 was the biggest Ferrari ever built; once on the move, though, it disguised its bulk fluently with the assistance of the latest stability control and adaptive damping technology. "A car of immense ability" was how *Autocar* magazine described it.

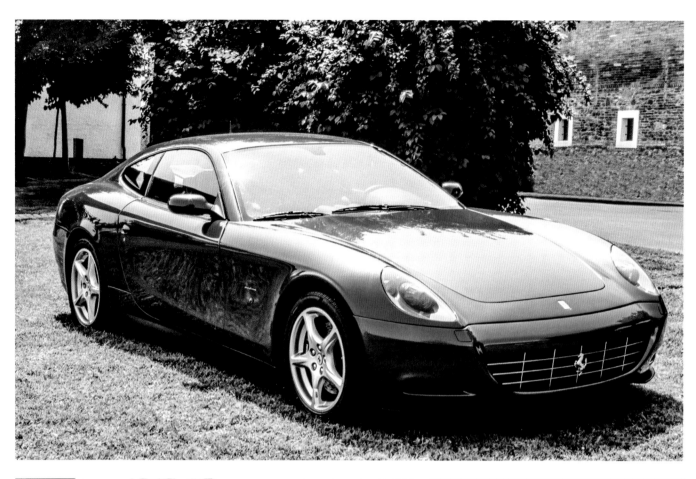

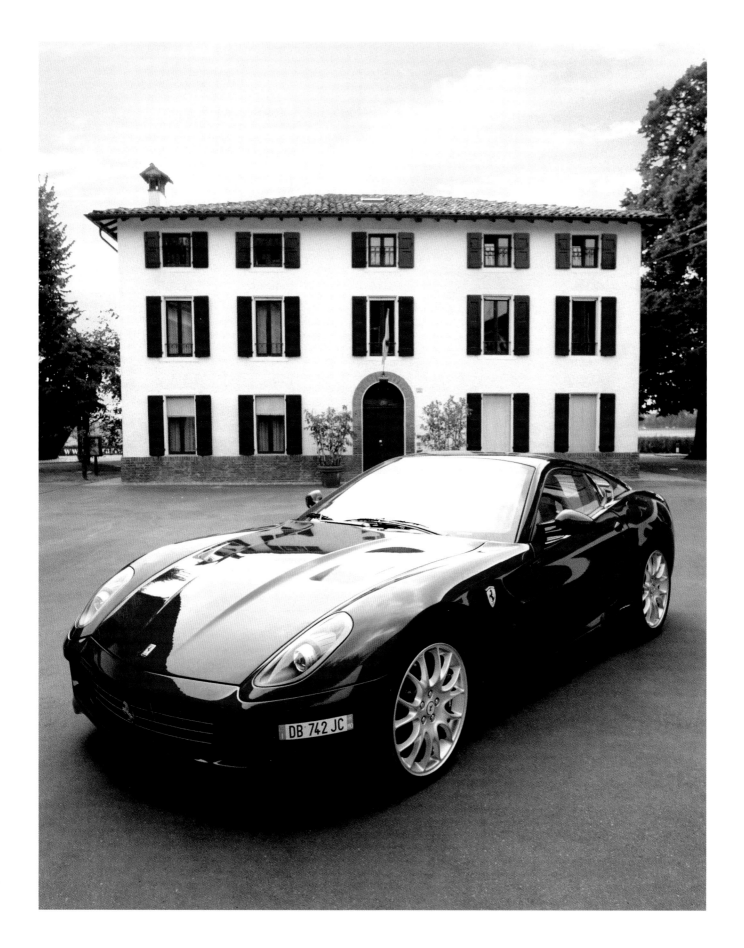

599
GTB Fiorano
2007

ENGINE // 5998CC, V12

POWER // 462KW (620BHP) AT 7600RPM

CHASSIS // ALUMINIUM SPACEFRAME

GEARBOX // SIX-SPEED

TOP SPEED // 330KM/H (205MPH)

WEIGHT // 1580KG (3483LB)

Ferrari had not quite finished running the gamut of evocative names and locations related to the company, alighting on "Fiorano" as an appellation for the 575's replacement. Fittingly for a car named after Ferrari's on-site figure-of-eight track, where Michael Schumacher had pounded through countless laps perfecting a series of championship-winning Formula 1 machines, the 599 GTB offered race-bred agility in a cosseting GT wrapping.

Mindful that the first 575s off the line were seen as less dynamically competent than the 550, Ferrari had set challenging benchmarks for the 599's engineers. The aim was no less than to offer levels of performance, poise, and driver engagement along the lines of Maranello's most exalted mid-engined products – perhaps even approaching that of the F40.

The aluminium spaceframe chassis had much in common with the 612 Scaglietti's, though it was shorter in the wheelbase. Pushing the Enzo-derived V12 as far back in the frame as possible and arranging the other masses to give a slightly rearward weight balance helped endow the 599 with a poise to match a mid-engined car, as well as giving the rear tyres the best chance of laying down 462kw (620bhp). Pininfarina's Jason Castriota cleverly disguised this configuration with a long, sweeping windscreen and a short front overhang; the bodyshell was elegantly understated in the coachbuilder's classic style.

Magnetorheological adaptive dampers, a dynamic stability system, and a new super-fast paddle-shift gearbox provided the driver with the tools to marshal the 599's extraordinary power. Performance was in the so-called supercar bracket occupied by the likes of the Pagani Zonda, a remarkable achievement for a GT.

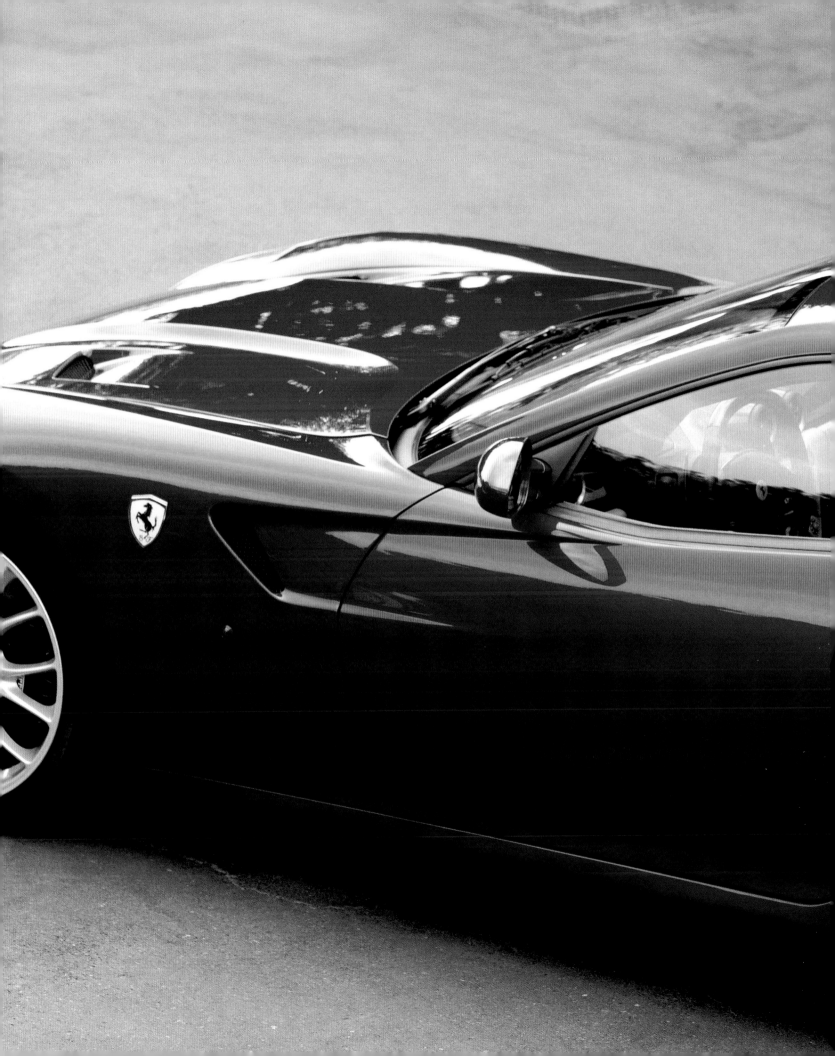

Index

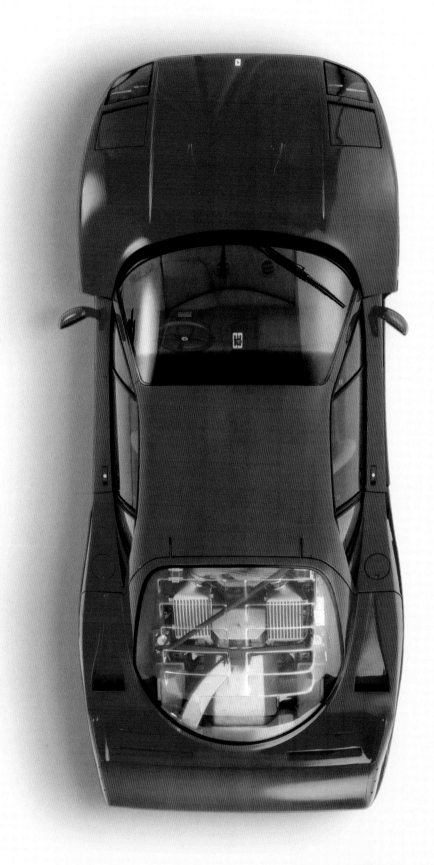